Between Union and Liberation

Between Union and Liberation

Women Artists in South Africa 1910–1994

Edited by
Marion Arnold *and*
Brenda Schmahmann

ASHGATE

Published by
Ashgate Publishing Limited
Gower House
Croft Road
Aldershot
Hants GU11 3HR
England

Ashgate Publishing Company
Suite 420
101 Cherry Street
Burlington, VT 05401-4405
USA

Ashgate website: http://www.ashgate.com

British Library Cataloguing in Publication Data
Between union and liberation : women artists in South Africa, 1910–1994
1. Art, South African – 20th century. 2. Women artists – South Africa – History – 20th century.
 3. Gender identity in art. 4. Politics in art. 5. Africa, Southern – In art
 I. Arnold, Marion I. II. Schmahmann, Brenda
 704'.042'0968'0904

Library of Congress Cataloging-in-Publication Data

Between union and liberation : women artists in South Africa 1910–1994/edited by Marion Arnold and Brenda Schmahmann, – 1st ed.
 p. cm.
 Includes bibliographical references and index.
 ISBN 0-7546-3240-7 (alk. paper)
1. Women artists – South Africa. 2. Art, South African – 20th century. 3. Feminism and art – South Africa. I. Arnold, Marion I. II. Schmahmann, Brenda.

N7395.6.B47 2005
704'.042'09680904–dc22 2004013981

ISBN 0 7546 3240 7

Printed on acid-free paper

Typeset in Times New Roman by D C Graphic Design Ltd, Swanley, Kent
Printed and bound in Great Britain by MPG Books Ltd, Bodmin

Contents

List of Plates

(between pages 32 and 33)

1 Bertha Everard, *Looking Towards Swaziland*, 76 × 102 cm
 (30 × 40 inches), oil on canvas, *c*.1920/21, Collection of the
 Pretoria Art Museum.

2 Irma Stern, *Bibi Azziza Biata Jaffer*, 91.7 × 84.8 cm (36 × 33^1/$_4$ inches),
 oil on canvas, 1939, Collection of the Rupert Art Foundation,
 Stellenbosch, Republic of South Africa.

3 Bonnie Ntshalintshali, *The Last Supper*, 52 × 32 × 55 cm
 (20^1/$_2$ × 12^1/$_2$ × 21^1/$_2$ inches), painted ceramic, 1990, Standard Bank
 Corporate Collection, Johannesburg.

4 Salphina Maluleke (of Chivirika embroidery project), *Crocodile, Trees
 and Two Birds*, 147 × 110 cm (57^3/$_4$ × 43^1/$_4$ inches), embroidery on
 black cotton, *c*. late 1980s, Private collection. Photograph by Obie
 Oberholzer.

5 Mmakgabo (Helen) Sebidi, *Modern Marriage*, 183.7 × 267.2 cm
 (72^1/$_4$ × 105^1/$_4$ inches), oil on canvas, 1988, Collection of the
 Johannesburg Art Gallery.

6 Mmakgabo (Helen) Sebidi, *I Have Seen Through Him*, 105 × 80 cm
 (41^1/$_4$ × 31^1/$_2$ inches), mixed media on paper, 1989, Standard Bank
 Corporate Collection, Johannesburg.

7 Penny Siopis, *Embellishments* (detail), 150 cm × 202 cm
 (59 × 79^1/$_2$ inches), oil and plastic ballerinas on canvas, 1982,
 Collection of the University of the Witwatersrand, Johannesburg.
 Photograph by Wayne Oosthuizen.

8 Penny Siopis, *Patience on a Monument – 'A History Painting'*,
 198 × 176 cm (78 × 69^1/$_4$ inches), oil and collage on board, 1988,
 Collection of the William Humphreys Art Gallery, Kimberley.

List of Figures

List of Contributors

Marion Arnold lectured at the University of South Africa and the University of Stellenbosch and is now an independent art historian, lecturer and artist based in Norfolk, United Kingdom. Her publications include *Zimbabwean Stone Sculpture* (1986), *Irma Stern: A Feast for the Eye* (1995), *The Life and Work of Thomas Baines 1820–1875* (with Jane Carruthers) (1995), *Women and Art in South Africa* (1996) and *South African Botanical Art: Peeling Back the Petals* (2001).

Jillian Carman is an art historian and museologist based in Johannesburg, with an interest in the history of South African museums and public art collections, current art and heritage debates, and creative Johannesburg inner city initiatives. She was a curator at the Johannesburg Art Gallery for a number of years and is the author of various catalogues, articles and essays on the gallery's collections and history.

Wilma Cruise is a sculptor working mainly in clay, an independent curator and a writer on art and ceramics. She is the author of *Contemporary Ceramics in South Africa* (Struik Winchester, 1991). Represented in major South African collections, she has had many one-person exhibitions and is the creator of the National Monument to the Women of South Africa in Pretoria.

Brenda Danilowitz is Chief Curator at the Josef and Anni Albers Foundation, Bethany, Connecticut. She has taught Art History at universities in South Africa and the USA. Her publications include *The Prints of Josef Albers: A Catalogue Raisonné 1915–1976* (Hudson Hills Press, 2001) and essays in journals and exhibition catalogues on contemporary southern African artists and on Josef and Anni Albers.

Nessa Leibhammer works independently in the art and heritage field. Formerly a museum curator of African art collections at the University of the Witwatersrand and the Johannesburg Art Gallery, she has also held the position of portfolio manager of a corporate art collection and its associated social investment programme.

Jacqueline Nolte is Department Head of Visual Arts at the University College of the Fraser Valley, Canada. Formerly a lecturer at the University of Cape Town, she chaired the Board of Trustees at the Community Arts Project in Cape Town and served as board member for the South African National Gallery. Her publications include essays in catalogues, journals and books on contemporary South African art.

Brenda Schmahmann is Professor and Head of the Fine Art Department, Rhodes University, Grahamstown, South Africa. Her recent publications focus on South African artists, Southern African needlework projects and gender issues. *Material Matters* (Wits University Press, 2000) accompanied a travelling exhibition of needlework from Zimbabwe and South Africa. *Through the Looking Glass* (David Krut Publishing, 2004) explored self-portraits by South African women artists.

Liese van der Watt taught at the University of South Africa and currently teaches Art History and Popular Culture in the Department of Historical Studies at the University of Cape Town. Her recent research and journal publications focus on white identity and visual culture in post-apartheid South Africa.

Acknowledgements

The editors of this publication had a vision: we wanted to bring the work and lives of South African women artists to the attention of the western world. Although South Africa was readmitted to the world community in 1994, long years of political and cultural isolation had curtailed the circulation of information about twentieth-century South African women artists. Their stories need to be told to an audience beyond Africa and the works they made should be visible. This book attempts to address these issues.

We are indebted to many people for helping us to bring our vision to fruition. First, sincere thanks go to Erika Gaffney, Senior Editor at Ashgate Publishing in the United States, for her support from the time this project was first proposed. We also want to thank our contributors who wrote specially for this publication. Their essays, reflecting their expertise and specialist research, enabled us to construct a book that ranges over women's lives in South Africa and explores their creativity from different perspectives.

All writers rely on goodwill and generosity of spirit from many institutions and individuals. We have had excellent cooperation from a multitude of people who have met our requests to assist financially and practically. Individuals and institutions supplied images, granted permission to reproduce artworks and waived or reduced fees; others contributed to reproduction expenses or funded images.

Special thanks go to Rhodes University, Grahamstown, for generously funding images and research expenses. We are also very grateful to the following people and thank them for all that they did to help us: Fée Halsted-Berning, coordinator of Ardmore, KwaZulu-Natal; Deon Hurselman and the Rupert Art Foundation, Stellenbosch; Christopher Peter, Curator of the Irma Stern Museum and the Museum Trustees, Cape Town; the staff of the Pretoria Art Museum; Carol Brown and the Durban Art Gallery; the MTN Foundation, Johannesburg; the Board of Control of the Voortrekker Monument, Bloemfontein; the Voortrekker Museum, Pietermaritzburg; the Research Council of the University of Cape Town; the Johannesburg Art Gallery; MuseuMAfrica, Johannesburg; the William Humphreys Museum, Kimberley; the Sasol Art Collection, Johannesburg; Goodman Gallery, Johannesburg; the Standard Bank Art Gallery, Johannesburg; Julia Charlton and the University of the Witwatersrand Art Gallery, Johannesburg; Kate Abbott and Historical Papers, William Cullen Library, University of the Witwatersrand; the South African History Archive; Nicholas Fox Weber, Executive Director of the Josef and Anni Albers Foundation, Bethany, Connecticut; Liesl Dana, photo services coordinator at the National Museum of African Art Washington DC; and the University College of the Fraser Valley, Canada.

Finally, we want to record our gratitude to Patricia Stuart Lorber and Paul Mills for their unfailing love and support while we worked on this publication.

Marion Arnold and Brenda Schmahmann

Visual Culture in Context
The Implications of Union and Liberation

MARION ARNOLD

'I believe that an attempt to base our national life on distinctions
of race and colour . . . will . . . prove fatal to us'.
(Olive Schreiner, *Closer Union*, 1909, cited in Butler, 1999, p.18).

Union is a seemingly innocuous word but it has a sting and Olive Schreiner
(1855–1920), well-known feminist, writer and activist, foresaw the dangers
that lay ahead for a proposed Union of South Africa. The political process of
bringing parts together is seldom devoid of tension as the United Kingdom of
Great Britain and Northern Ireland, the United States of America and the
Union of Soviet Socialist Republics all discovered after attempting to establish
national identities after territorial mergers. The Union of South Africa was
created in 1910 and, until liberation from apartheid rule in 1994, successive
white minority governments tried to forge a nation, on their own terms, from
fractious parts and peoples with radically different histories.[1]

The British Parliament established its new African dominion from four
colonies, the Cape, Natal, the Transvaal and the Orange Free State, the last two
being former independent Boer states that had fought Great Britain in the
Second South African (Anglo–Boer) War (1899–1902). After an election in
1910, in which only men voted, General Louis Botha (1862–1919) became
Prime Minister of a country that was anything but unified politically, although
it comprised a logical geographical entity (Fig. 1.1). The population was
composed of white settlers, predominantly of Dutch, British and French
Huguenot ancestry, nine major black groups – Zulu, Xhosa, Tswana, Venda,
Sotho, Ndebele, Tsonga, Swazi, Pedi[2] – as well as a mixed race, 'coloured'[3]
group, and people of Asian, mainly Indian, ancestry. The people spoke
English, the 'Dutch' tongue that officially became Afrikaans in 1925 and a
variety of black languages, while the dominant religions were Christianity,
indigenous African religions, Islam and Hinduism.[4]

After Union, three cities were accorded capital status: Cape Town (the
Mother City) became the legislative capital, Bloemfontein in the Orange Free
State was the judicial capital, and Pretoria, the city from which the Boer leader
Paul Kruger (1825–1904) had ruled the South African Republic, was
proclaimed the administrative capital.[5] It was decided to construct new

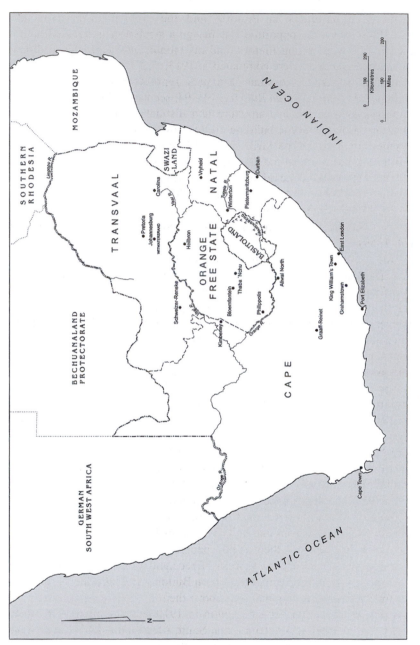

Fig. 1.1 South Africa in 1910.

2

administrative buildings in Pretoria and the architect Herbert Baker (1862–1946) seized the opportunity to design a symbol of unity. He chose a prime hill site overlooking Pretoria and his monumental buildings, redolent with imperial grandeur, were completed in 1913.

Although stylized, Rossinah Maepa's representation of the Union Buildings, *New South African Rule* (c.1993–94; see jacket illustration and Fig. 8.5), shows their impressive structure and distinctive profile. Between the semicircular frontage of the building are two towers; Baker intended them to represent unity between the Afrikaners and English. The prime aim of Union had, after all, been to heal the deep rift between white South Africans rather than to address black–white relations. Always fraught with tension, attempts at achieving unity between Afrikaans- and English-speaking South Africans, let alone black and white communities, were finally quashed in 1948 when the Afrikaner Nationalist government assumed power under Dr D.F. Malan (1874–1959).

By the 1950s, the concept of union no longer had any meaning within South Africa. The Nationalist government was systematically introducing apartheid[6] and enforcing its separatist ideology in legislation that promoted racial discrimination and divided black and white people socially and territorially. Moreover, the government resented the historical relationship between the Union and the United Kingdom and decided to sever the ties. On 31 May 1961 South Africa became a republic and ceased to be a member of the Commonwealth of Nations. Britain's former dominion, long accustomed to geographical separation from Europe, drifted into political isolation, a condition that was exacerbated as the world community condemned apartheid and initiated economic sanctions and academic, cultural and sporting boycotts.[7]

The Nationalists ruled South Africa from 1948 until 1994 when peaceful, democratic, adult suffrage elections were held. Nelson Mandela (b.1918), who is identified in Maepa's enchanting embroidery portrait by his name rather than his distinctive appearance, was inaugurated as the first black President of the Republic of South Africa at the Union Buildings on 10 May. The ceremony took place amidst optimism that unity would finally be achieved as the 'new South Africa' was born and the 'rainbow people' (Archbishop Desmond Tutu's memorable phrase) initiated a process of reconciliation. In her embroidery, Maepa updates the symbolism of the Union Buildings by introducing the new, colourful South African flag that flies above them.

Appraising the period between Union in 1910 and liberation from white minority rule in 1994, it is apparent that South Africa embarked on a process of nation building that was flawed from the outset by hostility between English- and Afrikaans-speaking Europeans, and by black–white racial tension. Although the race issue had dominated South African life from the time of European settlement at the Cape in 1652, after the 1948 election racial

classification permeated and affected every level of political and social interaction. From the 1950s the Nationalist government systematically entrenched racism in the legislation of a non-democratic society that promoted inequality and enforced separation.

Residential apartheid was strictly administered and, under the Group Areas Act, the government also controlled segregation in places of entertainment, libraries and even churches in white areas. Access to buildings such as post offices and shops was established by separate entrances, while public transport, benches and beaches bore the signs 'Europeans' and 'Non-Europeans'. There were separate health facilities and schools for different population groups and, after 1957, apartheid was extended to university education with the founding of four ethnic university colleges.[8] Given the fact that it was difficult to make meaningful daily contact across the colour barrier, it was not surprising that women were unable to share experiences ranging from childbirth to domestic violence and patriarchal oppression.[9] In effect, apartheid not only divided people along racial lines but also suppressed the politics of gender while strengthening patriarchal power and attitudes: discrimination against women was masked by racial discrimination.

The women's movement was slow to gain credibility in South Africa. Both white and black men mounted propaganda against it: white people were informed that *die swart gevaar* (the black threat) was the primary danger while black people were told that 'a woman's place is in the struggle'. This popular catchphrase appeared on 1980s resistance posters and although the visual language of the struggle posters included women, they were invariably placed behind their male comrades.[10] Individuals were urged to see race, not gender, as their primary identity because race determined experiences of privilege or oppression, opportunity or deprivation, wealth or poverty, freedom of movement or restriction. It promoted or impeded access to education and health facilities, and defined opportunities for personal growth and economic empowerment. Although women's rights were addressed in the post-liberation 1997 South African constitution, the rule of men continued to prevail nationally, locally and domestically. Furthermore, the horrific level of male violence against women, which characterizes post-1994 South Africa, indicates that liberation is still a concept rather than a reality for many female South African citizens in the twenty-first century.

Politics and Women

When considering the political decisions and events that shaped twentieth-century South African history, some are particularly relevant to understanding women's lives and their cultural productivity.

In 1908, just prior to Union, the Women's Enfranchisement League was

established in Cape Town and Olive Schreiner was appointed vice-president.[11] In 1911 Schreiner's important feminist text *Women and Labour* was published[12] and in the same year suffragists met in Durban to found the Women's Enfranchisement Association of the Union (WEAU). In 1912 the African National Congress (ANC) was founded, and the following year the Bantu Women's League (later the ANC Women's League) was established within the ANC under the presidency of Charlotte Maxeke (1874–1939). Despite this recognition of black women, the 1919 ANC Constitution denied women full membership and voting rights, and only in 1943 did the organization commit itself to a policy of universal adult suffrage and include women in the definition of 'adult'.

In 1930 the vote was granted to all white women over the age of 18 but, far from being a liberal gesture made by a government committed to addressing women's rights, this was an expedient attempt to enfranchise more white voters and dilute the black vote. It successfully reduced the African electorate from 3.1 to 1.4 per cent of the total electorate.[13]

For black women, and white women with left-wing leanings, the 1948 electoral victory of the National Party inaugurated a period of systematic racial oppression and human rights abuse. In 1952 the ANC launched its Defiance Campaign of civil disobedience against unjust laws and a number of women – black and white – assumed prominent activist roles. Apartheid legislation built on earlier 'native policy' such as the Native Land Act (1913), which imposed territorial segregation,[14] the Native Affairs Act (1920), which determined political representation, and the Natives (Urban Areas) Act (1923), which controlled urban living. New laws, designed to augment the social engineering policies of apartheid, included the Prohibition of Mixed Marriages Act (1949), the Population Registration Act (1950) and the Group Areas Act (1950). Blatantly racist, these laws determined marital relations, how people were classified (which, in turn, determined social opportunities or restrictions) and where they could live. In short, legislation controlled and policed human contact.

This had profound implications for cultural development since art cannot remain innocent of its circumstances of production and distribution. The Group Areas Act was especially damaging to cultural activities. Black and coloured people were subject to forced removals from areas that the government wanted to develop as white residential zones. Both Sophiatown in Johannesburg and District Six in Cape Town had multicultural communities and long histories of vibrant cultural activity; this ended when the populations were expelled and buildings were demolished.[15]

The 1950s apartheid legislation raised political awareness and colour consciousness throughout South Africa, helping to foster a new spirit of cooperation amongst ethnic groups and political organizations which had not automatically become allies merely because they were not Caucasian whites.

A 'Congress of the People' was held in June 1955 and from it came the Freedom Charter.[16] Equally important for women was The Women's Charter, drawn up and adopted on 17 April 1954 at the inaugural conference of the Federation of South African Women (FSAW).[17] The preamble states:

> We the women of South Africa, wives and mothers, working women and housewives, Africans, Indians, European and coloured, hereby declare our aim of striving for the removal of all laws, regulations, conventions and custom that discriminate against us as women, and that deprive us in any way of our inherent right to the advantages, responsibilities and opportunities that society offer to any one section of the population.
>
> (cited in Barrett, Dawber, Klugman et al., 1985, p. 238)

Referring to 'National Liberation', the Charter proclaimed solidarity with men, affirming, 'we march forward with our men in the struggle for liberation' (p. 239). Helen Joseph (1905–92), National Secretary of FSAW, commented in 1957, 'The fundamental struggle of the people is for National Liberation and … any women's movement that [stands] outside this struggle must stand apart from the mass of women' (in Walker, 1991, p. xxxi). The struggle drew women into it but made no special acknowledgement of gender issues.

In 1952 a Natives (Abolition of Passes and Coordination of Documents) Act required all black women as well as men to carry reference books with personal details. Passbooks were designed to control access to urban areas and in 1956 moves were made to implement the law and issue these documents to black women.[18] Motivated by labour organizations, black women mobilized, burning passbooks and demonstrating publicly. In May 1955 the Women's Defence of the Constitution League, a largely white anti-apartheid organization, was founded. It was popularly known as the Black Sash. The League's women, wearing trademark black, mourning sashes, protested courageously against social injustice on innumerable occasions by staging silent vigils in public spaces where they endured verbal abuse.

Apartheid history – and with it, women's history – is punctuated by events and dates that became engraved upon national consciousness. One of the most memorable occurred on 9 August 1956. Thousands of women attired in traditional dress or the green, black and gold ANC colours marched through Pretoria to the Union Buildings, unwittingly echoing the public spectacle of British suffragette processions decades earlier. The words they uttered, addressing the Prime Minister, have become legendary: 'Strydom, you have tampered with the women, you have struck a rock.'[19] From then on, women became increasingly active politically and many were arrested, imprisoned, banned and subjected to house arrest. They became part of struggle politics but did not seek to create a women's liberation movement.

Black activism reached a bloody climax on 21 March 1960 when 69 people were shot dead and 180 were injured at Sharpeville for protesting against the pass laws and increased rentals. In April the ANC and PAC (Pan-Africanist

Congress, founded in 1959) were banned, ending 50 years of peaceful struggle and initiating underground militancy[20] and repressive retaliatory measures by the state.

The next violent and memorable watershed in resistance politics occurred on 16 June 1976 when an illegal student march in Soweto, near Johannesburg, was stopped by police gunfire. Although the black students had been protesting against the compulsory use of Afrikaans (deemed 'the language of the oppressor') as a medium of instruction, resentment was part of widespread antipathy to the inferior schooling offered to black students. Here it should be noted that black education was designed primarily to impart literacy and manual skills; there was little or no art tuition at state schools. Mission schools, the most significant of which was Rorke's Drift,[21] played an important role in providing some art tuition. Traditional skills, valued for their assertion of group identity, became a complex and contentious issue when co-opted into school curricula that had been devised and controlled by white, government education officials.

From 1976 onwards, unrest simmered, helping to shape the Black Consciousness Movement and to politicize urban black youth.[22] The urban black population tested the ingenuity of the Nationalist government. While black labour was required to drive the economy, a permanent black urban population was deemed undesirable. Thus resettlement programmes were disguised as attempts to 'share' power with ethnic groups located in their own 'homelands'. This term is deeply ironic: for many urbanized black and coloured communities the 'home' they knew was not the place once inhabited by their forebears, and 'land' was something owned only by whites. The Bantu Homelands Citizenship Act of 1970 imposed citizenship (determined on the basis of language and culture) of one of the 'homelands' (bantustans) on all black people in the Republic despite the fact that many of them had never resided outside 'white' urban areas. Eventually self-government was conferred on homelands and finally 'independence' was granted to compliant territories (Fig. 1.2).[23]

The state's malevolent manoeuvres with identity led to yet more fragmentation when it devised a new parliamentary system that again co-opted culture to legitimize it. The Tricameral Parliament was an attempt to woo Indian and Coloured communities by offering them opportunities to elect their own members to their own legislative chambers where they could determine issues deemed to be 'own affairs'.[24] Loosely speaking, 'own affairs' were 'cultural' matters. (In South Africa 'culture' and 'tradition' are words fraught with particular instability and innuendo.)

The Tricameral Parliament system stimulated a reaction that led to the formation of the United Democratic Front (UDF), an umbrella organization uniting workers' groups, trade unions, women's organizations and anti-conscription groups. At last a large opposition block became functional and

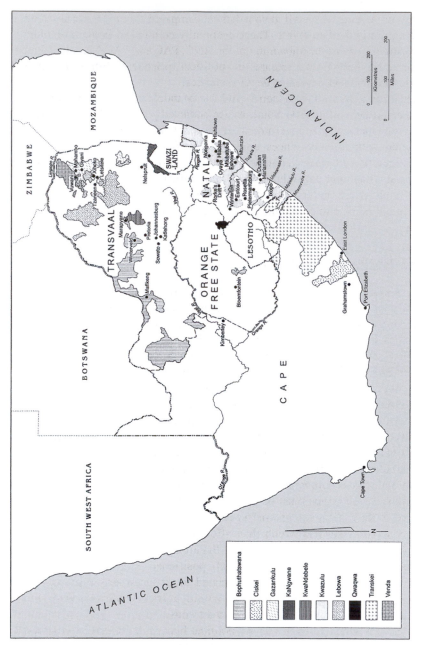

Fig. 1.2 South Africa in 1982.

Legend (map key):
- Bophuthatswana
- Ciskei
- Gazankulu
- KaNgwane
- KwaNdebele
- Kwazulu
- Lebowa
- Qwaqwa
- Transkei
- Venda

8

began organizing the civil disobedience campaigns that dominated South African life in the late 1980s. These eventually culminated in the momentous events of the 1990s: the unbanning of the ANC, PAC and SACP (South African Communist Party), the release of political prisoners, lifting of media restrictions and suspension of death sentences.

On 11 February 1990 Nelson Rolihlahla Mandela walked to freedom after 27 years in jail and in 1994 South Africa achieved political liberation under a black president and a government of national unity. The country was re-designed with nine provinces and eleven official languages (Fig. 1.3), a reconfiguration of parts characterized by people of different colours bearing their individual and collective histories. Significantly, the constitution of the new South Africa conferred rights on all citizens, giving women the hope that they might be able to contribute to all aspects of national life.

Visual Culture and Modernity

Throughout the twentieth century South African visual culture evolved steadily against a background of simmering political unrest. However, much of what was achieved within the visual arts failed to be known beyond the country's borders, especially throughout the years of isolation when South African art was deliberately ignored and excluded from international exhibitions owing to the cultural and academic boycotts. In 1994 academic links were re-established, cultural exchanges were promoted and South Africa was reinserted into the global art community. Although renewed international interest in South African art was welcome, it was often selective, seeking to construct what the West perceived as an authentic black African identity and overlooking the fact that cross-cultural exchanges had shaped the contradictory character of visual production in South Africa.[25]

To understand contemporary South African art, especially that produced by women, cognisance must be taken of a long history of picture and object making within different communities, and of many convoluted, troubled stories and the ways in which they affected women's creativity. The years between Union and Liberation provide the art of 'the new South Africa' with a context, enabling it to be more securely positioned in relation to its historic and regional origins. It can also be related to art elsewhere in postcolonial Africa as well as being understood within a framework of twenty-first-century postmodern, global pressures and trends.

Although burdened by a weighty political history that inevitably impacted on the visual arts, the period between 1910 and 1994 spans the decades when the country's economy changed as it came to terms with the imported condition of modernity and processes of modernization. Initiated in the industrialized West, modernization impinged on colonial South Africa

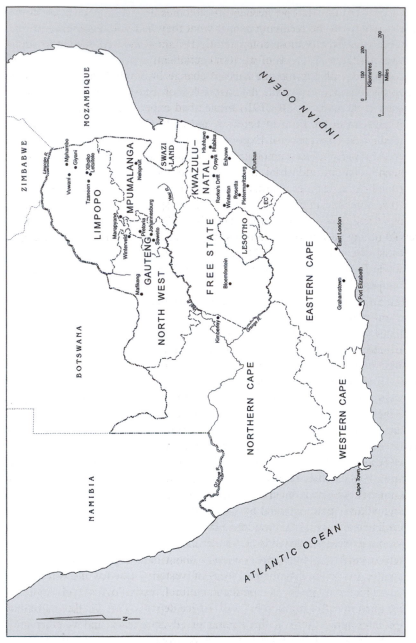

Fig. 1.3 South Africa in 2003.

primarily because Europe needed its colonies to fuel its own economic development. On the receiving end of what they had not negotiated, African countries – especially those colonized by Britain – were compelled to adjust to the exploitative demands of western capitalism.

Compared with Europe, the pace of change in South Africa on all fronts was slow. In the art world, the principles of European modernism were received with suspicion. By 1910 France had experienced twentieth-century avant-gardism in the form of Fauvism and early Cubism, and Germany was witnessing the emergence of Expressionism. All leading European cities had expanded rapidly to accommodate huge population influxes generated by the nineteenth-century industrial revolution and the 'look' of modernity was imprinted on spaces and forms as diverse as city design, slum tenements, suburbs, domestic interiors, factories and transport systems. At the time of Union, Cape Town was characterized by 258 years of European history. Devoid of any vestige of modernist style, architecture displayed Dutch gables or British, Georgian-influenced façades, while the new city hall, built in 1905 in pseudo-Renaissance style, contributed assertively to the grandeur associated with imperial buildings.[26]

The South African War speeded up industrialization and Durban's harbour soon outstripped Cape Town's because it was more accessible for Johannesburg and the Witwatersrand. Johannesburg, founded after gold was discovered in 1886, was a brash, expansive mining town, known in 1910 for its large community of white, working-class residents. As Egoli – the place of gold – it would become the pulse of South African modernity and drive the economy, exacting a terrible human price from migrant workers, who manned the mines, and their families, who remained in the rural areas.

The divide between rural and urban communities was deep. Outside of urban centres, twentieth-century technology hardly intruded on rural consciousness. White settlers, who had imported vines, grain and sheep from Europe, farmed the richest arable lands and, on poorer lands, black communities practised subsistence farming and maintained long-established communal activities sustained by well-defined gender roles. There was little discernible evidence of the 'modern age'.

What the West understands as 'modernism' – at best always a convoluted concept devoid of a definitive consensus about meaning – cannot be neatly transported to societies on the periphery of western influence and values. The ways in which modern ideas – political, cultural, technological and economic – were assimilated or rejected in South Africa depended on whether particular groups interpreted them as threatening or advantageous, and whether they substantially altered lifestyles for better or worse. Throughout most of the twentieth century, the contest in South Africa was not necessarily between progressive and traditional ideas but, in many instances, between shades of conservatism entwined round concepts of identity espoused by different ethnic

groups, each of which invoked 'tradition' to validate its self-concept. As part
of this process, those seeking to sustain or acquire political power and status
often manipulated visual culture; invariably realism and symbolism were
favoured to promote explicit (politicized) meaning, while stylization and
metaphor might suggest progressive or oppositional ideologies.

The strongest influence on early twentieth-century white South African art
was British but Britain had embraced the visual dynamics of modernism much
more cautiously than continental Europe. Just as 1910 was a turning point in
South African history, so it was a pivotal year in Britain. The succession of
George V signified a final break with Victorian values and social change was
evident in the enhanced tempo of life and activities of the suffragette and
labour movements. A sense of insecurity was exacerbated at the end of 1910
when the art world was shaken by an exhibition that introduced modern French
art to an astonished British public. 'Manet and the Post-Impressionists',
organized by art historian, critic and painter Roger Fry, issued a radical
challenge to notions of art as a mirror of appearances and a repository of moral
values but in South Africa these principles continued to be esteemed.

Ironically, although modern art was of little interest in 1910 in South
Africa, Union created an opportunity to raise the profile of the visual arts in
the new nation. For art to become visible it needed places of permanent display
and Florence Phillips, wife of Randlord, Lionel Phillips, became the driving
force behind the foundation of the Johannesburg Art Gallery. Her initiatives
led to the acquisition of a core collection of modern, western art funded by the
Randlords and assembled by Sir Hugh Lane.[27] Involvement in the arts offered
Phillips, whose political instincts were strongly imperialistic, a philanthropic
way of 'civilizing' Johannesburg's citizens, supporting working-class and
colonial upliftment and, after 1910, promoting nation building.

The decision to collect 'modern art' for the new gallery was partly
pragmatic; it was less expensive than a second-rate old master collection
would have been. But Lane's choices of 'modern art' also indicate how fluid
this concept was in 1910. Compared to French modernism and the work with
which Roger Fry scandalized London (paintings by Van Gogh and Cézanne
drew particularly vitriolic, hostile comments), Lane's collection was bland,
although it contained examples of advanced painting and works by four
women artists.[28]

Florence Phillips's activities at the time of Union raise issues around the
implications of 'modern art' and 'national art' in South Africa and, indeed, the
very meaning of 'art' itself. Phillips, seeing no reason why crafts should be
marginalized, presented the Johannesburg Art Gallery with a valuable collection
of old lace, needlework and embroideries, crafts long practised in Europe.[29]

For the earlier part of the twentieth century, South African art was
dominated by western aesthetics and the 'fine arts' (predominantly figurative
painting and sculpture) were theorized as superior to utilitarian crafts. 'Art'

was believed to provide evidence of the imagination and intellectual fibre of an advanced civilization. It was easy to argue that 'art' was the province of white artists, predominantly male, since – on the available evidence – black people produced 'craft' and three-dimensional objects such as pots and headrests which, Europeans assumed, were exclusively functional. In Europe, art was displayed in art galleries while artefacts were placed in ethnographic collections and South African curators followed this model.[30] Western art, and western-derived art, displayed in public art galleries throughout much of the twentieth century, persuaded many white South Africans of the superiority of European civilization, while the absence of 'art' made by black South Africans seemed to confirm assumptions about their 'primitive', unsophisticated nature.

From the time of Union, assessments of European and colonial art were ones of qualitative difference. Imperial paternalism regarded colonial art as backward at worst and transitional at best in relation to advanced western art. Similarly, the colonial mindset of many South African artists saw them deferring to Europe and yearning for international approval. Only with the collapse of modernism, and scepticism about formalism as a critique, was South African art able to assert its multicultural nature, and to theorize its identity in postmodern and postcolonial terms. When it did so, the cultural heritage and activities of all South Africans were acknowledged and the nation's art was revealed as extraordinarily rich and diverse. It also became obvious that women had always made a substantial contribution to a broad range of visual arts and not merely to modern art, where white women artists had become particularly conspicuous.

In the decades when modernism dominated the South African art world, 'art' was promoted in opposition to 'craft'. Postmodernism, however, embracing inclusiveness, abandoned purist definitions of practice and offered a way of acknowledging cultural creativity and diversity.[31] South African revisionist art historians and exhibition curators, abandoning reliance on western definitions of art, expanded creative concepts of visual culture to accommodate African artefacts and aesthetics as well as objects defined as 'women's work'. It is useful to note that in twentieth-century Europe the art/craft debate shifted to art/design, a terminology more suited to highly industrialized societies. However, for much of the twentieth century in South Africa, 'craft' continued to acknowledge the characteristics of functional, handmade objects created outside of the requirements of mass production and beyond the competitive demands of industry and manufacturing.

The re-definition of 'art' meant that embroidery, tapestry, ceramics and basketry, largely created by women, were collected and accorded a visibility which, for many years, had been obscured by the authority of western modernism and gender-based definitions of cultural work. Although challenges to art terminology can be attributed to the politicization of culture in the 1980s, shifts in collecting practice and patronage begin earlier. In the

late 1960s the South African National Gallery and the Durban Art Gallery both acquired tapestries woven by women who had studied at Rorke's Drift (Fig. 1.4).[32] It is perhaps significant that tapestry, being predominantly pictorial in its concerns, may well have been easier to assimilate into a collection of paintings and sculptures than objects which belonged to what were termed the 'functional', 'decorative' or 'ethnographic' arts.

While the history of classification and division within South African art endorsed the supposedly superior creativity of certain groups, once modernist ideas were challenged, visual creativity benefited. The economic potential of 'craft' facilitated a reassessment of 'women's work', which was identified as a way of initiating personal and financial empowerment, especially for rural black women. From the perspective of art theory, the political nature of culture in colonial and apartheid South Africa emerged strongly when objects of material culture (including beaded clothing; Fig. 1.5)[33] as well as paintings, prints and sculpture were studied in relation to their ethnic and gender origins. Furthermore, their makers began to be identified by name. Individual black women became visible.

Women and Modernism

When considering the relationship between women artists and modernism, it becomes apparent that in some instances the integrity of women's visual expression, and especially the narration of personal objectives, could be respected

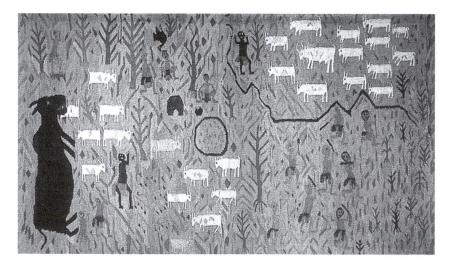

Fig. 1.4 Regina Buthelezi, *Once There Came a Terrible Beast*, 145 × 257 cm (57 × 101.2 inches), tapestry, *c*.1968, Collection Durban Art Gallery.

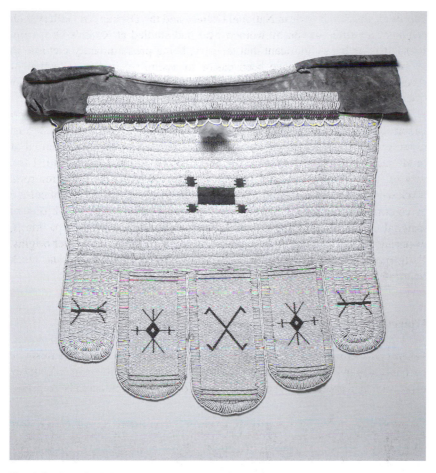

Fig. 1.5 *Ijogolo* (bridal apron), Ndebele, South Africa, (h) 63 cm × (w) 72 cm (24.8 × 28.3 inches), hide, beads, *c*.1910, Standard Bank African Art Collection (Wits Art Galleries). Photograph by Wayne Oosthuizen.

only by refusing to make concessions to modernist styles. However, the antithesis is also true: a self-conscious identification with modernity (and the 'look' of modernity) offered opportunities for diversification, the redefinition of female creative roles and routes to self-assertion. In all instances women, confronting the pressures exerted by black or white nationalism as well as patriarchy, were compelled to reach quite personal decisions about the importance of their cultural origins, places of domicile, the economic imperatives of their lives, private and social existence, and the goals of their art-making.

In the early twentieth century, while Florence Phillips led a campaign to promote ties with British culture and the Johannesburg Art Gallery displayed its new core collection of European art, the Women's Memorial at the Women's Monument (*Vrouemonument*) at Bloemfontein drew attention to Afrikaner women. Over 26 000 women and children had died in the British concentration camps during the Second South African (Anglo-Boer) War and a plan to commemorate this loss was proposed. The commission was awarded to the South African sculptor Anton van Wouw (1862–1945),[34] who designed a three-figure, freestanding bronze depicting two women and a child (see Fig. 5.2).[35] The memorial was inaugurated in 1913, and the realist style and symbolism satisfied conservative Afrikaners. Ironically, although the memorial was intended to honour the memory of Afrikaner women, the Women's Monument project became subsumed by the ideology of Afrikaner nationalism. This remained a potent force and the 1938 centenary of the so-called Great Trek (the emigration of Afrikaners from the Cape to the north) ignited strong emotion in Afrikaans-speaking South Africans. Celebrations culminated in the construction of the Voortrekker Monument near Pretoria. Its associated projects were devoted to narrative, symbolic art, and the tapestry panels woven by Afrikaner women from male-originated designs depict Afrikaner history in highly idealized terms.

While some Afrikaner women artists looked back nostalgically at history, a number of English-speaking South African women artists embraced modernity enthusiastically and their commitment to the present often initiated transgressive, non-stereotypical female behaviour. For sculptor Mary Stainbank (1899–1996), painters Bertha Everard (1873–1965) and Irma Stern (1894–1966), and photographer Constance Stuart Larrabee (1914–2000), art offered opportunities to locate themselves as individuals in the modern world who rejected a conservative art canon.[36] The artworks created by these women demonstrate a tension between their adoption of modernist visual language and African subject matter, and between formal language and social content. Their careers have little in common and much that indicates how difficult it is to use modernism as a prism through which life and art outside Europe can be refracted.

These women, and many others, gained visibility in the art world because they utilized the facilities to which they – as white people – had access. Stainbank, Stern, Everard and Larrabee studied and travelled in Europe[37] and, on returning to South Africa, they exhibited their work publicly in individual and group exhibitions. Although Stern gained a national reputation, Stainbank's and Everard's works were undervalued in their lifetimes, and Larrabee left South Africa to settle in the United States. These artists, and others, competed with men under conditions imposed by men. Their art was invariably assessed in formalist terms that contributed to rendering it marginal to political activity and ineffectual in alerting the public to relationships between gender and art practice, and to the politics of representation.

While white women were able to study art in South Africa or Europe, black women had neither the financial resources nor the opportunities under segregated education to study art at South African art schools. The women who created murals on walls of rural homesteads or produced ceramics and baskets were trained within their communities, usually by female family members, and their work, if it reached museum collections, was invariably catalogued without recording their names. The absence of named black women artists in written documents until the 1980s (with a few telling exceptions) is as poignant a comment on the idiosyncrasies of South African culture as the presence of many white women who produced distinctive, iconoclastic work.

Urban black women had even fewer opportunities than those in the rural areas to express themselves visually. When opportunities are restricted, the first person to break through barriers acquires historical significance as a role model. Gladys Mgudlandlu (1917–79), who was largely self-taught, achieved the distinction of being the first black South African woman easel painter to acquire a reputation that was sustained in press coverage.[38] Her achievements summarize the tension between freedom and restriction that operated in the art world that women artists attempted to enter, the complexities of which were exacerbated for black women.

Mgudlandlu, called 'the African Queen' by the residents of the Nyanga township near Cape Town where she lived from 1944, grew up in the Eastern Cape and learnt about Fingo and Xhosa cultural heritage from her grandmother. Having begun to train as a nurse, she moved to Cape Town, became a teacher and, in 1961, held her first exhibition. Her success was a combination of luck and ability. Like Irma Stern, Mgudlandlu attracted the attention of the media (both artists were presented as 'characters' with decisive, robust personalities). She also gained the support of white women who promoted and bought her work. But she was an anomaly – a black woman artist – and the print media that promoted her career, patronized her by playing on the human-interest aspects of her achievements. White art critics appraised her images in formal terms and failed to interpret her content in relation to the social disruptions she had experienced, while the black writer Bessie Head (1937–86), who believed that art should render social commentary, was sharply critical of Mgudlandlu's 'escapism' (cited in Miles, 2002, p. 7).

Mgudlandlu worked for herself. Her imagery is not drawn directly from observation but dredged from memory mediated by the apartheid legislation that determined what work black people could undertake and where they had to live. Living in a small 'matchbox' township house, Mgudlandlu transformed life into resonant, colourful, broadly brushed images that enabled her to transcend her immediate circumstances. Whether evoking rural life, and speaking of communal activities as in *Landscape* (1962; Fig. 1.6), or portraying a bleak huddle of homes on the barren Cape flats, Mgudlandlu made painting an act of personal affirmation.[39]

Permeating the work of many twentieth-century South African women artists is a deep consciousness of working in South Africa. Even artists who disengaged themselves from direct socio-political commentary created artworks that refer obliquely to local circumstances and the inflections given to female creativity by the paralysing weight of racial identity, racist institutions and patriarchal authority. As South African society became increasingly politicized in the late 1970s, cultural activity assumed an activist role. A turning point was a conference organized at the University of Cape Town in 1979. Delegates at 'The State of Art in South Africa' passed two important resolutions. One demanded that educational facilities be opened up to artists of all races and the other asked artists to boycott all state-sponsored

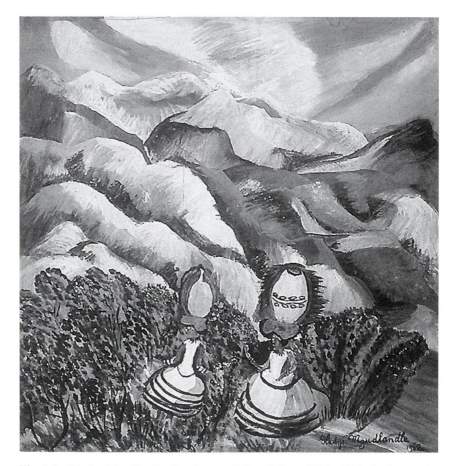

Fig. 1.6 Gladys Mgudlandlu, *Landscape*, 61.9 × 60.9 cm (24.4 × 24 inches), gouache on paper, 1962, MTN Art Collection, Johannesburg.

exhibitions until the first requirement was met. Notably absent from the debates was direct reference to gender discrimination.

Not until the 1980s did gender emerge as a significant political and cultural issue. By this time postmodernism offered South African art ways of theorizing complexity, contradiction and ambiguity, of utilizing intertextuality and re-reading history. In 1985 the art–gender debate was aired in works shown in a series of important exhibitions.[40] Although women artists raised issues embedded in feminist theory, in some quarters these were seen as relevant only to white, not black women (black men were particularly hostile to feminism and vocal about 'our culture', by which they meant black culture, in which women assumed secondary roles to men). But, increasingly, women were committed to exposing the politics of representation.

The Essays in this Volume

The essays gathered here explore the years between Union in 1910 and Liberation in 1994. They focus on and analyse the lives and achievements of women artists and cultural workers, while exploring the asymmetrical power relationships that defined, controlled, restricted or sustained women's participation in visual culture. They do not offer a comprehensive history of South African women artists. Instead they draw attention to the diversity of ideas and practices – vibrant, affirming, courageous and colourful – that determine years which are, in so many respects, dominated bleakly by black and white tensions.

Any study of the years between Union and Liberation must reflect the historical realities of the time. Hence those essays in this volume that explore art in the first part of the twentieth century focus on the achievements of white women. They were visible in the art world. They were acknowledged as artists while creative black women were hidden by an interpretation of cultural production that effaced them. Black women artists only became the subjects of serious research and exposure through exhibitions when art history itself became politicized and reassessed its parameters. Black artists had to be retrieved from the past and information is still incomplete and, in some instances, speculative.

Research into art made by black women is rendered difficult by a paucity of black women historians and art historians within South Africa. There is no history of commitment to western-derived 'fine art' in the black community since apartheid education offered no art teaching and, although increasing numbers of black women are now acquiring university qualifications, few elect to study art history or fine art courses. For black parents and students who face the financial burden of tertiary education, degree courses must offer reasonable wage-earning prospects and, for young black women, the art world

makes no such promise. And so the question – where are the black women researchers? – delivers the answer that they have not yet emerged in significant numbers. Furthermore, the middle-class black community does not offer significant patronage to the visual arts and has yet to be convinced that the visual arts (and academic, art-oriented research) offer competitive career prospects, especially for women.

With 'culture' and 'tradition' being such value-laden, politically sensitive concepts in the new South Africa, and both political correctness and charges of racism hovering as menacing presences over interpretation, historical studies are contentious. They require a commitment to speaking about (not claiming to speak for) women. Women's twentieth-century histories must be written so that the palimpsests of the period, created by women in paint, print, thread, cloth, fibre, wood and clay, can feed their narratives into the post-1994 period and contribute to understanding women's struggles and achievements.

Our examination of the years between Union and Liberation commences with Jillian Carman's study, 'Florence Phillips, patronage and the arts at the time of Union'. In a careful examination of archival sources, Carman presents the forceful personality of Lady Florence Phillips who, although motivated by an imperialistic vision of 'civilization', nevertheless ensured that Johannesburg gained a notable art gallery and a valuable permanent core collection. Her battle for an art gallery pitted her against civic bureaucracy and wealthy, potential patrons.

Carman's account of the early history of the Johannesburg Art Gallery explores Florence Phillips's battle with the Randlords who had made their money from South African diamonds and gold but were reluctant to assist the development of South African culture. The desire to replicate western culture in a colonial mining city had repercussions on the Johannesburg Art Gallery's acquisitions policy, and the subsequent visibility and invisibility of artists. This case study raises issues about institutional power and the contributions made by art museums to a theory of visual culture that dominated much of the official story of twentieth-century South African art. Concluding that Florence Phillips was probably outmanoeuvred by the men with whom she interacted, Carman suggests that Phillips 'is remembered for a project that was incomplete and not a true reflection of her original intentions'.

In my study, 'European modernism and African domicile: women painters and the search for identity', I consider the fractured sense of identity experienced by Bertha Everard and Irma Stern. While both artists rejected picturesque naturalism and adopted modernist styles characterized by expressive colour and mark-making, their experiences of modernism, womanhood and South African life were as different as their personalities. Both women rebelled against feminine stereotypes, tried to reconcile womanhood with life in a colonial, masculinist society that accorded a low priority to visual culture, and were deeply affected by the space and

inhabitants of Africa. By studying the lives and work of Everard and Stern in Europe and Africa, it becomes obvious that white women artists – even those who embraced modernist ideas – cannot be understood generically; differences outweigh similarities. However, for Everard and Stern, modernism as a culturally inherited mental map was a personal reality that was quite as important as their lives and travels in Africa. While Stern managed her career astutely and became South Africa's most famous artist, Everard failed to insert herself into the South African art world during her lifetime. Her life story indicates that the opportunities white women enjoyed in relation to black women of the period offered no guarantees of artistic success and acclaim.

Brenda Danilowitz discusses the work of another woman who consciously explored modernist aesthetics, which had been learnt in Europe, practised in South Africa and subsequently defended in the United States, where she settled in 1949. In 'Constance Stuart Larrabee's photographs of the Ndzundza Ndebele: performance and history beyond the modernist frame', Danilowitz alerts us to the power of the documentary photograph and the power of artistic contrivance expressed through formalist aesthetics. Like Stern, Larrabee saw black women as beautiful, exotic objects. Danilowitz explores Larrabee's relationship to her Ndebele subjects and she demonstrates that while the photographer wanted to exclude social readings of her images, the very nature of documentary photography (even when intentionally aestheticized) invites contextual interpretation.

Larrabee controlled her image construction, privileged form over content and attempted to control the surrounding discourse. However, as Danilowitz explores the different contexts where Larrabee's images, with text and/or titles, were displayed, she indicates how history seeps into Larrabee's realist photography despite the photographer's desire to present her subjects as timeless.

While Danilowitz focuses on images of black women constructed by a white English-speaking South African, Liese van der Watt considers Afrikaner culture in 'Art, gender ideology and Afrikaner nationalism – a case study'. Van der Watt analyses the *volksmoeder* ('mother of the nation') and reveals how Afrikaner men and women revered this idealized concept of domesticity and loyalty to both family and people (*volk*). She traces the visual manifestation of the *volksmoeder* in a narrative frieze of tapestry panels, woven by women from male-originated designs.

Suggesting that the tapestries, housed in the Voortrekker Monument in Pretoria, are much more than didactic representations of a feminine stereotype, Van der Watt argues that the images are a complex manifestation of ideology that forged a subordinate identity for Afrikaner women. Women's lesser status is confirmed pictorially, just as the medium in which they worked is positioned as 'craft' rather than 'art'. In her analysis of the panels Van der Watt relates a complicated story of gender relations, and power play between agency and

canons of propagandistic representation that made Afrikaner women's work a site of both conflict and self-realization. She alerts us to the way in which the Afrikaner woman (quite as much as the black woman) was urged to conceive of her identity in ethnic rather than gender terms.

In 'Technologies and transformations: baskets, women and change in twentieth-century KwaZulu-Natal', Nessa Leibhammer examines the impact of the modern world on basketry, a functional art form that possesses complex social origins. Her research reminds us that conjecture is still a significant component of theory when examining what are deemed to be 'traditional' artforms. She indicates that we do not know who the historical basket makers were in KwaZulu-Natal. Historical sources are contradictory and contemporary informants do not know whether fibre utensils were made exclusively by men or by women.

Leibhammer traces the background to gender-specific labour with regard to carving and metalwork but suggests that, because fibrous materials were freely available, their use was not subject to royal authorization. This indicates that women as well as men probably produced woven forms. However, twentieth-century migrancy upset the balance of labour and women assumed more of the work. Today, when mass-produced containers are readily available in rural areas, baskets – crafted by women – are produced commercially but are marketed as 'traditional'. These objects have made the transition to the modern world from rural communities without disclosing either the original identities of their makers or the politics of changes in production and reception.

Wilma Cruise's essay, 'Breaking the mould: women ceramists in KwaZulu-Natal' discusses three different groups of women ceramists whose work reveals the fusion of western and African ideas and practices. She indicates that indigenous techniques were not encouraged at the Rorke's Drift school, where the forms and decoration of studio ceramics were influenced by the input of Scandinavian teachers and the requirements of the Swedish market. In contrast, rural, black, women potters in the 1980s, typified by the Nala family, were encouraged to market pots with 'African' identity. Cruise analyses the ways in which Nesta Nala and her daughters adapted the form and character of Zulu beer pots, and revived pottery as 'women's work' while gaining new economic and social empowerment with their apparently authentic African pottery.

At the University of Natal (now the University of KwaZulu-Natal), female mentorship is traced from Hilda Ditchburn to Juliet Armstrong to Fée Halsted-Berning, the Ardmore ceramic studio and Bonnie Ntshalintshali. Ditchburn, eclipsed by forceful male potters working in the Anglo-Orientalist tradition, emerges as a significant teacher. White and black women of different generations are seen to respond to clay as a medium and to diverse visual and technical stimuli which yielded works that broke 'the mould' of expectations about women's work with clay.

'On pins and needles: gender politics and embroidery projects before the first democratic election' is a closely argued discussion in which Brenda Schmahmann examines the economic empowerment of rural black women through the development of embroidery projects. Tracing the evolution of four projects where functional cloth articles were decorated by designs embroidered in colour thread, she analyses the complex intersections between rural poverty, social relationships damaged by apartheid and efforts to attain a degree of economic independence.

She studies three needlework projects in the Limpopo Province – Xihoko, Chivirika and Kaross Workers – and the Mapula project in the Winterveld, in the North West Province. Illustrating her study with reference to particular women's lives, she reveals the complex social structures and customary law within rural communities in apartheid South Africa where women were neglected by the authorities and frequently abused by their menfolk. Once skills had been acquired, the needlework projects offered employment and upliftment to the most economically disadvantaged South Africans and many of the initiatives have been extended since 1994 as 'craft' has become a growth point in the economy.

The issues Schmahmann raises about African, ethnic and female identity formation structured by apartheid legislation, also constitute the focus of Jacqueline Nolte's essay, 'Narratives of migration in the works of Noria Mabasa and Mmakgabo Sebidi'. These two artists used sculpture and painting respectively to explore their cultural origins and personal experiences of loss, displacement, racism and sexism. Investigating the provisional nature of settlement for black women, Nolte traces the life stories of two courageous women whose lives transgressed the norms established for rural black women. She identifies the censure and social disapproval that the women faced in their own communities for undertaking activities that were not culturally sanctioned and discusses the strictures of apartheid as experienced in Venda (Mabasa) and Bophuthatswana (Sebidi).

Both Mabasa and Sebidi attribute great significance to their ancestors whose manifestation in their lives occurs through dream, vision and spirit possession. In detailed analyses of works by Mabasa and Sebidi, Nolte unravels the ways in which the artists express their connectedness with their cultural past and deal with the presence of their works in the capitalist art market of the present.

In the final essay in this book, 'Representing regulation – rendering resistance: female bodies in the art of Penny Siopis', Brenda Schmahmann applies a number of the themes that recur in earlier essays to work by Penny Siopis. The period from Union to Liberation was dominated by regulation; it permeated the lives of all South Africans but, for creative women, art offered opportunities – covert and overt – to express resistance to the politics of exclusion and the operation of patriarchal power. Feminist artist Penny Siopis

sites her resistance within the female body and its intimate relationship to the body politic.

After South Africa rejoined the international community in 1994, Siopis's work received considerable attention, particularly for its resonance in a postcolonial framework. Schmahmann's study connects such work to its origins and to the feminist perspective that permeated Siopis's work from the 1980s. Offering an assessment of Siopis's iconography and strategies of pictorial representation, Schmahmann explains how the imagery was formed by specifically South African experiences. She focuses on representations of the body, finding the concept of the 'abject' body particularly useful for validating interpretations of work made to protest regulation. In concluding that the personal always occupied a role in Siopis's work (and continues to do so), Schmahmann alerts us to an important fact about all the women artists in our book. They were, and are, individuals and their feminine consciousness and lived female experiences have been, and are, forcefully present in their art.

Liberation?

Our narrative ends in 1994, a year of liberation that many had thought would never be attained peacefully. Remarkably, negotiations between the Nationalist government and the black liberation movement succeeded. Apartheid ended. South Africans, believing that a new, democratic South Africa had been created, were hopeful that things would change. They did. And they didn't.

Promises can be made and paper constitutions can be printed, but for social transformation to occur, attitudes have to change. South Africans had to confront racism. This they knew. They also had to acknowledge the existence of sexism but, since patriarchy continued into the new South Africa, the concept of liberation meant different things for men and women. Sexism continues to be a festering wound after a decade of black government.

Post-1994 South Africa was launched on a wave of optimism with a new constitution that acknowledges women's rights. In 1999, a Monument to the Women of South Africa was proposed at the Union Buildings where there are many statues of 'great' (white male) South Africans. After an open competition inviting the submission of proposals for the monument, Wilma Cruise (b.1945) was awarded the commission. Mindful of the history of Pretoria's Union Buildings, the symbolism associated with the space and the memorable gathering of women on 9 August 1956 (Fig. 1.7),[41] Cruise (in collaboration with architect Marcus Holmes) created *Strike the Woman Strike the Rock: Wathint' Abafazi Wathint' Imbokodo* (2000), (Fig. 1.8).

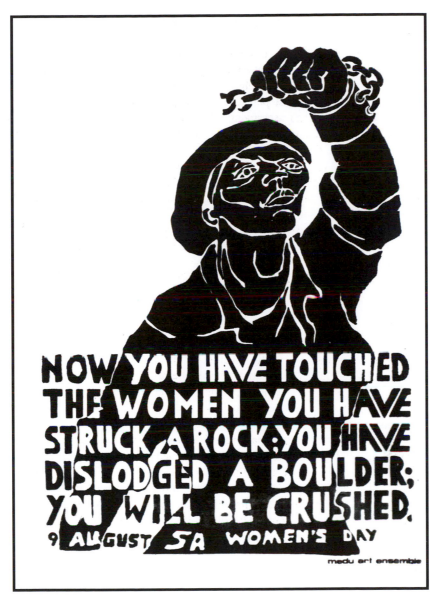

Fig. 1.7 *Now You Have Touched the Women You Have Struck a Rock*, 58 × 40 cm
(22³/4 × 15³/4 inches), poster designed by Judy Seidman, silkscreened on paper by
Medu, 1981, South African History Archive in Historical Papers, William Cullen
Library, University of the Witwatersrand.

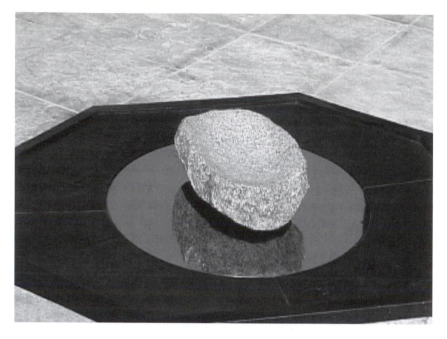

Fig. 1.8 Wilma Cruise and Marcus Holmes, *Strike The Woman Strike The Rock: Wathint' Abafazi Wathint' Imbokodo*, Monument to the Women of South Africa, 2000, grinding stone, part of the installation at the Union Buildings, Pretoria. Photograph by Adam Cruise.

The multi-media installation (Fig. 1.8) utilizes an *imbokodo*, a Zulu grinding stone. It is placed on a polished, circular bronze disc set on a dark, matt bronze octagonal plate that rests on the sandstone floor of a vestibule in Herbert Baker's Union Buildings. Baker's imposing, cathedral-like space is the point where the east and west wings of his design meet to symbolize the reconciliation between the English and Afrikaners desired at the time of Union. The vestibule, defining the north–south axis of the building, offers a view of Meintjies Kop to the north and the city to the south. Thus the site assumes particular significance for Cruise's installation: while celebrating South African women it is also intended to symbolize reconciliation between black and white in the new South Africa.

The memorial gains a documentary dimension from the steps leading to the vestibule. The risers of the steps carry key phrases, rendered in metal, extracted from the protest letters, *The Demand of the Women of South Africa for the Withdrawal of Passes for Women and the Repeal of the Pass Laws.*

Within the vestibule words become sound as the presence of viewers activates a sound text, a chorus of voices whispering, 'You strike the woman, you strike the rock', in the eleven official languages. The memorable words, carrying the history of the famous 1956 protest march, resonate in the presence of the ovoid, grinding stone, womb-like in appearance and evocative of the literal and symbolic nature of women's labour.[42]

The memorial, unveiled on 9 August 2000 (Women's Day), confirmed the important contribution that women had made in the past and implied that they were now equal with men in the new South Africa. But as happens so often in women's history, deeds not words render finality.

The Union Buildings are no longer accessible to the public. They have become a restricted zone. The memorial, installed with high hopes, cannot project its homage to history or insert its presence into twenty-first century rhetoric about justice and equality. Anyone wishing to view the Women's Memorial now has to make an appointment, well ahead of the expected visit, via the Office of the President.[43]

In the new century, women's art continues to represent uncomfortable social facts. The era of union has gone. Colonialism belongs to the past. The long, sad years of apartheid ended a decade ago. But, as long as inequality continues to permeate opportunities available to South African women and men and the appallingly high level of violence against women persists, women's liberation remains incomplete.

Notes

1. For a comprehensive history of South Africa see Davenport and Saunders, 2000.
2. South Africa was first settled by hunter-gatherers – Bushmen, also known as San, Khoikhoi or Khoisan, who were displaced south by invading negroid Bantu peoples. In 1652 the Dutch established a permanent presence at the Cape of Good Hope. The British occupied the Cape in 1795 during the Napoleonic Wars, and again, permanently, in 1806.
3. 'Coloured' will be used to define the mixed race group because, although the term was employed during apartheid as a category of racial classification, it endures post-1994 being used by many 'coloured' people to acknowledge their historical identity. It is still used for census purposes. In the 1997 census the population was 42.3 million, composed of 75.6 per cent black Africans, 13.6 per cent whites, 8.6 per cent coloureds and 2.6 per cent Asians. Blacks (over 75 per cent of the population) earned 28 per cent of the income, while whites (13 per cent) earned 61 per cent, and white farms (87 per cent of the land) produced 90 per cent of the agricultural output. The classificatory terms cited above were used in the census.
4. The Jewish population, although relatively small numerically, exerted a decisive influence on the economy and many Jews were important cultural patrons.

5. All major cities can be located on the three maps that indicate the political geography of South Africa; see Figs 1.1, 1.2, 1.3.

6. The literal translation of *apartheid* is separateness. Although apartheid ideology occasionally paid lip service to the idea of separate and equal, draconian legislation enforced discrimination and inequality.

7. In 1969 the General Assembly of the United Nations adopted Resolution 2396 requesting 'all states and organizations to suspend cultural, educational, sports and other exchanges with the racist regime and with other organizations and institutions in South Africa which practice apartheid' (Campschreur and Divendal, 1989, p.174).

8. The colleges were at Bellville (Coloured), Ngoye (Zulu), Durban (Indian) and Turfloop (Sotho-Tswana). Fort Hare University, at Alice, in the Eastern Cape was founded in 1916 and many African leaders including Nelson Mandela, Oliver Tambo and Mangosuthu Buthelezi studied at it. A collection of contemporary black South African art was begun by the Department of African Studies in 1964 and a Department of Fine Arts was established in 1971, enabling black students to obtain degrees in Fine Art.

9. One point of daily contact between women was within the homes of white women but the 'maids and madams' interaction was defined by economic power relations (see Cock, 1989).

10. See *Images of Defiance*, 1991.

11. She left the movement in protest when coloured women were not allowed to vote. Schreiner's famous novel *The Story of an African Farm* (1883) was first published under the pseudonym Ralph Irons to avoid contemporary prejudice against women novelists.

12. In the concluding sentence of her tract, Schreiner appeals for 'Labour and the training that fits us [women] for labour!' (Schreiner, 1978, p. 283).

13. Although after 1930 white women could participate in government they were slow to do so; in 1936 Mrs Denys Reitz became the first elected woman member of parliament; in 1989 President de Klerk appointed the first woman cabinet minister. The most celebrated woman MP is Helen Suzman (b. 1917) who entered Parliament in 1953. She was the sole Progressive Party representative for 13 years and was acclaimed internationally and within South Africa for her uncompromising stand on human rights and her trenchant, courageous opposition to apartheid. For short biographies of prominent South Africans see Joyce, 1999, and for longer entries see *They Shaped Our Century: The Most Influential South Africans of the Twentieth Century* (multiple authors, 1999).

14. The Land Act deprived Africans of the right to own land outside of designated reserves that constituted about 13 per cent of the land.

15. In 1956 Sophiatown was re-zoned for whites and renamed Triomf. In 1966 some 60 000 people were forcibly removed to the inhospitable Cape Flats. District Six was not developed by the government; it remained as a scar, devoid of people, within the Mother City until February 2004 when former South African president Nelson Mandela handed over symbolic keys to the first two homeowners to resettle in District Six. An estimated 4000 homeowners are to be resettled in the area over three years.

16. The Freedom Charter commences,

 We, the people of South Africa, declare for all our country and
 the world to know:

that South Africa belongs to all who live in it, black and white, and that no government can justly claim authority unless it is based on the will of all the people;

that our people have been robbed of their birthright to land, liberty and peace by a form of government founded on injustice and inequality.

For the full text see Campschreur and Divendal, 1989, pp. 242–5.

17. FSAW was the first women's organization in South Africa to assume a major political role. It drew members from the Congress Alliance, the African National Congress, the South African Indian Congress, the South African Coloured People's Congress and the Congress of Democrats.

18. By 1951 the percentage of black women living in urban areas had increased to over 21 per cent, more than treble the 1921 figure, and only 23.7 per cent of all women were economically active. The state considered the primary function of black women to be reproductive rather than productive.

19. For an account of this and other political activities see Walker, 1991.

20. In 1961 Nelson Mandela established Umkhonto we Sizwe (MK, Spear of the Nation), the militant wing of the ANC.

21. On Rorke's Drift see Hobbs and Rankin, 2003. Women who worked at Rorke's Drift include ceramist Dinah Molefe and Allina Ndebele who designs and weaves tapestries. Also see Sack, 1988.

22. The Black Consciousness leader Steve Biko, detained and subjected to severe assaults by the police, died of his injuries on 12 September 1977.

23. In 1982 the independent homelands (dates of independence are in parentheses) were the republics of Transkei (1976), Bophuthatswana (1977), Venda (1979) and Ciskei (1981). The self-governing homelands, some of which had refused the offer of 'independence' were Gazankulu, KaNgwane, KwaNdebele, KwaZulu, Lebowa and Qwaqwa.

24. The three parliamentary chambers were a House of Assembly for Whites, a House of Delegates for Indians and a House of Representatives for Coloured people.

25. The contribution made by white artists to contemporary South African art is virtually ignored in Kasfir (1999), a text which is otherwise a useful overview of contemporary African art, although – in the South African discussion – dependent on material supplied by art dealers.

26. By 1910 Cape Town possessed a public library and museum. However, it did not get an art gallery until the South African National Gallery was opened on 2 November 1930 with a ceremony organized by Lady Florence Phillips, who had devoted considerable energy to its establishment.

27. The Randlords were a small group of mining magnates who amassed enormous wealth from South African diamonds (first discovered in 1866) and gold (discovered on the Witwatersrand in 1886). The name was applied to the men when they settled in Britain and adopted lavish lifestyles.

28. Interestingly, Fry responded favourably to Lane's collection when it was shown in London prior to going to Johannesburg, commenting 'the new gallery which Johannesburg has just founded is already far more representative of the whole scope of modern British art than anything that we have in England. Not only so, but ... this able director has managed to get exceptionally good examples of each of the many artists represented' (1911, p.178). The women whose work was

purchased were Annie Swynnerton, Laura Knight, Mary Davis and Emma Ciardi (my thanks to Jillian Carman for this information).

29. Believing that the working classes might be educated culturally if they could be exposed to examples of good art and design, in March–April 1910 Phillips organized the first Arts and Crafts Exhibition in South Africa. It displayed artworks loaned from local citizens and had a section for 'native work', consisting of mats, pottery and basketry.

30. The Durban Museum, established as a natural history museum in 1887, included items such as spears and pots, collected from South African groups and Australian Aboriginals. In 1892 moves were made to establish a separate art gallery and this was achieved in 1911.

31. By the 1980s a number of exhibitions offered evidence of socio-political commentary and a desire to erode barriers separating creative genres and different people. 'Tributaries' (1985) was sponsored by BMW, the German auto manufacturer, the Rembrandt Group sponsored four national Triennial exhibitions from 1982; the Standard Bank sponsored the annual National Festival of the Arts in Grahamstown.

32. In 1967 the South African National Gallery purchased *The Lions in the Fire* (n.d.) by E. Mdluli. In 1968 the Durban Art Gallery acquired *Once There Came a Terrible Beast* (*c*.1968) by Regina Buthelezi (b.1928). Mdluli and Buthelezi studied at Rorke's Drift, the Evangelical Lutheran Arts and Crafts Centre. Information on them is scant and the best known of the Rorke's Drift tapestry artists is weaver-designer Allina Ndebele (b.1939). (My thanks to Philippa Hobbs and Brenda Schmahmann for alerting me to these purchases and to Hayden Proud for confirming Mdluli's initial, which is incorrect in the 1985 SANG catalogue, *Women Artists in South Africa*.)

33. This beautiful Ndebele bridal apron (*ijogolo*), made of hide and beads, dates from about 1910 when Florence Phillips was drawing attention to craft items and the need for South Africans to become conscious of their national cultural identity. But exquisitely designed and worked items such as this did not become part of the discourse of the period. The apron was purchased in 1986 by the University of the Witwatersrand Art Galleries.

34. The English pacifist Emily Hobhouse (1860–1926) championed the monument proposal. She had espoused the Boer cause during the war and her ashes were interred at the Monument after her death in 1926.

35. For details of the commission see Arnold, 1996, pp. 34–6.

36. The most concerted effort to assert modern values in art and indicate that South Africa had progressive artists came with the formation of The New Group in 1938 (the same year as the nostalgic, nationalistic Great Trek celebrations). The initiative united Cape and Transvaal based artists and included a significant number of women painters. See Berman, 1983, and Schoonraad, 1988.

37. Other significant twentieth-century women artists who trained in Europe include Maggie Laubser (1886–1973), Dorothy Kay (1886–1964), Maud Sumner (1902–85) and Cecil Higgs (1900–1986). Allina Ndebele, of a later generation (see note 32 above), received a Swedish scholarship in 1964 to train as a teacher-weaver and is probably the first black woman artist to undergo formal study in Europe.

38. The first monograph on Gladys Mgudlandlu is Miles, 2002. Mgudlandlu was given her first retrospective at the South African National Gallery in May 2003.

Miles (1997, pp. 89–90) draws attention to Valerie Desmore, a 'coloured' artist who exhibited in 1942.

39. Some interesting parallels can be drawn between Mgudlandlu's work and that of Mabasa and Sebidi whose use of memory in relation to migration is discussed by Nolte in Chapter 9.

40. The exhibitions were 'Tributaries', the Triennial exhibition, a Women's Festival of the Arts presented in Johannesburg, and 'Women Artists of South Africa', mounted at the South African National Gallery, Cape Town.

41. This poster, designed by Judy Seidman, was made when she was living in Botswana in 1981. Produced by Medu, it was printed in black, marbled with green and yellow at the bottom. The text is from the song sung on the historic women's march, of which slightly different versions exist in English.

42. For a fuller commentary on the memorial see Becker, 2000. I am grateful to Wilma Cruise for discussion on her work.

43. Even Wilma Cruise is not free to visit the memorial to ascertain if her piece is in working order without an appointment. Recent enquiries suggest that the work has not been correctly maintained and cleaned.

References

Arnold, Marion (1996), *Women and Art in South Africa*, Cape Town and Johannesburg: David Philip, New York: St. Martin's Press.

Barrett, Jane, Dawber, Aneene, Klugman, Barbara et al. (1985), *Vukani Makhosikazi: South African Women Speak*, London: Catholic Institute for Race Relations.

Becker, Rayda (2000), 'The new monument to the women of South Africa', *African Arts* 33 (4), Winter, 6–9.

Berman, Esmé (1983), *Art and Artists of South Africa*, new updated and enlarged edition, Cape Town, Balkema.

Butler, Guy (1999), entry in *They Shaped Our Century: The Most Influential South Africans of the Twentieth Century,* Cape Town, Pretoria, Johannesburg: Human & Rousseau.

Campschreur, Willem and Divendal, Joost (eds) (1989), *Culture in Another South Africa*, London: Zed Books.

Cock, Jacklyn (1989), *Maids & Madams: Domestic Workers Under Apartheid* (rev. edn), London: The Women's Press.

Davenport, Rodney and Saunders, Christopher (2000), *South Africa: A Modern History*, London: Macmillan.

Fry, Roger (1911), Catalogue of the Municipal Gallery of Modern Art, Johannesburg (review), *Burlington Magazine* 19, July.

Hobbs, Philippa and Rankin, Elizabeth (1997), *Printmaking in a Transforming South Africa*, Claremont: David Philip.

———, ———, (2003), *Rorke's Drift: Empowering Prints*, Cape Town: Double Storey Books.

Images of Defiance: South African Resistance Posters of the 1980s (1991), Johannesburg: Ravan Press.

Joyce, Peter (1999) *A Concise Dictionary of South African Biography*, Cape Town: Francolin.

Kasfir, Sidney Littlefield (1999), *Contemporary African Art*, London: Thames & Hudson.

Miles, Elza (1997), *Land and Lives: A Story of Early Black Artists,* Johannesburg: Johannesburg Art Gallery.

——— (2002) *Nomfanekiso who Paints at Night: The Art of Gladys Mgudlandlu,* Vlaeberg: Fernwood Press.

Sack, Steven (1988), *The Neglected Tradition: Towards a New History of South African Art (1930–1988)*, Johannesburg: Johannesburg Art Gallery.

Schoonraad, Murray (1988) *Nuwe Groep/New Group 1938–1954*, catalogue, Cape Town: South African National Gallery.

Schreiner, Olive (1978), *Woman and Labour*, first published 1911, London: Virago.

They Shaped Our Century: The Most Influential South Africans of the Twentieth Century (1999), Cape Town, Pretoria, Johannesburg: Human & Rousseau.

Walker, Cherryl (1991), *Women and Resistance in South Africa*, 2nd edn, Cape Town and Johannesburg: David Philip.

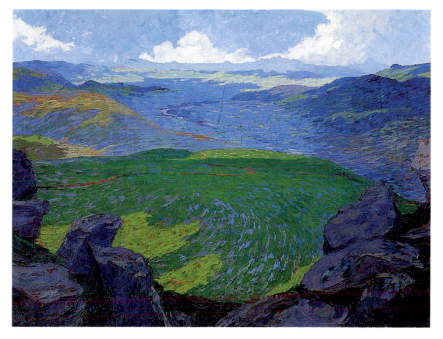

1 Bertha Everard, *Looking Towards Swaziland*, 76 × 102 cm (30 × 40 inches), oil on canvas, *c.*1920/21, Collection of the Pretoria Art Museum.

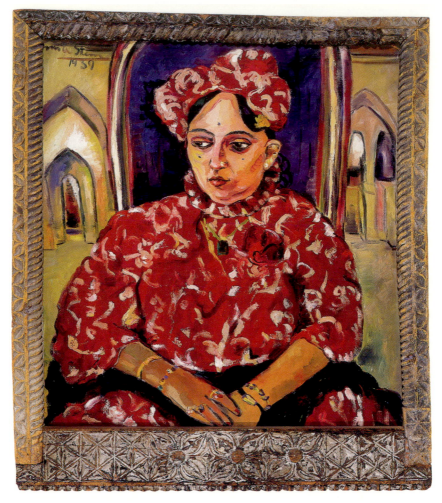

2 Irma Stern, *Bibi Azziza Biata Jaffer*, 91.7 × 84.8 cm (36 × 33¹/4 inches), oil on canvas, 1939, Collection of the Rupert Art Foundation, Stellenbosch, Republic of South Africa.

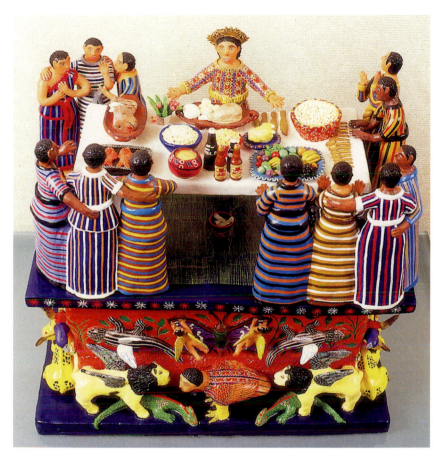

3 Bonnie Ntshalintshali, *The Last Supper*, 52 × 32 × 55 cm (20¹/₂ × 12¹/₂ × 21¹/₂ inches), painted ceramic, 1990, Standard Bank Corporate Collection, Johannesburg.

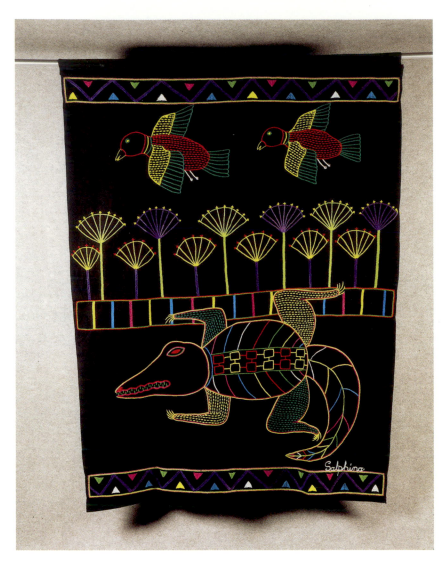

4 Salphina Maluleke (of Chivirika embroidery project), Crocodile, Trees and Two Birds, 147 × 110 cm (57³/₄ × 43¹/₄ inches), embroidery on black cotton, *c.* late 1980s, Private collection. Photograph by Obie Oberholzer.

5 Mmakgabo (Helen) Sebidi, *Modern Marriage*, 183.7 × 267.2 cm (72¼ × 105¼ inches), oil on canvas, 1988, Collection of the Johannesburg Art Gallery.

6 Mmakgabo (Helen) Sebidi, *I Have Seen Through Him*, 105 × 80 cm
(41¹/₄ × 31¹/₂ inches), mixed media on paper, 1989, Standard Bank Corporate
Collection, Johannesburg.

7 Penny Siopis, *Embellishments* (detail), 150 cm × 202 cm (59 × 79¹/₂ inches), oil and plastic ballerinas on canvas, 1982, Collection of the University of the Witwatersrand, Johannesburg. Photograph by Wayne Oosthuizen.

8 Penny Siopis, *Patience on a Monument – 'A History Painting'*, 198 × 176 cm (78 × 69¹/4 inches), oil and collage on board, 1988, Collection of the William Humphreys Art Gallery, Kimberley.

Florence Phillips, Patronage and the Arts at the Time of Union[1]

JILLIAN CARMAN

The first notable art museum in South Africa with a purpose-designed building was established by a woman in the year of Union. The Johannesburg Art Gallery collection of modern British and European art opened in temporary premises in the colonial mining town of Johannesburg on 29 November 1910 and moved five years later into its Edwin Lutyens building in Joubert Park. The driving force behind its founding was Florence Phillips, who achieved her objectives through co-opting others to implement her plans and, in turn, was herself used to further differing agendas.

Florence Phillips (Fig. 2.1) occupies a significant place in South Africa's early twentieth-century cultural history. A woman of considerable energy and determination, she enjoyed committee work, especially if she held positions of authority and was permitted to use her initiative to attain her objectives. As will be argued in this essay, she worked hard in the cause of art and her ideas about an art gallery and its collections had considerable relevance for cultural development in the new dominion. Yet ultimately she was outmanoeuvred by powerful men – the Randlords who gave or withheld finance, Hugh Lane who assumed control of shaping the Johannesburg collection and marginalized her interest in the applied arts, and Johannesburg town councillors who objected to the costs of an art gallery. Discussion of the gallery project explicitly deals with patronage, thus highlighting an issue that has been significant in shaping the evolution of South African art through visibility in public and corporate collections of western (and western derived) painting and sculpture. Early public collections – specifically the Johannesburg Art Gallery's foundation collection – conveyed to the public the impression that fine art was dominated by men. Women appeared as subject matter but the collection of some 130 items assembled by Hugh Lane for Johannesburg contained only four works by women artists.[2] For women viewers, particularly those who worked as artists, there was little in the foundation collection to indicate that art offered women a profession that would generate status and income. Ironically, South African modernist art, particularly after 1920, came to be dominated by women.

Florence Phillips was the wife of mining magnate Lionel Phillips, who with other Randlords provided funds for purchasing Johannesburg's artworks.

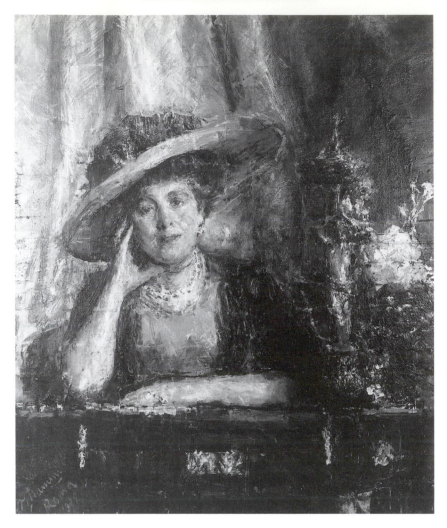

Fig. 2.1 Antonio Macini, *Portrait of Lady Phillips*, 25.5 × 20.4 cm (10 × 8 inches), oil on canvas, 1909, Collection of the Johannesburg Art Gallery.

An Anglo-Irish art dealer, Hugh Lane – renowned for establishing a modern art gallery in Dublin and collecting French Impressionist paintings – assembled the collection in London and recommended Edwin Lutyens as the architect for the building. The collection, shown twice in mid-1910 at the Whitechapel Art Gallery in London before being sent to South Africa in September 1910, was considered by British critics to be more advanced than

any modern art collection in the metropole. It included contemporary British artists such as Philip Wilson Steer, Walter Sickert and William Orpen, and the French Impressionists Claude Monet and Alfred Sisley, none of whom were represented in British national collections.

By 1910 there were art collections in Cape Town, Pietermaritzburg and Durban but these were inadequately curated and housed. The South African National Gallery in Cape Town, established by a bequest from Thomas Butterworth Bailey in 1871 and proclaimed by an act of Parliament in 1895, consisted of a motley collection of bequests, gifts and purchases. It was so poorly accommodated in 1910 (it only received its own building in 1930) that a government report lamented, 'Surely no other city in the British Empire of the importance of Cape Town could have been so neglected in the matter of an Art Gallery!'[3]

A collection compiled for Pietermaritzburg in 1903–4 by Ada Tatham assisted by William Richmond RA and Edward Poynter, President of the Royal Academy and Director of the National Gallery in London, was no longer on public display in 1910. Durban's municipal art gallery, started in 1892, was expanded in 1899 with publicly funded acquisitions from a travelling show of British pictures and, shortly thereafter, with the assistance in Britain of a Royal Academician. However, it was considered no more than a subordinate department of the Natural History Museum with which it shared premises. By contrast a number of South African urban centres in 1910 had fully-fledged natural or social history museums, many with their own buildings or with a prominent and dedicated space within a municipal structure like a town hall or public library.

Public art galleries were evidently not the preferred medium for expressing civic pride, nor was their worth recognized in civic government as it was by British local authorities like Manchester City Council. By 1903 the latter fully acknowledged the advantages of an art gallery in the development of municipal and commercial life through stimulating good taste among local people and thus improving the quality of the city's industries.[4]

Florence Phillips intended that the Johannesburg Art Gallery would have as beneficial an effect on civic life as Manchester's art gallery. However, the outcome was probably closer to the personal ambitions of Hugh Lane, who assembled the collection. Phillips was introduced to Lane in April 1909.[5] She was in Britain partly to source applied art items for an arts and crafts exhibition planned for Johannesburg in 1910 under the auspices of the South African National Union (SANU), and her pursuit of an arts and crafts initiative for a brash new town needs to be seen in the context of her background.

South African born and educated, Florence Phillips (1863–1940) married an Englishman on the Kimberley diamond fields in 1885. She lived for extended periods in Britain where she and her husband owned property,

aspired to the lifestyle of the British aristocracy and looked to the metropole for cultural affirmation. However, she claimed her primary allegiance was to South Africa and her works of patronage affirm this. She sought to better the lot of South Africans in a variety of ways and took a particular interest in Johannesburg, which became the Phillipses' principal place of residence in the years immediately preceding Union.

The Phillipses first lived in Johannesburg in late 1889 when Lionel joined H. Eckstein and Co. (the Corner House), the South African branch of the London-based Wernher, Beit and Co. Their fortunes increased dramatically on the Witwatersrand gold fields, although Lionel was never on a par with the wealthiest Randlords, Julius Wernher and Alfred Beit, whose brother Otto inherited his estate in 1906. Florence and the children adopted the colonial practice of returning 'home' to Britain for periodic long visits, occasionally joined by Lionel. Britain became their principal place of residence after Lionel's implication in the Jameson Raid (late December 1895 to early January 1896) and the subsequent commuting of his death sentence to a fine and banishment from the Transvaal Republic.[6]

Having resided in Britain for the duration of the Second South African (Anglo–Boer) War of 1899–1902, Lionel returned to South Africa to settle in late 1905, and Florence followed him in early 1906. The London directors of Wernher, Beit and Co. virtually instructed Lionel to return to Johannesburg to resuscitate the gold-mining industry on which their wealth depended. Notorious for living beyond their means, by late 1908 Lionel and Florence Phillips had to make Johannesburg their principal place of residence, sell Tylney Hall in England and build a new home in Johannesburg. By this time the post-war reconstruction of Johannesburg initiated by Alfred Milner, High Commissioner for South Africa and Governor of the Transvaal and Orange River Colony, was well advanced.[7] The seat of local government had been moved from Pretoria to Johannesburg, a parks department had been created to encourage and manage open recreational areas, school education was on a sound footing and Johannesburg had a civic infrastructure that was infinitely superior to anything before the war of 1899–1902.[8] It had discarded its disreputable mining camp character and become a town suitable for stable family life but it still lacked cultural amenities.

Lionel and Florence Phillips regretted leaving the cultural comforts of the metropole. Their patronage initiatives can be seen as little more than attempts to compensate for a lack of amenities, thereby creating conditions that would attract immigrant families, encourage a stable workforce for the mines, and thus enhance the source of their wealth.[9]

Florence Phillips's patronage interests tended towards home industries, the manufacture and sale of local goods, and the preservation of cultural and natural heritage. She attempted to implement Arts and Crafts ideals rooted in the British nineteenth-century movement associated with William Morris and

John Ruskin. Her concerns can be linked to post-war reconstruction initiatives such as the home-industry movement started by Emily Hobhouse with young Boer girls in Philippolis in the Orange Free State (see Fig. 1.1) in 1905, although Florence Phillips operated in a profoundly different manner.[10] She did not engage in the more humble aspects of transmitting skills or alleviating poverty but operated on a more elevated level, lending her name to causes, sitting on committees, organizing fund-raising events and directing others in implementing her plans.

She supported the National Society for the Preservation of Objects of Historic Interest and Natural Beauty in South Africa, founded in Cape Town in 1905; commissioned botanist Rudolf Marloth in 1905 to produce a monumental work on the flora of South Africa;[11] and actively supported Lionel in the resuscitation of the Witwatersrand Agricultural Society, of which he became president in 1906 while she became president of the newly formed ladies' committee in 1908. Her principal focus, however, and one that had the most direct bearing on the founding of the Johannesburg Art Gallery, was her involvement with the South African National Union (SANU).

The SANU, an important part of post-war reconstruction prior to Union, originated in a successful exhibition of South African products coordinated by Pieter Bam in February 1907 at the Royal Horticultural Society's London hall. A centre to promote South African goods was established in Johannesburg in November 1907 and the SANU was formally constituted in May 1908. Its principal objective was 'To promote the spirit of patriotism and the sense of partnership throughout British South Africa in the development of our country, its products and its industries', and also to 'aid ladies in the formation of ladies' branches to encourage the use of South African products and manufactures' (quoted in Beirne, 1910, pp. 82–3).

Florence Phillips was elected a member of the general executive council of the new SANU and, with other delegates at the founding conference in Bloemfontein in 1908, she visited Emily Hobhouse's school of spinning and weaving. Early in 1909 she moved the formation of a Johannesburg ladies' branch of the SANU of which she was elected president. At the inaugural meeting she announced that two major projects of the new ladies' branch would be 'to get members to organise an exhibition of furniture and arts and crafts … [and] to help forward a loan exhibition of old furniture and other Colonial articles … to have a permanent exhibition of all the products of the country' (*The Star*, 27 January 1909). This was the beginning of an initiative on which Florence Phillips increasingly focused her energies and which in due course mutated from an exhibition of arts and crafts to a gallery of modern art.

The original intention of the ladies' branch was to have both a temporary and a permanent exhibition of South African arts and crafts items, old and new, to encourage excellence in local production. There is no mention at this

stage of the inclusion of foreign or fine art items, yet these two elements were to characterize the Johannesburg Art Gallery's foundation collection, to the exclusion of both local artists and examples of crafts. The change in focus came about partly through the intervention of Hugh Lane, who had his own ideas about what Johannesburg should have, and partly through the direction of Florence Phillips, who acceded to Lane's ideas without consulting her SANU ladies' branch. The latter action, however, does not seem to have been considered problematic in that Florence Phillips's autocratic approach to patronage enabled her to seize opportunities without the delay of consultation, and she was praised for taking such initiatives. There was an unchallenged belief amongst English-speakers that the metropole, not the colonies, should provide the type of museum and collection that would enhance the colonial quality of life and serve as an incentive for local creativity. This belief is displayed both in the final composition of the SANU Arts and Crafts Exhibition held at the Wanderers Club, Johannesburg, from 28 March to 23 April 1910, and in a speech delivered by the British High Commissioner, Lord Selborne, when he visited the exhibition on 30 March 1910.

The SANU Arts and Crafts Exhibition was the first major exhibition of its kind in South Africa, comprising a crafts and fine arts competition for local artists and a loan exhibition of museum-quality items. It drew entries from around the country in two competitive sections, 'Modern Arts and Crafts' and 'Fine Arts: South African Work', and had a large loan section from local private collections of 'Arts and Crafts and Fine Arts' items.[12] The latter included some historic local pieces, such as pre-1850 furniture, but was mainly characterized by craft and fine art items from Europe, many of them sourced in Britain by Florence Phillips. The principal purpose of the exhibition was to show what creative talent there was in the country and, by means of the loan section, to provide examples of excellence for the encouragement of further creativity and employment opportunities.

Addressing members of the exhibition committee and invited guests, Lord Selborne expressed surprise at the quality of art being produced in South Africa. He observed, however, that there was no room for complacency as comparison of works in the South African section with those in the overseas loan section showed there were many gaps remaining to be filled in the South African sphere of arts and crafts. By encouraging the best artmaking in those 'who have the instinct or genius for painting or handicrafts or architecture or music or what ever it may be', an example would be created for handicraftsmen or mechanics (*Rand Daily Mail*, 1 April 1910).

Selborne's speech climaxed in a sequence of rhetorical questions and statements. He declared that great cities should have 'art galleries or art exhibitions or art museums' as citizens needed to look to examples of past great artists to develop latent artistic genius. Johannesburg, in his opinion,

had not even begun to address such needs (intriguingly he does not mention the incipient Johannesburg Art Gallery, which was public knowledge by then). Dismissive of Cape Town's national gallery efforts, he asked, 'Where is our national gallery, our museum? Where is the replica of those institutions which are to be found in all the old cities of the world?' (ibid.).

The speech's key elements are the association of art galleries and museums with civic pride and development, the opinion that permanent exhibitions possess educational value since they encourage creative excellence by example and facilitate employment opportunities, the belief that a museum like the Victoria and Albert is the epitome of such educational exemplars, and the view that arts and crafts in South Africa, in their infancy, need guidance by example. Florence Phillips shared this outlook. Her original intention was evidently to have a Victoria and Albert type museum for Johannesburg, with a fine art collection as one of the components, and Hugh Lane's brief was to put together the fine art component using money obtained by Florence Phillips from the Randlords.

When Florence Phillips and Lane met in Britain in April 1909 she may already have had an idea of starting a fine art collection but does not seem to have discussed this with the SANU exhibition committee before leaving South Africa. Lane (1875–1915) was renowned for his canny judgements in the field of both old master and modern painting and for establishing a gallery of modern art in Dublin, for which he was knighted in mid-1909. He was looking for fresh opportunities to exercise his curatorial skills, and suggested a direction with which Florence Phillips agreed: to put together a collection that would demonstrate the best of British and European modern art and the traditions on which it drew. Lane's reasons for taking on the Johannesburg job are not the focus here; the important points are why Florence Phillips so readily agreed to his plan of action and the extent to which the Randlord donors were involved.

It is not surprising that Florence Phillips, like other British South Africans, accepted that the appropriate prototypes for colonials should come from the metropole. What is less obvious is why she allowed the fine art side of her general museum plan to become so dominant. I believe this happened without her initial awareness of the outcome. There is evidence in the terminology used in the draft and final deeds of donation, in Florence Phillips's ongoing correspondence with the Victoria and Albert Museum, and in her constant battle with the Johannesburg council after the fine art collection opened, that she believed she and Lane were engaged in a joint project for Johannesburg, 'an Art Gallery and Museum of Industrial Art'.[13] Her side of the project, which was to consist of textiles, furniture, ceramics, an art school and an art library, was never successfully realized and thus women's visibility in an inclusive concept of art failed to materialize.

Also intriguing is why Hugh Lane was authorized to create a modern fine

art collection. This was at variance with the Randlord funders' private collections where eighteenth-century British portraits and landscapes and seventeenth-century Dutch scenes were preferred, and 'modern' only featured in commissioned portraits from the likes of Giovanni (Jean) Boldini, Antonio Mancini (see Fig. 2.1) and John Singer Sargent.[14] Florence Phillips seems to have perceived Lane's talents immediately. (A less kind assessment would say she was infatuated with this *cicisbeo* who had a devoted following of older women.) But she initially had no support from the Randlords in engaging him to start an art collection. Although Lionel Phillips loyally endorsed his wife's plans, other Randlords such as Beit, Wernher and Michaelis were reluctant to commit funds without a guarantee of proper housing which would have entailed a corresponding commitment of funds from the Johannesburg town council. Their cynicism in withholding funds from a town recovering from a war and which was the principal source of their wealth, and then promoting a collection so removed from their own tastes, is matched only by the cultural apathy of the all-male town council that was reluctant to accept the gift of an art collection. In 1909–10 Johannesburg was the largest urban centre in South Africa yet it did not have a single museum building, a public library, an adequate town hall or a public concert auditorium.[15]

By April 1910, a year after Hugh Lane and Florence Phillips acquired the first three paintings for Johannesburg, it seemed increasingly likely that the Johannesburg town council would accommodate the collection and the Randlords, particularly Otto Beit, started to commit funds and promote the idea of a modern art gallery.[16] At a meeting on 1 June 1910 the council eventually voted £20 000 for the purposes of providing a building to be used as an art gallery.[17]

The idea that a young city of mining camp origins needed a vibrant collection – a modern collection – appears to have been a widely accepted view promoted particularly by Lane. However, the vociferous Labour section of the town council, at the meeting of 25 October 1910 at which the gift of an art collection was accepted, suggested another reason why modern art was promoted by the patrons: it cost a fraction of the old master works they acquired for their own collections. For a minimum outlay that excluded maintenance and building costs the Randlords expected public gratitude and to have their names immortalized at the public expense, to dictate the terms of the gift and to decide who should design the building. The Johannesburg Art Gallery collection was accepted with reluctance.[18]

With regard to the appointment of Edwin Lutyens as architect, which Florence Phillips and her co-patrons hoped to effect without going to public competition, the Labour sector of the town council sided with the Association of Transvaal Architects to protest against the importation of a contract worker.[19] Lutyens's hotly contested appointment was authorized only when

the mayor used his casting vote at a council meeting of 26 April 1911 (*Rand Daily Mail*, 27 April 1911). Objectors linked the mine-owners' efforts to deny work to local architects with the meagreness of their gift and their attempts to avoid paying a fair proportion of rates and taxes on their properties in Johannesburg. '[I]f they (the magnates) had paid their fair proportion of the rates of this town they (the Council) would now be in a position to afford their own art gallery and buy their own pictures', Councillor Mulvey commented (ibid.).[20]

Although the Randlords had enabled the creation of what the Duke of Connaught called, 'the first notable art collection in South Africa' (*The Transvaal Leader*, 30 November 1910), their patronage was neither generous nor committed. They soon sidelined Johannesburg in favour of Cape Town as their choice of liberal arts capital.

Otto Beit, the most generous of the Johannesburg Art Gallery patrons, made a donation of £10 000 and he was one of the most supportive of Lane and his London-based successor Robert Ross. Yet his donation was relatively minor and Julius Wernher's £5000 was negligible compared to an initiative on which Beit and Wernher embarked before the Johannesburg collection had even arrived in South Africa. About mid-1910 they proposed to Jan Smuts that, provided Alfred Beit's 1906 bequest to start a university in Johannesburg was diverted to Cape Town, they would add to it materially to achieve 'Cecil Rhodes' old dream of a great National University on his Groote Schuur Estate'.[21] This plan compounded Smuts's removal of liberal-arts university status from Johannesburg on the eve of Union, and downgraded Johannesburg as a teaching centre for the arts.[22] The diversion of funds and arts status from Johannesburg started just as the first major public art collection in South Africa was gifted to a reluctant local authority.

The Randlords' meagre patronage as far as Johannesburg and art for South Africa are concerned seems inexplicable. Johannesburg's gold, after Kimberley's diamonds, was the principal source of their wealth. Their patronage of the Johannesburg Art Gallery was ungenerous by their standards of taste and possessions. On their behalf Hugh Lane bought items which were totally different from (and far less expensive than) their own private collections and they were not always prompt in handing over their promised funds, if indeed they gave funds at all.

Lionel and Florence Phillips, the least wealthy of the Randlord class, were the exceptions. Otto Beit was also supportive and prompt in refunding expenses Lane incurred on his behalf but only after he had held back for almost a year until his condition of finding accommodation was met. Julius Wernher, the wealthiest patron, was a tardy donor[23] while Max Michaelis promised £5000 but only £2000 of this was spent by Lane before the opening, and in early 1911 Michaelis tried to give three inferior paintings instead of the balance of £3000.[24] Sigismund Neumann, in South Africa from September to

November 1910, seems not to have committed any money beforehand, but subsequently funded a small Pre-Raphaelite collection (and then repudiated claims to the rest of the funds he had promised).[25] Abe Bailey failed to make a donation before the opening of the foundation collection and Joseph Robinson never gave anything.

Randlords such as Beit and Wernher, who had substantial private collections, chose not to endow South African institutions with artworks to which they had a personal attachment. When Wernher died in May 1912 he left a major item from his collection, Jean Antoine Watteau's *La Gamme d'Amour*, to the National Gallery in London and nothing to a South African art museum (Stevenson 1997b, pp. 67, 383). Wernher and Beit had a number of seventeenth-century Dutch paintings that they neither gave during their lifetimes nor bequeathed at their deaths to any South African institution.[26] This was despite Lane's comment, in his preface to the 1910 catalogue, that old master paintings were prohibitively expensive but 'We can only hope that some public-spirited owner of a great collection may some day be induced to lend, give or bequeath his collection to the Gallery' (Johannesburg Art Gallery, 1910, pp. i–ii).

Despite increasing consensus after Union, generated by Jan Smuts and others, that seventeenth-century Dutch paintings should feature in South African public collections to acknowledge the roots of the Afrikaner, South Africa's first notable public collection of seventeenth-century Dutch paintings, the Michaelis Collection in Cape Town, did not emanate from private Randlord collections.[27] It was assembled by Hugh Lane, bought by Max Michaelis at the persuasion of Florence Phillips in November 1912 (after he had haggled over the price) and presented by Michaelis to the Union of South Africa with an eye to receiving a knighthood.[28]

With the exception of Abe Bailey and Max Michaelis, the Randlords were reluctant to use their private art collections to commemorate their names in the country that supplied their wealth. In this they were unlike American magnates such as Henry Clay Frick or Isabella Stewart Gardner (Hugh Lane had dealings with both of them). Abe Bailey came closest to establishing such a memorial when he bequeathed his private collection of British eighteenth- to nineteenth-century portraits and sporting pictures to the South African National Gallery in 1940.[29] Max Michaelis is also commemorated by an art collection, although he did not establish the Michaelis Collection with his private possessions. However, he and his wife later added to it through personal loans and gifts, also endowing the South African National Gallery and the incipient Pretoria Art Museum – but these were gifts of unequal quality and certainly not of the stature, for example, of the Beit private collection.[30]

Even Florence Phillips, whose efforts brought about the Johannesburg Art Gallery, did not give major paintings from her private collection. She

evidently considered an educational museum, with a fine art collection as merely one of the components, more appropriate than a collection focusing exclusively on major pieces of fine art. She gave Johannesburg items from her lace and textile collection that she had lent to the SANU exhibition but not the George Romney portrait of Lady Hamilton she had lent to the same exhibition, nor paintings she and Lionel owned by John Constable and Thomas Gainsborough, which were disposed of by Hugh Lane and Christie's in 1912–13.

The Johannesburg Art Gallery as prototype of patronage in 1910 presents some interesting complexities. The magnate funders of the collection paid lip-service to the concept of giving something back to the community from which they drew their wealth in an effort 'to counteract those tendencies which produce an exaggerated sense of hatred in the minds of the "have nots" against the "haves" ... [and to] ... contribute to the people's enlightenment and contentment'.[31] They did not fund a building or endow a curatorship or invest personal interest. Their gifts did not come from their private collections but were chosen by a dealer for a fraction of what they spent on their own collections and they expected a local government authority to carry housing and maintenance costs.

Florence Phillips, who drove the project, did not get what she wanted: an art gallery and museum of industrial art with an attached art school and reference library. The full range of her scheme was never realized; only the art gallery part was and she grew increasingly embittered in later years at the lack of cooperation from the Johannesburg town council in fulfilling her goals.[32]

Johannesburg was given the collection at a time of growing antagonism towards the mine-owners and the cultural elite they represented. The gift was reluctantly accepted, there were objections to the hidden costs and an imported architect, and insufficient funds were allocated so that only a portion of the Lutyens plan was erected. Apart from the building there was little municipal investment in the early years and the gallery remained on the periphery of council structures until the late 1930s, when P. Anton Hendriks was appointed curator, the position was made full-time and permanent, and Lutyens-authorized extensions to the incomplete building were begun.[33]

On the surface it would appear that the winner in all this was Hugh Lane. With the Johannesburg commission he created his second public art collection after Dublin, established the contacts for creating his third in Cape Town and, on the strength of his public works, achieved his career goal – the directorship of the National Gallery of Ireland in February 1914.

Because of the Randlords' lack of engagement Lane was allowed the freedom to curate what was considered, after Dublin, the most representative collection of modern art at that time. Progressive critics believed this collection eclipsed what was available in the metropole. It contained French

Impressionist paintings before any English institution did and a wider representation of modern British art than could be seen in the motherland. It was considered unique and in historical terms still is, pre-dating the advent of British modernism which soon overshadowed this remote colonial collection in the only museum ever designed and built by Edwin Lutyens.[34]

Because of Florence Phillips's perspicacity, tenacity and imperious way of operating, the ideal circumstances were created for putting together a unique collection. She perceived immediately the unusual curatorial talent of Hugh Lane and engaged his services without going the committee route (and, therefore, ensured that Lane did not have to defer to committee decisions). She inveigled money and commitments out of reluctant patrons by any means at her disposal, from using social connections to skilfully crafted letters to well-timed press announcements. She ensured Hugh Lane had free rein in putting together the collection, fiercely guarding his autonomy in selecting what should be included. And, through intervention at council sub-committee meetings and in the letter pages of the press, she was largely instrumental in getting Lane's choice, Edwin Lutyens, appointed as architect.

The irony is that she seems to have given Hugh Lane such unstinting support because she believed they were co-workers on a joint project. He was handling the fine art side; she was handling the applied art and educational side with the intention of creating a joint Art Gallery and Museum of Industrial Art. But only the art gallery project was fulfilled.

The story of the arts at the time of Union is a commentary about the eloquence of absence – the invisibility of women practitioners in the visual arts – and the ways in which even as forceful a presence as that of Florence Phillips was defeated by male money and power. Florence Phillips, the most important patron of the arts in the year Union was inaugurated, is remembered for a project that was incomplete and not a true reflection of her original intentions.

Notes

1. This essay draws on Carman, 2002b, in which comprehensive acknowledgements and references to source material are listed. I wish to thank the National Research Foundation (SA) for funding my doctoral research, Professor Elizabeth Rankin of the University of Auckland for her insights and support, the Johannesburg Art Gallery and other institutions which gave me access to their archives, and colleagues who generously shared their knowledge.
2. Oil paintings by Annie Swynnerton, Mary Davis, Laura Knight and Emma Ciardi (Johannesburg Art Gallery, 1910, catalogue numbers 34, 44, 46 and 80).
3. *Report*, 1947, Annexure C. This investigates the irregular selling of items from the South African National Gallery in the 1940s and draws attention to the poor display conditions at the time of Union. For information on the South African

National Gallery see Becker and Keene, 2000; Green, 1966; Langham-Carter, 1971; Tietze, 1998. For information on the Tatham Art Gallery, Durban Art Gallery and other museums of the time see Becker and Keene, 2000; Bell, 1995; Fransen, 1978; Miers and Markham, 1932.

4. Views expressed by William Stanfield of the City of Manchester Art Gallery in a letter to Hugh Lane, 20 January 1903, National Library of Ireland, Manuscripts Department, Hugh Lane papers, 13.071/2. For information on the nineteenth-century museum movement in Britain and its relevance for South Africa see Carman, 2002b, Chapter Three.

5. Where possible I avoid using titles. Florence Phillips is often referred to as 'Lady Phillips' in later publications but was not titled at the time of Union (Lionel Phillips was knighted in January 1912), nor were art gallery patrons Otto Beit and Max Michaelis. Hugh Lane was knighted in June 1909 and was not titled when he and Florence Phillips first met. Biographical details for Florence Phillips and Hugh Lane come principally from Carman, 2002b; Gregory, 1973; Gutsche, 1966; O'Byrne, 2000.

6. The Jameson Raid was an attempt to legitimize British seizure of the gold fields of the Witwatersrand which were under control of the Transvaal Republic. See Brenthurst Press, 1996.

7. Milner was recalled to Britain in April 1905. Lionel Phillips, who had a high regard for Milner and his reconstruction initiatives, dedicated his book on the Transvaal to him 'with admiration and respect' (Phillips, 1905). For Milner's reconstruction ideals see Marks and Trapido, 1981.

8. For developments in civic government see Maud, 1938.

9. Lionel Phillips expresses regret about leaving the cultural amenities of Europe in a letter to Friedrich Eckstein, 15 February 1909, Barloworld Archives (Johannesburg), Archives of H. Eckstein and Co., letterbook HE 155. His engagement in public affairs was far-ranging. He resuscitated the Witwatersrand Agricultural Society, became president of the Chamber of Mines again (he had held this post in the 1890s), resided over various cultural, scientific, social and sporting bodies, gave input into the national convention of October 1908 to September 1909 that established the grounds for Union (although he was not one of the delegates) and in due course gained a seat in the first Union parliament. See his autobiography (Phillips, 1924 and Fraser, 1986); Fraser and Jeeves, 1977; Gutsche, 1966, 1972.

10. For a discussion of the Arts and Crafts movement in Britain, its interpretation in South Africa and the initiatives of Emily Hobhouse and Florence Phillips see Carman, 2002a. Hobhouse was principally renowned for her exposure of conditions in British concentration camps for Boer women and children during the Second South African War and her work after the war in establishing Boer home industries in the Orange Free State and Transvaal (Van Reenen, 1984).

11. Florence Phillips entered into an agreement in May 1905 with botanist Rudolf Marloth to produce an exhaustive work on the flora of South Africa financed by Lionel. Volume I appeared in 1913 and the third and final volume in October 1931.

12. Information from the schedule that Florence Phillips sent to F.V. Engelenburg with a covering letter, 15 January 1910, Johannesburg Art Gallery archives. Descriptions of the exhibits are given in numerous press reviews in Florence Phillips's 'Scrapbook of newscuttings relating to the Arts & Crafts exhibition Johannesburg, 1910', African Studies Library, Johannesburg, S Store 7 (06) (J) Phi.

13. Wording from the 'Deed of Donatio Inter Vivos', January 1913, based on the draft deed of trust tabled at council on 25 October 1910. Correspondence with the Victoria and Albert Museum is in the Johannesburg Art Gallery archives and in the Victoria and Albert Museum, Research Department, Johannesburg Art Gallery and Lady Phillips files.

14. For an analysis of the private collections of Otto Beit (started by his brother Alfred), Julius Wernher, Max Michaelis and the Phillipses, all of whom were patrons of the Johannesburg collection, see Stevenson, 1997b, 2002. Joseph Robinson, the fifth major Randlord whose collection is analysed by Stevenson, never endowed a South African art institution. Abe Bailey, who bequeathed his collection to the South African National Gallery in 1940, started collecting a decade or two after the other Randlords and is not treated in depth by Stevenson.

15. For comments on the regrettable lack of cultural facilities see Maud, 1938. Johannesburg had a museum collection – the Geological Museum of the Chamber of Mines, started as a private initiative in 1890 and taken over by the Chamber of Mines in 1904. In 1927 it was absorbed into the public library. The municipality only took responsibility for the library in 1924; before then Johannesburg was served by a private subscription library.

16. Within a week of meeting Hugh Lane in April 1909 Florence Phillips had been persuaded by him to buy three paintings from Philip Wilson Steer's retrospective exhibition at the Goupil Gallery. The Randlords' commitment a year later was publicly announced in a series of articles in the British-based weekly publication *South Africa*, starting on 9 April 1910.

17. The money, in effect, came from central government, which diverted rent from the market to the Johannesburg town council on condition the funds were used for a gallery building.

18. The meeting was reported in detail in the press the next day (cuttings in Florence Phillips's 'Scrapbook of newscuttings relating to the Johannesburg art gallery', African Studies Library, Johannesburg, S Store 7 [08] [J] Phi).

19. The Association of Transvaal Architects petitioned the town council on the matter (Council minutes, 29 March 1911).

20. Today the Johannesburg Art Gallery occupies only a portion of Joubert Park but originally there were plans for the park and Union ground to be joined by covering the railway cutting, positioning the gallery in the centre of a landscaped setting. A Lutyens church was to be built on part of Union ground (Miller, 2002).

21. Account by Wilfred Murray, first Registrar of the University of Cape Town, quoted in Murray, 1982, p. 45. Smuts at that time still occupied the colonial secretary's office (he was Colonial Secretary and Minister of Education in the Transvaal government) and was to be appointed Minister of the Interior, Mines and Defence in the new Union cabinet (see entries in Hancock and van der Poel, 1966).

22. The decision to incorporate Johannesburg's Transvaal University College (TUC) at Pretoria and to change the former TUC to the South African School of Mines and Technology was made during the last session of the Transvaal parliament in April 1910. This 'more or less ensured that Johannesburg would be bypassed when provision was made for teaching universities in the new Union of South Africa' (Murray, 1982, p. 30). In 1916 the Beit trust was transferred by an Act of Parliament, with Lionel Phillips's support, from Johannesburg to Cape Town. It was proposed that Pretoria be the headquarters of a new federal university and Johannesburg's School of Mines be no more

than a technical branch without authority to teach the arts or pure sciences. For the diversion of funds and the protests on the Witwatersrand that won the right to establish a university see Murray, 1982, pp. 39–58.

23. Julius Wernher authorized Hugh Lane to buy John Everett Millais's *The Cuckoo* at Christie's (telegraph, 6 May 1910, National Library of Ireland, Manuscripts Department, acc. 5073) but a month later had still not refunded him (Lane complained about this to Florence Phillips, 3 June [1910], Paula Hunt private collection, London).

24. The inferior paintings are discussed in letters exchanged between F.V. Engelenburg and A.E. Balfour in March and June 1911, Johannesburg Art Gallery archives. Balfour's wife and Engelenburg were trustees of the Johannesburg Art Gallery.

25. Sigismund Neumann is mentioned as one of the donors in Lane's preface to the 1910 catalogue, but there is no record of any purchases made with his money at this early date. He financed a collection of 29 Pre-Raphaelite and other works assembled by Henry Tonks during 1911 and 1912 (Johannesburg Art Gallery, 1912). There was a good deal of money left over, yet Neumann did not hand over the balance and, shortly before his death in September 1916, repudiated a claim to it. Florence Phillips outlined the background in a letter to Sigismund's brother Ludwig Neumann, 31 August 1917 – a masterpiece of genteel blackmail – and persuaded the executors of Neumann's estate to hand over the balance of £3000 (correspondence in the Johannesburg Art Gallery archives, Ross papers).

26. The 'exit' dates and destinations of artworks are given in Stevenson, 1997b (Otto Beit, for example, bequeathed two Jan Steens to the National Gallery, London on his death in 1930). For a discussion of the tendency since the time of the first colonial settlers in 1652 to repatriate seventeenth-century Dutch paintings and other valuable possessions to the motherland see Carman, 1994, Introduction. For the Randlords' general lack of commitment to South Africa in the area of their private collections – with the exception of Abe Bailey's bequest to the South African National Gallery – see Stevenson, 2002, Postscript.

27. Joseph Solomon notes that, during Hugh Lane's visit to South Africa, September to December 1910, Jan Smuts inspired in him the desire to make a collection of old Dutch Masters for South Africa, 'and together we conspired to get our South African magnates to start a National Art Collection Fund, which might purchase works over a period of years' (Solomon, 1915, p. 13).

28. The collection was bought by Michaelis in November 1912, opened to the public on 2 October 1916 in the Old Town House and formally inaugurated on 8 May 1917 (Carman, 1994; Fransen, 1997; Stevenson 1997a, 2002). According to Joseph Solomon, who stayed with Hugh Lane in London at the end of 1911, Lane had already by that time added to his own collection 'a completely representative group of Dutch and Flemish Seventeenth Century Masters' which was subsequently bought by Max Michaelis (Solomon, 1915, p. 13). Some letters dating from October 1912 in the National Library of Ireland (Manuscripts Department, acc. 5073) reveal that Michaelis haggled about the price and suspected Lane was doing a 'clever deal'. A peeved Lane, who claimed to have held on to the pictures for two years and not to be making any profit, threatened to sell the collection elsewhere.

29. The collection of 400 items arrived in 1947 (*The Sir Abe Bailey Bequest*, 2001).

30. Twenty-one items were given on loan to the Michaelis Collection in 1923 and donated in 1933 by Lady Michaelis after her husband's death. Lady Michaelis also gave a collection of 53 old master drawings to the South African National

Gallery in 1930 and, in 1933, 59 paintings to the South African National Gallery and 58 to Pretoria. The South African National Gallery tried to refuse their part of the gift as it was not considered of museum quality (Stevenson, 1997a, p. 41). Michaelis is also remembered for providing the funds to establish the Michaelis Art Library in Johannesburg and the Michaelis Art School in Cape Town.

31. Lionel Phillips sets out the duties of restitution (or 'retribution', the term he uses) in a letter to Julius Wernher, 30 May 1910 (Fraser and Jeeves, 1977, p. 224, letter 100).

32. For a synopsis of the thwarting of her plans see Carman, 2002b, Conclusion.

33. For the subsequent history of the Johannesburg Art Gallery see Carman, 1988, 2003. For the incomplete Lutyens building and its extensions, which opened in 1940, see McTeague, 1984. Even after these 1940 extensions (the south-west and south-east pavilions) the Lutyens building remained incomplete, lacking the entire north wing and its pavilions. In 1986 extensions designed by Meyer Pienaar and Partners were opened, completing the northern aspect.

34. The Johannesburg collection opened in the same month, November 1910, as Roger Fry's *Manet and the Post-Impressionists* at the Grafton Galleries in London. Its two London displays at the Whitechapel Art Gallery, 9 May to 19 June 1910 and 9 to 23 July 1910, pre-dated the Fry exhibition. The perceptions in the metropole of the advanced nature of the Johannesburg and Dublin collections and of Hugh Lane's curatorial abilities, the use at the time of terms like 'modern' and 'contemporary', and the interim period between Lane's modern collections and the impact of Fry's exhibition are discussed in Carman, 2002b.

References

Becker, R. and Keene, R. (eds) (2000), *Art Routes: A Guide to South African Art Collections*, Johannesburg: Witwatersrand University Press.

Beirne, L.J. (ed.) (1910), *Johannesburg: Its Municipality, Art Endeavours, Associations, Clubs, Communities, Institutions, Public Bodies, Regiments and Societies*, organized and edited by the Secretary L.J. Beirne for the Royal Visit Commemorative Presentation, Johannesburg: Beirne and Nissen (printed by *The Transvaal Leader*).

Bell, B. (1995), 'The Tatham Art Gallery Victorian Collection: the end of colonial art?', in Matthews, M. (compiler), *Victoria/DASART*, Howick: Brevitas, pp. 9–31.

Brenthurst Press (1996), *The Jameson Raid: A Centennial Retrospective*, various authors, Brenthurst Press Third Series 1, Johannesburg: Brenthurst Press.

Carman, J. (1988), 'Acquisition policy of the Johannesburg Art Gallery with regard to the South African collection, 1909–1987', *South African Journal of Cultural and Art History* 2 (3), July, 203–13.

——— (1994), *Seventeenth-century Dutch and Flemish Paintings in South Africa: A Checklist of Paintings in Public Collections*, compiled in collaboration with the Netherlands Institute for Art History, The Hague, Johannesburg: Johannesburg Art Gallery.

——— (2002a), 'Arts and crafts and reconstruction', paper delivered at the annual conference of the SA Association of Art Historians, University of Pretoria, July.

——— (2002b), '"Modern art for South Africa": the founding of the Johannesburg Art Gallery', unpublished PhD thesis, University of the Witwatersrand.

——— (2003), 'Johannesburg Art Gallery and the urban future', in Tomlinson,

R., Beauregard, R., Bremner, L. and Mangcu, X. (eds), *Emerging Johannesburg: Perspectives on the Postapartheid City*, New York: Routledge, pp. 231–56.

Fransen, H. (compiler) (1978), *Guide to the Museums of Southern Africa*, Cape Town: Southern African Museums Association.

—— (1997), *Michaelis Collection, The Old Town House, Cape Town: Catalogue of the Collection of Paintings and Drawings*, compiled in collaboration with the Netherlands Institute for Art History, The Hague, incorporating sections of the 1981 catalogue by D. Bax and a chapter by M. Stevenson, Zwolle: Waanders Uitgevers.

Fraser, M. (ed.) (1986), *Some Reminiscences: Lionel Phillips*, Johannesburg: Ad Donker.

—— and Jeeves, A. (1977) *All that Glittered: Selected Correspondence of Lionel Phillips 1890–1924*, Cape Town: Oxford University Press.

Green, E. (1966), 'The South African National Gallery', *Lantern* 15 (3), March, 11–27.

Gregory, Lady (1973), *Sir Hugh Lane: His Life and Legacy by Lady Gregory*, foreword by J. White, general editors T.R. Henn and C. Smythe, the Coole Edition, Gerrards Cross: Colin Smythe.

Gutsche, T. (1966), *No Ordinary Woman: The Life and Times of Florence Phillips*, Cape Town: Howard Timmins.

—— (1972), 'Phillips, Sir Lionel (Bart.)', in *Dictionary of South African Biography*, Pretoria: Human Sciences Research Council, vol. 2, pp. 544–6.

Hancock, W.K. and van der Poel, J. (eds) (1966), *Selections from the Smuts Papers*, 4 vols, Cambridge: Cambridge University Press.

Johannesburg Art Gallery (1910), *Municipal Gallery of Modern Art. Johannesburg. Illustrated Catalogue*, biographical notes compiled by C. Campbell Ross, prefatory notice by Hugh Lane, Johannesburg: Argus.

—— (1912), *A Catalogue of the Neumann Gift to the Municipal Gallery of Modern Art Johannesburg*, ed. C.H. Collins Baker, London: Philip Lee Warner Publisher to the Medici Society.

Langham-Carter, R.R. (1971), 'The picture collection of Thomas Butterworth Bayley', *Africana Notes and News* 19 (8), December, 340–51.

McTeague, M. (1984), 'The Johannesburg Art Gallery: Lutyens, Lane and Lady Phillips', *The International Journal of Museum Management and Curatorship* 3 (2), 139–52.

Marks, S. and Trapido, S. (1981), 'Lord Milner and the South African State', in Bonner, P. (ed.), *Working Papers in Southern African Studies*, Johannesburg: Ravan Press, vol. 2, pp. 52–96.

Maud, J.P.R. (1938), *City Government: The Johannesburg Experiment*, Oxford: Clarendon Press.

Miers, H.A. and Markham, S.F. (1932), *A Report on the Museums and Art Galleries of British Africa ... to the Carnegie Corporation of New York*, the Museums Association survey of Empire museums, Edinburgh: Constable.

Miller, M. (2002), 'City beautiful on the Rand: Lutyens and the planning of Johannesburg', in Hopkins, A. and Stamp, G. (eds), *Lutyens Abroad: The Work of Sir Edwin Lutyens Outside the British Isles*, London: The British School at Rome, pp. 159–68.

Murray, B.K. (1982), *Wits: The Early Years. A History of the University of the Witwatersrand Johannesburg and its Precursors 1896–1939*, Johannesburg: Witwatersrand University Press.

O'Byrne, R. (2000), *Hugh Lane 1875–1915*, Dublin: The Lilliput Press.

Philips, L. (1905), *Transvaal Problems: Some Notes on Current Politics*, London: John Murray.

——— (1924), *Some Reminiscences*, London: Hutchinson.

Report of the Commission Appointed in Connection with the S.A. Art Gallery, Cape Town (1947), Union of South Africa, Department of the Interior, Pretoria: The Government Printer.

Solomon, J.M. (1915), 'Sir Hugh Lane: a memoir', *Country Life in S.A.* 1 (3), June, 11–13.

Stevenson, M. (1997a), 'History of the collection', in Fransen, H. (1997), *Michaelis Collection, The Old Town House, Cape Town: Catalogue of the Collection of Paintings and Drawings*, compiled in collaboration with the Netherlands Institute for Art History, The Hague, Zwolle: Waanders Uitgevers, pp. 29–43.

——— (1997b), 'Old Masters and aspirations: the Randlords, art and South Africa', unpublished PhD thesis, University of Cape Town.

——— (2002), *Art and Aspirations: The Randlords of South Africa and their Collections*, Vlaeberg: Fernwood Press.

The Sir Abe Bailey Bequest: A Reappraisal (2001), with a preface by H.R. Proud and an essay by A. Tietze, Cape Town: Iziko Museums of Cape Town.

Tietze, A. (1998), 'Classical casts and colonial galleries: the life and afterlife of the 1908 Beit Gift to the National Gallery of Cape Town', *South African Historical Journal* 39, November, 70–90.

Van Reenen, R. (ed.) (1984), *Emily Hobhouse: Boer War Letters*, Cape Town: Human & Rousseau.

European Modernism and African Domicile

Women Painters and the Search for Identity

MARION ARNOLD

Pictorial modernity made an abrupt, public entrance into the Union of South Africa in February 1922 with 'An Exhibition of Modern Art by Miss Irma Stern at Ashbey's Art Gallery' (catalogue cover). The 27-year-old artist, who had returned to the land of her birth after studying art in Germany, exhibited in a colonial city where Impressionism was still considered radical. Her bold announcement, containing the provocative word, 'modern', produced results. A reporter writing for the *Cape Argus* newspaper on 17 February 1922 noted, 'As a "draw" to the public, no show of pictures has ever succeeded like the exhibition by Miss Stern now on display at Ashbey's galleries. There is a constant stream of visitors through the day and once, at least, during the lunch hour, the crowd was so great that waiting queues had to be formed.'[1]

Executed in a raw, expressionist style, Irma Stern's works challenged the tasteful romantic realism characteristic of the art scene in South Africa's mother city that was, a critic acknowledged, 'far removed from the scene of action'. He also noted, 'we are inclined not only to accept old values long after they have been discredited, but even to reject, without new examination, new values when they are presented' (H.E. du P., *Cape Argus*, 8 February 1922). Stern's canvases asserted new values while the artist herself undermined the prevailing notion that women painters were refined young Englishwomen whose education was completed by the acquisition of pictorial skills demonstrating accomplishment, rather than professional commitment born of formal art training.

Irma Stern (1894–1966) was not English. Born in Schweizer-Reneke, formerly in the Transvaal (see Fig. 1.1) but now in the North West Province, she was German-Jewish. When she returned to South Africa in 1920 from Berlin, she had spent half her life in Germany and become conversant with modern art and avant-garde cultural debates.[2] Familiar with the tenets of German Expressionism and friendly with Max Pechstein, Stern had held her first one-person exhibition at the Fritz Gurlitt Gallery, Berlin, in 1919, exhibited at the *Freie Sezession* and been a founding member of the progressive *Novembergruppe*.[3]

Although Stern launched her career in South Africa with a big exhibition,[4] she was not the first South African woman artist producing paintings that broke with academic conventions. Bertha Everard (1873–1965), who was almost a generation older than Stern, had rejected English picturesque naturalism and presented paint as substance to interpret, rather than imitate, nature. Everard (née King) was born in Natal but grew up in England where she studied art prior to returning to South Africa in 1902 to teach in Pretoria. In 1903 she married a rural storekeeper and began living beyond metropolitan influences on a farm near Carolina in the Eastern Transvaal (see Fig. 1.1), now Mpumalanga. Stern and Everard exemplify two different strands of influence that infused South African modernism – the dynamic avant-gardism of continental Europe, transmitted to South Africa as Expressionism, and a modified Post-Impressionism which was Britain's cautious reception of progressive modernity.

Different in almost every respect other than their restless temperaments and forceful personalities, Irma Stern and Bertha Everard present a gendered anomaly within South African modernist art practice. Domiciled in a masculinist, frontier African society on the periphery of western influence, women artists such as Everard, Stern and Maggie Laubser (1886–1973)[5] took the initiative in creating and exhibiting progressive painting. In so doing, they defied popular taste and defined themselves as serious artists contesting feminine stereotypes and the male authority entrenched in a conservative art scene.[6]

Far from the turbulent metropolitan debates characterizing the pre- and post-war European art scene, white South African women artists confronted the conflicting demands of heritage and domicile. For them, the tension generated by inherited cultural identity and personal experience of life in Africa was given particular inflexion by the racial dimensions of gender. Since race controlled, promoted or inhibited opportunities for self-realization, an analysis of female subjectivity is consistently mediated by factors requiring 'woman' to carry the burden of the provocative, qualifying adjectives, 'black' or 'white'. 'White' offered the privilege of opportunity.

Bertha Everard was a white, English, Christian South African who married and had three children. Irma Stern was a white, German-Jewish South African who married, divorced and was childless. Both women travelled constantly. Stern, based in Cape Town, journeyed throughout South Africa, West Africa, the Congo and Zanzibar, and made numerous, long visits to Europe, especially Germany. Everard moved between several farms in the Eastern Transvaal, travelled within South Africa, re-located to England for four years, and visited France and Italy.

The issue of whether Stern and Everard defined themselves as European or South African depended on where they were located and whether they considered one place as the dominant centre. Each journey made by Everard

and Stern required the boundaries of 'home' to be redefined and the relative merits of actual places to be evaluated in relation to cultural and private spaces. Their mental journeys and physical travel contributed to the production of paintings encapsulating questions of personal, social and artistic identity while simultaneously describing and interpreting familiar or new scenes and people. Furthermore, as women travellers they exemplify the gendered dimensions of travel. Enloe (1989, p. 21) observes: 'In many societies being feminine has been defined as sticking close to home. Masculinity, by contrast, has been the passport for travel … a principal difference between women and men in countless societies has been the licence to travel away from a place thought of as "home".' As travellers, Stern and Everard disregarded the European association of femininity with 'home'; for them and many other colonial women, travel over long distances was undertaken as a matter of course. Where the artists differed from fellow South African women is that they invariably travelled in the cause of art, either to study it, or to find motifs and subjects, or to exhibit.

For the women artists who encountered modernist ideas within Europe, stylistic innovation possessed historical and geographical parentage. Forms of expression were generated partly as historical process but also by responses to the visual dynamics of northern-hemisphere countryside and its relationship to urbanization and technological progress. Although European modernism witnessed the erosion of mimetic principles by artists seeking to correlate visual experiences of modernity with distinctively contemporary pictorial language, their creative activities were undertaken within cultural contexts that generated theory to explain practice. Modernism, as a discourse of modernity, possessed – like earlier argumentation – an inherent capacity to connect art to life within western culture, however disruptive and transgressive its styles initially seemed to be in the late nineteenth and early twentieth centuries.

The fluidity of modernism as a shifting and unstable series of innovations relating to new socio-political circumstances offered young European women artists ways of intervening in the art world and inserting themselves as liberated and significant voices. But what were colonial women to do within more authoritarian societies where they encountered landscapes and metropolitan environments decisively different to those of Europe?

Some women acted as agents of change.[7] The reason women artists took initiatives to introduce modern art to South Africa is not straightforward. Modernism, subject to national pressures, assumed many different local forms within Europe and such differences were exacerbated as time and distance moderated stimuli reaching beyond Europe. Although South Africa enjoyed dominion status within the British Empire after 1910, it remained a frontier, masculinist society where white colonizers imposed British rule on indigenous people. The settler population introduced and enforced the norms, values and bureaucracy of a capitalist British political system, and male administrators

and officials devoted time and energy to the practical implications of settlement and imperial ideology. 'Culture', an offspring of western civilization, was conceived as the embodiment of intellectual achievements acquired by serious study and demonstrated by professional practice within established criteria, and it valorized skill, labour and intellectual superiority. Although not central to colonialism, 'culture' offered evidence of British values and was esteemed accordingly. Modern art, however, was perceived as a provocative symptom of change within Europe and, since the Union of South Africa required the maintenance of order, cultural practices signifying uncertainty and radical change were unwelcome. South African culture, trying to determine its new national character, had to demonstrate that the Union had absorbed long-established British conventions; signs of visual experimentation were interpreted as undermining social stability.

For white South African painters, the issue at hand was whether their artistic inheritance – a learnt, formal, representational language – was sufficiently flexible to become an effective system of communication beyond its place of origin. For Everard and Stern it was not. The mimetic principles of descriptive naturalism did not encourage the expression of complex personal responses to African domicile and their identity as women. However, these two women confronted the issues of cultural inheritance and African domicile in markedly different ways.

Everard worked in relative isolation, struggling to find the vocabulary to articulate her feelings about the spacious landscapes she encountered daily. While challenging the procedures of pictorial production, she accepted the conventions of reception. As a result, the limitations of the South Africa art world – its smallness, institutional male dominance, parochial conservatism, regionalism, severely restricted purchasing power and relative social inconsequentiality – defeated her. Isolated in a rural community, her attempts to enter the art world were sporadic.[8] She did not acquire a substantial reputation in her lifetime and her support system was restricted to her sister Edith King and her daughters, Ruth and Rosamund.[9] Furthermore, she devoted only part of her time and energy to art. As well as being a painter, she was a wife, mother, farmer, teacher, mission worker and architect/clerk of the works for the Church of the Resurrection, built at Carolina in 1932. These important components of her life infused her art with its unique identity but did not, in the early decades of the twentieth century, contribute to the promotion of her artistic career.[10]

Stern, on the other hand, recognized the relationship between art production and reception. She understood the crucial connections between product, publicity/marketing and sales, and the ways in which they shape careers. Devoting time and energy to self-promotion, she not only inserted herself into the South African art world but also became its best-known and most successful player. More has been written about Irma Stern than any other

South African artist.[11] Her reputation grew throughout her lifetime and has never waned. It sustains the high prices her works continue to fetch at auction and contributes to the interest now being evinced in her by German scholars.[12] Highly focused on her career, Stern used the lack of competition in the South African art world to her advantage, citing her reception in Germany to promote her work in South Africa, and emphasizing her African experience to impute authenticity to representations of black people she exhibited in Europe.

Bertha Everard's art training was thoroughly academic[13] and her acquisition of a distinctively personal artistic identity was slow. By 1902, when she went to Pretoria, she had produced a body of work characterized by a painterly naturalism, indicating her mastery of basic graphic and pictorial techniques. After marrying in 1903, Everard's immediate physical horizons were restricted to the South African highveld. The rural farming community offered scant intellectual stimulation and evinced little interest in painting, and Everard's knowledge of progressive culture was gleaned second-hand from imported literature such as *The Studio* and Clive Bell's *Art* (1913). Her 1916 critique of this text, indicating a shrewd grasp of the argument and its limitations, reveals some of her objectives and opinions on modernism. She observes of Bell:

> He hopelessly contradicts himself when he bars imitation and yet owns that the representation of [the] third dimension is necessary in pictorial art. What is representation of the third dimension but imitation? There seem to me to be three essentials in all good art only differently proportioned according to the kind of art. Decoration (line and colour), Imitation and Representation, Decoration taking the first place. But I detest illustrations which in their anxiety to be decorative ignore the text, much as I dislike cubist portraits. And about imitation. Pure and simple it isn't art; rather conjuring, but a certain amount is not only good but absolutely necessary.
>
> (quoted in Harmsen, 1980, p. 46)

Everard's first public success as a South African artist came in 1910 when she exhibited at the South African National Union Arts and Crafts Exhibition, organized by Florence Phillips in Johannesburg. Designed to indicate the importance of British cultural values in the new dominion, the exhibition offered Everard the opportunity to submit *Mid-Winter on the Komati River* to the 'Modern Arts and Crafts' section. It was awarded the gold medal because of its assured description of the veld.[14] This depiction of an emphatically African landscape contributed to debates on national style and imagery that were to gain momentum in the media. One journalist observed that Everard had 'caught the heat and atmosphere and brilliance of South Africa in a marvellous manner, and with her European training has been able to interpret it all in a way to delight the beholder' (quoted in Harmsen, 1980, p. 31). This comment neatly encapsulates the interaction between a South African subject and its interpretation in a mimetic western style.

The issue of a national South African art preoccupied Edward Roworth who contributed an article on 'Landscape Art in South Africa' to a special 1917 edition of *The Studio* magazine devoted to 'Art of the British Empire Overseas'. Conceding that, owing to the great diversity of terrain, 'there is no such thing as a school of South African landscape painting', Roworth (1917, p.115) argued the appeal of distance as a recurrent thematic characteristic. For Everard, who expressed annoyance that her painting did not receive a mention by Roworth, landscape motifs had little to do with public discourse on nationalism. She evinced no interest in the problems relating to the politics of representation, and her choice of subjects was personal, not patriotic. For her, 'home' was not demarcated by lines on a map or historical patterns of conquest and settlement, but was instead the place where her family lived. By 1910 the family members who were the focus of passionately possessive, obsessive attention were her elder sister, Edith, and her three children.[15]

Everard experienced landscapes from two angles – practically, as a farmer, and aesthetically, as an artist. As a farmer, she acknowledged the problems of gender, commenting ruefully, 'My greatest difficulty is my sex even after all these years. It is hard to manage a native if you are male but for the female it is almost impossible but I get things done nevertheless' (unpublished letter to Edith King and Ruth Everard, 27 March 1927).[16] Home – the farms Bonnefoi and Lekkerdraai – offered livelihood and security but demanded hard, time-consuming work that eroded the hours available for painting. In 1927, while directing the building of a dam, Everard wrote:

> With this water we mean to irrigate crops during the winter … I am also directing ploughing, sowing and fencing and a little road making. It does keep me running about. These last few days I have begun long before breakfast and gone on till dark. I shall not always be so strenuous but if I am to make the farm pay, no time is to be lost. Painting is very very far off. Yet sometimes I look about with a painter's eye. Some of the pictures I see are tenderly beautiful.
> (unpublished letter to Edith King and Ruth Everard, 27 March 1927)

In the years after her success in Johannesburg, Everard produced paintings that transmit an individual vision born of her response to the spacious natural beauty of familiar Eastern Transvaal topography, as well as her volatile temperament. An emotional personality subject to bouts of self-pity and depression, Everard appears to have used art to externalize strong feelings about her life, its multifaceted daily routines and her complex interpersonal relationships. Through painting, she seems to have sought to conquer self-doubt and the spiritual crises that overwhelmed her as she tried to practise Christian goodwill[17] and control her quick-tempered impatience with farm workers and family. Painting offered solitude and mental focus and, although she often complained of frustration in realizing her objectives, she recognized that she could transmit emotion through pictorial process.

Looking Towards Swaziland (*c*.1920/21; see Plate 1) encapsulates her formal solution to the problem of conveying her feelings about nature.[18] It is the result of a deep knowledge of the scenery she viewed habitually. The rolling hills, their rhythms enhanced by flickering light and shadow from overhead clouds, signify both ephemeral moments and enduring structure. Initially called *Opal Valley*, Everard's painting interprets a panorama apprehended from the Skurweberg. Viewed from a high, rocky vantage point, the scene is based on an actual space but the brilliant, saturated blue-green colours offer optical equivalents for the sensation of shimmering, opalescent, light-drenched African hills and valleys. The brilliant-hued impasto, layered with a palette knife, marks a watershed in Everard's development. Freeing coloured mark from descriptive function, she gives visual language independent expressive potential as substance and sign.

Everard took *Opal Valley* to Britain and submitted it to the Royal Academy in London and the Paris Salon in 1924. It was accepted for both exhibitions. Writing to her husband about the Royal Academy exhibition, Everard appraised her work in relation to the show as a whole. Her comments reveal a deferential attitude towards British art and her wish to assert her South African identity. She observes:

> Monday was varnishing day. I got one in and after seeing the work there I am not surprised that only one was hung ... The standard of work is tremendously high and I was *amazed. Brilliant* technique. Mostly large works and only two deep. Nothing is skied now. I found my 'Opal Valley'. The last I painted in Africa. It is much too small to tell in that crowd and it is rather unfortunately neighboured by a Laura Knight and the most violent scarlet so that my opal colours have a bad time. However I am in very good company. All the works in that room are by good people ... I have called my 'Opal Valley' 'Looking towards Swaziland, Transvaal'. I wanted to locate it.
>
> (quoted in Harmsen, 1980, p. 85).

Although Everard wanted her painting to declare its geographical location, her depicted space is devoid of people, black or white. People, however, dominated her daily existence and the demands of her farm workers and household, especially her children, absorbed her energy. From infancy to adulthood she controlled their existence, teaching them at home rather than sending them to boarding school, then re-locating to Cape Town before taking them to England in 1922 for their studies. In effect she created a burden that became almost insurmountable as she tried to balance her own needs as an artist with the self-imposed responsibilities she assumed as a mother and grandmother.[19]

Everard and her children spent four years in Britain, moving between temporary homes. Aged 50, the artist finally encountered modern painting in reality. She visited galleries in Italian cities, London and Paris and, studying

the Post-Impressionists, she was especially moved by Van Gogh's work. However, absorbed in organizing family life and involved in daughter Ruth's art studies, she painted sporadically in England. She found it difficult to identify subjects that offered expressive potential. 'Give me the wide landscape, free and harsh,' she wrote. 'Let me go. Let me leave this pretty pleasant spot with its little sweetnesses and its gentle unstirred life. Stir me up' (unpublished letter to Edith King, 1926).

Her most significant European paintings were generated by French landscapes – woodlands, cliffs and ploughed lands – and by Delville Wood, where thousands of South Africans perished in the First World War. In 1926, still devastated from war damage, this terrain offered much to stir up an artist who responded to rhythm. Everard's Delville Wood paintings are overtly expressionistic, earth and broken trees being defined by broad brush and knife strokes and strong colour. Everard had probably seen Paul Nash's Delville Wood war paintings but her own interpretations of violated earth reveal her assimilation of a range of modernist sources. First-hand contact with Europe renewed her artistic energy and offered evidence that the pictorial solutions she had reached cautiously and intuitively in South Africa were valid vehicles for personal communication. However, preparing to return to South Africa in 1926, she wrote: 'Soon I shall leave England and somehow I feel this is really my last of her. England is not for me. I must go home wherever that may be. It certainly isn't England' (quoted in Harmsen, 1980, p. 131).

Arriving back 'home' in the Transvaal in October 1926, Everard was unable to consolidate on her European experiences. She became immersed in farming and the realities of rural South Africa. If local interest in her painting was minimal, comprehension of them was practically non-existent, and the Delville Wood paintings were particularly poorly received. She was, however, chosen to represent the Transvaal in the Imperial Art Exhibition in London in 1927. *Looking Towards Swaziland* was exhibited and was praised by several critics. The reviewer for the *Yorkshire Post* observed, 'It is in many ways the most striking picture in the exhibition, and the one which is most "different" from the work to which we here are accustomed' (quoted in Harmsen, 1980, p. 137).

Back in South Africa, Everard rediscovered artistic isolation and wrote, 'I hate this country for art. If only art is being done, it must be done in Europe' (unpublished letter to Edith King, 5 January 1928). For three years after her return to South Africa, Everard did not paint. When she resumed painting, her style was boldly reductive and her subjects spoke of her domestic life, not enclosed interiors, but highveld landscapes – the family farms she traversed and the land she worked. In *The New Furrow* (early 1930s; Fig. 3.1), the bright, white and blue river is an insistent rhythm cutting through a muted purple, brown, ochre and green landscape.[20] The new furrow, not yet carrying water, is an unobtrusive straight form on the right. It offers no visual

Fig. 3.1 Bertha Everard, *The New Furrow*, 88 × 156 cm (34½ × 61½ inches), oil on canvas, early 1930s, Collection of the Pretoria Art Museum.

competition to the natural course of the river but signifies the manual labour required to irrigate the African soil. Exhibited in 1931,[21] the painting drew ambivalent comment from a critic who observed: 'Bertha Everard's two large canvases gave a decided impression of the country they were meant to depict. The harsh technique adopted by the artist seemed to me rather to excess, though it certainly conveyed a sense of power' (Lefebre, 1931). The river echoes the roads winding through the centre of Everard's French landscape series and the lines between the hill profiles in *Looking Towards Swaziland*. Metaphorically, the late landscapes speak of forceful rhythms, drawing the traveller/viewer into the distance. In *Looking Towards Swaziland*, the distance held promise; in *The New Furrow*, the distance imposes barriers.

Although Everard died in 1965, by the end of the 1930s she had virtually stopped painting, seemingly because she lost confidence, although she continued to support the efforts of her daughter Ruth and granddaughter Leonora. Throughout her working life, Everard painted in a cultural environment that remained hostile to modern art and deeply suspicious of its intentions. As enlightened critics were few and far between, it was left to artists themselves to promote and defend their work, and publicize their objectives. This Everard did not do and, despite the efforts of Edith King who sent paintings to exhibitions and arranged for reproductions of paintings to be made, the public at large knew little of Bertha Everard and her work. While her isolation in the Eastern Transvaal offers a partial explanation for her sporadic engagement with the small South African art world, it does not provide a full answer.

Unsure of whether art should be the most significant component of her existence, Everard produced a relatively small oeuvre and re-cycled works for public exhibition. She was also ambivalent about whether her artistic identity should be located in Europe or Africa. Although the reception of her work in London gratified her, she did not want to live in England. However, her modernist style and creative objectives, stimulated by her western heritage, were at variance with the conservative values of the place she chose as home. Ultimately her private space did not forge a satisfactory relationship with the public space of the modern, twentieth-century art world in either Europe or South Africa. The very reverse can be said of Irma Stern.

Stern constructed her career by using her dual South African–German identity to her advantage and ensuring, as a constant traveller, that she felt at home in different spaces. Realizing that she could exploit her experiences of 'exotic' Africa to her advantage in South Africa and Europe, she fused her life with her art and built a reputation that survived her death. Instead of perceiving South Africa to be disadvantaged by its distance from Europe, Stern recognized that 'authentic' experiences of Africa could be marketed in Europe because interest in primitivist art and its dichotomous relationship to modernity was well established. German Expressionism, positioned as

'modern', was ambivalent about 'civilization' and was permeated by both backward- and forward-looking tendencies.[22]

While living in Germany, Stern studied Post-Impressionist and German Expressionist art at first hand. She became familiar with the tensions between primitivism and modernity inherent in *Die Brücke* painting and wood carving as well as with significant publications such as Carl Einstein's *Negerplastik* (1915), which emphasized the religiosity of African art, and Gauguin's *Noa Noa* (published in German in 1908). Moreover, she was acquainted with Max Pechstein (1881–1955) and they visited one another's studios and corresponded. Not only did Pechstein invite Stern to join the *Novembergruppe*, but he also persuaded Fritz Gurlitt to give her an exhibition in Berlin in 1919. Stern knew of Pechstein's trip to the South Sea Palau Islands (1914–15) and the romantic, idealized works his escapist expedition produced. Her early work shows his influence and she acknowledged his help, commenting in the *Cape Argus* in 1926 that 'to this generous and noble-minded artist I owe more gratitude than to anybody else'. Paying tribute, she cannot have been unaware that mentioning a relationship with a renowned foreign artist would give her credibility in parochial South Africa.

After her poorly received 1922 exhibition[23] Stern travelled to Natal where she discovered Umgababa, a small seaside resort on the south coast of Natal, 35 kilometres (12 miles) from Durban. It was completely different to the Africa that she had known in the barren, parched Transvaal of her childhood. The Zulu people with their distinctive culture and the tropical landscape provided catalysts for Stern's interpretation of Africa as paradise:

> By pure chance I have found everything my heart desires, sea, wonderful tropic vegetation, natives as beautiful as gods – honestly, if one goes down to the river and sees their brown slender figures strolling along with beautiful black clay vessels on their heads, and their marvellously harmonious movements – then I feel as though I dream it all.
> (letter to Trude Bosse, September 1922, quoted in translation in Dubow, 1991, p. 84)

Although Stern's encounters with Africa were real and were presented as truth authenticated by the artist as authoritative eye-witness, her construction of Africa was a fictional, imaginative mixture of childhood memories, nostalgia and adult romantic idealism filtered through a German modernist concept of primitivism. Accustomed as Stern was to making paintings, it was easy to make word pictures[24] and promote them as dramatic realities rather than inventions.

Launching her career on two continents, Stern courted the press. Cape journalists found her expeditions into rural areas as newsworthy as the Germans did, and Stern's life started to inform her art.[25] She engaged the attention of German critic Max Osborn, who had published a monograph on Pechstein in 1922. Interested in 'the exotic', Osborn was aware of

contradictions within primitivist modernity and he expressed his doubts about 'civilization' in his 1927 publication on Stern. (This text includes a clumsy English translation of his essay and 'Umbagaba', an abbreviated version of Stern's *Umgababa Buch* in German.)[26] Relying on information from Stern, whose recollections of her youth were both selective and embroidered with fancy, Osborn (1927, p. 27) exaggerated and sentimentalized Stern's knowledge of Africa, observing:

> There has probably never been any white person who has understood the nature and the original inhabitants of South Africa in this manner. With deep feminine feeling she submerged herself in the individual life of the brown and black people, above all in the life of her colored sisters, the girls and women of these mysterious races, whose noble origin was disclosed in the wonderful, slender, proportionately formed bodies, whose native innocent and simplicity of feeling could be seen in their faces by one able to interpret their expression.

Imputing a 'feminine' consciousness to Stern, Osborn (p. 28) also observed: 'These paintings speak with broad, energetic, quite masculine colored spaces'. He was not the only writer on Stern to find her visceral, visual language to be 'masculine'. Osborn was correct in finding that Stern produced some of her most eloquent paintings of female subjects. She was drawn to the grace and rhythms of female bodies, seeing them as essentially picturesque vehicles for her modernist aestheticism, but many of her observations about her models are naïve and patronizing. Her comments deny black people contemporary, individual identities as participants in a developing South Africa; she locates them as types in an idyllic, timelessness characterized by languorous display. This is apparent in *Three Swazi Girls* (1925; Fig. 3.2), painted after a trip to Swaziland. In a reminiscence published in *Frau und Gegenwart* (1927), Stern wrote:

> in front of a hut I found three girls of magical, colourful loveliness which I immediately tried to capture. They reminded me – I don't know why – of three rococco girls – they stood pressed close together – all three of them had their hair cut in the same way and coloured with white chalk – colourful cloths wrapped round their bodies, their slender wrists and ankles encircled with a touching thread of coloured wool, the same colour which I found at the throat – they were dainty and graceful – and I thought that I had never seen so much beauty together. They conducted me to their Queen, and advised me to take along her favourite delicacy as a present: caterpillars, beautiful, fat, live caterpillars.
>
> (quoted in translation in Schoeman, 1994, p. 86)

The girls, who constitute a repeat pattern of interlocking rhythmic shapes punctuated by blue, red and yellow cloths, are not overtly sexualized but, standing against a background of folded hills, are locked into the earth and signify Africa.

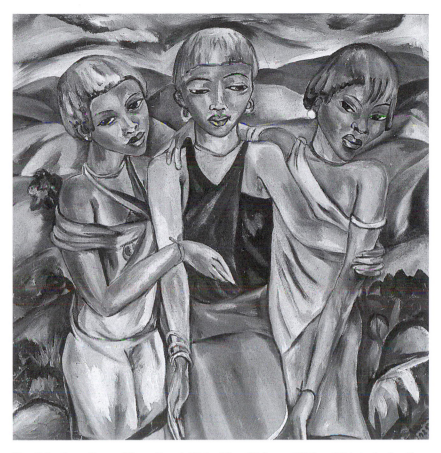

Fig. 3.2 Irma Stern, *Three Swazi Girls*, 98 × 97.5 cm (38¹/₂ × 38¹/₂ inches), oil on canvas, 1925, Collection of the Irma Stern Museum, University of Cape Town.

The models Stern considered appropriately primitive for European audiences were slow to find favour in South Africa where the 'native subjects' were reminders of everyday realities and the unsolved racial issues intrinsic to Union politics. By emphasizing the exotic nature of her models, Stern was, in fact, arguing the cause of difference and separation, not unity and democratic nation building. Her representations of different ethnic groups endorsed her opinion of black people living 'a happy life, in close connection with their soil, beautiful in their primitive innocence … lovely and happy children, laughing and singing and dancing through life with a peculiar animal-like beauty' (Stern, 'My Exotic Models', *Cape Argus*, 3 April 1926).

At the time Stern wrote her articles and granted interviews, her opinions were controversial in South Africa because she endorsed black culture and saw black people as beautiful. Retrospectively, the racism in her remarks is troubling although unremarkable for the time. Stern's opinions, paternalistic as they are, must be contextualized as part of her programme to be defined as an artist. In a larger community, her injudicious comments would have been challenged and she may have become more self-critical, but she wanted to acquire a distinctive voice and to insert herself as representative of the 'new woman' in the patriarchal, conservative South African art scene. As it was, her independence, forceful personality, adventurous lifestyle and prodigious creative energy won recognition in South Africa and in Europe. Her reputation in Europe, although modest, was as an 'African' artist although, in 1920s Weimar Germany, primitivism no longer constituted a central discourse in radical art practice.

Stern's African domicile assumed importance in the 1930s as the Nazis gained power in Germany and anti-semitism assumed momentum. When considering Stern's artistic identity, the fact that she was Jewish must not be underestimated. Although not a practising Jew, Jewishness was part of her social identity, and in both Berlin and South Africa she depended for contacts, intellectual stimulation and patronage on Jewish communities. By the early 1930s she recognized the threat Hitler posed. She commented, 'I get terribly frightened when I think of Germany's future' (to Trude Bosse, 24 April 1933, quoted in Dubow, 1974, p. 105) and she paid her last pre-war visit to Germany in 1931–32.[27] Although her contacts with Jewish Germany were drastically reduced, South African Jews remained loyal supporters. Articles about Stern appeared regularly in Jewish newspapers and many Jewish art collectors acquired substantial numbers of her works.[28] The unsettled nature of Europe in the early 1930s caused Stern to assess her priorities as an artist. In 1933 she divorced her husband, Johannes Prinz, and from then on she focused single-mindedly on her career and on her artistic identity in relation to Africa.[29]

In 1942 Joseph Sachs published *Irma Stern and the Spirit of Africa*. Eulogizing Stern's 'exuberance', 'vitality', 'sensuousness' and 'passionate temperament', Sachs (1942, p. 36) re-cycles the Stern origin myth[30] and, defining the character of her work, he suggests that 'the spirit of Africa and that of Europe meet and mingle' (p. 7). By 1942 Stern had reached out beyond the borders of South Africa into Africa for her subjects, partly through disillusionment generated by changes she discerned in the local people, who were losing their distinctive cultural identities as economic deprivation afflicted rural black communities.[31] Stern looked elsewhere for the exotic, travelling to Dakar in West Africa in 1937 and 1938, the Congo in 1942 and 1946, and Zanzibar in 1939 and 1944. These journeys were major expeditions, testifying to Stern's resilience and courageous determination to broaden her artistic horizons. They resulted in numerous paintings and drawings as well as two comprehensively illustrated books – *Congo* (1943) and *Zanzibar* (1948), both published in limited editions.

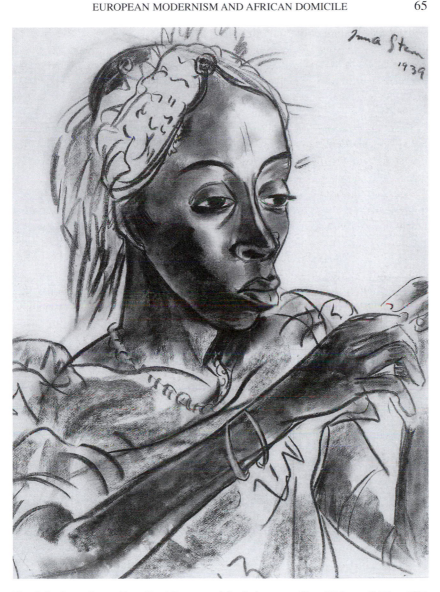

Fig. 3.3 Irma Stern, *Zanzibari Dancer of the Lelemama*, 63 × 47.5 cm (24³/₄ × 18³/₄ inches), charcoal on paper, 1939, Collection of the Pretoria Art Museum.

In multicultural Zanzibar Stern found many subjects among the Swahili people and the Arabs. *Zanzibari Dancer of the Lelemama* (1939; Fig. 3.3) is typical of Stern's economical, gestural charcoal drawings with their decisive delineation of facial features. In her book, *Zanzibar* (1948, p. 94), Stern describes an Arab wedding where she watched the Lelemama dance and explains that it was, 'An old Arab wedding dance performed today mostly by prostitutes. It is a motionless dance, with only hands clicking a brass ram's horn. They stand in a row and have their eyes shyly cast down, but their hands play a great game. Their dance is replete with highly suggestive sexual movement.'

Her Zanzibar expeditions offered Stern many colourful models. She was undoubtedly a fine portrait painter: throughout her career, when confronted with a model who captured her imagination, Stern rendered the individual and not the type. *Bibi Azziza Biata Jaffer* (1939; see Plate 2) is a study of the Sultana of Zanzibar's formidable lady-in-waiting in her customary architectural setting in the harem. Unidealized and authoritative, Bibi Azziza – central to the regularity of harem life – fills the picture format, seemingly occupied with her own thoughts. Resplendent in rich clothes and turban, and liberally endowed with jewellery, she exudes a confidence and competence that are confirmed by a contemporary reminiscence.[32]

An ornately carved wooden frame enhances the painting's decorative character. Stern, who had long been alert to the intrinsic quality of African art, assembled an excellent collection of masks and artefacts that are now housed at the Irma Stern Museum, Cape Town.[33] When she discovered the carved wooden doors of Islamic Zanzibar, she purchased a number from which she made picture frames for her oil paintings. Literally framed by their cultural context with the sculptural element emphasizing the detachment of the image from documentary reference, the paintings fulfil modernist objectives by proclaiming themselves as aesthetic forms.

By the time Stern exhibited her first Zanzibar paintings in 1940, vicious hostility to modernism had subsided in South Africa. Bertha Everard had virtually stopped painting but Stern, who had become the country's most renowned painter, had renewed her energy by embracing a wider experience of Africa than that which was available nationally. She had refused to allow the restrictions of gender, nationality or geography to shackle her creative drive and, once she realized that she had to cultivate a public persona as artist, her search for identity became highly focused.

While one can only speculate about why Everard abandoned painting, at least part of the reason must be that she could not cope with self-promotion. For her, living in a remote rural area, engagement with the metropolitan infrastructure of modernism was too burdensome to be pursued, especially when the demands of farming and family were insistent. Unlike Everard, Stern

used both European modernism and African domicile to her advantage to achieve public recognition.[34] Ultimately a lack of cogently argued criticism within South Africa and a generous dose of flattery meant that Stern became complacent about her work and dismissive of opinions contradicting her own.

In comparison to Everard, Stern had no family obligations. Her identity was defined by her professional career. She entered a man's world and vanquished the men who initially denigrated her and then became irrelevant when she received attention for her distinctively assertive work, frequent, well-publicized exhibitions and her ability to gain and maintain celebrity status. Stern's career as a white South African artist indicates that an emphatic adoption of modernist practice engaged productively with the politics of representation, and that gender was not necessarily an impediment to artistic and social success.

Notes

1. All newspaper cuttings about Stern that I cite in this essay are located in The Irma Stern Collection (MSB 31), Clippings Books, South African Library, Cape Town.
2. Stern studied at the Grossherzogliche Sächsiche Hochschule für bildende Kunst, Weimar under Carl Frithjof Smith, Gari Melchers and Fritz Mackensen, and Martin Brandenberg in Berlin.
3. The *Novembergruppe*, formed at the time of the German revolution in November 1918, was an alliance of Expressionists and Dadaists. Stern was invited to join by Max Pechstein, one of the initiators. She left Germany before rifts in the group emerged. Although she identified with the radical sentiments expressed in the 1918 Manifesto she showed no overtly leftist political sympathies in South Africa.
4. The show featured 96 oils, watercolours, drawings, woodcuts and lithographs as well as 28 items of hand painting on kimonos, sunshades and firescreens.
5. Laubser studied at the Slade School, London, and lived in Germany where she knew Schmidt-Rottluff. She held her first Cape Town exhibition in 1925.
6. The leading Cape artists Edward Roworth (1880–1964) and Gwelo Goodman (1871–1939) were English-trained, academic painters. Roworth, a landscape and portrait artist, was an influential art critic who outspokenly condemned modern art. Appointed to the Chair of Fine Arts at the University of Cape Town in 1938, he became Director of the South African National Gallery in 1941.
7. It is interesting to assess the work of colonial South African women in relation to modernist painting produced by women in Canada and Australia. There are affinities between the South Africans and Emily Carr (1871–1945) in Canada and Kathleen O'Connor (1876–1968) in Australia.
8. Everard exhibited at the South African National Union Exhibition, 1910 and thereafter she showed intermittently in group exhibitions in the Transvaal and Natal. During her domicile in England (1922–26) she exhibited in London and Paris and was represented in the South African section, British Empire Exhibition, 1924 and was selected to represent the Transvaal at the 1927 Imperial Art Exhibition, London.

9. Most writing on Everard has discussed her within the context of the 'Everard Group'. Bertha, her sister Edith King (1871–1962) and daughters Ruth Everard Haden (1904–92) and Rosamund Everard-Steenkamp (1907–46) all painted, as do the women from the next two generations. As a group, these women raise interesting issues in the nature/nurture debate and about female networking. See Harmsen, (1980), Arnold (1995) and Arnold (2000).

10. While acknowledging that publicity was necessary when exhibiting, Everard was uncomfortable about being the focus of attention. In an unpublished letter (April 1927) written after a newspaper interview, she wrote, 'How horrible self advertisement is. I will never *never* do any more again.'

11. See Arnold, 1995, p. 154 and Daneel, 1981. Daneel lists 1504 'Newspaper and Magazine Articles' written between 1918 and 1969. For discussion on her reputation see Arnold, 2003.

12. See Jutta Hülsewig-Johnen and Irene Below, 1996.

13. Everard studied at the Slade and Westminster Schools, London, and the Herkomer Art School, Bushey, from 1893 before settling in St Ives, Cornwall, in 1897 for two years, where she studied with Julius Olsson, a member of the New English Art Club and the Royal Society of British Artists. She gained a Teacher Artist Certificate and taught art for nearly two years at Walthamstow Hall, Sevenoaks, Kent. She exhibited at the Royal Society of British Artists (1899, 1901) and the Royal Academy (1900).

14. The confusion between this work and a similar painting, *Peace of Winter* (1909), is clarified in Harmsen, 2000.

15. See Arnold, 2000 for discussion on Everard's relationship to her sister and daughters.

16. All my references to unpublished letters by Bertha Everard have been gleaned from the Everard Letters, Family collection, Pietermaritzburg, South Africa.

17. Everard's sister Edith was a deeply committed Anglican; Bertha struggled with her faith although she built churches and worked as a preacher.

18. Attempting to define her attitude to 'feeling', Everard wrote: 'I know I have "felt" all that I have painted but that is not enough. It is the *base* of all art but it is not the complete structure. There must be the "artistry" so to speak and the craft. My work lacks both in most cases. Yet I am not despondent, for it is only a stage in my development' (unpublished letter to Edith King, 17 November 1927).

19. Edith and Bertha King had a very insecure childhood. Their mother, subject to marital abuse, fled to Britain from Durban with her children when Bertha was a year old. She went into service in Ireland leaving her girls in care in Cumberland. Bertha's dependency on her elder sister was forged in childhood and the desire to protect her own children was probably a result of her upbringing. Her increasing disregard for her husband is likely to have been exacerbated by the absence of a father figure in her own life and her lack of experience of marital unity. She found women sufficient for her emotional needs and, increasingly, came to project her own thwarted aspirations onto her elder daughter, Ruth.

20. I wish to thank Leonora Haden for granting me permission to reproduce the works by Bertha Everard.

21. The work was exhibited in 1931 in the 12th Annual Exhibition of the South African Academy together with *Hills, Eastern Transvaal* (*c*.1930).

22. See Lloyd, 1991.

23. W.R.M. (*Cape Times*, February 1922) wrote of 'the frank disgust at the general nastiness of the work'. H.E. du P. (*Cape Argus*, 8 February 1922) was much more sympathetic and perspicacious, observing, 'yet her position in splendid isolation has its compensations. For here Miss Stern has a clear field, even if she find little favour.'

24. Stern created literal word pictures in her illustrated letters and the journal she kept between 1919 and 1924; see Dubow, 1991. Her letters, like Everard's, are replete with self-dramatization and melancholic comments on depression and loneliness.

25. In the 1920s and early 1930s Stern exhibited frequently in South Africa and Europe. She held solo exhibitions in Cape Town in 1922, 1925, 1926, 1927 and 1932, and in Johannesburg and Bloemfontein in 1926. In 1923 she exhibited in Berlin and in 1924 in Frankfurt, Leipzig, Chemnitz, Vienna and Berlin. She was awarded the Prix de Honneur at the Bordeaux International Exhibition in 1927. She showed in London in 1924 and 1929 at the Empire Exhibition, Wembley, and held her first solo London show in 1932.

26. Max Osborn's publication was vol. 51 in the *Junge Kunst* series. Nos 49 and 50 were devoted to Picasso. Pechstein, Schmidt-Rottluff, Modersohn-Becker and Grosz were also featured.

27. From 1933, the notes in Stern's Clippings Book are written in English.

28. Stern's Jewish journalist friends included Richard Feldman, as well as Roza von Gelderen and Hilda Purwitzsky who often wrote under the pseudonyms 'Hora' or 'Rozilda' for Jewish journals. In 1929 Stern's work was included in the International Jewish Exhibition, Zurich.

29. For information on Stern's marriage, see Schoeman, 1994 and Arnold, 1996.

30. Sachs drew heavily on Irma Stern's 'How I Began to Paint' (*Cape Argus*, 12 June 1926).

31. After a trip to Swaziland in 1933, Stern expressed displeasure at the changes she had witnessed: 'It was a shock to me to see how the natural picturesqueness of the native in his kraal had almost entirely disappeared ... he has submitted to civilization' (*Cape Argus*, 5 July 1933).

32. In 1940, the *Cape Times* commented that when Mrs P.I. Hoogenhout visited Stern's exhibition where the portrait was shown, she recalled meeting the model some years earlier. She and her husband had dined with the Sultan of Zanzibar as part of an official South African delegation. 'The Sultana, being in purdah, was not at the dinner ... After dinner, however, the women of the delegation took coffee with the Sultana in her apartments. Mrs Hoogenhout clearly remembers the original of Irma Stern's picture. This lady-in-waiting stood stiffly against the wall watching the Sultana's every move. As the young children present one by one grew sleepy she pounced on them and handed them over to the attendants outside' (*Cape Times*, Tuesday, 13 February 1940).

33. Stern produced a large number of still-life paintings, many of which feature objects from her collection and testify to her recognition of African sculpture and textiles as art rather than ethnographic objects.

34. After the Second World War Stern, disillusioned with the encroachment of reality on her romantic vision of Africa, turned to Europe for her themes, spending long periods in Spain and Madeira and producing many studies of peasant life.

References

Arnold, Marion (1995), *Irma Stern: A Feast for the Eye*, Cape Town: Fernwood Press.
———— (1996), *Women and Art in South Africa*, Cape Town: David Philip and New York: St. Martin's Press.
———— (2000), 'Bertha Everard and the ties that bind', in *The Everard Phenomenon: An Exhibition of Paintings by the Everard Family*, Johannesburg: The Standard Bank.
———— (2003), 'Irma Stern: a reputation in print', in *Irma Stern: Expressions of a Journey*, Johannesburg: The Standard Bank.
Daneel, L.S. (1981), *A Guide to Sources on Irma Stern*, Pretoria: Human Sciences Research Council.
Dubow, Neville (1974), *Irma Stern*, Cape Town: Struik.
———— (ed.) (1991), *Paradise: The Journal and Letters (1917–1933) of Irma Stern*, Diep River, Cape: Chameleon Press.
Enloe, Cynthia (1989), *Bananas, Beaches and Bases: Making Feminist Sense of International Politics*, London: Pandora Press.
Everard Letters, Family collection, Pietermaritzburg, South Africa.
Harmsen, Frieda (1980), *The Women of Bonnefoi: The Story of the Everard Group*, Pretoria: J.L. van Schaik.
———— (2000), 'Preface: the Everard Group', in *The Everard Phenomenon: An Exhibition of Paintings by the Everard Family*, Johannesburg: The Standard Bank.
Hülsewig-Johnen, Jutta and Below, Irene (eds) (1996), *Irma Stern und der Expressionismus Afrika und Europa: Bilder und Zeichnungen bis 1945*, Bielefeld: Kunsthalle Bielefeld.
Lefebre, Denys (1931), *South African Architectural Record*, March, 13–14.
Lloyd, Jill (1991), *German Expressionism: Primitivism and Modernity*, New Haven and London: Yale University Press.
Osborn, Max (1927), *Irma Stern*, Leipzig: Verlag Klinkhardt & Bierman.
Roworth, Edward (1917), 'Landscape Art in South Africa', *Art of the British Empire Overseas*, special issue of *The Studio*, ed. Charles Holme.
Sachs, Joseph (1942), *Irma Stern and the Spirit of Africa*, Pretoria: J.L. van Schaik.
Schoeman, Karel (1994), *Irma Stern: The Early Years, 1894–1933*, Cape Town: South African Library.
South African Library, Irma Stern Collection (MSB 31).
Stern, Irma (1943), *Congo*, Pretoria: Van Schaik.
———— (1948), *Zanzibar*, Pretoria: Van Schaik.

Constance Stuart Larrabee's Photographs of the Ndzundza Ndebele

Performance and History Beyond the Modernist Frame

BRENDA DANILOWITZ

'The photograph awakens a desire to know that which it cannot show.'

(Edwards, 2001, p.19).

Constance Stuart – or Constance Stuart Larrabee (1914–2000), her married name that she began using privately and professionally in 1949 – came of age at a time of burgeoning modernity in South Africa. During her relatively short working career there, she produced a large oeuvre of photographs that ranged from studio portraits to her work as a war correspondent with the South African Forces in Italy from 1943 to 1944.[1] These war photographs, together with her photographs of black South Africans (a treasure-trove of more than 3000 negatives) have assured her legacy in the annals of photography.[2]

Larrabee, following her own prescription, viewed her photographs of black South Africans, and wanted others to view them, in purely formal terms. In 1994 she told Scott Wilcox: 'The people to me were works of art. They were so photogenic that I didn't have to do anything for them, they did things for me as a photographer' (Wilcox, 1995, p. 15). Over 50 years earlier, in a lengthy article in the *Pretoria News*, she had been quoted as saying: 'Natives are the most photogenic people. They are a really marvellous medium for photography. Their skin reflects the light so well.'[3]

Purposefully choosing an aesthetic discourse, Larrabee removed her photographs and their interpretation from history and framed them as beautiful objects, as the photographs themselves frame their subjects. She would not be drawn into a discussion of context, as I discovered when I interviewed her in November 1994. When I asked her why, when, where, how and with whom she had photographed the Ndebele, her reply was simply 'It was my great love.'

What was Larrabee's relationship to her Ndebele subjects? Was it the people, or the act of photography itself, that was her 'great love'? What role did the notion of an idealized and essential Africa play in her photographs?

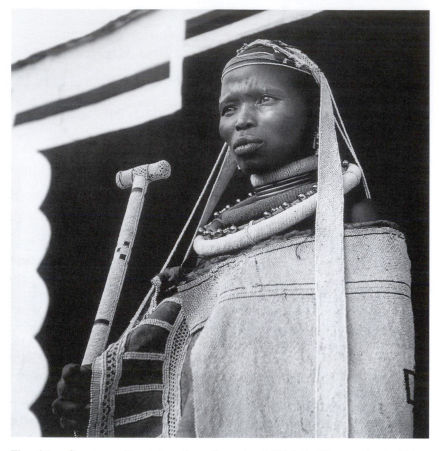

Fig. 4.1. Constance Stuart Larrabee, *Portrait of Ndebele Woman, South Africa*, photograph, between 1936 and 1949, National Museum of African Art, Smithsonian Institution, Image no. EEPA 1998-060528.

To better understand Larrabee's photographs one needs to try to discover the contexts that she avoided.

A typical Larrabee image is a portrait of a young Ndebele woman in elaborate beaded traditional dress (Fig. 4.1). I will refer to it as *Ndebele 1947*, its title in an exhibition catalogue from 1984 (Livingstone).[4] The woman is framed by an architectural background. A small triangle of sky in the upper left corner is the only element of nature that intrudes and allows any clue as to the edge of the architecture. The woman is thus doubly framed, once within the photograph by the geometries of the wall decoration and the second time by the edges of the photograph itself. The tight framing and square format are a

hallmark of Larrabee's work. She took pride in her eye's ability to frame a tableau and usually printed her images full frame. Her preferred square format was dictated by the twin-lens reflex Rolleiflex cameras that she used exclusively. The double framing Larrabee has used puts the photographer in firm control of the image. The viewer is allowed only the information the photographer selects.[5]

The Ndebele woman stands upright, draped in a heavily beaded garment of animal skin. Around her neck she wears beaded rings and on her head a circular beaded headpiece whose trains are artfully arranged on either side of her head. One of these long white beaded strips extends from the headpiece down the side of her head in a line that ends abruptly where the photograph's frame cuts it off. This strong vertical line parallels the scalloped painted line on the architecture at the left edge of the photograph and together these lines balance the white horizontals painted on the architecture above. She holds a beaded staff inclined at a slight angle away from the strict vertical. Its horizontal top bar exactly parallels the painted horizontal line above, and the distance between this bar and line almost exactly equals the distance between the right edge of the woman's face, sharply delineated by the light, and the short white vertical of the painted line – an effect which flattens the entire image. Within this deliberate, formal composition the woman's face is poised in slight three-quarter view. She is positioned so that the light strikes her forehead, cheeks, nose and lips, while the left side of her face fades away to merge with the shadows behind her. Only her gaze is directed out beyond the confines of the frame where it engages with neither the photographer nor the viewer.

Focusing on the formal qualities of this image reveals and underlines the modernist strategies at play in it: smooth surfaces, clear design, sharp tonal contrasts, uncluttered composition, textural veracity and the elimination of extraneous detail to create a universally accessible image. They were some of the strategies Larrabee learned in the cradle of modernist photography, mid-1930s Germany. Yet, on its own, a formalist reading of this photograph seems incomplete. The question remains of what lies beyond the frame. Who is this woman? Where does she live? What is she wearing? What was the photographer's relationship to her? Are there other photographs of her? Under what circumstances was this photograph taken? And, finally, what does this photograph tell us?

Photographs, as Elizabeth Edwards (2001, p. 22) claims, are 'raw histories ... They have a rawness, uncontainability, resistance and ultimately unknowability, despite their clamorous claims to the contrary. By their very nature photographs are sites of multiple contested and contesting histories.'[6] Just as she controlled the framing of her images, Larrabee throughout her life quite narrowly controlled what was beyond the frame – the disposition, display and discussion of her work. It is understandable, as all artists make judgements

about their work, that she selected to print, exhibit and publish only a fraction of her photographs. But she went further than that and controlled, as well, the discourse around her work, giving out little information to curators, critics and admirers alike.[7]

A formalist reading of *Ndebele 1947* accords with the aesthetic framework in which Larrabee first photographed the Ndebele in the late 1930s. It was a framework of western European modernism transported and adapted to a colonial South African setting. An account of Larrabee's early career will provide a better understanding of this framework and Larrabee's place in it.

After completing her high school education at Pretoria Girls' High School in 1932 Larrabee, already interested in photography, travelled overseas to train first in London from 1933 until 1935 and then in Munich from September 1935 until June 1936. This path was one she had in common with many young people in colonial South Africa where tertiary educational opportunities were limited and for whom Europe held out the promise of modern culture and technology.[8] Significant among these South Africans were artists, some of whom would form the New Group in 1938, and would seek alternatives to the derivative, academic, conventional, descriptive styles (themselves based on earlier western European examples) that dominated art production in South Africa at the time. Schoonraad (1988, p. 41) observes in a catalogue essay on the New Group:

> During the thirties many of the younger artists such as Gregoire Boonzaier, Cecil Higgs, Alexis Preller, Terence McCaw and Freida Lock either lived in Europe or travelled there. They returned to South Africa with new reformative ideas and found the situation here insufferable. The New Group was born out of this energetic, restless and disgruntled younger generation.[9]

Terence McCaw and Alexis Preller, both key figures in the founding of the New Group, were close friends of Larrabee, and she often related how – together with Preller – she made regular weekend field trips to photograph the small Ndebele community on the outskirts of Pretoria in the late 1930s.[10]

The New Group's exhibitions focused exclusively on painting and sculpture. Larrabee, a photographer, was by definition excluded. But she stated her faith in photography as a valid art form in a short article, 'Photography as an art', published in 1938 or 1939, not long after she started photographing the Ndebele.[11] Her writing echoes the themes of European modernism, 'Some people consider that photography can never be art,' she wrote. 'This is a little ridiculous as all art begins with a struggle to perfect technique. The technical process can be used as an instrument for expression just as a painter uses his brushes.' Rejecting the pictorialist school, she continued:

> To me it is important to keep photography pure ... A soft diffused effect on the finished print may be flattering to the one photographed, but it is an unnecessary combination of two schools, that of photography and that

of painting ... Perfect composition and rendering of texture is of more artistic worth than a photo that is bolstered up with artificial influences.

She concluded with a call for a new photography: 'Photography is on the threshold of a new era ... There is an increase in people who are using a sound technical training as a background for imaginative photography. These are the pioneers who will build up photography as an art' (Larrabee, 1938–39, unpaginated).[12]

Larrabee learned the techniques of the so-called 'New Photography' at the Bavarian State School of Photography in Munich in 1935 and 1936.[13] Perhaps because she is known to have studied in Germany, her style of photographic realism is sometimes mentioned in the context of the Bauhaus, the German school of art, architecture and design that championed modernism between 1919 and 1933. For example, Geary (1998, unpaginated) suggests, 'In the tradition of the Bauhaus ... she experimented with form, silhouette, line, texture and light. Larrabee's photography embodies this aesthetic.' Yet Larrabee's style is more accurately considered as having been determined by another strain of German modernism, *Neue Sachlichkeit* – 'new objectivity' or 'new realism' – epitomized in photography by the work and writing of Albert Renger-Patzsch whose work depended on detailed observation of form.[14] Photography at the Bauhaus, on the other hand, and especially as practised by its most voluble proponent, Lazlo Moholy-Nagy, was primarily concerned with expanding the boundaries of perception and experimenting with exposures, light effects and uncommon viewpoints. Eskildsen (1978, p. 107) observes that 'on the one hand technical considerations were regarded as important in so far as they helped capture the essential character ("reality") of the subject; and, on the other, they were thought to be the basis for "a new way of seeing" in which the camera's vision became the subject of the photograph'.

Both practices, however, disregarded context. As Eskildsen (ibid.) notes, 'Common to both was the fact that any discussion of what was represented and how it was represented – that is, an evaluation of form in terms of content – was avoided.' Larrabee's own avoidance of her photographs' diverse roles and her privileging of form over content fit this pattern.

To move beyond the constraints of formal analysis demands that we dissect both the reality quotient inside the photograph and the changing contexts beyond its frame. It is difficult to shake off the expectation that photographs mirror the reality and truth of everyday vision – this is in spite of the fact that we look at and pay attention to photographs in a way that is far more intense and controlled than everyday practices of casual observation. Because we view photographs in such a concentrated way, they can be said to be more theatrical than real, and their performative space is controlled by the ways they are framed. Edwards (2001, p. 20) distinguishes three types of performance in photographs, namely 'the performance of the image through the spatial

dynamic of its framing ... the performance of making photographs [where] power relations are acted out spatially ... [and] the theatre or performance within the frame'. This notion of performance is useful in understanding Larrabee's work.

Although, as she claimed, Larrabee may not at first have intended any particular audience for her photographs ('I didn't take them to be used. I took them totally for my own pleasure' [Wilcox, 1995, p. 16]), photographs cannot be pinned down to a specific agenda. They have unstable lives. In the case of Larrabee's photographs of black South Africans, the subject matter makes it more or less inevitable that they would be used as ethnographic evidence, as indeed they were (Larrabee, 1946; Larrabee, 1950). In 1949, soon after Larrabee moved to the USA, 11 of her Ndebele photographs appeared in a feature article in *Natural History*, the magazine of New York's American Museum of Natural History. The photographs illustrated a text entitled, 'The Ndebele of South Africa', by noted University of Cape Town anthropologist Isaac Schapera (1949).[15] On the magazine's cover was a colour image of two Ndebele women (Fig 4.2). Schapera's text refers briefly and in general to Larrabee's photographs, but text and images seem to have been conceived independent of one another. More than Schapera's text, the descriptive captions to the photographs, which may have been supplied by Larrabee herself, frame the way the photographs are read.[16]

The subheading to the article highlights its major theme. The Ndebele are described as, 'a colorful people who have not surrendered their identity to the firm grasp of Western culture' (Schapera, 1949, p. 408). In *Natural History*, whose other featured contents in November 1949 were stories about palms and cattails, the White Squirrel, the Hognose Snake, the Lake Trout, 'Giants of the Animal Kingdom' and 'the lost world' of the New Zealand bird, the Takahe, presumed extinct but rediscovered in 1948, the Ndebele people are treated as yet another endangered species. An implicit parallel is drawn between the Ndebele with their 'traditional culture' and the recently rediscovered Takahe. As the caption to the cover image cautions, 'Those who unconsciously encourage the native to conform to the white man's gadget civilization might well think twice before hastening the day when such a rich artistic tradition is thrust into the forgotten limbo of vanished cultures.'[17]

The captions frame the photographs as documentary evidence of a culture that stretches back to a time beyond memory, whole and unchanged. It is a culture that deserves to be protected from the encroachment of western values that are somehow seen as corrupting to the pure traditions of these native people. Defying historical and political realities, images and texts mould the Ndebele into a construct that accommodates modernist aesthetics and colonial discourses. Because these were the same discourses in which Larrabee's world was framed, questioning them simply did not occur to her and others at this time. As Comaroff and Comaroff (1991, p. 15) indicate:

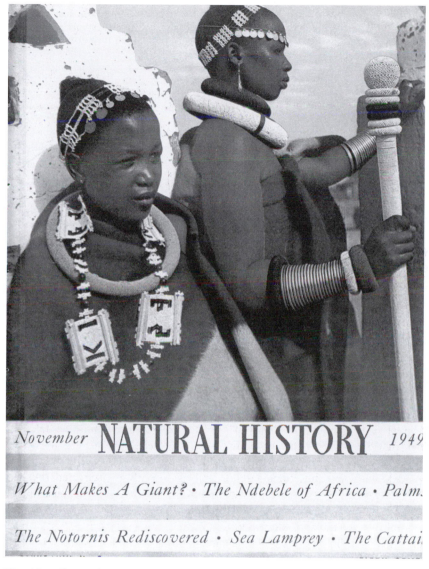

Fig. 4.2. Cover of *Natural History* LVIII (9), November 1949.

> [T]he essence of colonisation inheres less in political overrule than in
> seizing and transforming 'others' by the very act of conceptualising,
> inscribing, and interacting with them on terms not of their own choosing;
> in making them into the pliant objects and silenced subjects of our scripts
> and scenarios; in assuming the capacity to 'represent' them, the active
> verb itself conflating politics and poetics.

The Ndzundza Ndebele, members of a chiefdom with significant resources in
the mid-nineteenth century, were defeated by Afrikaner commandos of the
Zuid Afrikaansche Republiek in 1883. Divided and dispossessed of their land,
they were indentured as labourers to white farmers under harsh conditions.
Five years later, when their indenture period was up, the Ndebele continued to
live in small groups on white farms where they laboured, often without any
remuneration. Delius (1989, p. 235) observes:

> At the end of a bitter and prolonged war, individuals who had belonged to
> a powerful and independent chiefdom with rich resources found
> themselves scattered across the breadth of the Transvaal. Their villages
> had been destroyed and their land had been alienated. They had lost their
> stock and their weapons. The full effect on their consciousness of defeat
> and indenture cannot now be recreated and indeed defies imagination.[18]

Whatever the prehistory of the Ndebele had been, by the early twentieth century
it was irrevocably changed. Delius (p. 250) has shown that the so-called
'traditionalism' of the Ndebele was, in fact, a response to these colonial
interventions. White Afrikaner farmers, who more or less controlled Ndebele
lives, had their own reasons for insulating their labourers from western
influence. Fearful of the possibility that westernization would introduce political
aspirations and so 'corrupt' a docile labour supply, farmers encouraged Ndebele
traditionalism, and in some cases even forbade western clothing. Delius (p. 249)
cites a comment made by a member of the Ndzundza Ndebele, 'In the decades
after 1900 the Ndzundza [Ndebele] wore "skins … You were not even able to
wear a pair of trousers. You dare not come onto the farm wearing … clothes –
You would be shot dead! A kaffir wearing clothes – No!"'[19] Over time the
Ndebele turned this policy on its head, and Ndebele beaded garments and wall
painting became a source of creative energy and pride.

 One of Larrabee's photographs that illustrates 'The Ndebele of South
Africa' (Fig. 4.3) is another view of the woman in *Ndebele 1947* (see Fig. 4.1).
Here she is seen in full-length from behind so that the beaded cloak of animal
skin and other details of her costume are revealed. Again care has been taken
with the formal arrangement, and again painted architecture is part of the
scheme. She is positioned on a ledge, leaning against a wall whose painted
decoration, and especially the bright white lines, are aligned with the verticals
in her costume. The caption informs the reader that:

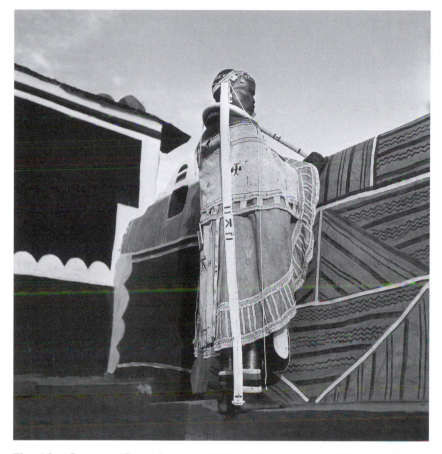

Fig. 4.3. Constance Stuart Larrabee, *Ndebele Woman, South Africa,* photograph, between 1936 and 1949, National Museum of African Art, Smithsonian Institution, Image no. EEPA 1998-060531.

This magnificent cloak is worn by the bride on her wedding day but never again. Three months before her marriage, her father kills a sheep and fashions this skin cloak for his daughter. Then her friends set to work on the embroidery. The long strip hanging from her headdress takes the place of a wedding veil. She carries a short wedding stick.

(Schapera, 1949, p. 412)

The contexts that were excluded by the framing of the portrait photograph were designed to encourage a formalist reading. This second image widens the frame and provides added information that the woman is in bridal clothes. The caption elaborates on the significance of her garments. The photograph in its new role as an anthropological document 'could not be trusted to speak for

itself' (Faris, 1992, p. 255). In a symbiotic relationship the photograph displays the visual evidence for the text, and the text provides the facts that establish the documentary or truth-value of the photograph. The caption, in fact, tells little about Ndebele marriage ritual (although this is discussed in Schapera's text) but is refracted through [Larrabee's?] western lens. The bride's cloak, like a western bride's white wedding dress, is worn 'on her wedding day but never again'. The beaded length of her headdress is freely interpreted as a substitute for a western bridal veil.

Ndebele 1947, now reframed as *Ndebele Bride*, has shifted from the aesthetic to the anthropological world, and in the process the mute portrait image has acquired language. In the course of this shift, meaning has been both added and taken away. The calculatedly iconic subject, having acquired a caption and inserted into text, now straddles the boundary between aesthetic and documentary, form and content. The viewer is challenged to hold a doubled performance in a single gaze. To take pleasure in the photograph's formal perfection is to suppress the meanings given by its texts. To read the photographs for their potential historical, political or scientific meaning is to devalue their formal rigour.

Whatever the readers of *Natural History* made of these images in 1949, they were primed by the context to believe that they were witnessing a people whose traditions originated way back in the mists of time. Half a century later, the history has been written which tells us that these so-called traditions were in fact fairly recent interventions, created over a period not much longer than the previous two decades. The anthropological context that settled on *Ndebele Bride* in 1949, reflected through historical accounts, is itself a construct. As we will see, the performance enacted within the photograph is likewise a constructed moment.

Ndebele 1947 and *Ndebele Bride* were images Larrabee selected for exhibition and publication. They are photographic prints that best filled her criteria for 'strong' photographs that had 'that extra something' (Wilcox, 1995, p. 16). Larrabee credited her own 'natural gift' and her 'good fortune to have been born with an eye' for the 'iconic quality' of her African photographs, and when pressed on the question of how she was able to avoid the appearance of self-consciousness in her subjects, explained, 'You take it when they're not self-conscious ... [I]n Germany [I learned] how to get people off their guard' (Wilcox, 1995, p. 14). That may well have been part of it, but the process turns out not to have been quite as straightforward as she would have us believe.

As she grew older, Larrabee – like most artists – thought long and hard over what would become of her negatives, the prints and her personal and professional papers. It had long been her intention to deposit her work, along with any secrets it held, in a museum archive.[20] In the archive, the entire oeuvre would be seen whole and unedited, and new relationships and juxtapositions

could be discovered. With the online publication of a large number of the photographs in the Elisofon Archive the work has, within the space of very few years, been made freely available around the globe at the click of a mouse in a way that Larrabee could not have anticipated.

In the archive, *Ndebele 1947* in its formal perfection and *Ndebele Bride* with its caption text, rejoin nine other images taken at the same time. The group of photographs provides a narrative of the photo shoot. The woman is first seen standing in the doorway of the building, then self-consciously taking a step forward. There are two portraits, three images taken from behind with her head inclined at a slightly different angle in each, and one close-up showing her hands and the details of part of her costume. In an additional vignette, the bridal headgear is hung on a wall and two women finger it admiringly.[21] There are no images to suggest that the photographs were taken in the context of an actual marriage ceremony, however. Rather, the 'bride' has been dressed for the photographer's purpose and perhaps her pleasure. Reviewing the photographs as a sequence, it is easy to picture the photographer directing the young woman's performance as she tentatively moves forward from the shadow of the doorway, then takes up a series of positions against the wall.

Returning to the archive from their appearance in *Natural History*, the photographs are brought back full circle to their original context, the moment of their creation. In the archive, relationships between individual images can be discovered and reconnected to previously unknown images. In another particular group of Ndebele photographs in the Elisofon Archive, Larrabee herself as well as her friends and collaborators (all white, all unidentified) are present. In this group of images 'the performance of making the photograph' can be examined.

A curiosity of the making of the 1949 *Natural History* article is revealed through three photographs in the archive, one of which is shown here (Fig. 4.4).[22] A photographer – white and male – positions a Ndebele woman and a young girl against a wall of a homestead. His camera and flash are set on a tripod. He appears to be taking what will be the cover image for *Natural History* (see Fig. 4.2) even though in the magazine, the cover image is credited to 'Constance Stuart'. Another two photographs show two other white males, both wearing jackets and ties, among a group of Ndebele women and children. In one of these, camera equipment resting against the wall of the thatched dwelling in the background indicates that a fairly elaborate photo session is in progress. In yet another image an unidentified white woman, well-dressed, walks away from an Ndebele house, smiling, camera in hand.[23]

Larrabee may or may not have taken the colour photograph on the cover of *Natural History* herself. That point is less important than the realization that her enterprise was probably more deliberate than she ever disclosed, involving more people than just herself and Alexis Preller. The battery of white men and

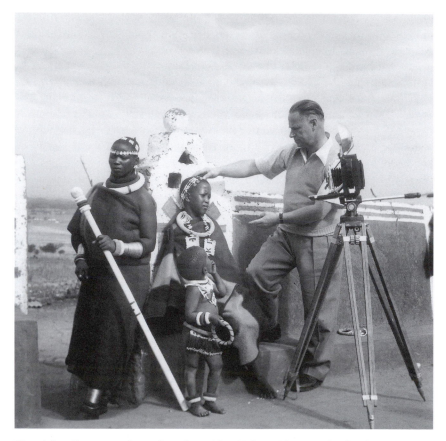

Fig. 4.4. Constance Stuart Larrabee, *Man Taking Photograph of Ndebele People, South Africa*, photograph, between 1936 and 1949, National Museum of African Art, Smithsonian Institution, Image no. EEPA 1998-060576.

women, armed with their cameras, is a subtle but prevailing reminder of the power that modern technology could wield. Because none of the photographs have a date, it is impossible, with present knowledge, to tell which were taken in the 1930s and which later. The most that Larrabee disclosed, cryptically, in a reference to the occasion in 1949 when she met and photographed the writer Alan Paton, was the following:

> All the years I'd been taking these photographs among the black people of South Africa, I did that by myself. Through that I got to know a lot of people who were interested as I was, all for different reasons. They worked among these people, so they were delighted that I came and photographed what they were doing.
>
> (Wilcox, 1995, p. 21)

On close reading, Larrabee's words tell almost nothing. The information disclosed by the archive has its limits too, and again leads to questions. Did the Ndebele women know they were to be featured in *Natural History*? Did they ever see the publication? For that matter did Larrabee ever show them any of her photographs? Might they have valued these documents of their lives?

Because she was the only recognized photographer in her group, and because of the type of claim made in the statement above ('I did that by myself'), Larrabee has been seen as a photographer working more or less in isolation. But, in fact, she was intensely social and identified with her artist peers. As early as August 1936, she began holding exhibitions of her own and other artists' works in the tiny commercial photographic studio she had set up in Pretoria on her return from Munich. 'We were all young ambitious artists trying to make our way,' she told me nearly 50 years later.[24] A number of the group, such as Wilfred Mallows, were architects and he observes:

> She was firmly established as an artist in photography when I arrived
> from London in August 1937 ... She was, in those immediate pre-war
> years, part of a whole group of young artists in Pretoria of whom Alexis
> Preller was the best known and [which] included architects such as
> Helmutt Stauch, Norman Eaton and Gordon McIntosh ... We all admired
> Constance's work.[25]

Like their counterparts all over the world, young South African architects were inspired by the modern forms and social aspirations of the dominant European modernist architects of the time (Le Corbusier in France and Mies van der Rohe and Walter Gropius in Germany), and they embraced an aesthetic in which pure, simplified structures signified a new vision that rejected the encrustations and ornament of past architecture and proclaimed a visual language that was scientific, democratic and universal. Articles by and about the modern European masters appeared regularly, and were hotly debated, in the *South African Architectural Review*. The Johannesburg architect Rex Martienssen invited Le Corbusier to visit South Africa in 1939, and a group of South African architects that included Helmutt Stauch and Norman Eaton had visited the Bauhaus in Dessau, Germany, in January 1929.

Larrabee may, in fact, have met Alexis Preller through their mutual friend Norman Eaton, who like them was drawn to the life of Pretoria's Ndebele settlements.[26] Although Larrabee was vague about which of these settlements she photographed, many of the images in the Elisofon Archive can be identified as having been taken at the same location. The most likely site was the farm Hartebeesfontein, on the Pretoria city outskirts.

The Hartebeesfontein settlement was especially well known to architects, including Eaton, whose eclectic modernism embraced the simple forms of Ndebele architecture equally with the pared down smooth-walled, flat-roofed boxes of Le Corbusier and Gropius. For Eaton, the simple vernacular forms of Ndebele architecture and the spatial organization of Ndebele homesteads

conveyed authenticity, and offered 'a lesson to us who, in our highly complex and confused way of life today, lose sight of the values it brings into sharp focus'. His idealized view allowed him to imagine the Ndebele universe as a perfect place, 'these kraals combined in themselves all the essentials of simple human living, so beautifully in fact that I was conscious of experiencing a sort of revelation in the art of living in one of its purest forms' (Eaton, 1953, cited in Harrop Allin, 1975, p. 68).[27] In a curious equation of the appearance of the architecture with the quality of the lives lived within it, Eaton contrasted this idyllic locale with the new apartheid architecture of urban African townships which he railed against as 'cancerous growths upon the violated face of Africa' (Harrop-Allin, 1975, p. 70).

Professor A.L. Meiring, who became head of the newly established architecture department at the University of Pretoria in 1943, began visiting Hartebeesfontein in 1944. Meiring and his students rigorously studied, documented and mapped the settlements.[28] His 1955 article, 'The Amandebele of Pretoria', described the architecture of the village in detail. The village, Meiring commented, is a 'magnificent settlement … on the northern slope of the Magaliesberg' a site chosen, he pointed out, to shelter the homesteads from the southern winter winds and give maximum exposure to the sunny north aspect (1955, p. 27).[29]

Larrabee's photographs of this architecture are little known, if at all. They have not, to my knowledge, been published. The photographs show off the bold patterns with which the Ndebele women painted especially the outer walls of the homesteads. The photograph of the entrance area with its arrangement of stepped levels and surfaces is a visual feast (Fig. 4.5). It is easy to see how the symmetrical geometry of the structure and its flat patterned decoration, combined with the authenticity of its construction, would have appealed to the modernist eye. Even in black and white, the striking natural colours seem visible. As described by Meiring (1955, p. 34):

> The colours … run right through the colour circle. Except for the blues and blacks … all the colours are natural ones … obtained from clay deposits … At first I had difficulty in believing that such a range and such brilliant colours could be obtained from common clay … White is obtained from slaked lime … [T]he very brilliant [blue] consists of a mixture of clay and Reckitts blue. Black is clay with soot mixed in … The predominant colours are raw and burnt sienna.[30]

The painted walls of the homesteads with their crisp white areas do not give the whole story of rural living in colonial South Africa. Larrabee's archive also contains other photographs that provide evidence of the world that lay just beyond the carefully framed and selected dwellings. One of these, described as 'Area Near Ndebele Homestead' gives a behind-the-scenes glimpse of Ndebele life (Fig. 4.6). In a dry, sandy enclosure near a thatched roof structure, a woman is filling a tin bath with water from a large metal drum mounted on

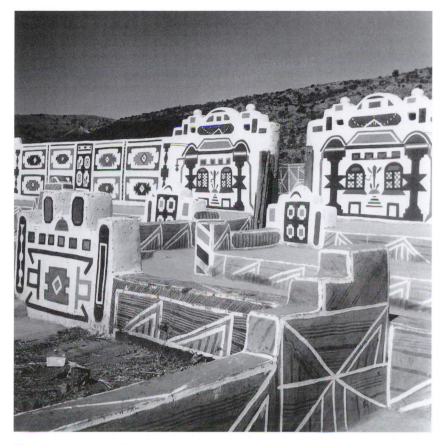

Fig. 4.5. Constance Stuart Larrabee, *Ndebele Architecture, South Africa*, photograph, between 1936 and 1949, National Museum of African Art, Smithsonian Institution, Image no. EEPA 1998-060676.

what looks like the back of a donkey cart. Her feet are bare and she wears a blanket drawn about her body. Immediately behind her is a man in western dress and in the background men, women and children stand about idly, alone or in small groups, most of them also in western dress. A pile of rubble fills the foreground and just beyond it is a plough.

 This photograph informs us that this is a dry land with no running water, where people do not walk around dressed in elaborate beaded garments. It is a world that is hard to square with Eaton's evocation of kraals that combined 'all the essentials' of human living. And it is a world – as her photograph itself is evidence – which Larrabee well knew existed. But it was not a world that fitted her goals as a photographer, nor one that she chose to examine too closely.

Fig. 4.6. Constance Stuart Larrabee, *Area near a Ndebele Homestead, South Africa,* photograph, between 1936 and 1949, National Museum of African Art, Smithsonian Institution, Image no. EEPA 1998-060876.

Larrabee was the quintessential liberal in 1930s and 1940s South Africa. English-speaking, educated, philanthropically inclined, committed to altruistic, compassionate humanism, she was enchanted and enticed by the rich sensations of Africa. She identified with the land, yet, like almost all white South Africans, she was trapped in a vision of a white universe and unable to conceptualize an alternative social structure to the existing reality. That reality was a world divided into urban (white) and rural (black) spaces. It was one in which, as Lewsen (1987, p. 104) observes, the 'fear of losing "the purity of the white race" was felt by the great majority of whites. Even liberals objected to social intermixture; with rare exceptions.'[31]

Integral to that conception of reality, as Michael Wade (1993, p. 8) has described, was an enduring 'pastoral perception' that in literature was 'already

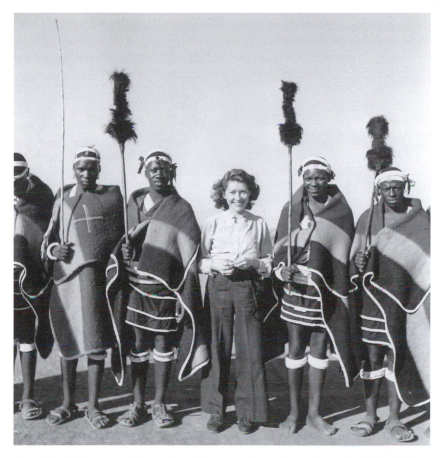

Fig. 4.7. Unknown photographer, *Constance Stuart Larrabee with Ndebele Men, South Africa*, photograph, between 1936 and 1949, National Museum of African Art, Smithsonian Institution, Image no. EEPA 1998-060866.

institutionalized in the white myth structure by the time [Olive] Schreiner wrote [*The Story of an African Farm* in 1883]'.[32] Wade (1993, p. 9) observes further that William Plomer, in his 1929 novella *Ula Masondo*, suggested that whites 'keep going by enveloping themselves in their pastoral dream (which enables the blacks, unwittingly to fill an important empty space in the whites' perception of themselves)'. The pastoral dream was the preserve not only of white writers but of visual artists as well.

Though barely 10 miles from Sir Herbert Baker's Union Buildings, the imposing architectural symbol of the colonial state, completed in 1913 and

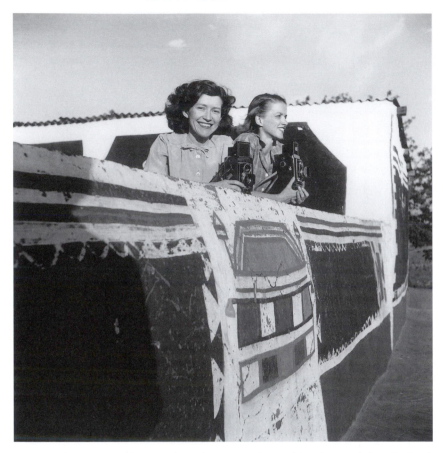

Fig. 4.8. Unknown photographer, *Constance Stuart Larrabee and friend, South Africa,* photograph, between 1936 and 1949, National Museum of African Art, Smithsonian Institution. Image no. EEPA 1998-060852.

sited on a commanding Pretoria hilltop, the Ndebele settlement at Hartebeesfontein was at a distance sufficient to remove Larrabee, Eaton, Preller and others to a space where they could enact their 'pastoral dreams' and imagine a South Africa free of the inequalities, exploitation and degradation that had been inscribed in its history for three centuries. Here it became possible for Eaton to construe a world of authentic, honest architecture; for Preller to create an exotic, fantastic world of sensual painted forms and colours; and for Larrabee to exult in the formal beauty of bright sunlight illuminating perfect black bodies.

Larrabee's desire to identify with this pastoral world is confirmed by the discovery that she is present at the centre of some of her photographs. In one she is flanked by a group of young Ndebele men in traditional dress (Fig. 4.7).[33] Smiling engagingly at the camera, the girlish young photographer in her mannish, wide-bottomed pants and shirt seems perfectly at ease. Her companions' facial expressions range from avoidance of the camera to a game smile. Leaving aside the question of who might have taken this photograph, it is a remarkable image. The strangeness of this young white woman among a group of bare-legged young black men in traditional clothing is offset by Larrabee's palpable pleasure as she inserts herself knowingly into the pastoral scene. Momentarily she has found a way to infiltrate a world that is so attractive yet ultimately untenable for her. It is a trophy shot, the souvenir of travel to an exotic place, evidence that she was, indeed, there.

In another photograph Larrabee and a young white woman lean over a painted homestead wall (Fig. 4.8). Both women hold cameras and the shadow at the left indicates the possible presence of a photographer.[34] While her companion gazes into the distance, Larrabee looks straight out at a third, invisible, camera and engages the spectator, performing exactly the kind of direct engagement she avoided when photographing others. For the moment she has usurped the role of her Ndebele subjects. Fleetingly, yet in an image frozen for all time, she imagines herself in the place of the women who populate her photographs. She displays her camera, the symbol of her professional identity and the instrument of her authority and power.

Larrabee's Ndebele photographs are true to their time. Detached from context they are all about surfaces. Even though the very painted walls of the Ndebele homesteads were in constant flux, repainted each year as the elements eroded their naturally degradable pigments, the photographs could provide a vision of permanence. Surface appearance and pattern could be mistaken for realism and immutability.[35] Caught in the psychic moment of her times, the photographer did not dig beneath these surfaces. Perhaps, as Wade suggests, she sensed that what she might find would be too much to bear. Instead, Larrabee held on to the myth that the world she had captured in her camera's lens was unchanging and beyond the reach of politics and history. 'Even today I'm very happy to think that they are timeless', she said of the photographs in 1994 (Wilcox, 1995, p. 16).[36]

Notes

1. Larrabee's father, Alan Stuart, was a mining engineer who emigrated from England to South Africa in 1914 to be manager of a tin mine in Groenfontein in the far northern Transvaal. Larrabee and her mother joined him when Constance was three months old. The marriage was not a happy one and, when Constance reached school-going age in 1920, her mother took her to live in Pretoria. The

Stuarts were separated and Larrabee had almost no contact with her father from then on. These and other biographical details were told me by Larrabee when I visited and interviewed her at her home in Chestertown, Maryland, USA in November 1994.

2. Larrabee bequeathed her entire body of Southern African photographs to the National Museum of African Art, Smithsonian Institution's Eliot Elisofon Photographic Archive. She left her Second World War photographs to the Corcoran Gallery of Art.

3. *The Pretoria News*. Newspaper cutting inscribed by Larrabee 'July 1942' (Larrabee Papers).

4. The same photograph is reproduced in a 16-page brochure published in conjunction with the exhibition *South Africa 1936–1949, Photographs by Constance Stuart Larrabee* at the National Museum of African Art, Smithsonian Institution (20 September 1998–28 February 1999) where it is captioned 'Ndebele Woman Eastern Transvaal (now Mpumalanga Province), 1947'. The online catalogue of the Eliot Elisofon Photographic Archive assigns the date '1936–1949' to all of the 549 images listed in the collection as 'Ndebele' <http://siris-archives.si.edu>.

5. 'The central act of photography is the act of choosing and eliminating' (Szarkowski, 1966, p. 9).

6. Edwards (2001, p. 14) advocates a method of 'social biography' that approaches photographs as dynamic material objects: 'Integral to social biography is the way in which the meaning of photographs, generated by viewers, depends on the context of their viewing, and their dependence on written or spoken "text" to control semiotic energy and anchor meaning in relation to embodied subjectivities of the viewer.'

7. An outcome of this has been a paucity of critical writing on Larrabee's work. I experienced this first hand in 1994. In preparation for a catalogue essay I had been commissioned to write for the exhibition *Constance Stuart Larrabee. Time Exposure* at the Yale Center for British Art in 1995, Larrabee invited me to her home and gave me access to a significant portion of her papers. Using this material, I wrote an essay in which I attempted to place her work in the context of South African history of the period. On reading a draft of my essay, which I had sent her for comment on factual accuracy, Larrabee deemed my writing too political, disputed my interpretations of individual photographs and insisted that the museum withhold publication, which they did.

8. 'In South Africa in those days everybody's ambition was to get to Europe', Larrabee told Wilcox (1995, p. 9).

9. According to this catalogue, 84 artists participated in New Group exhibitions during the group's 16-year history. Of these, a high proportion – 33 – were women, while only one (Gerard Sekoto, who exhibited with the New Group in 1944) was black. Of the 28 artists featured in the 1988 South African National Gallery exhibition, 27 had studied in the United Kingdom or Europe and 10 of these had been born overseas. For more on the history of the New Group see Berman, 1983, pp. 307–309 and Berman 1993, Chapter 5.

10. Confirmed in conversation with the writer, November 1994. According to Larrabee, these visits took place 'in the late 1930s' (Wilcox, 1995, p. 15). Preller was studying in Paris in 1936 when Larrabee returned to Pretoria from Munich. He was back in Pretoria some time in 1937 and joined the New Group in 1938, showing in their first exhibition that year. In 1939 he travelled to the Congo and, from 1940 until 1943, served in the South African Army (Berman, 1983, p. 349). The date of the earliest Ndebele photographs is therefore probably 1937.

11. 'Photography as an art' appears in *Pretoria a City of Culture*, which is undated. However, Larrabee wrote '1938–1939' on the cover of the copy of this pamphlet in her files.
12. In a 1994 interview, the exhibition curator Scott Wilcox asked Larrabee whether the question of photography as art had been raised when she studied in Munich. She responded: 'I didn't think of it as art at all until the Corcoran Gallery of Art in Washington, DC, invited me to have a show in 1984. That was the first time I thought of my photographs as being works of art. I'd always thought of myself as a photographer, never an artist ... I didn't grow up thinking I was an artist' (Wilcox, 1995, p. 12).
13. In Munich, Larrabee told Wilcox (1995, p. 10), 'I shed most of the ideas that I'd learned in England.' Mellor (1978, p. 7) observes that The New Photography as a term 'had wide currency in Germany at that moment'. The term is perhaps best known through its use in Werner Gräff's 1929 book *Es Kommt der Neue Fotograf* [Here Comes the New Photographer], published to coincide with the landmark *Film und Foto* exhibition in Stuttgart that year.
14. The movement, first defined in connection with painting, took its name from a 1925 exhibition in Mannheim, *Malerei der Neuen Sachlichkeit*.
15. In 1953 the Museum of Natural History mounted *Tribal Women*, an exhibition of Larrabee's photographs.
16. I do not have any information about the genesis of this article, but it is likely that it was brokered by Black Star, Larrabee's New York photo agency, which it credits. The editors of *Natural History* most likely asked Schapera to write the text. There is no evidence that Larrabee and Schapera were acquainted or collaborated on this article. Delius (1989, p. 251) notes that Schapera's text is heavily dependent on the work of Van Warmelo.
17. Unnumbered title page, *Natural History* LVIII(9), November 1949.
18. Delius's essay is a seminal investigation of Ndebele history in the period immediately preceding Larrabee's encounter with this group. Frescura (2003) provides additional details.
19. Delius is citing University of the Witwatersrand, African Studies Institute, Oral History Project, Interview with J. Motha by V. Nkumane, 11 September 1979.
20. It was a constant topic of discussion in telephone conversations with me – and doubtless with her other acquaintances as well.
21. Eliot Elisofon Photographic Archive (EEPA) 1998-060523–EEPA 1998-060533 and EEPA 1998-060789.
22. EEPA 1998-060574 - EEPA 1998-060576.
23. EEPA 1998-060565 and 1998-060574. The equipment can be seen in EEPA 1998-060565. The woman is in EEPA 1998-060781.
24. Conversation Chestertown, 17 November 1994.
25. Letter from Wilfred Mallows to the author, 16 January 1994.
26. Richard Cutler, Larrabee's studio assistant who took over her studio after she left in 1949, and whom I interviewed at his home in Parkview, Johannesburg, in October 2001, told me that Eaton had introduced Larrabee to Alexis Preller.
27. Bunn (*c.*1998) has commented on 'the strong sense of neo-primitivist nostalgia in the writings of architects like Eaton'. Bunn points out how Eaton's domestic dwellings are centred on rectilinear modernist forms which 'fall away' at the edges into rounded organic forms and rough stone walls which 'memorialise' vernacular architectural forms.
28. Adriaan Louw Meiring (1904-79), educated abroad, received his architectural education at the Liverpool School of Architecture, graduating in 1932, according to Walker (n.d.). Whether he was part of Larrabee's group is unclear. He was

certainly known to her. In 1960, on one of her return visits to South Africa, Larrabee photographed Meiring in Pretoria alongside the Ndebele documentation made in the 1940s and 1950s (EEPA negative numbers 060908–060917). I thank Professor Roger Fisher, Department of Architecture, University of Pretoria, for providing Meiring's biographical information.

29. Meiring had an aerial survey made of the settlement published by Frescura (2003).
30. Reckitts Blue is a commercial product used in laundering to increase whiteness. Meiring also gives an illuminating account of Ndebele construction methods.
31. Larrabee was a member of the South African Institute of Race Relations. Lewsen (1987, pp. 100-101) observes that 'by 1936 ... [this organization] included a large spectrum of welfare activity and promotion ... Though not politically aligned, the Institute was broadly liberal in its quest for individual freedoms and social advancement.' Larrabee's name appears on the Institute's membership list for 1948. It is unclear when she became a member.
32. Wade (1993, p. 7) theorizes that the binary theme of rural versus urban is 'one of the most strongly and inevitably recurrent dimensions of white perception of blacks ... [in which] the noble savage, whatever the difficulties attending the conditions of his existence, is none the less noble. Uproot him, transplant him to an urban situation in which he becomes a wage labourer, and his moral collapse is swift, inevitable and complete.'
33. They are probably dressed for initiation ceremonies, which the Ndebele resurrected in the twentieth century to maintain their identity in the face of their dispossession (Delius, 1989, p. 248). A photograph showing these men with their bicycles – perhaps used to transport them to work in the white city – is a rare juxtaposition of the two worlds that the Ndebele negotiated (EEPA 1998-060858).
34. Since the negatives and contact prints of these photographs form part of Larrabee's collection, it must be assumed that they were taken with one of her cameras.
35. The Ndebele settlement at Hartebeesfontein existed only for about 70 years. Established around 1883, it endured through the patronage of a benevolent farmer, Wolmarans, and ended when he died in 1953 and his heirs sold the land to be developed into Wonderboom Airport. The inhabitants were moved, partly through the intervention of Professor Meiring, to Odi, 31 miles (50 km) to the north, where they re-established themselves. Here at KwaMzisa a new 'traditional' Ndebele settlement was established. See Frescura, 2003.
36. I extend my thanks to Sorrel Danilowitz, Michael Godby, Scott Wilcox and Diana Wylie for their patient listening and wise advice over the years I have spent contemplating the work of Constance Stuart Larrabee.

References

Berman, Esmé (1983), *Art & Artists of South Africa: An Illustrated Biographical Dictionary and Historical Survey of Painters, Sculptors & Graphic Artists Since 1875*, Cape Town: Balkema.
——— (1993), *Painting in South Africa*, Halfway House: Southern Book Publishers.
Bunn, David (c.1998), 'Whited sepulchres: on the reluctance of monuments', in Judin, Hilton and Vladislavic, Ivan (eds), *blank____: Architecture, Apartheid and After*, Cape Town: David Philip and Rotterdam: NAi, C4, unpaginated.
Comaroff, John and Comaroff, Jean (1991), *Of Revelation and Revolution: Christianity, Colonialism and Consciousness in South Africa,* vol. 1, Chicago and London: University of Chicago Press.

Delius, Peter (1989), 'The Ndzundza Ndebele: indenture and the making of ethnic identity 1883–1914', in Bonner, Philip, Hofmeyer, Isabel, James, Deborah and Lodge, Tom (eds), *Holding Their Ground: Class, Locality and Culture in 19th and 20th Century South Africa*, Johannesburg: Ravan Press and Witwatersrand University Press, pp. 227–58.

Eaton, Norman (1953), 'Native art and architecture', unpublished paper, Norman Eaton records and papers.

Edwards, Elizabeth (2001), *Raw Histories: Photographs, Anthropology and Museums*, Oxford and New York: Berg.

Eliot Elisofon Photographic Archive, http://siris-archives.si.edu

Eskildsen, Ute (1978), 'Photography and the Neue Sachlichkeit movement', in Mellor, David (1978), *Germany – The New Photography 1927–33*, London: Arts Council of Great Britain, pp. 101–12.

Faris, James C. (1992), 'A political primer on anthropology/photography,' in Edwards, Elizabeth (ed.), *Anthropology and Photography 1860–1920*, London: Royal Anthropological Society, pp. 253–63.

Frescura, Franco (2003), 'KwaMsiza', Special project, http://www.sahistory.org.za/specialprojects/kwamsiza/menu.html

Geary, Christraud (1998), *South Africa 1936–1949: Photographs by Constance Stuart Larrabee*, Washington DC: National Museum of African Art.

Harrop-Allin, Clinton (1975), *Norman Eaton: Architect*, Cape Town and Johannesburg: C. Struik.

Larrabee, Constance Stuart (1938–39), 'Photography as an art', in *Pretoria a City of Culture*, Pretoria: Pretoria Centre of the South African Society of Music Teachers, unpaginated pamphlet.

——— (1946), 'The last of the Rain Queens', *Libertas* 6 (13), December, pp. 40–43.

——— (1950), 'Basutoland', *Natural History* LIX (7), September, pp. 130–32.

Lewsen, Phyllis (1987), 'Liberals in politics and administration, 1936–1948', in Butler, Jeffrey, Elphick, Richard and Welsh, David (eds), *The Liberal Tradition in South Africa: Its History and Prospect*, Middletown, Cape Town and Johannesburg: Wesleyan University Press and David Philip, pp. 98–115.

Livingstone, Jane (1984), *Constance Stuart Larrabee: Tribal Photographs*, Washington DC: Corcoran Gallery of Art.

Meiring, A.L. (1955), 'The Amandebele of Pretoria', *The South African Architectural Record*, 40 (4), April, pp. 26–35.

Mellor, David (1978), *Germany – The New Photography 1927–33*, London: Arts Council of Great Britain.

Schapera, Isaac (1949), 'The Ndebele of South Africa, photographs by Constance Stuart', *Natural History* LVIII (9), November, pp. 408–14.

Schoonraad, Murray (1988) 'History of the New Group', in *New Group 1938–1954*, exhibition catalogue, Cape Town: South African National Gallery, pp. 41–48.

Szarkowski, John (1966), *The Photographer's Eye*, New York: Museum of Modern Art.

Wade, Michael (1993), *White on Black in South Africa: A Study of English-Language Inscriptions of Skin Colour*, Basingstoke and London: Macmillan.

Walker, Joanna (n.d.), 'Biographical Dictionary of South African Architects', unpublished electronic database, Archives, Department of Architecture University of Pretoria.

Wilcox, Scott (1995), 'Interview with the photographer', in *Constance Stuart Larrabee: Time Exposure*, New Haven: Yale Center for British Art, pp. 9–24.

Art, Gender Ideology and Afrikaner Nationalism – A Case Study

LIESE VAN DER WATT

The impertinence of a postcard produced in 1995 by South African graphic artist Anton Kannemeyer seems typical of the irreverence for which *Bitterkomix* – the comic strip that he co-authors under the alias Joe Dog – has become well-known (Fig. 5.1).[1] Picturing a gleeful young woman in her underwear and fishnet thigh-high stockings, standing next to a table into which a bloody knife is pegged, the postcard carries the Afrikaans subscript of 'Seks Dwelms Geweld Plesier' (Sex Drugs Violence Pleasure). However, it is the addition of a *kappie* or a bonnet on the woman's hair that makes the image one of thorough iconoclasm. The *kappie* invokes a historical realm: it presents the viewer with that most revered ideal of Afrikaner womanhood, the *volksmoeder* – although, in post-apartheid South Africa, this one has clearly strayed from the herd.

Literally translated as 'mother of the nation,' the *volksmoeder* ideal was one that was carefully nurtured in the early years of Afrikaner nationalism not only by patronizing Afrikaner men, but also by Afrikaner women keen on having agency in the fabrication of their self-image. The hermeneutics of the *volksmoeder* ideal dates back to the Second South African War (1899–1902) and has expanded over the years to comply with shifting definitions of Afrikanerhood, but by and large it combined domesticity with service and loyalty to the family and the Afrikaner *volk*. A number of feminist historians, critical of the relative absence of gender issues in most accounts of Afrikaner nationalism, have focused on the ideal of the *volksmoeder* in literature and on its intersections with issues of class and race.[2]

In this essay, I explore the *visual* articulation of this ideal, specifically as it is imaged in a narrative frieze of tapestry panels that is now housed in that symbol of bygone Afrikaner unity, the Voortrekker Monument in Pretoria. I suggest that a close reading of the official history of the Voortrekker Tapestry also reveals a lesser known history, namely that of the construction of a feminine ideology and, in particular, of subordinate identities for Afrikaner women. I argue that this gender ideology is embedded in both the production and the iconography of the tapestries and is also paralleled in the historically sanctioned separation of 'art' from 'craft'. Just as craft has been marginalized in relation to art, so the Voortrekker tapestries – and the women who made

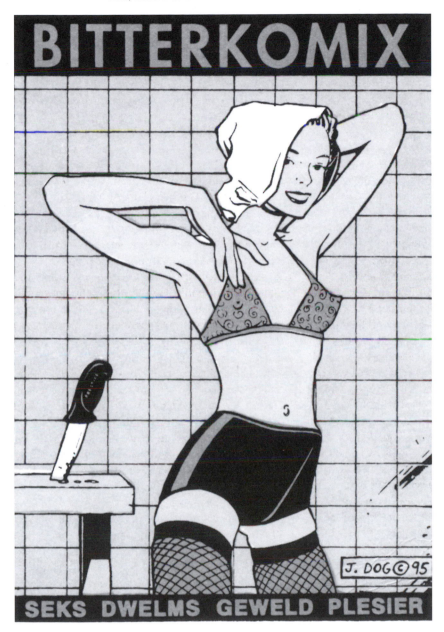

Fig. 5.1. Anton Kannemeyer (alias 'Joe Dog'), *Seks Dwelms Geweld Plesier*, 14 × 10 cm (5¹/₂ x 4 inches), postcard, 1995.

them – were marginalized from the public spheres that were inhabited and controlled by Afrikaner men.

The idea of a tapestry frieze was first proposed in 1952 at a meeting of the Vrou- en Moedersbeweging (Women and Mother Movement) of the Afrikaanse Taal-en Kultuurvereniging (Afrikaans Language and Culture Association) or ATKV, an organization with strong links to Afrikaner nationalist movements such as the Broederbond. At this meeting Nellie Kruger, well known for her patriotic fervour for the newly victorious Afrikaner nation,[3] proposed that Afrikaner women should bestow something of lasting value to the Afrikaner *volk* which would serve as an inspiration for generations to come. Kruger's intention was that the tapestry be made specifically for the Voortrekker Monument, a huge structure just outside Pretoria that was inaugurated in 1949, one year after the victory of the National Party.

The Monument was built to commemorate the Afrikaners' forefathers, the Voortrekkers, and their so-called Great Trek – the emigration of frontier farmers from the Cape Colony to the interior of South Africa in 1838. According to official mythology of the Great Trek, Afrikaner farmers departed en masse from the Cape into the 'unexplored' and 'virgin' interior in protest against British interference and the abolition of slavery in the Cape. In 1938, the year of its centenary, the trek was celebrated by Afrikaners across the country as a powerful unifying symbol in the drive for Afrikaner nationalism, and it was during these spectacular centenary celebrations that the foundation stone of the Voortrekker Monument was laid.

Kruger conceived her idea for a tapestry project in the context of what was called the *Moedersveldtog* or 'Motherhood crusade'– a campaign launched by the Vrou- en Moedersbeweging in 1952 aimed at *moedershuldiging* or 'mother veneration'. As Mrs Pienaar, the chairperson of the Vrou- en Moedersbeweging, explained, 'every righteous person feels a dormant desire in him or her to pay homage to his or her mother' and there is a need to 'express the love, veneration and appreciation for the devoted mothers of the *volk* which every person feels in his or her heart' (my translation).[4]

The peculiarity of an official nationwide 'motherhood crusade' can only be explained in the context of the ideology of the *volksmoeder*. In an article that compares notions of motherhood constructed by Afrikaner nationalism, on the one hand, and the African National Congress, on the other, Deborah Gaitskell and Elaine Unterhalter (1989) identify three different conceptions of Afrikaner motherhood in the twentieth century. In its initial conceptualization after 1902, that is after the South African war, 'Afrikaner motherhood is exalted as saintly in suffering, admired for stoicism in victimization, its strength an inspiration to the rest of the defeated nation. The emphasis is on nobility, passivity, virtuous nurturing and protection of children' (Gaitskell and Unterhalter, 1989, p. 60).[5]

This version of the *volksmoeder* found early visual expression in the so-called Women's Memorial which was erected just outside Bloemfontein in

1913 to commemorate the suffering of the 26 000 Afrikaner women and children who died in British concentration camps during the South African war. A sculpture by Anton van Wouw shows two women – one sitting with a dying, emaciated child on her lap, the other staring out into the distance (Fig. 5.2). What is clearly emphasized in this context is not simply suffering womanhood as some scholars have argued,[6] but suffering *motherhood*. In addition, the mothering of children has been expanded to invoke the notion of a mothering of the *volk*. 'By portraying the Afrikaner nation as weeping women', Anne McClintock (1993, p. 72) comments in her discussion of the Afrikaner nation and gender, 'the mighty male embarrassment of military defeat could be overlooked.' Such a depiction in fact obfuscated the reality of strong women who farmed in the absence of their soldier husbands. As McClintock (ibid.) puts it, 'the memory of women's vital efforts during the war' is 'washed away in images of feminine tears and maternal loss'.

But the *volksmoeder* did not remain a passive object of virtue, and the image of the suffering *volksmoeder* was displaced gradually as increasing importance was given to active and strong women who wanted to take part in their own self-definition. Gaitskell and Unterhalter (1989, p. 61) describe the construction of motherhood during the second phase of Afrikaner nationalism – from the founding of the National Party in 1914 until 1948, when it finally assumed power – as being far more 'active and mobilising'. In these years, the home was identified as an appropriate arena in which to inculcate nationalist sentiment, and Afrikaner women took an active role in raising their children in 'an Afrikaner way' by reading Afrikaans books and magazines to them.[7] As Gaitskell and Unterhalter (1989, p. 63) explain, the hope was that the Afrikaner home would be 'a maternal powerhouse of domestic ethnic mobilisation'. Elsabé Brink (1990, p. 273) remarks in an article focusing on the *volksmoeder* that 'the Afrikaner woman was depicted not only as the cornerstone of the household but also as a central and unifying force within Afrikanerdom and, as such, was expected to fulfil a political role as well'.

Throughout the third phase of Afrikaner motherhood, the 1960s and after, women were called on to defend the home from hostile forces and 'to assist in the survival of white domination', and the home thus remained the primary locus of power for Afrikaner women (Gaitskell and Unterhalter, 1989, p. 67). Afrikaner women were hence vital in the construction of the nation, but in a form that was clearly circumscribed and policed closely by both Afrikaner men and females themselves. McClintock (1993, p. 72) observes aptly that the *volksmoeder* icon is paradoxical: 'on the one hand it recognizes the power of (white) motherhood' but 'on the other hand it is a retrospective iconography of gender containment, containing women's mutinous power within an iconography of domestic service'.

Because of the legacy of domestic service and the assumption that a woman's rightful place is in the home, Afrikaner women's participation in the

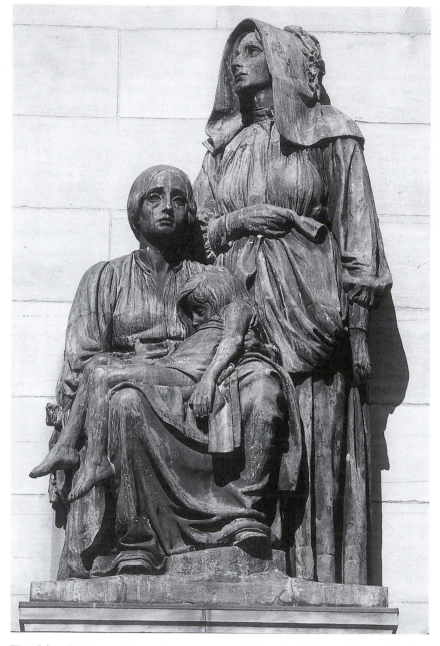

Fig. 5.2. Anton van Wouw, *Vrouemonument (Women's Monument)*, over life size, bronze, 1913. Photograph by Paul Mills.

public sphere was met with much ambivalence throughout the early twentieth century. For instance, when the Women's Enfranchisement Association of the Union campaigned for the female vote in the 1920s, Afrikaner women were mostly absent from this effort. On the one hand, they were alienated by its almost exclusively English-speaking urban membership. On the other, they submitted to the tenets of the Afrikaner Dutch Reformed Church that opposed suffrage for women on biblical grounds, arguing that the vote belonged 'to the man as the head of the family'. Under pressure, through increased urbanization and in a strategic measure to dilate the black vote in the Cape, all white women were finally enfranchised in the 1930s.

Viewed in the light of a historical context in which Afrikaner women had little say in public matters, except through the many welfare and cultural organizations which they managed, Nellie Kruger's proposal for a gift tapestry should be read as an effort both to comply with *volksmoeder* ideology *and* to expand on it. While the making of the tapestry presented an excellent opportunity for Afrikaner women to take on the role of *volksmoeders* through their mammoth show of *volksdiens* or 'service to the nation', it also offered possibilities for females to find representation in a public realm that, by and large, excluded them, except as symbols.

Nine women, selected from hundreds of volunteers, worked for about eight years to execute the 3 353 600 stitches in 'gros point' (the size of a match head) on fifteen panels, each 91.5 cm (36 inches) high and between 152.5 cm (60 inches) and 274 cm (108 inches) in width, in 130 colours of wool. While not all Afrikaner women could be part of the actual execution, they contributed enthusiasm and financial support by collecting a considerable sum of money (R26 000) from as far as Rhodesia and were given regular updates on the progress of the tapestries, their collective gift to the Afrikaner *volk*. Moreover, by insisting that their tapestries be housed in the Voortrekker Monument, a masculine space built to commemorate the stories of Voortrekker heroes, these women looked to transgress the well-defined boundaries of the *volksmoeder* ideal that had banished them to hearth and home.

The women approached W.H. Coetzer (1900–1983), an artist with a reputation for producing what might be termed Afrikaner nationalist art, to design the tapestries. In 1938, the time of the centenary of the Great Trek, Coetzer produced a whole series of images that were based on the writings of historian and cultural entrepreneur Gustav Preller, who had popularized the stories of the Voortrekkers. For the tapestry project, Coetzer devised a frieze of 15 panels, which was meant to be 'read' from left to right, and which relates the trek into the interior of South Africa in terms of a linear progression of key events told in terms of a history of cause and effect. The frieze begins with the exit from the Cape Colony, and it then depicts various battles and incidents that preceded the Battle of Blood River, which is represented in the fourteenth panel. Central in Afrikaner historiography, the Battle of Blood River tells how

days of praying enabled the Voortrekkers to secure the help of God, which in turn allowed them to massacre the Zulus and take possession of the land.

When the women presented their proposal to the Board of Control of the Monument, it was suggested that the gift tapestry should focus on the cultural and domestic aspects of the Great Trek of 1838, those areas that were simply assumed to be the domain of women. The work that was designed did not, however, comply with this suggestion. Although the tapestries were intended to provide a counterpart for the marble frieze inside the main Hall of Heroes of the Monument, which supposedly focuses on the more 'masculine' military and political aspects of the Trek, there is in fact no significant difference between these two friezes. Women are not excluded from the marble frieze, and nor are men absent from the tapestry frieze. On the contrary, the overall and enduring impression of both is of a frontier history told in terms of the actions of men *and* women, and which emphasizes their mutually supportive – albeit different – roles.

In a book dealing with New Deal art and theatre in America in the 1930s, Barbara Melosh identifies a similar quality in the retrospective depiction of the American frontier. She coins the useful term 'comradely ideal' to describe 'a recurring configuration [which] show[ed] men and women side by side, working together or fighting for a common goal' (Melosh, 1991, p. 4). She notes that, 'at the same time, each image registers sexual difference, women and men are complementary but not alike' (p. 2). In the tapestries, likewise, there is sustained emphasis on separate gender spheres and it is clear that the story of the Afrikaners' forebears is told in terms of the mythology of its time. *Volksmoeder* ideology looms large in the continuous association of Voortrekker women with children as well as the sick, the frail and the home, albeit only an ox-wagon. Men in turn take up a range of more authoritative positions: it is the male who departs on horseback, for instance, or who conducts the family's religious devotions.

Stylistically, this strict division of labour is reinforced in the tapestries by a consistent association of women with rest and stasis, and men with movement and travel. The first panel of the tapestries, *Birthday* (Fig. 5.3), is important in establishing a visual key for the rest of the panels in terms of different gender spheres. The panel depicts 'the good old days prior to the Great Trek'[8] and celebrates the birthday of an ageing Voortrekker woman. The seated grandmother, with cat at her feet, seems to epitomize domesticity, and she is situated within a hedged garden, an emblem of civilized life in the colony. Her family is gathered around her, particularly women and children, while a man – already on horseback and outside the walled garden – anticipates the coming Trek. In the foreground, the young boy, who plays with a knucklebone oxen-and-wagon, embodies the restless spirit of the pioneer, even before the start of the impending journey.

This association of women with the permanence of settlement, exemplified by the stately homestead and the tamed garden, is sustained in a number of ways throughout the other panels, despite the fact that all deal primarily with

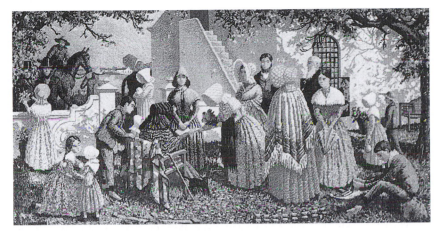

Fig. 5.3. Members of the Woman and Mother Movement of the Afrikaanse Taal-en Kultuurvereniging (embroidery) and W.H. Coetzer (design), *Birthday*, 91.5 cm (36 inches) high, wool on tapestry gauze, 1952–60, Collection of the Voortrekker Monument, Pretoria.

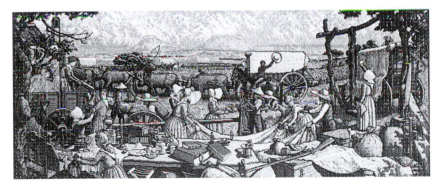

Fig. 5.4. Members of the Woman and Mother Movement of the Afrikaanse Taal-en Kultuurvereniging (embroidery) and W.H. Coetzer (design), *Exodus*, 91.5 cm (36 inches) high, wool on tapestry gauze, 1952–60, Collection of the Voortrekker Monument, Pretoria.

the Trek and therefore with impermanence and motion. On the one hand the ox-wagon signifies domesticity, and on the other the display of objects invokes a cultural sphere, two areas which were conceptualized as female arenas according to *volksmoeder* ideology of the day. In the second panel, entitled *Exodus* (Fig. 5.4) and which depicts the Trekkers who are still in the Cape

colony preparing for their trek, remnants of 'culture' – crockery, furniture, a Bible, books, a brass candlestick, a flat-iron, a mortar-and-pestle – are depicted in the foreground where the women are packing, while the far and distant mountains of the background suggest an ostensibly 'untraversed' nature into which men are already departing on horseback. Likewise, in the fifth panel, entitled *The Outspan at Thaba 'Nchu*, women dominate a scene intended to depict a moment of rest at a point of rendezvous along the Trek route. Women are depicted under a makeshift leather roof, invoking a domestic realm, and are busy with typical female chores such as washing, kneading dough, patching and sewing, making candles, hanging *biltong* (preserved meat) and cooking soap. In these panels, women display the objects they are taking with them, those emblems of 'civilization' that they are transporting into the unknown interior. Clearly, as dictated by *volksmoeder* ideology, women are depicted as the bearers of culture and civilization.

The association of women with the home and men with travelling is very tangible in the two panels dealing with the Voortrekkers' entrance into the province of Natal, a momentous moment in Voortrekker historiography because it pointed toward the end of their journey. In the eighth panel, *Across the Drakensberg*, women are disconnected from the ox-wagon as a symbol of domesticity and the whole representation conveys flux and motion, invoking the domain of the pioneer male figure. Diagonal lines and a plunging perspective intensify the steep slope that the Trekkers have to negotiate, while the danger of the operation is emphasized by the state of the ox-wagon. Usually a place of safety, the wagon now appears completely uninhabitable and the women stand to the side, preparing for the descent on foot. In the ninth panel, *Happy Prospect*, women are left to herd the sheep and to look after the children while the men initiate the descent into Natal. Significant in this panel is a young boy with a flag of the future republic, Natalia, marching downhill to claim ownership of the land, effortlessly assuming a position of leadership and authority.

However, true to the comradely ideal, men are also present in moments of settling, but in a manner which, more than ever, insists on a gendered division of labour and, as a consequence, the dependent character of the *volksmoeder* ideal. In the thirteenth panel, *Family Devotions*, for example, a greying grandfather reads to the family and servants from the Bible. This moment of stasis is dominated by the presence of the (oldest) patriarch, who enacts a ritual that carried major social significance and asserts the status of the man as the head of the household. The family listens attentively seated around the table at the inner circle, while servants are pushed to the margins of the scene, standing in the background or squatting to the right of the table. Likewise, in the sixth panel, depicting a funeral in the veld, the predominant figure is Louis Trichardt, one of the leaders of the Trek, who holds a Bible in his hands and clearly presides over the ceremony.

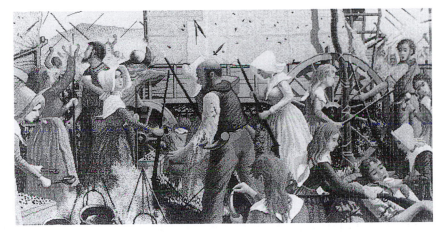

Fig. 5.5. Members of the Woman and Mother Movement of the Afrikaanse Taal-en Kultuurvereniging (embroidery) and W.H. Coetzer (design), *Vegkop*, 91.5 cm (36 inches) high, wool on tapestry gauze, 1952–60, Collection of the Voortrekker Monument, Pretoria.

It becomes clear that, similar to New Deal art, it is images of not only 'heterosexual partnership' but also family life more generally that 'lay at the heart of the usable past' (Melosh, 1991, p. 34). Hence, in *Vegkop* (Fig. 5.5), for example, the Voortrekker family are shown united against hostile forces. Depicted in the foreground on the hither side of a row of ox-wagons that are intended as a barrier between them and the black attackers, men shoot at their adversaries while women load guns and attend to the wounded. The female role in such moments of conflict is circumscribed as merely an auxiliary one. Clearly, a sustained emphasis on separate gender spheres in the tapestries did not simply convey a partial reading of Voortrekker life, but also represented patriarchal hierarchies as an ideal to the contemporary Afrikaner 'family'.

In her exploration of the gendering of the national imaginary, McClintock (1993, p. 63) writes that the trope of the family is often used to signify national relations because it 'offers a "natural" figure for sanctioning social *hierarchy* within a putative organic *unity* of interests'. She continues:

> since the subordination of woman to man, and child to adult, was deemed a natural fact, other forms of social hierarchy could be depicted in familial terms to guarantee social difference as a category of nature ... The metaphoric depiction of social hierarchy as natural and familial ... thus depended on the prior naturalizing of the social subordination of women and children within the domestic sphere.
>
> (McClintock, 1993, p. 64)

Fig. 5.6. Members of the Woman and Mother Movement of the Afrikaanse Taal-en Kultuurvereniging (embroidery) and W.H. Coetzer (design), *Symbolic Résumé*, 91.5 cm (36 inches) high, wool on tapestry gauze, 1952–60, Collection of the Voortrekker Monument, Pretoria.

At mid-century when these tapestries were commissioned, the trope of the family – central to the icon of the *volksmoeder* – was an important way to relay the need for unity, security and continuity on a national level.

Nationalist rhetoric reaches a climax in the last two panels. *The Battle of Blood River* does not include any women but, clearly, such a central event in Afrikaner historiography could not be omitted from any narrative of the Great Trek. *Symbolic Résumé* (Fig. 5.6), which concludes the frieze, shows the result of this and other battles and hardships, namely the triumph of civilization. The entire frontier history of the Afrikaner seems to be condensed into one symbolical panel. While the left side of *Symbolic Résumé* depicts the chaos of travelling and exploring, its right reveals the triumphs of settling, symbolized by the Greek goddess of victory, Niké. On the right, the viewer is presented with signifiers of permanence – modern structures like high-rise buildings – while houses have replaced the ox-wagons of the other panels.

The prosperity that the Voortrekkers had left behind in the Cape Colony, symbolized by the permanence of the homestead and garden in the first panel, is regained in this panel with its cultivated fields and buildings which invoke concomitant associations of progress and permanent settling. On the left of this panel, a vivid picture of chaos and darkness is created, symbolized by the dragon that is also a reference to the Drakensberg Mountains that the Voortrekkers had to cross on their way to freedom and prosperity. It is significant that Voortrekker women are leading the way for the ox-wagons. Carrying torches 'to signify the coming of civilisation' (Kruger, n.d., p. 20),

they head the move from the chaos on the left of the panel to the order on the right. In its virtual exclusion of men, this final panel ostensibly pays tribute to women specifically. Yet the allusion to women as symbols of culture and civilization means that it is also the panel in which *volksmoeder* ideology that delimited female roles within the most narrow and carefully circumscribed boundaries is most overt.

Traditional assumptions about the rightful role of women governed not only the choice of subject matter, but also the medium of the tapestries. When Kruger proposed a tapestry project, she was thinking of a representative gift that would be done in a 'strikingly feminine manner'.[9] When the Board of Control suggested that the tapestries should focus on the domestic aspects of the trek, they were likewise forging a link based on the popular assumption that needlework is somehow essentially 'women's work'. In *The Subversive Stitch* (1984), Rozsika Parker has pointed out that it is precisely this supposed existence of an intimate alliance between needlework and femininity that has given rise to the inferior status of needlework as craft. She writes:

> When women paint, their work is categorized as homogeneously feminine – but it is acknowledged to be art. When women embroider, it is seen not as art, but entirely as the expression of femininity. And, crucially, it is categorized as craft ... [T]here is an important connection between the hierarchy of the arts and the sexual categories male/female. The development of an ideology of femininity coincided historically with the emergence of a clearly defined separation of art and craft. This division emerged in the Renaissance at the time when embroidery was increasingly becoming the province of women amateurs, working from the home without pay. Still later the split between art and craft was reflected in the changes in art education from craft-based workshops to academies at precisely the time – the eighteenth century – when an ideology of femininity as natural to women was evolving.
>
> (Parker, 1984, pp. 4–5)

Repeatedly during the process of making the tapestries, Kruger tried to change the perceived inferior status of needlework as craft to that of an art form in order for it to be 'worthy' of entering the sacred public sphere of the Voortrekker Monument. At the outset of the project, she was careful to locate needlework within a longstanding tradition that began with the famous Anglo-Saxon Bayeux Tapestry of 1088. For Kruger, the Bayeux Tapestry was sufficient justification for Afrikaner women to feel confident that their tapestry, likewise, could serve as an important cultural object, in this instance a document of Afrikaner history that they would immortalize through their skill and devotion. Kruger in fact comments, 'It feels to me as if the Afrikaner women can create a piece of art greater than the famous Bayeux tapestry. We just have to start.'[10]

Kruger links this international tradition with what she identifies as a local tradition of needlework by Afrikaner women which originated in the clothing

that the Voortrekker women had to make for their households. The fact that Kruger locates the beginnings of Afrikaner needlework with these functional pieces is telling. Not only does she forge a link between needlework and women in general, but also, more specifically between needlework and Afrikaner history. In addition, it would seem that the artistry of the tapestries is located in the labour-intensiveness of the project. The fact that the Voortrekker tapestries took about eight years to complete becomes standard information whenever they are discussed after their completion, and the intensive work of the women is used to legitimize their participation in the public sphere.

Kruger argues in diverse ways for the recognition of needlework as 'art'. Her attempts at redefinition are, however, thwarted by her refusal to question the perceived 'natural' connection between needlework and femininity. It is in fact the supposed naturalness of women's association with needlework that underpins what Parker (1984, p. 16) describes as 'the extraordinary intractability of embroidery, its resistance to re-definition'. In order to re-negotiate the status of tapestry as an 'art' rather than a 'craft', the perception of needlework as a signifier of sexual difference must be contested. Since the *volksmoeder* ideology depends on the acceptance of gendered essentialisms, however, it is hardly surprising that an adherent such as Kruger does not take up this challenge.

Since the Renaissance, needlework has been associated not only with women, but also with the domestic sphere. The moment it moves into the public sphere, the domain of men, it tends to fall under male control and is subject to ruthless criticism and inspection, based on preconceived ideas about women's work. In this instance, the Board of Control of the Voortrekker Monument would only accept the gift tapestry 'if it were satisfactory in quality and objective', as they observed in a letter to Kruger and the women of the Vrou- en Moedersbeweging. The women accepted these terms of control. Kruger (1988, p. 5) explained, 'We did not blame them. We understood it well. They were men who had to consider a proposal of women's work completely unknown to them.' Furthermore, in accordance with their unquestioning acceptance of needlework as women's work, the embroiderers involved in the project did not question W.H. Coetzer's authority. Despite her attempts to locate the Voortrekker tapestry in the realm of art, Kruger repeatedly refers to the women embroidering the panels simply as 'the workers'. The women's deference to Coetzer is also evident in Kruger's description of the embroiderers' anxiety when he was due to inspect their work: 'The day when he came to look at the work, it was covered with a cloth. Would it satisfy him? ... It was a weighty and anxious moment when I lifted the cloth.'[11]

Clearly Kruger accepts the idea of a craft workshop in which there is one designer or 'artist' and numerous 'workers'. Parker and Pollock (1981, p. 69) write that in craft history the concern is usually more with the objects – how

they were made, their purpose and function – than with the makers, who are of secondary importance. The fact that this prejudice effectively undermined the status of the tapestries as 'art' as well as the creative contribution of the embroiderers became plain in their having to ask permission to embroider their names onto the panels they had executed. Although the Board of Control consented, this was only on the proviso that these signatures 'would not be prominent' (Kruger, 1988, p. 29).[12] While the 'workers' had to request permission to add their names inconspicuously, the initials of Coetzer, the 'artist', appear prominently on each tapestry and his full name is included in the middle panel.

This attempt to police the presence of women was reinforced ultimately by the lengthy controversy about the location of the tapestries. As I have mentioned, the tapestry gift was expressly intended for the Voortrekker Monument. Nellie Kruger had in fact suggested that the 24-metre (80-feet) wall at the basement of the Monument, which was to become a museum for Voortrekker antiquities, would be an appropriate space to exhibit the frieze. Some of the embroiderers, however, felt that a basement was not suitable for a project that took so long and so much effort to complete, and there were also fears that the works would suffer water damage in this space. It seems that the women then requested that the tapestries be placed closer to what is arguably the focal point of the Monument – the cenotaph of Voortrekker leader Piet Retief and his comrades. In addition to being a prestigious area, an opening in the floor of the Hall of Heroes above the basement meant that it had additional light. In 1958, however, the Board of Control of the Voortrekker Monument asserted that the tapestries would be out of place in the venerable atmosphere of this 'holy' space, and, despite the women's objections, the Board decided to go ahead with plans to place the tapestries in the basement against the furthest wall. To make matters worse, the tapestries were to be placed only 3.7 metres (12 feet) away from glass cases containing antiquities. Coetzer, in particular, felt that this would not allow enough space for the viewer to step back and view the tapestries properly.

The Board arranged for the handing-over of the tapestries to the Monument to take place on 14 December 1960 at a private ceremony. This was neither The Day of the Vow (16 December), the date of central significance in Afrikaner history on which the Battle of Blood River is commemorated, nor the first Republic Day, 31 May 1961, as Kruger had hoped. Kruger's disappointment is clear:

> The function was organized in haste. The Organizing committee [of the Vrou- en Moederbeweging] were planning to arrange a magnificent presentation on 31 May 1961 when South Africa's new status as a Republic was to be celebrated at the Monument . . . The important moment we waited for all those years, went by quietly. Before we knew it, everything was finished.
>
> (Kruger, 1988, p. 48)

The Board of Control argued that many visitors were expected at the Monument during December and January, and that the public was impatient to see the tapestries. While these were legitimate considerations, there were probably other factors at play. Given the Board of Control's marginalization of the Voortrekker tapestries, it is likely that members of the Board actually regarded them as too insignificant to be received on 31 May 1961, that momentous day for Afrikaners seeking the self-realization and independence which is believed to have informed the aims of the people depicted in the tapestries.

On 29 September 1966 the tapestries were moved from the basement of the Voortrekker Monument to a newly erected Voortrekker Museum across the street, a building that stands outside the granite wagon-laager encircling the Monument as a symbol of unity and protection. Although W.H. Coetzer expressed satisfaction with this arrangement because the tapestries were better displayed in the new building where a special room was built for them, the Vrou- en Moederbeweging felt that the works ought to be kept inside the Monument, and particularly within the circle of ox-wagons that symbolically protects this emblem of Afrikaner power. The removal of the Voortrekker tapestries can in fact be understood as a final attempt by the Board of Control to regulate the presence of Afrikaner women in the Voortrekker Monument complex, indeed to exclude females from a main building reserved for masculine activity and which presented a public symbol of Afrikaner power.

In 2000 the tapestries were returned to the inside of the Monument, and they now share a room with Piet Retief's cenotaph, the hallowed space from which they were banned in 1958. The museum that used to house the tapestries has been transformed into an art gallery and all material about Voortrekker history seems to be concentrated inside the Monument. In the current dispensation, the Afrikaner[13] is increasingly marginalized from the political and cultural scene, and the transferral of the tapestries to the inside of the Monument was probably necessitated by budget cuts and the need to rationalize what was once a state-sponsored institution. It is ironic that it took a democratic (black) government, and the ramifications of its policies, for Afrikaner Nationalist women to be afforded credit in terms of the placement of these tapestries. But it is also possible that in a context where inclusiveness has become fashionable, the decision to place the tapestries in a prestigious position in the Monument speaks of a discredited people endeavouring to claim legitimacy by turning to politically correct measures.

Notes

1. I extend my thanks to Anton Kannemeyer, and the Board of Control of the Voortrekker Monument for granting permission to reproduce images. Thanks also to the Research Council of the University of Cape Town for financial assistance in reproducing images.

2. For discussions of literature see Hofmeyr, 1987 and Kruger, 1991. For considerations of class and race see Brink, 1990.

3. Nellie Kruger was born in 1907. She obtained a Masters degree in Afrikaans-Nederlands and worked as a journalist at the republican and nationalist newspaper *Die Volksblad*. In 1947 she launched a weekly journal, *Die Ruiter*, with her journalist husband J.J. Kruger. In the first edition of *Die Ruiter* the editors claimed that *Die Ruiter* (9 May 1947, p. 2) 'will help to keep the unfaltering heartbeat [of Afrikanerdom] strong and its blood pure' and expressed the explicit desire to be 'of service to the nation'. Kruger joined numerous welfare and cultural/women's organizations, including the Afrikaanse Christelike Vrouevereniging and the Vrou- en Moederbeweging van die ATKV, which all reserved their charity for an exclusively Afrikaner constituency.

4. The words of Mrs Pienaar are recorded in N. Kruger's 'Unbound Supplements'. These unbound notes and research material, collected by Kruger while in the process of writing her 1988 book, are numbered and located in files in the Cultural History Museum, Pretoria.

5. It was a conception mostly left in the hands of male cultural entrepreneurs. As Gaitskell and Unterhalter (1989, p. 60) point out, women were 'themselves as silent as their stereotypical portrayal'.

6. Here I take issue with Lou-Marie Kruger's reading that *volksmoeder* ideology was not yet clearly articulated at the opening of the Women's Memorial and that it is womanhood generally, rather than motherhood specifically, that is stressed in the oral addresses at this event. See Kruger, 1991, pp. 142–3.

7. For a discussion of women's role in the cultural sphere see Hofmeyr, 1987.

8. This description is taken from an official booklet distributed at the Monument with historical background about every tapestry panel (Kruger, n.d.). Although Nellie Kruger compiled this document, the many references in the text to compositional devices and symbolism in the tapestries clearly represent the voice of W.H. Coetzer.

9. This statement is on p. 3 of the Unbound Supplements to Kruger, 1988, my translation. See also note 4.

10. Taken from p. 5 of the Unbound Supplements to Kruger, 1988, my translation. See also note 4.

11. Taken from p. 9e of the Unbound Supplements to Kruger, 1988, my translation. See also note 4.

12. These women were M.S. Pienaar, J.W. Prinsloo (who did three panels), H. Rossouw (two panels), N. Kruger (two panels), J.F. Coetzer (two panels), H.J. Combrinck, M.B. de Wet, A.W. Steyn (two panels) and M.R. Oosthuizen.

13. It is worth pointing out that Afrikaans-speaking peoples are as heterogeneous as other language groups. The term 'the Afrikaner' should be qualified as referring to a diminishing group of Afrikaans-speaking people that still identify with such constructs as 'the Afrikaner *volk*' or aspire to attain an 'Afrikaner identity'.

References

Brink, Elsabé (1990), 'Man-made women: gender class and ideology of the *volksmoeder*', in Walker, C. (ed.), *Women and Gender in Southern Africa to 1945*, Cape Town: David Philip, pp. 273–92.

Gaitskell, Deborah and Unterhalter, Elaine (1989), 'Mothers of the nation: a comparative analysis of nation, race and motherhood in Afrikaner Nationalism and the African National Congress', in Anthias, N. and Yuval-Davis, F. (eds), *Women-Nation-State*, London: Macmillan, pp. 58–78.

Hofmeyr, Isabel (1987), 'Building a nation from words: Afrikaans language, literature and ethnic identity, 1902–1924', in Marks, S. and Trapido, S. (eds), *The Politics of Race, Class and Nationalism in 20th Century South Africa*, London: Longman, pp. 95–123.

Kruger, L.M. (1991), 'Gender, community, and identity: women and Afrikaner Nationalism in the *volksmoeder* discourse of Die Boerevrou (1919–1931)', unpublished MA thesis, University of Cape Town.

Kruger Nellie. (n.d.), *The Voortrekker Tapestry*, booklet published by the Board of Control, Voortrekker Monument, Pretoria.

—— (1988), *Die Geskiedenis van die Voortrekkermuurtapisserie: Geskryf op Versoek van die Beheerraad van die Voortrekkermonument*, Pretoria: ATKV.

McClintock, Anne (1993), 'Family feuds: gender, nationalism and the family', *Feminist Review* 44, Summer, pp. 61–80.

Melosh, Barbara (1991), *Engendering Culture: Manhood and Womanhood in New Deal Public Art and Theater*, Washington and London: Smithsonian Institution Press.

Parker, Rozsika (1984), *The Subversive Stitch*, London: The Women's Press.

—— and Pollock, Griselda (1981), *Old Mistresses, Women, Art and Ideology*, London: Routledge and Kegan Paul.

Technologies and Transformations

Baskets, Women and Change in
Twentieth-century KwaZulu-Natal

NESSA LEIBHAMMER

An illustration by George French Angas (Fig. 6.1) is one of a number of nineteenth-century images by artists working in the KwaZulu-Natal[1] region of South Africa that depict objects of daily use. These images show a diversity of coiled baskets made from plant fibre. They appear more numerous than the ceramic and carved wooden vessels also illustrated in the images, suggesting the ubiquity of baskets in the past.[2] However, unlike ceramic vessels, which are still made and used today in rural KwaZulu-Natal homesteads for brewing and serving *utshwala* (sorghum beer), baskets are now made only to be sold commercially in

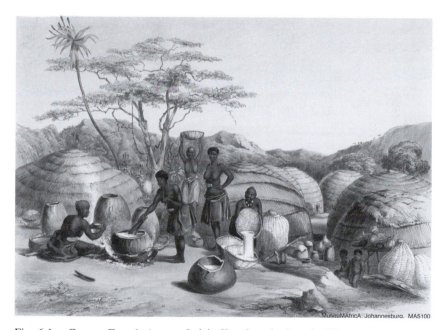

MuseuMAfricA. Johannesburg. MA5100

Fig. 6.1. George French Angas, *Judu's Kraal at the Tugala. Women Making Beer*, coloured lithograph reproduced in *The Kafirs Illustrated*, published by J. Hogarth, London, 1848.

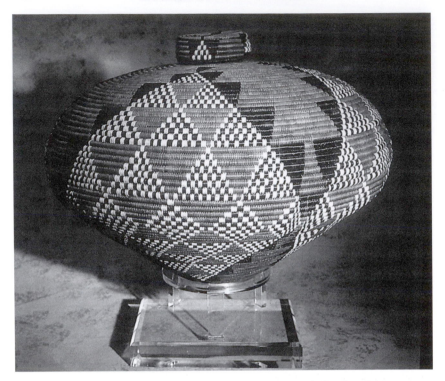

Fig. 6.2. Beauty Batembile Ngxongo, coiled basket, MTN Collection, Johannesburg.

urban shops, roadside stalls or for export. Even in the most rural areas, plastic and metal containers are used for carrying, storing and holding liquids, and these have almost exclusively replaced the baskets that once served these needs.

Considered to be a male activity in the past, the making of coiled baskets was largely an occupation for women by the late twentieth century (see Fig. 6.2). In this essay, I will examine how social and political changes affected makers and markets for these baskets in KwaZulu-Natal from 1910 until 1994. I will also challenge the assumption of a rigid gender division amongst the earlier basket makers. Furthermore, I will probe the concept that baskets made and sold today can still be referred to as 'traditional'.

Although the period between 1910 and 1994 is the main concern for this essay and the volume as a whole, an examination of what might be considered 'traditional' in KwaZulu-Natal necessitates my inclusion of information about labour and social systems prior to the twentieth century. As the specific type of basket making from KwaZulu-Natal I discuss occurs almost exclusively in rural areas, the histories and social changes affecting these, rather than urban

areas, will be explored. As the most important contemporary movements in basket making have occurred north of the Tugela, particularly in the Hlabisa area (see Fig. 1.2), this region will be my area of focus.

Reconstructing the history of basket making is no easy task. The subject has not received much attention in the early writings on South African culture, and details of manufacture, significance and use – especially from the nineteenth century – are scant.[3] Basket making receives only passing attention in the early and mid-twentieth-century writings of scholars such as Eileen Krige (1950) and James Stuart (Webb and Wright, 1976–86). More recently, however, Jack Grossert (1978), Megan Jones (2001) and Jannie van Heerden (2003) have studied the subject in some depth, concentrating on makers, production, materials, markets and influences. Nevertheless, because the historical depth and detail of much information on basket making is lacking or no longer available, the arguments contained in this essay are, of necessity, speculative.

Men or Women as Basket Weavers?

It was undoubtedly women who dominated the basket-making industry in KwaZulu-Natal by the late twentieth century, but available literature presents inconsistent accounts about who precisely made baskets in the past. The art historian Carolee Kennedy (1978, p. 3) expresses the most generally held notion in her brief study on the art and material culture of the Zulu-speaking peoples:

> Although basketry is usually considered a woman's art, it was traditionally the domain of adult Zulu males. In fact, men once made all basketry forms, except mats and, possibly, the large grain storage baskets (*isilulu*) … Today, on the other hand, women are responsible for all basketry, although some old men are still working at the craft.

Similarly, in her comprehensive master's thesis on Zulu basketry and related craftwork, Megan Jones (2001, p. 8) writes:

> Grasswork production was divided by gender, with basket-work done by males who learnt to work with fibres as part of their informal study of the veld undertaken while tending cattle as children. There they began by plaiting braids, graduating to more complex grasswork pieces until they became responsible, as young adults, for producing coiled baskets and the *izilulu* granaries for the general household. Women were responsible for making the homestead's required mats, spoon bags, brooms, beer skimmers and strainers.

Most authors of early literature on the area agree with these gendered divisions. When Adulphe Delegorgue, a French traveller and writer who journeyed through South Africa from 1838 until 1844, described the interior scene in a traditional 'Zulu' home, he observed men 'squatting or lying on

mats' around the hearth 'engaged in leather work or basket-making, talking or resting' (Delegorgue, 1990, p. 168). In 1929, the Revd Bryant described the duties of men around the homestead in a similar vein:

> To the Zulu man it falls to build the huts and keep them in repair; to erect and renew the various fences of cattle-fold and kraal; to hew down the bush and cut the long grass from such spots as the females are to cultivate; to milk the cows and generally tend all stock ... Then, again, many of the elder men are constantly engaged with special offices, professions, or trades – of doctoring, divining, metal-working, wood-carving, basket-making, stock-castrating, skin-dressing, head-ring making.
>
> (Bryant, 1929, p. 74)

In her doctoral study, Sandra Klopper (1992, p. 51) remarks that 'In Zululand itself, it was in fact common for the heads of ordinary homesteads to weave the baskets needed by their families for storing grain and beer' and that 'In view of the fact that men appear to have done most of the weaving in 19th-century Zululand, it is ironic that basket-weaving has since been "revived" as a "female" craft.'

Not everyone, however, has subscribed to the view that basket making was historically a male practice. Nathaniel Isaacs, one of the first Europeans to penetrate the Zulu kingdom during Shaka's reign, writes that 'girls ... collect reeds which they fabricate into baskets of different descriptions' (Isaacs, 1937, p. 237). Others suggest that both men and women possessed basket-making skills. Krige (1950, p. 207) explains how 'every woman makes her own sleeping-mats and the rougher kinds of basketware ... while the best baskets are usually made by men'. Jack Grossert, organizer, and later inspector, of arts and crafts for the Native Section of the Natal Education Department in 1948, writes how the craft of 'stitching a spiral coil of soft grass was learnt by young boys while out herding the cattle'. He acknowledges, however, that while this 'remained a craft particularly for men to do', it 'did not preclude women from making stitched baskets when the need arose' (Grossert, 1978, p.17).

Jones (2001, p. 8) has written that, following Roy Sieber's[4] categorization, the separation of coiled basketwork as a male activity and the weaving of mats, spoon bags and brooms as a female activity may be a technological specialization between coiling and weaving. Yet Sieber has written that 'men or women may make baskets' and that 'in Africa as elsewhere the sense of specialisation is tied to the medium' (1980, pp. 167 and 212). Hence Sieber's divisions are driven by medium and not technique. This distinction takes on greater significance when the links with medium and technologies of power in traditionalist Africa are made explicit, as I will reveal.

When I conducted interviews with basket makers in the Hlabisa region in February 2003 (see Figs 6.2 and 6.3), it became evident that none of these women could recall a strict division in the gender of basket makers in the past. Laurentia Dlamini (b.1936) confirmed that both men and women made

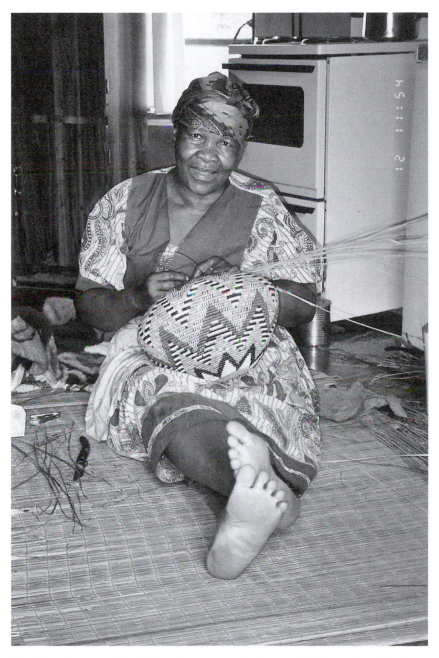

Fig. 6.3. Laurentia Dlamini working on a coiled basket, Hlabisa region, KwaZulu-Natal, February 2003. Photograph by Nessa Leibhammer.

baskets when she was young, and, similarly, Flora Hlabisa (b.1946) recalled that both her parents made baskets. Vina Ndwandwe (b.1962) remembered that, in her parents' time, more women than men made baskets: a female neighbour taught her mother in 1929 and her mother in turn taught her this practice. Neither of the parents of Beauty Batembile Ngxongo (b.1953) made baskets, but she learned basketry from Laurentia Dlamini, her aunt on her mother's side. Ngxongo was not sure who made baskets when she was very young but believes that men made *izimbenge*[5] and women other types of baskets.[6]

Those scholars who assert that the making of baskets was historically a male activity identify migrancy as the factor that resulted in this practice becoming the province of women. For example, Jones (2001, p. 74) believes that as 'more and more men were pulled out of the homestead ... women turned, largely of necessity, to supplying their own basketry needs rather than abandon these objects'. However, while male migrancy would certainly have affected the degree to which women took over basket making in the twentieth century, this reading does not explain why none of the basket makers I interviewed in the Hlabisa region could recall any particular division in the gender of basket makers at any stage in their lives, or indeed why community workers and traditional healers from the same region held that there was 'no problem with women making baskets in the past'.[7] It also fails to explain why some women in KwaZulu-Natal communities did not take up other historically male activities, such as iron smelting.

In this essay I will consider how activities such as metal smelting, pottery production and cooking in nineteenth-century Zulu culture are gendered as either male or female because of their strategic position within Zulu belief systems. I will suggest how, in contrast, the making of baskets does not appear to fall into these spheres of reference and, because of this, was probably not as rigidly gendered.

Lifestyle and Structures in the Past

Written records by nineteenth-century travellers describe how people living in the Zulu kingdom grew crops and kept cattle. Extended families lived in homesteads (*imizi*) under the authority of a married headman (*umnumzane*). Except in times of stress caused by, for example, drought, floods, plagues and warfare, each *imizi* was self-sufficient with its fields, cattle and labour. The families grouped within this unit constituted a social unit or clan.[8] The social system of the *imizi* was paternalistic and favoured the elder generations, both male and female, although a dominant lineage – traced through the male line – was considered the most important. Women, particularly young married women, did not occupy a high status within the social hierarchy.[9]

Domestic tasks were generally divided into male and female realms – divisions that exist in social systems in much of pre-colonial Africa.[10] Work roles were gender-specific across a range of activities and were seldom open to individual choice. Such categorizations have implications because they preserved power relationships based on access to goods, technologies, ritual skills and control of labour. Jane Guyer, in her study of the Beti of the Cameroon, describes the correspondence and coherence of the system in which male and female are embedded. She writes of the male sphere:

> Male activities were thought of in terms of warfare, hunting and tree-felling, however much or little time was spent on each. The male tools were iron and wood: the spear ... the hatchet ... The male activities carried explicit military and phallic symbolism, involving cutting down and building up, as with yam stakes and house poles. Men worked upright, climbed palm trees to tap the wine or cut the fruit ... The male milieu was the forest ... the source of wood for tools and the most prestigious meat for the diet.
>
> (quoted in Herbert, 1993, pp. 222–3)

In addition to the activities listed above, cattle herding and tending was also reserved for men in southern African traditionalist societies, as this livestock is linked to the ancestral line and thus to power.[11] The sphere of women, however, was different:

> Women's milieu was, by contrast, the earth itself, the open clearings or the savanna ... a woman worked the fields, bending over the earth with her short-handled hoe ... She cooked in earthenware pots, bending over the fire ... and she 'cooked' babies in her womb. Bending over the earth to tend it, shape it, and coax it to produce was woman's attitude. Her crops were the savanna crops, planted with the woman's tool, the hoe.
>
> (Guyer, quoted in Herbert, 1993, pp. 18–19)

Similarly, agricultural activities, beer brewing and general household tasks such as cooking and caring for young children were the domain of Zulu women. It was women who become specialist potters and created the shiny round forms of the household ceramics used for cooking, storage and the brewing of beer.

Technologies of Transformation

Eugenia Herbert (1993, p. 221) has written that these gendered divisions of workloads 'could not survive without an ideological basis, and this basis is rooted in both cosmology and history'. She explains that it is in the understanding of the technologies of transformation that the fundamental tenets of belief become clearest:

> [M]etallurgy, the creation of chiefs and kings, and hunting – are pre-eminently male domains; only the fourth, pottery, is primarily a woman's task. All four invoke the explanatory model of human reproductivity not simply as a symbolic system but as an active force that is integrally related to success or failure of the operation. Human fecundity in its various phases interacts reciprocally with each of these activities and is intimately connected with ancestral intervention and regeneration.
>
> (Herbert, 1993, p. 220)

Within this conceptual framework, her commentary indicates, there are important parallels between procreation, metallurgy and ceramics. These are all processes in which 'heat' is present and which involve a transformation of material. This transformation, from one physical state to another, is also a process that is not reversible.

Dr Axel-Ivar Berglund, a scholar of anthropology, ethnology and theology and a minister in the Lutheran Church who has worked for many years in KwaZulu-Natal,[12] has elucidated the connection between heat and procreation in Zulu belief systems. He explains how each lineage member of a clan is embodied with the potential for fertility and growth, powers that are described as 'hot'. Each child is born with this 'heat' and it burns everywhere but especially strongly in those 'places of work (sexual organs). That is where they (the shades) put the power' (Berglund, 1989, pp. 253–4).[13] Through the 'hot' activity of sexual intercourse, male seminal fluid and female 'fluids'[14] are 'transformed' into the child. This process of transformation is thought to be similar to those in which rough iron ore becomes malleable metal, soft earth and water transforms into hard ceramic and raw food becomes cooked. Collett (1985, p. 121) points out:

> The foetus and iron are linked because both of them involve a transformation of one substance into another and this transformation is mediated by heat … The inclusion of pots and cooking in this metaphorical grouping is also understandable. Cooking involves a heat-mediated transformation of the raw into the cooked and this takes place inside a vessel, the pot. Not only transformation but irreversible transformation.

These conceptual systems, which apply to many societies in Africa, are relevant also to the belief systems of people living in the KwaZulu-Natal region of South Africa. Potters are often midwives in Africa, while metal smelters and forgers are commonly the healers and diviners. These individuals frequently formed a caste of their own. The knowledge of metal smelting, in particular, was kept secret and limited to men in a few families. Such men were both respected and feared: their secrets and capacity to carry out their tasks successfully demanded magical powers that could only come from interfacing with the ancestral realm – a facility that made them both powerful and dangerous.

Technology and Power

The history of the rise of the Zulu kingdom is well documented (Hamilton, 1985; Hamilton and Wright, 1989; Wright, 1990) and it is clear that kings controlled all strategic resources, including the output of metal smelters and forgers. Kings were dependent on these blacksmiths for weapons and tools, which were essential to build economies and hold power in pre-modern southern Africa. Equally, through the control of strategic areas of production, the king was able to control and manipulate the symbols of status related to Zulu royalty. To do this it was mandatory for metal smelters and forgers to live and work close to the royal residences.[15] These blacksmiths made tools, weapons and status objects only on the king's command. The king also had exclusive say over the distribution of these objects.[16]

Specialist woodcarvers, dependent on royal patronage for their carving equipment, were by necessity closely aligned to the royal court. Klopper (1992, pp. 92–3) states that 'during the early history of the Zulu kingdom, the distribution of almost all artefacts produced by these carvers was controlled by the court'. Thus wooden milk pails were reserved for the use of the king's herdsmen and only the royal family used carved wooden platters for serving meat. In contrast, meat eaten by commoners was served on woven grass mats. In the absence of carved wooden pails, commoners used calabashes or watertight fibre baskets for the storing of liquids. Clearly, woven or coiled household baskets and other plant fibre utensils did not fall into the realm of high-status objects.[17]

It is noteworthy that baskets do not undergo transformation by heat and nor is their construction irreversible. Fibres can always be unpicked when a mistake is made. The harvesting and construction of objects from plant materials is also not critically dependent on metal tools. While wood cannot be carved effectively without metal tools, simple instruments made of bone or stone will suffice to cut grass, reeds and other soft plant materials. Coiling and stitching a basket requires an awl to pierce the previous coil of basketwork so that a fibre strand may be threaded through and wrapped around this lower coil, but while this awl could be of iron, it could equally be made of wood, bone or ilala bristle (Jones, 2001, p. 6). Thus the tools needed to harvest plant materials would not have been difficult to acquire in the nineteenth-century Zulu kingdom. Materials necessary for basket production must have been freely and abundantly available before extensive farming and over-harvesting caused shortages in the mid-twentieth century.[18] It is unlikely that the use of such materials could have been subject to authorization by the king or any of the privileged chiefly class, and no mention of the control of plant materials is made in the early literature.

The only constraint placed on women's making of baskets that becomes evident through literature and interviews is that females were not expected to

gather materials in the bush or forests as these 'wild places' were considered the domain of men. Occasionally informants indicated that women were not strong enough either to gather particular materials or to create very large, heavy baskets. When asked recently why men might have made baskets in the past, a traditional healer from Hlabisa replied that *ugonothi* (bamboo) which was 'used to make carrying baskets was very strong but you had to climb a tree to get it. Women couldn't do this.'[19] When asked the same question, Duduzile Biyela, liaison officer for the Africa Centre for Population Studies and Reproductive Health, gave a similar answer: women were not allowed to go into the forests and wild places because it was dangerous, and large baskets were heavy and difficult to make.[20]

While Zulu basketry appears not to carry the same significance as metal, wood and ceramic objects, this does not mean that the materials used in its construction are not deeply connected to realms of cosmology and healing. Plant substances are linked to the very myths of origin of the Zulu people and to concepts of fertility and abundance. Reeds, for example, play a significant part in southern African creation myths not only amongst Zulu-speakers but Sotho-speakers as well. It is said that through the union of reed, mud and water, humankind was created (Berglund, 1989, p. 35).

Plant fibre, in particular, was associated with fertility. It was used by initiates to create costumes worn during 'coming out' ceremonies, which marked their transition from a juvenile status to one of sexual and social maturity and responsibility. This connection to fertility is further evidenced in the *izifociya* belt, also made from plant fibre and worn by Zulu women three months after the birth of their first child. Grass articles formed an important part of ritual ceremonies. For example, the *umshopi* was performed when ill omens prevailed, such as illness or poor crops. Plant fibres also featured in the *umkhosi*, or first fruits ceremony: the king, enveloped completely in a costume made of *umuzi* grass, would appear to the assembled regiments of the *amabuto*[21] (Webb and Wright, 1986, pp. 120 and 271).

If plants are connected to the fertility of the individual and the nation, they are also valued for their protective properties, as are all things gathered in the bush. Grasses were understood to work as charms against evil spirits and the healing power of plants is well known. Ilala palm, used extensively in basket making, is considered one of the strongest medicinal plants.[22] Whether or not these medicinal or protective properties are relocated into the basket once it is complete is difficult to say, and more research would have to be done to establish this. What is evident, however, is that plant material was available to rich and poor and was used for the most basic household items in nineteenth-century Zululand. These included thatching, bedding, household utensils such as strainers, nets, items of clothing, floor covering and storage. Clearly plant fibres were a very egalitarian material.

Changes and Disruptions

By the early nineteenth century small chiefdoms, described above, had begun to amalgamate into larger political entities, culminating in the rise of the Zulu kingdom.[23] This polity remained under the rule of a Zulu king until its defeat in 1879 by British forces. Thus the end of the nineteenth century saw the power of the Zulu kingdom crushed and its people placed under increasing pressure through the alienation of their lands and the economic burden of taxation. In 1887 a large portion of the territory between the Pongola and Tugela Rivers became the Colony of Zululand, effectively controlled and administered by the British Colony of Natal.

In 1897 the Colony of Zululand was annexed to Natal and two-fifths of its land turned over to white farmers. Only three-fifths remained 'black reserves'. Black South Africans living on what was now white farmland were effectively reduced to tenant labour or were removed to 'black reserves'. The labour-hungry white farming and mining communites pressurized the government to introduce, in addition to the hut and dog tax, a new poll tax in 1906. Migrancy increased as the only way to pay this new tax was for more men to become labourers on farms or in mines.

But worse was to follow, and the beginning of the twentieth century was a disastrous period for black people in the Zululand area. Throughout the colony, the ravages of drought, crop failure and cattle fever (rinderpest) led to rampant poverty in the already overcrowded reserves. Many more young men were sent out to work. In the words of a spokesman at a meeting of Africans in 1905, 'Famine threatened us, but we were saved by our sons. They became the wagons which carried us, the gardens that fed us' (quoted in Morrell, 1996, p. 77). An economic depression followed the First World War, forcing already low wages even lower. Although migrancy increased, the demand was for male labour and few women found employment in urban areas, even as domestic workers. Most women were left behind in rural areas, and a steady decline into impoverishment in these areas was seen throughout most of the twentieth century. Overpopulation, over-cultivation and overstocking were the general characteristics of this process. Droughts in the 1930s and 1940s further aggravated the situation. This general deterioration had serious social consequences. Malnutrition and ill health became widespread. Migrancy undermined family life, weakened parental authority and upset the sexual division of labour (Morrell, 1996, p.101).

The economic situation in the rural areas deteriorated even further during the 1970s. Urban wages had not increased since the early 1960s, and this affected rural communities that relied on these remittances. Poverty worsened as forced removals of rural communities escalated. Land was lost, crops were forfeited and livestock was impounded. In white farming areas, labour tenants

were forced out through hut burnings and arrests. Social networks were destroyed as black communities all over the region, urban and rural, were uprooted and relocated. During the 1970s and 1980s, 73 per cent of rural income in KwaZulu-Natal was from formal economy and migrant wages. Homesteads had few resources of crops and livestock. Seventy-eight per cent of the economically active population was living below the poverty datum line. The amount of arable land per family decreased to the point where few were able to produce enough to cover their basic needs (Morrell, 1996, pp. 141–3).

Modernity, in the form of capitalist economy and industrialization, coupled with colonialism and apartheid rule, inflicted considerable disruption on many previously self-sufficient black homesteads. Restrictions on personal freedom, loss of wealth, loss of land and loss of self-determination were felt increasingly. Capitalist economies clashed with traditional homestead economies, forcing change throughout KwaZulu-Natal. The shift from the old social system to new adaptations was, however, not sudden, as pockets of the old survived well into the twentieth century.

The contention that women took over the domain of basket making because of male migrancy is compelling. Certainly, the political disruptions in KwaZulu-Natal and the social and economic hardships which forced men increasingly into the wage labour market on farms, mines and urban centres left rural women with little choice other than to take over many duties previously undertaken by men. In so far as basket making was concerned, however, this was not a straightforward adaptation. There was no need to produce baskets for domestic use because new products were rendering baskets obsolete as household utility objects. There was also resistance, in certain sectors, to the promotion of basket making as a means to earn a living.

Formal and Informal Projects

In the twentieth century, a number of initiatives in both the formal and informal educational sectors began to promote traditional craft. This was often driven by the intention of providing a source of income for black people, especially in the poverty-stricken rural areas. There appears to have been some ambivalence towards this promotion, however, especially in so far as basket making was concerned.

In the nineteenth century and early part of the twentieth century, education for black South Africans was largely through mission schools, and this continued well into the twentieth century. However, in 1953, five years after the pro-Afrikaner Nationalist government came to power, this regime introduced a new educational dispensation for black schoolchildren called 'Bantu Education'. This inferior form of instruction was conceived as a way of teaching Africans to accept their 'proper place' as workers in a country where

white supremacy strove to dominate. Hendrik Verwoerd, then Minister of Native Affairs in the Nationalist government, is recorded as saying, 'The school must equip the Bantu to meet the demands which the economic life … will impose on him … What is the use of teaching a Bantu child mathematics when it cannot use it in practise? … Education must train and teach people in accordance with their opportunities in life' (quoted in Oakes, 1988, p. 379).

Even before the apartheid era, education for black South Africans had differed from that of whites. In 1849, soon after British rule of the Natal region was established, the Secretary of State expressed satisfaction at the levy of a seven shillings and sixpence hut tax imposed on all blacks living in the area. He saw this as a way to raise money for the establishment of schools where 'Natives … would learn the habits of industry' (quoted in Grossert, 1968, p. 59). The syllabus included what was taught in elementary schools in England as well as a practical component such as gardening and farming for boys, and housework, sewing, cooking and washing for girls.

Charles T. Loram, who became Chief Inspector of Native Education in 1918, introduced grass weaving and plaiting into some black primary schools as an experiment in 1917. By 1919 he wrote in his annual report that 'there are large numbers of schools doing grass work, considering the subject was only introduced two years ago. The fact that 73 per cent are doing this work is very encouraging' (Grossert, 1968, pp. 71–2). Teaching grass weaving or basket making in white schools was never even a consideration.

Black parents voiced their objections to the teaching of traditional skills at schools. Grossert (1969, p. 77) pointed out: 'Parents were looking to education to lift their children out of the primitive way of life and labouring work, and any failure on the part of the schools to convince them of the higher ideal of "education through crafts" … would arouse their suspicions.' Parents were, in fact, openly hostile to the idea of teaching traditional crafts. In 1934 an education committee consisting of four white and eight black members from the Transkei

> emphatically express[ed] the opinion that the time spent on teaching handicrafts i.e. clay-modelling, basket-work etc., is time wasted … When this subject was introduced it was in the hope that, in addition to the training of hand and eye, it would mean the resuscitation of old Native industries and might open avenues for Native industry. But, if the handicrafts ever existed on any large scale among the Natives, which your committee doubts, we are convinced that their day has long gone by.
>
> (Grossert, 1968, p. 77)

Open hostility to the teaching of traditional crafts at schools was evident and there was resistance to it in other institutional projects as well.

The plight of black women in rural areas in the mid-twentieth century was drawing the attention of overseas churches and institutions. In 1961 a young Swedish couple, Peder and Ulla Gowenius, were sent out to Zululand under

the auspices of the Evangelical Lutheran Church to 'research the material culture of the area and consider viable opportunities for the encouragement and marketing of arts and crafts to assist black people there, especially women' (Hobbs and Rankin, 2003, pp. 16–17). The project resulted in the establishment of the now well-known Evangelical Lutheran Arts and Crafts Centre at Rorke's Drift near Dundee.

The Goweniuses soon identified a need for occupational therapy amongst patients in hospitals in the area. The many patients suffering from tuberculosis, in particular, underwent a long convalescence 'without recreation or occupation to keep depression at bay' (Hobbs and Rankin, 2003, p.18). The couple's decision, however, was not to introduce traditional crafts because of the ideological contention surrounding their promotion. Hobbs and Rankin (2003, p. 19) write:

> It is significant that there was little idea of utilising the crafts already known to the patients as part of their rehabilitation programme. There was no inclusion of, for example, any weaving with grass or reeds, or basket making … the Goweniuses were quickly made aware of contention around the fostering of indigenous crafts, which was sometimes looked on with suspicion. Critics saw it not as an attempt to conserve indigenous cultures, but as part of the general aim of Bantu Education to prevent black people from acquiring knowledge of western culture and ideas.

The Goweniuses were deeply critical of government policy and they chose to distance themselves from it, particularly as a growing number of black people had begun to perceive the encouragement of indigenous crafts as a 'tribalising, even pernicious ploy' (Hobbs and Rankin, 2003, p. 20).[24]

Dissatisfaction with the unequal system of education continued throughout most of the twentieth century. 'In the era of school protest over Bantu Education, subjects such as craftwork came under heavy fire for reinforcing stereotypes and abetting in systems that limited African potential for self-development' (Jones, 2001, p. 62). This simmering dissatisfaction came to a head in 1976 when more than 20 000 pupils from the black township of Soweto in Johannesburg staged a protest march. Police opened fire on them and many died. Deep grievances felt by South Africa's black population against the injustices of apartheid caused unrest to spread rapidly throughout the country. This was brutally repressed by the police and army. It was, however, an important step in the growing consolidation of protest action in South Africa that eventually led to the new dispensation in 1994.

The teaching of craft skills at schools remained a contentious area and, by the 1970s, was in decline. However, these skills, especially basket making, found another outlet as the lot of women in rural areas remained a serious problem. Informal training programmes were set up with a 'definite economic focus, aimed less at younger generations striving to enter the urban Western workforce and more at adults struggling to make ends meet in the rural

environments' (Jones, 2001, p. 62). The Vukani project, formed in 1972 by the Swedish Reverend Kjell Lofröth and based in Eshowe (see Fig. 1.2), encouraged the production of homecraft in remote areas of KwaZulu-Natal. The aim of the project was to form co-operatives of weavers and basket makers, promote the work and maintain high standards. Duduzile Biyela, a public liaison officer who is in contact with many of the Hlabisa basket makers, commented on the important work that Vukani undertook, remarking that this project did much to help producers. Vukani assisted them to 'polish' their skills and final products and also taught them how to use a greater range of natural dyes.[25] Jones has similarly written:

> Of all the training efforts that has had the greatest impact on Zulu basketry and grasswork production was the Vukani, or 'Wake up and Go!', Association ... The Vukani Association of Eshowe spawned a new basket-making tradition based on the production of colourful and innovative works, which subsequently shifted to the Hlabisa region where it remains centred today.
>
> (Jones, 2001, p.104)

By the end of 1972 there were approximately one hundred individuals actively participating in making grasswork as well as sewing, beadwork and woodwork. Lofröth's vision for the project included emphasis on personal development and growth with problem-solving and organizational skill being a priority. The items produced by Vukani were primarily aimed at the export market. Importance was placed on innovation in terms of form and pattern and a high quality of production was emphasized.

Subsequent to Vukani, there have been a number of other outlets available to producers such as Ilala Weavers in Hluhluwe and the African Art Centre in Durban. However, basket makers interviewed in the Hlabisa region felt that, of all the projects, Vukani had been the most supportive. Even though the Revd Lofröth returned to Sweden in 1985 he left behind an important legacy. Vukani managed to consolidate the new form of basket production, one that was more decorative and colourful than the earlier forms and where shapes were less orientated towards usefulness and more towards aesthetic elegance. This helped weavers make a transition from the older styles to ones that were specifically designed for a western market.

The Current Context

Basket makers from the Hlabisa region have, on the whole, not earned a good return on their products. Hand coiling baskets is a very time-consuming activity. A particularly well-made basket consisting of approximately 85–100 coils, 35 cm circumference and 30 cm high with a lid, would take about 90 hours to make.[26] This is about two and a half weeks of full-time activity, a

calculation that does not include the collection, preparation and dyeing of the material. A basket maker, working part-time, would probably take about four to six weeks to make the same basket. A very finely made basket would today cost approximately R400.00 (about US $50.00) if purchased direct from the maker. This calculates to an hourly rate of R4.00 (or 50 US cents) per hour and does not include the cost of materials such as ilala palm, which the weaver must purchase. Prior to 1994 this would have been proportionally less.

'Zulu' baskets of an equivalent size, and not necessarily the same quality, sell over the web for anything between US $300 and US $400 or more to the overseas market.[27] This is a mark-up of around 600 to 800 per cent. The women interviewed in Hlabisa are aware of the high prices that their baskets command overseas and have expressed the desire to have greater control over the marketing of their products,[28] but they are frustrated in this endeavour. Hlabisa remains a relatively isolated rural area and none of the basket makers have their own transport. As Duduzile Kunene remarked, 'Improvement in their standard of living would depend where they lived – whether they were able to market their baskets successfully.'[29] Kunene also noted that women tend to be at a greater disadvantage than men in marshalling resources to improve their standard of living. Reuben Ndwandwe,[30] for example, was able to organize household resources and build a store in which to keep his own baskets, and those made by neighbours, to sell.

Duduzile Biyela confirmed that it is doubtful whether many women basket makers have benefited significantly from their craft and most of them have not done very well. She added:

> There is no protection for the makers. They sell their baskets at very low prices and these are resold overseas with huge mark-ups. There needs to be some balance here. There are also issues of quality – many baskets are not good quality and no one is helping the weavers to keep the standards up in the way that Vukani did.[31]

The circumscribed lives of Zulu women, especially young wives, were evident in the nineteenth century. As conditions changed during the twentieth century, with the decline of the self-reliant homestead, many of these women remained subject to the same restrictions. The daily life of women is also still dominated by the demands of an extremely time- and energy-consuming round of housekeeping, childcare and cultivation. In these difficult circumstances, informal money-generating activities such as basket making are attractive to women because of the flexible working hours and the ability to work at home.

A web search will reveal that most companies selling contemporary 'Zulu' baskets claim that these are part of some ancient tradition that has existed since time immemorial.[32] A well-known outlet, for example, maintains that it is 'a joy to see and feel the dignified elegance and beauty of a rich Zulu heritage that has become a collectable art-form, preserving an age-old tradition

proudly safeguarded and handed down through the generations'
(http://www.ilala.co.za/basket.html). However, if the Zulu kingdom of the
nineteenth century is our model for the 'traditional,' then baskets made in the
late twentieth century bear little resemblance to those from the past.

Baskets made in the past functioned as utility items in all rural homes.
Because of the shift in the target market, and the fact that baskets are now
objects for aesthetic display rather than for functional use, their general
appearance is different. Nineteenth-century baskets were fairly plain with
restrained self-weave patterns or limited coloured areas, created with fibres
dyed either black or red. Contemporary baskets made for sale to urban markets
are embellished with ever more virtuoso patterns in a widening range of
colours. Shapes have altered too. Whereas earlier baskets were generally broad
based and often bulb-shaped, baskets made in the late twentieth century are
frequently wide across the centre, tapering dramatically down to a small foot.
This shape causes the basket to be too unstable to be of any practical use. The
change in design occasioned comment as early as 1937, when Arthur Lismer
remarked that the type of instruction received under white guidance was
destroying the original simplicity of the objects. He observed, 'These naturally
formed objects, arising out of the simple use of materials, have been distorted
into pretty, useless objects that are completely subversive of character and
traditional taste. No greater tragedy could be depicted than this hopeless
misdirection of such good-intentioned teaching!' (quoted in Grossert, 1968,
p.143).

However, the most persuasive argument that can be posed against
considering late twentieth-century 'Zulu' baskets as still 'traditional' is that the
context and motivation determining their creation bears no resemblance to that
which existed in the nineteenth century. The political, social and economic
pressures imposed by colonialism, and later apartheid, disrupted a way of life
in KwaZulu-Natal that could be described as 'traditional'. Baskets made and
used in this context had, as far as can be ascertained, virtually died out by the
mid-twentieth century.

Metalworking, determined by cultural taboos as an exclusively male
domain in the past, had completely disappeared by the mid-twentieth century,
never to be revived. In contrast, coiled basket making experienced a revival in
late twentieth-century KwaZulu-Natal. Unfettered by gender restrictions,
women from impoverished rural areas of KwaZulu-Natal began making
baskets for the urban market as a way to support themselves and their families,
often in very difficult circumstances.[33] While the vast majority of basket
makers have been able to generate only sufficient funds to cover some of their
basic household expenses, there have been a few exceptions. Weavers such as
Beauty Batembile Ngxongo, Laurentia Dlamini and Sabina Mtetwa have
achieved individual recognition, are represented in art collections[34] and are
generally thought of as 'artists' rather than 'crafts workers'.[35]

Notes

1. The political status of the region that lies between the Pongola River in the north and the Tugela River in the south has undergone changes throughout the nineteenth and twentieth centuries. Equally, the region that is bounded by the Tugela River in the north and the Mtamvuna River in the south has changed. Each political alteration has been accompanied by a change in name. From 1840 the two regions were referred to as Zululand and the Colony of Natal respectively. From 1879, they were called Zululand and Natal and, from 1887, the Colony of Zululand and Natal. In 1910, the two regions were unified to become the Province of Natal with a number of 'native reserves' existing within its boundaries. During the 1970s the apartheid government consolidated its Bantu 'homeland' policy and eight scattered territories, situated within the province, became the KwaZulu Homeland. The term 'KwaZulu-Natal' which describes the whole region from the Pongola in the north to the Mtamvuna in the south is a post-1994 creation. Each change in name is, therefore, historically specific (see Figs 1.1, 1.2 and 1.3).
2. My thanks to Professor Frank Jolles (personal communication, February 2003) for drawing my attention to these images.
3. Earlier information on the area, written in English, does not appear to exist.
4. Roy Sieber, a scholar of African studies in America, published extensively on African art and craft.
5. *Izimbenge* are shallow, round, bowl-shaped baskets used to cover beer pots or to serve food. They symbolized respect and are given to the family of the future son-in-law.
6. Interviews with basket weavers, Hlabisa, February 2003.
7. Interview with traditional healer Freggie Jele and public liaison officers Duduzile Biyela and Duduzile Kunene from the Africa Centre for Population Studies and Reproductive Health, Matubatuba, February 2003.
8. There were no large chiefdoms in Zululand until the late eighteenth century. A political unit, or chiefdom, consisted of a number of clans, or elements of clans, under the leadership of the dominant lineage of the strongest clan. The boundaries of the chiefdoms, and the number of adherents owing an allegiance to a particular chief, were in constant flux.
9. When young women in southern African traditionalist societies marry, they move to the homes of their husbands and become outsiders in their marital contexts. They inhabit social margins as women, young brides and outsiders in patriarchal, age-governed and lineage-organized settings (Hamilton, 1998, p. 25).
10. See Herbert, 1993.
11. The ancestors, or shades, are believed to influence the realm of the living and were closely connected through cattle.
12. He lives and works at the Mariannhill Mission (see Fig. 1.2).
13. The 'shades' refer to the ancestors, lineage members who have passed on and now inhabit the spiritual realm. These are believed to have much influence in the lives of their living descendants.
14. It is believed that the female lineage shades are associated with menstrual blood, which is critical in the process of procreation (Berglund, 1989, p. 253).
15. This was the situation until the destruction of the Zulu kingdom in 1879.
16. Personal communication with archaeologist Ronette Engela, Johannesburg, 8 February 2003.

17. Individual baskets used by the king himself may have taken on importance due to the power of association rather than a characteristic inherent in the basket itself.

18. Writing in 1968 Grossert pointed out that by this time there was already an extreme scarcity of grasses in reserve areas such as those on the upper-middle Umzimkulu and Umkomaas Rivers (see Fig. 1.2 for the position of the latter) where he notes that vast stretches of land had become eroded and denuded of vegetation through over-stocking and poor agricultural methods (Grossert, 1968, p. 604).

19. Interview, Freggie Jele, Hlabisa, February 2003.

20. Interview with Duduzile Biyela, Africa Centre for Population Studies and Reproductive Health, Matubatuba, February 2003.

21. These were the regiments of young unmarried men and women from around the Zulu kingdom who gathered to serve the king during times of war and cattle raiding. Each young person was obliged to do this service and could only marry when released by the king.

22. Interview, Freggie Jele, Hlabisa, February 2003.

23. The power of the Zulu kingdom was only ever felt strongly in the area between the Pongola in the north and the Tugela River in the south. People living beyond the Tugela River were considered to be vassals and were never properly integrated as part of the kingdom.

24. Peder Gowenius and Grossert differed sharply in an argument over 'traditional' materials (personal communication, Philippa Hobbs, March 2003).

25. Interview, Duduzile Biyela, Africa Centre for Population Studies and Reproductive Health, Matubatuba, February 2003.

26. Calculation as per Professor Frank Jolles.

27. http://www.africart.com.ShopSite/zulubaskets.html and http://worlddesigns. freeserve.com/basket.html

28. Interview, Ncane Nxgongo, Hlabisa, February 2003.

29. Interview, Hlabisa, February 2003.

30. Reuben Ndwandwe was, for a number of years, the only man weaving baskets in the KwaZulu-Natal region. He lives in Hlabisa.

31. Interview, Hlabisa, February 2003. Conditions do not appear to have improved much since 1984 when social anthropologists Eleanor Preston-Whyte and Sibongele Nene researched rural poverty, women and the informal sector. They observed that, for some women, 'constraints may be set on economic success by a lack of experience and know-how engendered by the isolation of living in a "remote" rural area without even the intermittent contact with the outside world which migration brings to many men' and noted that 'many rural women are subject to a number of structural limitations inherent in the circumscribed nature of female role expectations and particularly those which affect the independence with which young wives and mothers living in an extended family household may act' (Preston-Whyte and Nene, 1984, p. 1).

32. www.africangoodies.com and http://www.ilala.co.za/basket.html

33. Laurentia Dlamini's father, for example, taught her to make coiled baskets when she was 9 years old. When her husband disappeared in 1990 she became the sole breadwinner for her family (interview, February 2003 and Jannie van Heerden, unpublished manuscript, 2003). Similarly, after Vina Ndwandwe was widowed, she began supporting her five young children through basket making alone (interview, February 2003).

34. Their work is represented in art galleries around South Africa. Nxgongo has work in the South African National Gallery, Cape Town and the University of the

Witwatersrand Art Gallery, Johannesburg. Dlamini's work is also in the University of the Witwatersrand Art Gallery and Mtetwa's work is represented in the Johannesburg Art Gallery.
35. I thank the MTN Foundation, Frank Jolles and Philippa Hobbs for their assistance with this essay.

References

Berglund, Axel-Ivar (1989), *Zulu Thought-Patterns and Symbolism*, London: Hurst.
Bryant, Alfred T. (1929), *Olden Times in Zululand and Natal*, London: Longmans and Green and Co.
Collett, David, P. (1985), 'The spread of early iron-producing communities in eastern and southern Africa', unpublished PhD thesis, Cambridge University.
Delegorgue, Adulphe (1990), *Travels in Southern Africa*, trans. F. Webb, vol. 1, Pietermaritzburg and Durban: University of Natal Press and Killie Campbell Africana Library.
Grossert, Jack W. (1968), *Art Education and Zulu Craft*, Pietermaritzburg: Shuter and Shooter.
——— (1978), *Zulu Craft*, Pietermaritzburg: Shuter and Shooter.
Hamilton, Carolyn A. (1985), 'Ideology, oral traditions and the struggle for power in the early Zulu Kingdom', unpublished MA thesis, University of the Witwatersrand.
——— (1998), 'Women and material markers of identity', in Dell, E. (ed.), *Evocations of the Child*, Cape Town and Johannesburg: Human & Rousseau and the Johannesburg Art Galley.
——— and Wright, John B. (1989) 'Traditions and transformations: the Phongolo-Mzimkhulu region in the late eighteenth and early nineteenth centuries', in Duminy, A. and Guest, B. (eds), *Natal and Zululand: From Earliest Times to 1910: A New History*, Pietermaritzburg: University of Natal Press and Shuter and Shooter.
Herbert, Eugenia (1993), *Iron, Gender and the Rituals of Transformation in African Societies*, Bloomington: Indiana University Press.
Hobbs, Philippa and Rankin, Elizabeth (2003), *Rorke's Drift: Empowering Prints*, Cape Town: Double Storey Books.
Isaacs, Nathaniel (1937), *Travels and Adventures in Eastern Africa*, ed. L. Heurman, Cape Town, Van Riebeeck Society for the Publication of South African Historical Documents, first publi. London: E. Churton, 1836.
Jones, Megan A. (2001), 'A discussion of the historical influences on the production, presentation and promotion of Zulu basketry and related "grasswork"', unpublished MA manuscript, Pietermaritzburg: University of Natal.
Kennedy, Carolee (1978), *The Art and Material Culture of the Zulu-speaking People*, Los Angeles: UCLA.
Klopper, Sandra (1992), 'The art of Zulu-speakers in Northern Natal-Zululand: an investigation of the history of beadwork, carving and dress from Shaka to Inkatha', unpublished PhD thesis, University of the Witwatersrand.
Krige, Eileen J. (1950), *The Social System of the Zulus*, Pietermaritzburg: Shuter and Shooter.
Morrell, Robert (ed.) (1996), *Political Economy and Identities in KwaZulu-Natal: Historical and Social Perspectives*, Durban: Indicator Press.
Oakes, Dougie (ed.) (1988), *Reader's Digest Illustrated History of South Africa*, Cape Town: Reader's Digest Association.

Preston-Whyte, Eleanor and Nene, Sibongele. (1984), 'Where the informal sector is not the answer: women and poverty in rural KwaZulu', in the Second Carnegie Inquiry into Poverty and Development in Southern Africa. Conference Papers, *Rural Development*, vol. 21, Paper 235, Cape Town: The Conference Organizers.

Sieber, Roy (1980), *African Furniture and Household Objects*, Bloomington: Indiana University Press.

Van Heerden, Jannie (2003), 'Zulu basketry', unpublished manuscript.

Webb, Colin de B. and Wright, John B. (eds) (1976–86), *The James Stuart Archives of Recorded Oral Evidence Relating to the History of the Zulu and Neighbouring Peoples [JSA]*, Pietermaritzburg and Durban: University of Natal Press and the KCAL, 4 vols, proceeding.

Wright, John B. (1990), 'The dynamics of power and conflict in the Thukela-Mzimkulu region in the late eighteenth and early nineteenth centuries: a critical reconstruction', unpublished PhD thesis, University of the Witwatersrand.

Breaking the Mould
Women Ceramists in KwaZulu-Natal

WILMA CRUISE

Rorke's Drift (see Figs 1.2 and 1.3), a small cluster of buildings on the banks of the Buffalo River in the rural heart of KwaZulu-Natal, is a site of historical significance. In 1879, the British supply garrison and hospital of 104 able-bodied men based at Rorke's Drift withstood a nightlong attack by 4000 Zulu warriors. Eleven Victoria Crosses were awarded to the surviving British soldiers – the largest number ever granted for a single battle. In the 1960s, the small settlement at Rorke's Drift would once more achieve significance, but this time through an initiative intended to empower the local community.

Missionaries, based in the area since the nineteenth century and prompted by a group of liberal-minded women artists in Sweden, established the Evangelical Lutheran Arts and Crafts Centre at Rorke's Drift. Hendrik Verwoerd's Bantu Education Act meant that an art education was not available to the black population of South Africa in the mid-1960s,[1] and so the school assumed a key role in educating black artists. A significant number of South Africa's most notable artists of the mid-twentieth century owe their training to this small enterprise.[2]

At the Craft Centre at Rorke's Drift black rural women – some of whom had worked within pot-making traditions but none of whom had received any formal education – were trained by white men and women educated in western fine art practices. Although the pots and sculptures that were produced were (and still are) marketed as being purely 'African', they were in fact the result of a synthesis of European and African traditions.

Parallel with developments at Rorke's Drift was the quieter revolution of traditional[3] ceramics by rural potters. The pots adhered far more closely to customary forms than those at Rorke's Drift, but they nevertheless also responded to changing circumstances, especially after the 1980s when the first intimations of liberation were felt. Prior to the 1980s, the traditional earthenware beer pot had been ignored as an object of aesthetic interest outside of the makers' own communities. Other than as an item of interest to the social anthropologist, these objects had no commercial currency beyond the local communities for which they had been made.

Complicating matters here were issues of gender as well as race. Black women were obliged to play out roles defined by their patriarchal societies,

while racial prejudices – encoded in apartheid laws – further ensured their lowly status. This meant that black women potters were bound for the most part by the strictures of a subsistence existence. However, as I will show, certain potters broke the mould and led the way for a revolution in their craft that resulted in new economic and social freedoms for themselves and their families.

Although it might be assumed that white women, who had access to skills and money, would have been free from the restricting prejudicial environments that affected black female potters, this was not in fact the case. The prevailing mode of studio practice, known as Anglo-Orientalism, exerted a considerable hegemony over ceramic production and the lives of women potters. A cult of masculinity had developed around the practice of studio ceramics that was to prevail until the mid-1980s and women ceramists were marginalized. However, like their black counterparts, certain white women broke free from these restraints. Aided and abetted by changes in the social climate after the mid-1980s as well as the impact of postmodernist ideas, female ceramists transgressed and defied aesthetic norms.

It was ultimately women – rural and urban, black and white, informally and formally educated – who would define key directions in ceramics in the area that is now KwaZulu-Natal. It was also women who would ensure the development of a vibrant ceramic art that, in many instances, fused western and African practices.

The Rorke's Drift Arts and Crafts Centre

In 1962, at the inception of the Evangelical Lutheran Arts and Crafts Centre, the missionaries listed a series of aims. These included, 'To expand the knowledge of spinning, weaving and other crafts', 'To preserve the old traditions in new materials' and 'To give a number of young women a chance to be independent' (Hobbs and Rankin, 2003, p. 24). The craft workshops would provide economic relief to the impoverished community, particularly to women whose husbands were absent migrant labourers. Weaving, printmaking and pottery were the primary focus of activity.

The pottery workshop was formally launched at Rorke's Drift in 1966. Initially Kirstin Olsson, an industrial designer with qualifications in ceramics, ran the workshop alone, but Peter Tyberg, a Danish potter, was appointed to the project in 1968 (Le Roux, 1998, p. 86). Like the Swedish couple, Peder and Ulla Gowenius, who were the first teachers at Rorke's Drift, Olsson had been trained at the Konstfacktskolan in Stockholm. Konstfack was modelled on Bauhaus principles, but with a distinct industrial emphasis (Hobbs, 2002, p. 6). This policy of integrating art and industry was driven by a functional formalist aesthetic and had a cohesive attitude to design, and the principles of the Konstfack were in turn transplanted via the teachers to the rural districts of Natal.

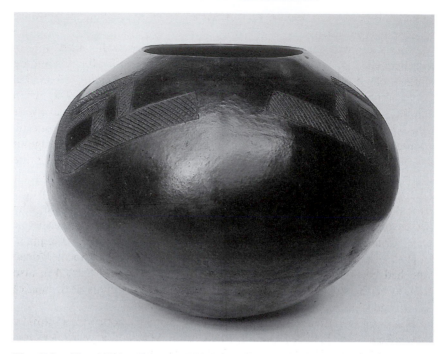

Fig. 7.1. Nesta Nala, *Beerpot (Ukhamba)*, 32 × 39 cm (12^1/$_2$ × 15^1/$_4$ inches), earthenware, *c*.1990, Private collection. Photograph by Doreen Hemp.

In Zulu and Sotho cultures it is the women who are the potters and create the beer pots used in social and ritual occasions. These pots are coiled into rounded shapes, burnished, decorated and fired in low-temperature pit fires. They are fired a second time in a low-temperature reduction[4] fire in order to carbonize and blacken the surface. The pots are then rubbed with animal fat to seal them and provide a low sheen on the burnished areas. Pot decoration is usually confined to the shoulder of the pot where low relief nodules called *amasumpa* (warts) are combined with abstract chevron patterns. A well-made and designed *ukhamba* (beer pot) is indeed a formally impressive object (Fig. 7.1).

Dinah Molefe, the first recruit to the ceramics studio of the Rorke's Drift centre,[5] was trained to produce *izikhamba* (beer pots).[6] However, the western mode of ceramic production at that time preferred high-fired reduced stoneware, which was at odds with the processes of making traditional earthenware beer pots.[7] Furthermore, as Hobbs (2002, p. 11) points out, Peder Gowenius was 'adamant that "traditional" [African] crafts … could not sell in Sweden as the Swedish market was already saturated by Mexican Crafts', and he maintained rather that an initiative which developed new skills would be

more likely to succeed. Hence, a priori, Molefe's skills at making earthenware pots were disregarded.

Efforts to produce a high-fired ware suitable for a Swedish market were in fact hampered by technical problems. Apart from the difficulty of sourcing suitable clay,[8] there was the problem of designing and building a kiln that could achieve the required temperatures,[9] and it was only in 1971, when Marietjie van der Merwe (1935–92) was teaching at Rorke's Drift, that a new kiln was successfully built.[10] Molefe was not invited to assist in finding solutions to these technical problems. While she must have had knowledge of clay sources and techniques of low firing, there is no evidence that the alternative methods practised by her were ever considered as options.

The initial stoneware pots at Rorke's Drift were dry unglazed objects covered by a slip that had 'sgraffito' patterns incised into them.[11] Van der Merwe, who had become informally involved with the pottery in 1968, developed a felspathic glaze for the dry slip-painted pots that gave them a low sheen and the required stoneware appearance. However, it seems that Van der Merwe, a South African who had been trained in Bauhaus functionalism (Calder, 1999, p. 46), also overlooked the low firing capabilities of the local women potters, their fund of knowledge and the pots that were being made in the region.

Men were identified for training as throwers when the pottery was formally established. They included Gordon Mbatha, in 1968, and a year later, Joel Sibisi and Ephraim Ziqubu (Calder, 1999, p. 41). Mbatha was also appointed foreman of the workshop. The women were not trained as throwers, and the division of labour at Rorke's Drift sanctioned a traditional gender divide. This seems to have been endorsed by the potters themselves: Dinah Molefe herself said that she had not wanted to work on the wheel, and referred to it as 'boys' work' (Molefe, 2002). It was presumably felt that men's use of the new technology of the wheel would mean that they would not impinge on an area of activity, the making of *izikhamba*, that was intended exclusively for women.

As a result of this separation of skills, the men and the women developed different styles of ceramics. The forms thrown by the men were simple formal pots that showed strong allegiance to the modernist aesthetics of their teachers (Fig. 7.2). Their narrative decorations, which were obtained by scratching through coloured slips, depicted local events both historical and contemporary. These images, 'appropriate' to the form of the pots, owed much to the men's training in the weaving and printmaking workshops, an opportunity that appears not to have been offered to the women potters.

In contrast, Dinah Molefe (Fig. 7.3) and the other women used the coil techniques of the traditional beer pot. However, they tended to add sculptured zoomorphic elements to the pots. Also, decoration was not restricted to the shoulder of the pots, as was customary, but the entire surface was instead embellished – and raised *amasumpa* cover the whole surface of some examples. Furthermore, although the pots showed some allegiance to the traditional beer

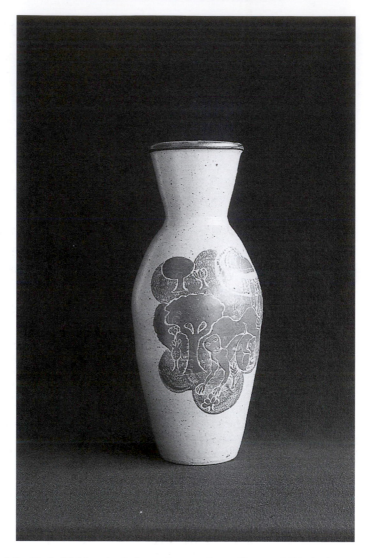

Fig. 7.2. Joel Sibisi, wheel formed pot, about 29 cm (11^1/$_2$ inches), reduced stoneware, *c*.1990. Photograph by Doreen Hemp.

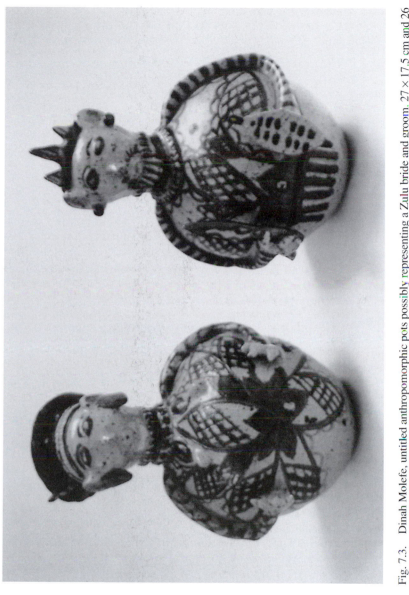

Fig. 7.3. Dinah Molefe, untitled anthropomorphic pots possibly representing a Zulu bride and groom, 27 × 17.5 cm and 26 × 17.5 cm (10½ × 7 inches and 10¼ × 7 inches), red,iced stoneware, 1982, Private collection. Photograph by Doreen Hemp.

pots in their rounded forms, they were smaller and heavier. The coil techniques that were ideally suited to low fire and the lively (living) surface of the flame seemed less suited to the stoneware clays, the high-fire techniques and the glazing that arose from a fundamentally different aesthetic. Ironically, however, it was the 'traditional' aspect of the women's pots that was lauded by contemporary commentators who identified an essential 'African' quality in them.

In 1974 Garth Clark claimed that the pots produced at Rorke's Drift were 'the only contemporary African pottery in the Republic [of South Africa]' (Clark and Wagner, 1974, p. 144). Yet, he felt that the pots made by women at the centre 'merely continue where their traditions left off'. He opined that the men were 'more adventurous', while the women did 'not stray far from the geometric patterns with which they were familiar' (pp. 147–8). A cursory comparison of the women's pots made at Rorke's Drift (see Fig. 7.3) with a traditional beer pot (see Fig. 7.1) makes plain just how little Clark saw beyond his basic assumptions. The women were not following the formal restraint that characterized the designs of their traditional ware, but had instead added more and more detail to small pots: stoneware qualities and sculptural additions mark the pots of women at Rorke's Drift as distinct from traditional beer pots.

Teachers at Rorke's Drift as well as commentators on the project ignored what should have been patently obvious – the existence of a tradition of indigenous pots. In the 1950s and 1960s in the Rorke's Drift area, potters like Molefe were making traditional beer pots (and indeed they continue to do so, as I witnessed in October 2002, when I visited a very old Molefe being assisted in this task by a member of her family). But it seems as if these pots were not considered suitable objects to market as aesthetic objects. Grossert (1958, pp. 123–4) exemplifies the dismissive attitude to these ceramics that would prevail until the 1980s. Zulu women, he remarks, 'have shown no initiative in practicing new forms or attempting new types of decoration, the conventional ones are being repeated over and over again'.

The only attention paid to *izinkamba* from outside traditional communities tended to be in ethnographic terms, and labels such as 'Zulu', 'Venda', 'Swazi' or 'Sotho' were used to identify them. The (female) creators of the pots generally remained unidentified. The first article on indigenous pottery that appeared in the national ceramics magazine in 1979 includes pictures of the Zulu potter who is not acknowledged by name (Jenkins, 1979, p. 14). In June 1981, when I reviewed an exhibition entitled 'African Odyssey', I noted the presence of pots by 'black African' potters in the exhibition, but I did not name these makers, presumably because they had not been identified by the exhibition organizers (Cruise, 1981, p. 9). As late as 1986, Ian Calder noted in his review of the only major ceramic collection in South Africa that the 'works of the many unknown Zulu potters of Natal … are not represented' (1986, p. 5).

The fact that apartheid relegated the material culture of black people to a lowly status would be one factor that explains the lack of attention directed at

the indigenous pottery of Zulu women. However, this does not account for the Swedish missionaries' blindness, since their aim was to undo damage created by the apartheid system. Nessa Leibhammer, in her study in this book, cites Hobbs and Rankin (2003, p. 19) who point out that 'the Goweniuses were quickly made aware of contention around the fostering of indigenous crafts' which critics saw 'not as an attempt to conserve indigenous cultures, but as part of the general aim of Bantu Education to prevent black people from acquiring knowledge of western culture and ideas'. While this would certainly have been important, an additional factor must be considered. The modernist aesthetic of the Konstfack fitted comfortably with the aesthetic of Anglo-Orientalism – that potent mix of Zen Buddhist, Arts and Crafts, and Bauhaus ideals that predominated in South Africa during the 1960s.[12] The chief exponent of this approach was the British potter Bernard Leach (1897–1979), who garnered a strong following in South Africa that was typified by potters such as Esias Bosch (b. 1923), Tim Morris (1941–90) and Andrew Walford (b. 1942). In accordance with the dictates of this approach, it was deemed necessary that work produced be high-fired reduction ware.

Reasons for Dinah Molefe's apparent willingness to abandon her role as a traditional potter can be found in the economics of the region. The Rorke's Drift area of Natal is dry and scrubby and the men of the region sought work as migrant labourers on the coalfields of Natal, about 100 kilometres north of the centre. It seemed preferable to Molefe to have permanent employment at the mission station than to attempt to eke out a living as an *izikhamba* maker. She was supported at Rorke's Drift by a group of women who also worked as potters – her daughter, Loviniah, as well as her relatives Lephinah Molefe, Ivy Molefe and Miriam Khumalo (Clark and Wagner, 1974, p. 148).

In the 1970s there was a political shift in Sweden, and the 1970 exhibition entitled 'Made in Africa' in Sweden was criticized on the basis of cultural imperialism. The church began to loosen its hold on the Arts and Crafts Centre at Rorke's Drift and, from 1976 onwards, first American and then South African teachers took over from the Swedes and Danes (Hobbs, 2002, p. 42). However, the Konstfack aesthetic had taken hold and a Rorke's Drift style emerged that would last to this day.[13]

The Pottery of Rural Zulu Women

Further north in the heart of Zululand, traditional potters were practising their craft beyond the reach of well-meaning teachers. Near Oyaya (see Fig. 1.2) in the Thukela valley, live Nesta Nala (born *c.*1945) and her mother, Siphiwe Nala (born *c.*1914). Siphiwe Nala had been trained by her paternal grandmother and had passed on the art to her daughter, Nesta Nala, who has been practising as a potter since the age of 12 (Garrett, 1998, p. 47). In 2002

the two elder Nala women were joined in their enterprise by three of Nesta Nala's daughters who had become significant potters in their own right.[14] It has been suggested that the matriarchal lineage of Nala potters can be likened to the famous Maria Martinez family, whose pottery based on traditional Pueblo Indian designs has received international acclaim.[15] However, this was not always the case. Although Nesta and Siphiwe had always been much respected in their local community as makers of *izikhamba*, their work was not known to the outside world prior to the mid-1970s.

In 1976 Reverend Lofröth in the town of Eshowe (see Fig. 1.2) aimed to promote Zulu craftwork under the auspices of the Vukani organization[16] and local talent scouts sought out Nesta Nala's pots (Garrett, 1998, p. 47). In 1983 Leonard van Schalkwyk, a local archaeologist who had heard about Nala through Vukani, commissioned her to copy some iron age designs which she then began to incorporate in patterns on her own pots. This initial interest from outside her community encouraged Nala to market her work and, in 1983 or 1984, she began making the long journey to Durban to sell her wares at the African Art Centre.[17]

In 1989, when Doreen Hemp and I were researching contemporary ceramics in South Africa, Jo Thorpe at the African Art Centre directed us to Oyaya in the far northern reaches of Zululand. We found Nesta and Siphiwe Nala living in a degree of rural poverty, and, at that stage, there was no hint of the matriarchal community of famous potters that was to develop. In fact I expressed an anxiety that the craft of the indigenous potter seemed to be dying (Cruise and Hemp, 1991, p. 124). All the traditional women potters that Hemp and I had interviewed, not only in KwaZulu-Natal but also in other provinces of South Africa, were over 50 years old: while most had learned their craft from their mothers, none of their daughters were practising potters. There was still a market for the beer pot in traditional communities but plastic containers were fast replacing other types of pottery. I suggested then that the only hope forward for what I perceived to be a dying art form was to redefine the market for traditional pots.

This in fact occurred, partly as a result of the promotion of Nesta Nala's work by sales at Vukani in Eshowe and the African Art Centre in Durban, and perhaps also after the publication of *Contemporary Ceramics in South Africa*, which, fairly radically, included a chapter on indigenous potters, who were identified by name rather than region. I intended to show traditional pottery as an important part of contemporary (art) ceramics in South Africa. As I noted, 'this does not suggest that context of the artwork … is irrelevant'. Rather, 'by briefly divorcing the work from its historical categorisation, one can see the vessel free from the biases of either the ethnographic or craft approach' (Cruise and Hemp, 1991, p. 123).

Nesta Nala's initial successes were followed in the 1990s by a number of accolades awarded to her at national ceramic exhibitions run by the Association of Potters of South Africa and the Craft Council, the first of which was her selection for the Cairo International Exhibition for Ceramics in 1994.

This was followed by the first of many premier prizes, namely the FNB Vita Craft Award that she received in 1995. Awards and concomitant financial successes (albeit initially regarded with suspicion) have led to the next generation enthusiastically embracing the art of pottery.

The fact that women are the potters in traditional society conforms to the general gendered division of labour and the cosmology of Zulu and Sotho cultures. Women and earth are associated with ancestor worship. The blackened pot, smeared with the dung of cows, is a mark of respect to the ancestors. Drinking vessels used socially and ritually are more likely to be blackened in honour of the *amadlozi* (ancestors), than the more utilitarian vessel used for brewing, for example (Reusch, 1998, p. 26).

Pots made for the curio market tend to be left unblackened, perhaps in response to market preferences, or are polished with black shoe polish (since respect for ancestors is clearly not an issue). Forms are also modified for the European market: an exaggeration of lips of a vessel is, for instance, common. Nesta Nala's pots do not follow this trend but instead conform closely to the traditional types and processes (see Fig. 7.1). A formal similarity with traditional prototypes is tautly realized in the balance and swelling proportions of the pot. Also, while their decoration might be slightly more elaborate than is customary, they remain firmly in the genre of the traditional pot in their maker's general exercise of restraint and their fineness of detail.

Market taste had clearly shifted in the years between the 1960s, when the Swedes arrived in Natal, and the 1990s, when Nesta Nala's work began to receive attention from art collectors. If the indigenous pot was rendered invisible in the 1960s, by the 1990s, when significant social and political changes had occurred in South Africa, the Nala pots were seen to be authentically African. The Nala daughters, like their mother, have remained largely true to the form and the spirit of the beer pot, but in one respect they differ from her. They have monumentalized the forms in terms of scale: the vessels have become virtuoso expressions of the craft and are a far cry from the utilitarian beer pot that is passed convivially from hand to hand. Decoration is also more adventurous. Zanele Nala, who was stimulated by seeing the work of the Venda potter Rebecca Matibe at the Durban Art Gallery in October 1993 (Addleson, 2003), now adds vigorous anthropomorphic animals to her vessels. About 1984, Nesta Nala began dating and signing her pots, indicating their newly emerging status as art collectors' items (Garrett, 1998, p. 48).

The University of Natal, Pietermaritzburg

The story of the Nala family's success is based on a tradition that has been passed down the generations from grandmother to mother to daughter. This system of mentoring finds an unlikely parallel at the University of Natal,

Pietermaritzburg, where it has led to the development and prominence of a number of women potters. Within the educational system of the university, a lineage can be traced from the inception of the school of ceramics under Hilda Ditchburn (1917–86), via Juliet Armstrong (b. 1950), to Fée Halsted-Berning (b. 1958) and ultimately to the development of the Ardmore Ceramic Studio.

It all started with a woman known as Hilda Lutando Ditchburn (née Rose)[18] who joined the Fine Arts Department at the University of Natal to teach ceramics in 1941 (Armstrong, 1999, p. 3). Ditchburn built the first oil-fired stoneware kiln in South Africa, which was first fired successfully in December 1954 (Armstrong, 1999, p. 5). This point is significant because the Anglo-Oriental/Leach approach places great emphasis on the firing process and therefore the access to this technology was important as a signifier of success. Received wisdom had it that the father of studio ceramics in South Africa was the potter Esias Bosch (b. 1923) – a viewpoint reinforced by Hym Rabinowitz (quoted in Bosch and De Waal, 1988, p. 9): 'Sias [Bosch] well and truly laid the foundation for craft pottery in this country, giving it its original momentum setting the stage for its coming of age, educating the public and paving the way for many to follow.' However, Bosch only built his fuel-burning kiln in 1960–61 (Bosch and De Waal, 1988, p. 34).

Why and how Bosch became to be perceived as 'the master' of the craft had much to do with the practice of studio pottery that, in terms of the dominant aesthetic of Anglo-Orientalism, tended to revolve around romanticized personalities. Bosch was a vigorous South African proponent of Anglo-Orientalism.[19] Anglo-Orientalism expressed a preference for simple life, natural materials and utilitarian pots made through the honest labour of the potter – qualities that were demonstrated by Bosch's life in rural Eastern Transvaal where he established himself in 1961.[20] There was in fact tyranny in this approach. It was assumed that the 'masters' of the craft were exclusively men. Women who were working from homes in urban areas and who did not dig their own clay or fire their own kilns with natural-burning fuels were scorned. They were variously labelled garage potters, in South Africa, and kitchen potters in the United Kingdom (Janet Leach quoted in Vincentelli, 2000, p. 233). Although Vincentelli (2000, p. 246) noted that, in England in the mid-century, the studio pottery movement offered 'some opportunities for women who were brave enough to take up the challenge', this was less the case in South Africa. As late as 1982, on the occasion of the tenth-anniversary National Ceramics exhibition run by the Association of Potters of South Africa, the list of invited potters – the luminaries of studio pottery – were all proponents of the Anglo-Oriental school and all were men.[21]

Women potters, such as Ditchburn, were sidelined. Ironically Ditchburn was an admirer of Leach and Michael Cardew, and she had imbibed many of the dictates of Anglo-Orientalism. Ditchburn met Leach in 1950 during a trip to the UK and asked his advice on building a kiln. He responded by providing

her with a letter of his from B. and S. Massey dated 7 November 1930 which included information on an oil burner for a kiln (Armstrong, 1999, p. 4). Ditchburn was fascinated by Leach's post-war approach to ceramics and, while she rejected his oriental calligraphy, preferring instead the Anglo part of his aesthetic, she nevertheless absorbed many of his tenets. Paramount was a truth to material dictum, which in stoneware translated into subtle colours, restrained decoration and appropriateness to the form of the pot. She collected Leach's 'standard ware' and used these constantly in her teaching (Armstrong, 1999, p. 4).

At the University of Natal in the 1950s, ceramics was regarded as a 'craft' and a minor adjunct to sculpture and painting. However, Ditchburn regarded herself as pioneer at a time when there was no awareness of stoneware in South Africa (Armstrong, 1999, p. 5). In 1951 she introduced the study of glaze chemistry and clay analysis into the ceramics course at the university.[22] As I have indicated, she achieved the first successful stoneware firing of the oil-fuelled kiln in December 1954. However, because the kiln was relatively large, it was fired only once or twice a year,[23] and Hilda Ditchburn chose instead to practise *oxidized* stoneware, which could be fired in an electric kiln.

During the 1970s, when the Anglo-Oriental orientation to fire and earth was paramount, the manipulation of flame to achieve the necessary reducing atmosphere in the kiln was one of the activities that fuelled the romantic myth of the male potter – he who laboured intensively and long to feed the hungry flames of his kiln![24] Oxidizing fires did not require this type of physical labour. In addition, Ditchburn challenged the received wisdom about the superiority of reduction firing. She commented:

> You see, with reduction firing, your firing is doing things for you, you only have to dip a pot into one glaze, and put it into a reduction kiln, whereas with electric firing you really have to be much more skilled in the actual glazing process and you have to know much more about glazes … This thing about reduction firing is terribly over-emphasized.
>
> (quoted in De Haast, 1981, p. 9)

Other than at the university and amongst a small circle of colleagues and supporters, Ditchburn's work was not known and, perhaps for this reason, she did not make a large impact on the practice of studio ceramics. However, Ditchburn was a noteworthy teacher and, in spite of her fairly conservative and stubbornly held views about the value of thrown functional ware, she was able to encourage the development of talents in new directions.

Her most notable pupil was Juliet Armstrong, who became a lecturer in 1977 and was appointed Associate Professor of Ceramics in 1998. In 1976 and 1977 Armstrong was doing the studio component for her Master of Fine Arts degree and, as a result of a series of mishaps and fallouts with her male supervisor, Ditchburn became Armstrong's de facto mentor. A close friendship developed between the two women that transcended the conventional

Fig. 7.4. Juliet Armstrong, *Whites*, 14 × 13 cm (5^1/$_2$ × 5 inches), bone china and bone, 1993, Collection of the artist.

teacher–student relationship. They shared their time collecting ceramics and silver and, on her death, Ditchburn bequeathed her considerable collection, including pots by Bernard Leach and Shoji Hamada, to Armstrong. After Ditchburn retired in 1981, Juliet Armstrong moved into her office at the ceramic department at the university. This small room is redolent of the combined histories of both women. Amongst the dust and patina of years is Ditchburn's collection of notebooks, letters, textbooks and pots, but it is overlaid with the accumulation of Armstrong's interests.

The most important bequest Ditchburn seems to have made to Armstrong is a work practice that has much of the old studio pottery values of good craftsmanship, disciplined ceramic practice and glaze chemistry. Somewhat surprisingly, given her personal tendency to conservatism, Ditchburn encouraged an iconoclastic approach in Armstrong (Armstrong, 2002). For her Master of Fine Arts degree, Armstrong chose to work figuratively. Her sculptural and large-scale works incorporated body casts taken from plaster of Paris moulds, and she was able to do this despite Ditchburn's preference for functional

pots and aversion to the use of plaster in the context of a ceramic studio.[25]

Armstrong is knowledgeable about clays and glazes and, through extensive research into ceramic material, has become the foremost sculptor in bone china in South Africa. Yet her work is not driven solely by material and technique but is imbued with pertinent social references. For example, her 'Whites' series that was made in the 1980s and 1990s alludes to the turbulent political landscape of those years (Fig. 7.4). In this series, delicate cone shapes, made from translucent bone china, have raised thorns on their surfaces. While the objects attract, they also repel. Fragile and prickly, they provide an apt metaphor for white experience in apartheid South Africa.

Hilda Ditchburn's encouragement of a non-functional approach in Juliet Armstrong finds an echo in Armstrong's mentorship of another prominent ceramist in KwaZulu-Natal – Fée Halsted-Berning, the developer of the Ardmore Ceramic Studio. As was the case with Armstrong, Halsted-Berning's initial degree was not in ceramics: she majored in painting, with ceramics as only a minor subject. Halsted-Berning (2002) remembers the ceramics department in the mid-1970s as being quite 'pot-orientated' because of 'Hilda's influence'. However, when she chose to do a two-year postgraduate study in ceramics after completing her undergraduate degree in 1979, Juliet Armstrong (who doubtless remembered the backing she received from Ditchburn) supported Halsted-Berning's break with 'pots'. Halsted-Berning chose a painterly approach to her ceramics, concentrating on the surface qualities of the material. When she expressed a wish to re-create the vibrancy of paint, Armstrong encouraged her to look for alternatives to the conventional choice of metal oxides, which tended to give muted colours and then only under a glaze. (Ditchburn had eschewed everything but the use of the natural raw oxides for colour effects.) Halsted-Berning's search for alternatives included the use of commercial on-glaze enamels and, indeed, she added actual paint to the ceramic surface in her works made in 1981 – perhaps the ultimate transgression of the 'truth to material' idea that had underpinned Ditchburn's training.

In spite of Armstrong's support, Halsted-Berning claims she was finally released from the autocracy, albeit a dying one, of the English studio tradition by the arrival of David Middlebrook at the university. Middlebrook came from America. Large, ebullient and iconoclastic, he broke the tyranny of the mud and water practitioners not only on the campus but also in the wider sphere of studio practice in South Africa. In this he was not alone: teachers such as Juliet Armstrong in Natal and Suzette Munnik in the Transvaal were encouraging a more inventive approach. New possibilities for ceramics would be tapped in an exhibition held at the South African National Gallery in Cape Town and again at the Johannesburg Art Gallery between April and July in 1985. Entitled 'Recent S.A. Ceramics', it showcased the *non* Anglo-Oriental pot, now referred to as the 'contemporary vessel', as well as sculpture.

After graduating, Halsted-Berning gained experience as a 'locum' running a pottery for David Walters at nearby Caversham Mill and, from mid-1984, she lectured at the Durban Technikon. In 1985 she was appointed a permanent lecturer at this institution, but, before the post could be ratified, she was retrenched along with all the other female members of staff (Halsted-Berning, 2002). During the same year, the newly married Halsted-Berning moved with her farmer husband to the Champagne Valley near Winterton (see Fig. 1.2), about three hours drive inland from Durban and far from any urban centre. Stranded with little outlet for her creativity and no employment, she set out to prove her worth. She asked Janet Ntshalintshali, who worked on the farm, to find her an assistant, and Janet offered the services of her daughter, Bonnie Ntshalintshali (1967–99), who was disabled by childhood polio and therefore unable to work well in the fields. Halsted-Berning set up a studio in an unused thatch hut. She bought a commercial plaster mould of a small duck and, along with Ntshalintshali, started a production line of little decorative objects that were painted in bright patterns with commercial non-ceramic paint. From this unlikely beginning, the Ardmore Ceramic Studio was launched, and Ntshalintshali became one of South Africa's most celebrated ceramists (see Plate 3).

Ardmore Ceramic Studio

The University of Natal had promoted an experimentalism in Halsted-Berning that was to provide the impetus for the colourful functional ware and ceramic sculpture of Ardmore Studio. As the business of Ardmore grew, Ntshalintshali was joined by a number of other Zulu and Sotho women from local communities. All were impoverished and had received little or no education, but the opportunities for employment provided by Ardmore and the unique system of payment at the studio[26] completely altered their circumstances. After 1995 the studio would also provide work to an increasing number of men.

Ardmore ceramics have garnered considerable fame locally and internationally. In 1990 Halsted-Berning and Ntshalintshali jointly won one of South Africa's most prestigious art awards, the Standard Bank Young Artist Award for Fine Art.[27] Ntshalintshali also received many accolades individually, the most significant of which was her selection for the Venice Biennale Aperto in 1993, where she became the first South African to be chosen in 25 years, and the first ceramist. In 2003, four years after Ntshalintshali's death, an exhibition of Ardmore ceramics was held at Christie's in London.

Like Rorke's Drift pottery made two decades previously, Ardmore ceramics are defined by a distinctive style. Energetic, colourful and highly decorated, the studio's functional ware is typified by sculptural additions. Zebras, leopards and hoopoe birds masquerade as spouts, handles or lids, while giraffes wrap themselves around tall vases. The ware is covered with detailed

patterning that owes its inspiration to African animal pelts as well as the floral forms on Sèvres porcelain.

In spite of the eclectic and wide range of visual sources, Ardmore ceramics, like the ware from Rorke's Drift from previous decades, are marketed as 'African'. Yet there was no practice of traditional pottery in the district of Winterton, where Ardmore is located,[28] and the only expressions in clay in local communities are the little oxen fashioned from unfired clay by pre-adolescent males. Other than Josephine Ghesa, a maverick sculptor at Ardmore,[29] none of the Ardmore artists had previous ceramic experience before they arrived at the studio. Furthermore, as Scott (1998, p. 15) points out, the artists had 'no knowledge of Western or African visual history'. The ware at Ardmore arises less from an African aesthetic than from African narratives, and one could indeed venture that the 'African' quality so prized by collectors of Ardmore has more to do with oral than visual traditions.

Also crucial are Halsted-Berning's ideas and, as Mentis (1998, p. 94) has observed, her 'participation is central to the continuing development and support of the studio infrastructure'. Halsted-Berning's nonconformist approach to ceramics is important, as is her interest in patterning, surface and colour and, as Mentis (1998, p. 93) notes, 'her vision and aesthetic predilections continue to shape the nature and the content of the studio's work'. Halsted-Berning places magazines, art books and myriad visual sources in front of the artists and, as she acknowledges (Halsted-Berning, 2002), the artists realize her painterly two-dimensional sources in three-dimensional form. However, it needs to be emphasized that the artists are not simply passive recipients of her inspirations. Instead, as in the case of Bonnie Ntshalintshali, a narrative tendency and an inclination for detail has merged with Halsted-Berning's creative impulses. This type of collaboration is in fact what defines much Ardmore work. Artists frequently collaborate on the same piece and the resultant works are co-signed.[30]

Halsted-Berning and Ntshalintshali's mutual collaborations were especially close in the early years of Ardmore and on some occasions the two women would work on a single piece together. Angels made by Ntshalintshali are incorporated into Halsted-Berning's relief panel *Adam and Eve* (1987), for example, and Ntshalintshali's candlesticks of the same year were designed by Halsted-Berning. The two women also influenced each other's choice of subject matter. Inspired by the birth of her son, Jonathan, Halsted-Berning worked on Madonna and Child themes, and Ntshalintshali picked up and continued to pursue biblical topics in works such as *Noah's Ark* (1988),[31] *Adam and Eve* (1990), *The Plague* (1990) and *The Last Supper* (1990; see Plate 3). In many of these renditions of Old and New Testament stories, references are made to both Zulu and western customs. For example, the composition of *The Last Supper* echoes

Leonardo da Vinci's well-known painting of the same theme, but while Christ is depicted as white, some of the disciples are black. Also, while Ntshalintshali represents 'western' foods such as Coca-Cola and beer, traditional Zulu foods such as a goat's head and sour porridge are also included on the depicted table (Mentis, 1997, p. 51).

From the mid-1980s, women were able to break the mould into which they had been cast. Nesta Nala seized small opportunities provided by Reverend Lofröth at Vukani and turned them into larger ones. Juliet Armstrong, with the support of Hilda Ditchburn, cracked the mould, which was then broken wide open by Fée Halsted-Berning, who in turn imparted her skills to rural women in the Winterton district, including Bonnie Ntshalintshali. All these women worked within the traditions in which they found themselves but, by pushing at the edges of received wisdom, they successfully redefined ceramic practice in Natal in the latter half of the twentieth century. It is a heritage that continues to this day.[32]

Notes

1. Art training at 'white' colleges and universities was closed to black students until 1979 (Sack, 1989, p. 16) but available at the 'black' University of Fort Hare from 1971.
2. Graduates who became household names were primarily printmakers – Azaria Mbatha, John Mufangejo, Cyprian Shilakoe, Vuminkosi Zulu and, later, Bongi Dhlomo. The school was closed in 1984 but the craft centre continues to this day, albeit in an attenuated form.
3. I use the word 'traditional' in this essay to refer to a practice that is passed down from one generation to the next, but I do not wish to imply that the forms, or the meaning of the forms, are static or unchanging.
4. Reduction is a process in which oxygen is taken away from metal oxides. In reduction the potter controls (reduces) the flow of oxygen in a fuel-burning kiln during firing or cooling in order to alter the colour of metal oxides in the clay or glaze. In a low temperature fire, reducing the flow of oxygen results in the deposit of carbon on the burnished surfaces of pots.
5. Dinah says she was born in the year of the Bambatho rebellion, which is 1906. Her birth date has been elsewhere given as 1918 or 1927 (Sack, 1989, p. 116). She retired from the craft centre in 1984 but still makes pottery for the community from home (Molefe, 2002).
6. The *ukhamba* denotes a drinking vessel of a certain size. The plural form, *izikhamba*, should not be confused with *izinkamba*, which is a generic term for all earthenware vessels (Reusch, 1998, p. 19).
7. Michael Cardew in Abuja, Nigeria, also encouraged local Nigerian potters to fire their earthenware to stoneware temperatures (Vincentelli, 2000, p. 65).
8. Initially the clay was sourced locally but it proved not to be very plastic (Gordon Mbatha quoted in Le Roux, 1998, p. 87). In addition, when fired the clay was 'very rough'.
9. Reduced stoneware pottery requires an organic-fuel-fired kiln that can reach temperatures of 1350 degrees centigrade.
10. The 4247 m³ (150 cubic foot) kiln was completed in March 1973. It fired on paraffin through six drip-feed burners (Clark and Wagner, 1974, p. 144).

11. For these reasons, ceramics were not as successful as the woven objects and prints from Rorke's Drift. In 1966 Lord Holford commissioned a Rorke's Drift tapestry for the council chamber of the Royal Scientific Society in London and the Museum of Modern Art in New York exhibited two lino prints by Azaria Mbatha.

12. I do not intend to conflate Swedish functionalism with Anglo-Orientalism, but rather to acknowledge that they share certain key qualities. These include formal austerity, truth to materials and a preference for high-fired ware.

13. In 2002 the centre was struggling. Suffering from a lack of funds, it desperately needed new direction. But the community was loath to accept outside control. A substantial financial offer of assistance from Germany was turned down because it came with the condition of the appointment of a German manager (Calder, 2002).

14. The three daughters are Jabu, Thembi and Zanele. Two other daughters, Nonhlanhla and Bongi Nala, are also potters (Greenberg, 2002).

15. Maria Martinez worked with her husband, sons, daughters, daughter-in-law and granddaughter. Encouraged by 'Anglo' intervention, they revived and modified a traditional craft (Vincentelli, 2000, p. 67).

16. See Nessa Leibhammer's Chapter 6 in this volume for further information on the Vukani project.

17. These pots were small 'curio' items that did not relate to the conventional Zulu beer pots, not even the smallest sized ones known as *omancishane* (Armstrong, 2002).

18. Ditchburn signed her work HLR, Hilda Lutando Rose. Lutando is a Xhosa name given to her by her father who was a missionary in the Eastern Cape district. He believed all children needed an African name (Armstrong, 2002).

19. In 1952, Bosch had worked at Wenford Bridge with Michael Cardew, Leach's most famous pupil. Bosch had also met Bernard Leach, regarded as the founder of the Anglo-Oriental school of ceramics (Bosch and De Waal, 1988, p. 19).

20. Although the ideals of frugality and humility tended to run counter to avant-garde trends in art, Anglo-Orientalism, visually and formally, had much in common with the practice of modernism.

21. They were Esias Bosch, Bryan Haden (who had been taught by Ditchburn), Tim Morris, Andrew Walford and Maarten Zaalberg.

22. In 1948 Ditchburn travelled to England on special leave to study at the Central School of Art under the renowned Dora Billington. There she was introduced to the technology of high-fired stoneware.

23. In 1977 the oil-fired kiln was declared unsafe and it was later dismantled (Armstrong, 1999, p. 6).

24. By the 1970s a personality cult had developed around the forceful character of Andrew Walford, the Natal exponent of the school of mud and fire practitioners. According to Armstrong (2002) Ditchburn thought that Walford's work 'was interesting ... [but] she felt it was not "authentic" but an Oriental copy'.

25. Armstrong was probably prompted by the fact that her degree was to be awarded in fine art rather than ceramics. Nevertheless, working figuratively and on a large scale was unusual for her, since both before and subsequent to her MFA studies, her work was small, fine and conceptual. In addition, her training just prior to commencing her MFA degree was in *industrial* ceramics and glass blowing at Leicester Polytechnic in England. As Armstrong (2002) noted, Hilda Ditchburn 'hated' industrial techniques.

26. 'Artists are paid a percentage for their work. They are given bonuses for work that is exceptionally well executed ... Ghesa, whose work sells only at irregular intervals, is paid a retainer in order that she can have a monthly income' (Mentis, 1997, p. 30).

27. In 1990 Bonnie Ntshalintshali was also a guest at the university ceramics department where she worked with the guidance of Juliet Armstrong. Armstrong said that she invited Ntshalintshali because 'she wanted to gather people who were good for the university'. Armstrong expanded Ntshalintshali's frame of reference by introducing her to stoneware and slip trailing techniques (Armstrong, 2002).

28. In 1996 the Berning family moved to the farm Springvale, near Rosetta (see Fig. 1.2) and started a second studio there. The one at Winterton was left in control of a manager, Moses Nqubuka.

29. Ghesa was taught pottery by her grandmother in Lesotho (Ghesa, 2003).

30. However, this does not always happen. In an odd inversion of normal practice this collaborative aspect is downplayed in the work of Josephine Ghesa, renowned as a sculptor of strong sculptural figures and one of Ardmore's most sought after artists. Ghesa eschews the decorative imperatives of Ardmore preferring instead to model zoomorphic figures that are intertwined in complex relationships. As with many of the other artists at Ardmore, she only does the initial modelling and leaves the firing, painting, colouring and patination to Moses Nqubuka or Halsted-Berning. Yet, their hand in Ghesa's work is not acknowledged and her works in fact remain unsigned. When questioned about this, Nqubuka (2003) said that since Ghesa's work was instantly recognizable it did not require a signature. This, however, does not explain why his or Halsted-Berning's hand in the work is not acknowledged. Nqubuka's interest in Ghesa's work actually reaches beyond mere colouration. When I visited the studio in January 2003 we discussed the possibility of adding one of Ghesa's small sculptures, a lion with a chameleon, to the back of a larger one of a horse. He wanted to do this in order to activate the simpler form of the larger sculpture. It should be noted that this 'interference' is entirely in keeping with the collective approach to Ardmore ceramics.

31. In 1989 *Noah's Ark* won joint first prize at the National Ceramic competition, which was held in Durban that year. The Corobrik Collection housed at the Pretoria Art Museum, Pretoria, now owns the work.

32. I would like to thank Doreen Hemp for her photography and creative eye, Fée Halsted-Berning for her time and for sponsoring the colour image of Bonnie Ntshalintshali's *The Last Supper*, Juliet Armstrong for the hours that we poured over Hilda Ditchburn's papers, and John Cruise who as a life and travel companion is indispensable.

References

Addleson, Jill (2003), correspondence with Juliet Armstrong, January.
Armstrong, Juliet (1999), 'Hilda Lutando Ditchburn', paper presented at the 15th Annual Conference of the South African Association of Art Historians, University of Natal, Pietermaritzburg, 24–26 September, pp. 3–6.
——— (2002), unpublished interview conducted by the author at the University of Natal, Pietermaritzburg in November.
Bosch, Andree and de Waal, Johann (1988), *Esias Bosch*, Cape Town: Struik Winchester.
Calder, Ian (1986), 'The Corobrik collection', *Sgraffiti*, (45), June, 4–5.
——— (1999), 'The inception of the Rorke's Drift pottery workshop: tradition and innovation', paper presented at the 15th Annual Conference of the South African

Association of Art Historians, University of Natal, Pietermaritzburg, 24–26 September, pp. 39–50.

———— (2002), unpublished interview conducted by the author at the University of Natal, Pietermaritzburg, November.

Clark, Garth and Wagner, Lynn (1974), *Potters of Southern Africa*, Cape Town and Johannesburg: C. Struik.

Cruise, Wilma (1981), 'S. Transvaal regional exhibition', *Sgraffiti*, (25), June, 9.

———— and Hemp, Doreen (1991), *Contemporary Ceramics in South Africa*, Cape Town: Struik Winchester.

De Haast, Ingrid (1981), 'Prof. Hilda Ditchburn', *Sgraffiti*, (26), September, 9.

Garrett, Ian (1998), 'Nesta Nala: an overview', in Bell, Brendan and Calder, Ian (eds), *Ubumba: Aspects of Indigenous Ceramics in KwaZulu-Natal*. Catalogue for an exhibition shown at the Tatham Art Gallery, 24 March–26 April and Durban Art Gallery, 6 May–26 June, pp. 47–9.

Ghesa, Josephine (2003), unpublished interview conducted by the author at Kwa-Vala, January.

Greenberg, Susan (2002), personal correspondence with the author, November.

Grossert, J.W. (ed.) (1958), *The Art of Africa*, Pietermaritzburg: Schuter and Shooter.

Halsted-Berning, Fée (2002), unpublished interview conducted by the author at Springvale Farm near Rosetta, July and December.

Hobbs, Phillipa (2002), unpublished, from Peder Gowenius's report, 'Report of the Principal of the Art School', Umpumulo Art School, 18/4/63.

———— and Rankin, Elizabeth (2003), *Rorke's Drift: Empowering Prints*, Cape Town: Double Storey Books.

Jenkins, Marilyn (1979), 'Pottery in Zululand', *Sgraffiti* (19), 14.

Le Roux, Penny (1998), 'Rorke's Drift pottery', in Bell, Brendan and Calder, Ian (eds), *Ubumba: Aspects of Indigenous Ceramics in KwaZulu-Natal*. Catalogue for an exhibition shown at the Tatham Art Gallery, 24 March–26 April and Durban Art Gallery, 6 May–26 June, pp. 85–91.

Mentis, Glenda (1997), 'A critical survey of Ardmore Ceramics: 1985–96', unpublished MAFA dissertation, University of Natal, Pietermaritzburg.

———— (1998), 'Bonnie Ntshalintshali at Ardmore Studio: the first decade', in Bell, Brendan and Calder, Ian (eds), *Ubumba: Aspects of Indigenous Ceramics in KwaZulu-Natal*. Catalogue for an exhibition shown at the Tatham Art Gallery, 24 March–26 April and Durban Art Gallery, 6 May–26 June, pp. 93–100.

Molefe, Dinah (2002), unpublished interview conducted by the author at Rorke's Drift, 30 October.

Nqubuka, Moses (2003), unpublished interview conducted by the author at Ardmore Ceramic Studio, Winterton, 30 October.

Reusch, Dieter (1998), 'Imbiza kayibil' Ingenambheki: the social life of pots', in Bell, Brendan and Calder, Ian (eds), *Ubumba: Aspects of Indigenous Ceramics in KwaZulu-Natal*. Catalogue for an exhibition shown at the Tatham Art Gallery, 24 March–26 April and Durban Art Gallery, 6 May–26 June, pp. 19–39.

Sack, Steven (1989), *The Neglected Tradition: Towards a New History of South African Art (1930–1988)*. Catalogue for an exhibition shown at the Johannesburg Art Gallery, 23 November 1988–8 January 1989.

Scott, Gillian (1998), *Ardmore: An African Discovery*, Vlaeberg: Fernwood Press.

Vincentelli, Moira (2000), *Women and Ceramics: Gendered Vessels*, Manchester: Manchester University Press and New York: St. Martin's Press.

On Pins and Needles

Gender Politics and Embroidery Projects Before the First Democratic Election

BRENDA SCHMAHMANN

A chance encounter between Jane Arthur, a medical doctor working at a hospital in Tzaneen, and Daina Mabunda, a Tsonga-Shangana[1] woman living in the small settlement of Radoo in the area of Xihoko, would have a significant impact on South African women's art. When Arthur encountered her, Mabunda was wearing a type of garment frequently seen on Tsonga women from the former 'homeland' of Gazankulu (see Fig 1.2).[2] The *nceka* is a rectangular-shaped cloth that is tied on one shoulder and slung, sarong-style, over the opposite hip: two of these cloths are worn at once, one across each shoulder. On this occasion, Mabunda happened to be wearing *minceka* (plural for *nceka*) that she had embellished with embroidery,[3] and Arthur recognized that they might provide a prototype for marketable embroideries. She commissioned Mabunda to produce first one embroidery, and then another, and the eventual outcome was the formation of the Xihoko project, officially called 'The Rural Development Project', in 1982.

Xihoko included only about 25 women at its most productive stages (Blecher, 2001) and would be operational for little more than a decade. It was, however, the first of a number of embroidery projects that were established as ways for women to negotiate the effects of impoverishment and disadvantage in apartheid South Africa, as I will reveal in this essay, and it would exert an important influence on subsequent initiatives.

Xihoko

Mabunda, like other women in her community, spoke no English – and Arthur spoke no Tsonga. Communication with women in Xihoko was via Daina Mabunda's husband, Reckson, a *n'anga* (diviner) in the village who was employed as manager for the project. Also involved were Jane Arthur's husband, David, and Aubrey Blecher, a mathematics lecturer then employed at the University of South Africa in Pretoria,[4] who handled fundraising, dealt with donors and assisted with the mounting of exhibitions. Funding was

obtained to build a workshop in Xihoko. Also, the project was expanded to direct itself at art forms besides embroidery, and included an initiative to provide the means for men in the community to sell carved spoons and an endeavour to market baskets by local women (Blecher, 2001).

The needleworkers in the Xihoko project made bedcovers, tablecloths and pillowcases that were embellished with embroidered animals, such as peacocks (Fig. 8.1), birds and fish, as well as geometric forms and in many instances wording. A use of templates allowed motifs to be refined before being traced onto cloths while also enabling them to be re-used if they proved popular with buyers.

Bronwen Findlay, a Durban-based artist who met Daina Mabunda in 1992, indicates that these motifs have complex origins. While many were probably derived from design elements on printed cloths that were sold to Tsonga women for use as *minceka* by Indian dealers, they seem also to have their genesis in designs on fabrics used for other purposes as well as printed images on labels and household goods. Findlay (1995, p. 55) observes that an exotic creature such as the peacock is associated with *minceka*: Arvind Gokal, a dealer, indicated to her that he had once sold printed *minceka* with peacock designs, and Aubrey Blecher 'remembers seeing a label depicting a peacock attached to *minceka* sold in a shop'. The motif is, however, also used extensively in what Findlay (1995, p. 55) terms 'Indian iconography', appearing 'on many goods such as trays, mats, plastic tablecloths, headscarves, among others'.

It needs to be borne in mind that women did not themselves necessarily select the motifs they embroidered. Findlay (1995, p. 95) notes, for instance, that potential imagery was 'collected by the Arthurs in different regions around Gazankulu, Venda and the Diagonal/Market Street shopping area of Johannesburg where they have bought cloths from Tsonga-Shangana people'. There were nevertheless opportunities for women in the project to contribute to the development of designs. Daina Mabunda (2001) observed that she was sometimes uncertain what Jane Arthur had in mind for an image, and she felt able to interpret given instructions in her own way. Also, since Daina trained other women in the project to draw, it is inevitable that their various interpretations would inform the designs that were produced. To identify the potential origins of Xihoko embroideries and the processes used to devise designs is in fact to discover a complex series of cross-cultural interchanges – ones that point to the fluidity and hybrid nature of cultural traditions.[5]

There is a custom amongst Tsonga-speaking men of doing needlework. In her account of this tradition, Findlay cites a text by Hugh Tracey published in 1952, which includes mention of bed linen and vests embroidered by Tsonga-speaking males employed on the mines in Johannesburg (Findlay, 1995, p. 48).[6] She also observes that the architect Peter Rich remembers the manservant of another well-known architect, Pancho Guedes, 'embroidering pictures onto

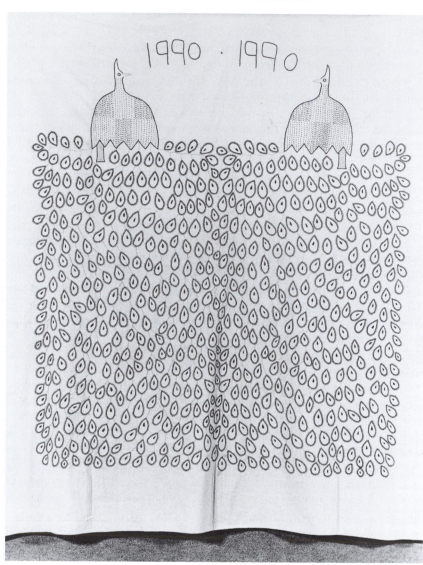

Fig. 8.1. Unknown artist of Xihoko project, *Two Peacocks*, 230 cm × 225 cm (90¹/₂ × 88¹/₂ inches), embroidery on white cotton cloth, 1990, Private collection. Photograph by Obie Oberholzer.

cloths in Mozambique in the 1960s' (Findlay, 1995, p. 60). Furthermore, Jameson Maluleke, a Tsonga-speaker who initiated the Chivirika Needlework Project that I discuss later in this essay, has indicated that men have a tradition of embroidering dustcoats: 'In the olden days we had men embroidering what you'd call a dustcoat. You'd write your nickname on this jacket … They used to be a personal type of clothing' (Maluleke, 2002).

Although the Xihoko project did not include male embroiderers amongst its members, some men in the community may occasionally have assisted in the completion of the embroideries. Findlay (1995, p. 50) mentions being told by Jane Arthur 'that when the men have returned to the village of Xihoko, from Johannesburg at Christmas time, they have been known to help with embroidery' and that 'there have been times when men have helped complete an order which is late'. Men's possible contribution to the production of embroideries should not be over-emphasized, however. The impact of a western construction of sewing as a female activity has affected Tsonga-speaking communities, and it is now unusual to find a male who embroiders.[7]

There is no evidence to suggest that Reckson Mabunda embroidered any Xihoko cloths. While he certainly appears to have undertaken some of the drawing and designing, the extent of his contribution is unclear. Findlay (1995, pp. 105–6) observes that newspaper reports tended to credit him with the design of *all* the cloths and that this is most certainly inaccurate. As spokesperson for the group, Reckson may have exaggerated the role he played. Alternatively, the Arthurs, Blecher and the various reporters visiting the project may have simply assumed, wrongly, that he took a more active part in the designing of works than was the case. Daina Mabunda (2001) indicated to me that he rarely contributed to the designing of works, and that what little skills he possessed in drawing were the result of training he received from her. Yet this reading is likely to be as incorrect as the assumption that he was Xihoko's only designer. As a person able to write in English, Reckson almost certainly played a role in devising the wording that appears on so many of the embroideries. In all probability, he also drew some of the cardboard templates that would be used to trace designs onto cloths that were being prepared for embroidery. Most importantly, as the interpreter when Arthur communicated with the needleworkers, Reckson's understanding of what she might have in mind for a design would have had some bearing on what was produced.

While Daina's indication that Reckson offered almost no contribution to the design process is doubtless inaccurate, it is nevertheless understandable in light of his treatment of her. In the early months of 1992 Daina became ill with symptoms of what would later be diagnosed as diabetes (Leeb-du Toit, 2001).[8]

Reckson's reaction was to deposit her at her maternal grandparents' home in the village of Runnymede. Cordelia Nkhwashu, a local woman who acted as interpreter when I interviewed Daina (Mabunda, 2001), explains the sequence of events as follows:

> She says she was sick and traditionally when you get sick your ancestors want you. So you have to be taken to your grandparents who organise a ritual. So he took her there: he went by her house and collected some members of her family, because you need your family there. So he took her to her grandmother. They have to kill a goat sometimes or a chicken. So while they were preparing that, he said he was coming back. But he left for good. They waited for him but he never came back. So the procedure is that they have to go back to him and ask him why he did not come back. He said: 'I don't want her anymore: I was just bringing her home.' That was his way of bringing her home. Then they had to take the news to her that she is not welcome in his house anymore. And they had to phone Jane [Arthur] and tell her that if she wants her she has to go directly to Daina's family.

As this commentary indicates, Daina Mabunda's position was not simply one of vulnerability but of fundamental passivity. Not only was she denied any capacity to exercise choice, but she was also divested of opportunities to protest against the actions of her husband: she was taken to her home village, she was left to wait, and she was told she was no longer wanted.

Daina Mabunda (2001) indicates that she suffered beatings during her marriage, and it is clear that she feared her husband. But this abuse cannot be explained simply as the outcome of deviant behaviour on the part of Reckson Mabunda. More invidiously it was just one symptom of overarching gender inequalities operative in the community – ones that created a situation in which women were afforded no protection from harsh disciplinary measures taken by their partners and were provided with few opportunities to control and manage their own lives. On marrying, a woman such as Daina Mabunda would leave her own family home to become part of her husband's family unit. A married woman was always on some level an outsider, somebody who lived among her husband's kin rather than her own. Even more importantly, the household would be structured so that the wife was dependent on her husband for economic support. Rather than being expected to find ways to earn her own income, it was assumed that she would look to her husband for the monies necessary to sustain herself and her children.

The Xihoko project, aimed at empowering women in the village, had to negotiate a set of norms that were actually at odds with this imperative. Blecher (2001) observes that the capacity of women to earn money to sustain themselves and their children was frequently less a source of relief to husbands with limited earnings than a cause of marital conflict: 'Some of their men would be on the mines, and they [their wives] would have nothing: the men would come back and they would find their wives had earned some money, and

this tended to upset them.' If men occasionally assisted with the completion of embroideries, as Arthur indicated to Findlay, this could well have been part of an endeavour to assert their own control over their wives' activities. More particularly, it might have been a way of ensuring that any monies owed for completed works would be delivered to them for discretionary management rather than being paid directly to their partners.

Reckson Mabunda, it seems, endeavoured to use the project in such a way that it might bolster rather than compromise his authority. Blecher (2001) suspects that Reckson's capacity to offer people employment enabled him to extend his power and status in the village. Also, as interpreter for Xihoko, his capacity to speak for the community and its needs undoubtedly made project members want to retain his favour. It was, however, a control that was fundamentally unstable. While Reckson might have wanted to establish himself as the driving force within Xihoko, Daina's capabilities were doubtless all too visible to others in the project and community.

Presumably to control her, Reckson reduced her earnings and, according to Daina (Mabunda, 2001), she sometimes received no money at all for works she had made. Daina's potential to achieve economic independence also probably made her especially susceptible to abuse. Nkhwashu explains this:

> in our culture, a man's pride is to be able to support his family, although this does not justify a lot of things our men do. When he can't support his family he is less of a man. So when he can't support his family and she gets a chance, it is an insult because a woman is supporting her husband. So he decides on a position of power, and the only way he can do this is abuse. He pretends to be manager. It is *my* house. It is *my* place.[9]

Reckson's probable inclination to prevent Daina from posing a threat to his authority within the Xihoko project may also in fact have underpinned his decision to remove her to Runnymede when she became ill. Nkhwashu (Mabunda, 2001) gives an account of Daina's commentary: 'When he took her home, he thought that he'd continue with the business. So even when she was gone, all the things still went to him.'

The retention of Reckson as manager of the project did not last beyond a few months, however, and moves were made to liaise with women via Daina. Although custom dictated that Daina's children remain with their father, they soon moved to Runnymede to be with their mother. And, no longer the small children they had been when the Xihoko project had first started, they also had sufficient grasp of English to act as interpreters and, more particularly, to provide outsiders working on the project with new perspectives on the dynamics of the community.

In 1992 Moses Mabunda indicated to Findlay that many of the designs his father, Reckson, had claimed as his own were in fact designed by his mother, Daina – and he made the same comment to her on subsequent occasions (Findlay, 1995, pp. 106–7). Even more seriously, it was discovered that

Reckson had for some time been topping up his salary by 'skimming' amounts off the payments intended not only for Daina but also for other needleworkers in the project. Xihoko needleworkers may have been ignorant of Reckson's manipulation of monies but even those who might have suspected dishonesty on his part would have been too afraid to make a case against him. According to Daina, other women in the project feared him and they never queried his instructions or decisions. She acknowledges they may possibly have questioned the amounts they were being paid amongst themselves but, to avoid possible retribution, they never articulated these anxieties to her (Mabunda, 2001).

In 1993, Jane Arthur and her husband decided to leave South Africa. Although the project was not simply closed down, but taken over by Adrienne Napper and re-named 'Shangaan Motifs', it did not lend itself to being resurrected as a sustainable enterprise. While many women felt inclined to continue to work alongside Daina Mabunda, their distance from Runnymede as well as Reckson Mabunda's influence in the Xihoko region (which lasted until his death in the late 1990s) mitigated against their continued involvement in the project. However, before leaving South Africa, Jane Arthur facilitated a meeting that would have significance for the long-term impact of Xihoko on needlework in South Africa. In 1992, shortly before Daina left Radoo for Runnymede, Arthur saw a painted cloth made by Findlay, and invited her to spend a few days working with women in the Xihoko project. The working relationship between Daina Mabunda and Bronwen Findlay that was subsequently established continues to this day.

Chivirika

Jameson Maluleke, a security officer at the University of South Africa in the mid-1980s,[10] learned about the Xihoko project from Aubrey Blecher. Maluleke felt that a needlework project could well have benefits for women in his own Tsonga-speaking community in the Mphambo Village. The Mphambo Village, like Xihoko, is now part of the Limpopo Province of South Africa but was then located in the so-called 'homeland' of Gazankulu (see Figs 1.2 and 1.3). In keeping with many settlements in the 'homelands' established by the apartheid government, it was not a space that lent itself to productive agricultural or industrial development. As Maluleke (2000, p. 116) explains it:

> Sandwiched between Giyani and Malumalele, the area is like any belt in the Lowveld – an arid piece of land with limited summer rainfall. Owing to its harsh geographical conditions, this tract of land offers nothing in terms of natural resources – no mining, no manufacturing, no husbandry. It is, in essence, land that serves only as a venue for subsistence farming by individual peasants.

It was, not surprisingly, an area where women experienced dire poverty. As Maluleke (2002) points out: 'There are some opportunities for women to work as teaching assistants. But very few [women] are professionals. They rely on land for their survival. So there is poverty, unemployment and starvation.'

Chivirika (which means 'toil and sweat') was initiated in September 1986. The first two women Maluleke recruited into the project were Mashao and Rossinah Nkuna, both wives of Samuel Nkuna, who was employed by a paint company in Johannesburg. Shortly thereafter, Tshamiseka Maluleke, who was married to Jameson Maluleke's cousin Patrick, and Salphina Maluleke, one of the five wives of another cousin, Charles, became participants. By the end of 1988, Chivirika included 25 women (Maluleke, 2000, p. 117).

While Jameson Maluleke wanted to assist women in obtaining an income and was perturbed by their lack of capacity to sustain themselves and their children, he was equally concerned that the project be used to assert a specifically Tsonga identity and affirm Tsonga cultural traditions. He notes (Maluleke, 2002): 'We are part of a minority tribe. Although there are many of our people scattered over the country, other tribes consider us a minority. We wanted [to express] something about our identity, something that can tell us more about our tradition as a people.'

In an apartheid context, promoting discrete identities amongst the people of South Africa provided the government with a means of bolstering its vision of the country as a constellation of separate ethnic states. Hence, as Ivor Powell (1995, p. 138) notes, 'the agenda of liberation politics was aimed at promoting unity and therefore, as often as not, a detribalized self-perception amongst black South Africans'. In an urban context, he observes, the expression of tribal identity 'was often perceived as evidence of collaboration, and nearly always anachronistic'. Yet, simultaneously, there was sometimes a tendency in rural communities to view the assertion of ethnic affiliation as a marker of dissent. Asserting one's African origins was seen as rejecting western culture and influences – even if this assertion was via objects intended to appeal to white buyers. This was almost certainly Maluleke's perspective. In his view, works made by the Chivirika group were a means of affirming the identity of a people who had been marginalized and suppressed by apartheid and thus, quite apart from economically empowering women in his community, the project offered 'a contribution to the struggle' (Maluleke, 2000, p. 116).

Maluleke's aim to find a visual form that would express a specifically Tsonga identity encouraged him to focus on *minceka*. As he explained: 'The *nceka* is the only traditional cloth that is left to our people. You can identify our people by that cloth, except for men – because men are wearing the same thing [as non-Tsonga people]. We took it as a symbol of our people. So that is the cultural aspect of the project' (Maluleke, 2002).

In the course of 1986 and 1987, Maluleke and women in the Chivirika project devised ways of adapting features of *minceka* so that these cloths might

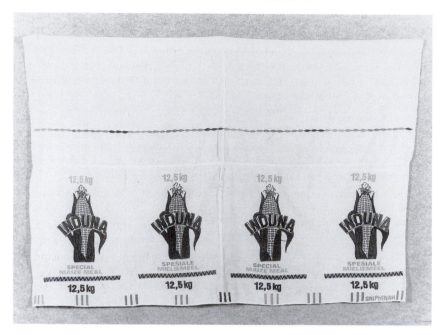

Fig. 8.2. Salphina Maluleke (of Chivirika embroidery project), *Nceka*, 100 × 143 cm (39^1/$_4$ × 56^1/$_4$ inches), embroidery on 'Nduna' mielie meal bags, 1980s, Private collection. Photograph by Obie Oberholzer.

be saleable to non-Tsonga people in urban communities. One solution was found in *minceka* constructed from cotton bags that were used to package maize meal. Before plastic was introduced as a substitute for cotton, women often embroidered the product logos printed on these bags, making them into festive and fashionable *minceka* that appealed to western eyes (Fig. 8.2). Input offered by Janétje van der Merwe, an employee in the Department of Marketing and Corporate Communication at the University of South Africa, resulted in the group producing another type of embroidered cloth (Plate 4). Also related to the *nceka*, but in this instance to a version of this garment that includes beaded and embroidered animals or geometric forms on black or dark blue fabric, the typical Chivirika work that was developed in 1988 had a black cotton ground. At its centre, embroidered in a series of bright colours, were animals and foliage, and, at its top and bottom (and sometimes also its sides) geometric patterning.

 Women from Maluleke's home village were wholly dependent on their husbands to obtain monies to sustain themselves and their children, and most men sought work outside Gazankulu, usually in cities such as Johannesburg and Pretoria. As my interviews with women in the Chivirika project revealed,

however, it was common for financial maintenance not to be forthcoming, leaving women without any means of support (Chivirika, 2002). Rosie Hlungwani, for instance, is married to a mineworker who comes home twice a year, but when she joined the project in 1988 her husband was unemployed and would remain so until 1992. Emily Novela's circumstances are the inverse of those of Hlungwani: she joined the project in 1988, while her husband was employed, but in the early 1990s he became too ill to work and she has needed to earn money to support them both as well as their children. There are also women in the project who were abandoned by their husbands: Lucia Chauke joined the project in 1990, shortly after her husband had left for Johannesburg never to return.

Some women have been further disadvantaged by being in polygamous marriages. If having a number of wives once served as a marker of a husband's wealth and status, by the 1980s it had become almost a guarantee that those women and their children were deprived of proper financial support. Yet, because a polygamist is likely to be even less amenable to revising customary gender roles than men in monogamous marriages, his wives are especially likely to encounter difficulties in attaining financial independence. Mashao and Rossinah Nkuna have both left Samuel Nkuna since his return to the Mphambo Village in the late 1990s, and Salphina Maluleke, who emerged as the principal designer for Chivirika, left the Mphambo Village and the project in the mid-1990s, apparently after a clash with her husband. While evidence I have gleaned is insufficient to argue that these marriages broke down specifically because women's earning potential posed a threat to the authority of their husbands, it is likely that such factors were at play.

Jameson Maluleke does not believe that, as a male, he had more authority when introducing the Chivirika project than a woman in the community might have had. While he acknowledges that his education gave him a certain status, he believes that age hierarchies should also be considered when assessing relations of power in the village:

> The two women I started the project with are older than me. And they know more about the traditional aspects of *minceka* than me. So they looked to me as somebody who has read books on traditional aspects of other people. But they also know that, because I am younger than them, I'm just trying to do these things [that is, introduce an embroidery project] in a friendly sort of way. There was always co-operation, like we were on the same level.
>
> (Maluleke, 2002)

Social stratifications in accordance with age certainly do exist in the Mphambo Village. However, in choosing to work initially with older women, Maluleke was probably not aiming for a situation in which any hierarchical distinctions between male and female or between educated and uneducated would be rendered inoperable through the existence of an equivalent hierarchical

distinction between old and young. Rather, his selection of Mashao and Rossinah Nkuna as collaborators would have enabled the newly initiated project to be accepted and supported amongst the community in a way that it is unlikely to have been if he had endeavoured to introduce needlework via younger females.

Furthermore, working with the two Nkuna wives enabled Maluleke to influence the direction of the project and its envisaged benefits for his community. While younger women will often see participation in a needlework project as a first step towards achieving independence from the constraints of their societies, older women in a community such as the Mphambo Village would be more likely to view the project as a way of fostering an identity amongst participants as Tsonga-speakers with solid links to custom. Hence Mashao and Rossinah Nkuna would have ensured that what Maluleke termed the 'cultural aspect of the project' would be given emphasis even if, as it happens, these two women subsequently resisted the constraints of their customary marriages and Mashao eventually departed from the project.

Kaross Workers

Xihoko and Chivirika were always modest projects, including on average about 20 participants. Kaross Workers, started in 1988, differs in the sense that it included about 125 needleworkers by the time of the first democratic election.[11]

Kaross Workers is in Letsitele, an area close to Tzaneen in what is now the Limpopo Province, but at the time it was initiated was in the Transvaal (see Figs 1.2 and 1.3). Irma van Rooyen, who started the project, was alert to the poverty of women seeking work on the orange farm that she and her husband had purchased. Consisting initially of five women, the project subsequently provided an income for people living not only on the Van Rooyen's farm but also on surrounding farms as well as in villages up to 100 km (62 miles) away, including settlements in the former 'homeland' of Gazankulu. While some participants have always used the project as a means of supplementing their earnings, embroidering wall hangings, cushion covers and tablemats has provided many others with their only source of income.[12]

Kaross Workers differs from Chivirika not only in the sense that members of the project are distributed over a wide geographical area, but also in terms of the variety of backgrounds of these participants. While most members are Tsonga speakers, the project includes a large number of people speaking other languages as well. If Chivirika operates within a community that keeps a close eye on Tsonga customs, and marriages between couples from different language groups are rare, many of the settlements that are home to participants in the Kaross Workers project are more fluid in composition. For example, Dora Nkuna, one of the five women in the initial group whom Van Rooyen

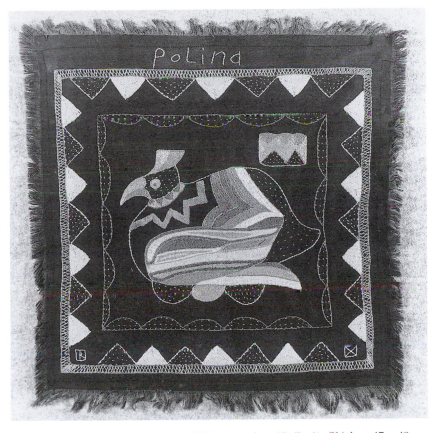

Fig. 8.3. Unknown artist of Kaross Workers project ('Polina'), *Chicken*, 47 × 48 cm (18¹/₂ × 19 inches) excluding fringe, embroidery on black cotton cloth, Private collection. Photograph by Obie Oberholzer.

trained, is a Pedi speaker who married a Tsonga speaker, moved to his homestead and remained there after their separation. Also, while women in Chivirika are all married, separated or widowed, there are many women in the Kaross Workers project who have always been single.

The extremely varied circumstances and backgrounds of the many women in the project make it difficult to provide an overarching account of the ways in which gender dynamics have informed their needs. Certainly some needleworkers in Kaross Workers, as in Xihoko and Chivirika, would have been subject to customs that worked to divest them of the capacity to initiate economic improvements in their lives. Yet the project also includes women who are undoubtedly largely unaffected by such strictures, but have been

disadvantaged through limited education, lack of access to birth control and a host of other sociological factors.[13]

Drawing at Xihoko and Chivirika was always the responsibility of members of the project even if outsider mediation operated. In contrast, Van Rooyen acted as the exclusive designer of Kaross Workers embroideries (Fig. 8.3) until the late 1990s.[14] Furthermore, while the primary source for embroideries at Xihoko and Chivirika was the *nceka*, Van Rooyen's approach to design was more eclectic. Elize Taljaard (1994, p. 33) refers to the influence of 'several Shangaan, Northern Sotho and Venda artists, like sculptor Noria Mabasa's wooden crocodiles and the wooden sculptures of the Ndou brothers' on the forms and shapes selected for embroideries. The idiom established for Kaross Workers may be related to that of Chivirika in the sense that works include centrally placed stylized animals and foliage that are surrounded by patterned borders.[15] However, the embroideries are usually more heavily worked than those of the Chivirika project and include a greater variety of stitches. In addition, Van Rooyen selects the colour combinations that will be used in embroideries and her preference is for subtle hues rather than bright primary colours. More importantly, Van Rooyen's choice of designs is not motivated by an aim of affirming identities or paying homage to cultural traditions. While presumably not envisaging the growth in tourism in South Africa that occurred immediately after 1994, she was nevertheless alert to the fact that visitors to the country were likely to constitute the project's primary market. Embroideries were designed with the tastes of tourists in mind, an imperative that was certainly also present, but less emphasized, by those devising Xihoko or Chivirika designs.[16]

Kaross Workers has included a few male embroiderers since the early 1990s. Almost all are workers on the Van Rooyen farm who practise embroidery in order to supplement their incomes. July Mhlongo, born in 1960 to a Tsonga-speaking father and a Swazi-speaking mother, indicates that neither taught him embroidery and that he learned needlework on joining the project in 1993. While Mhlongo may have encountered male embroiderers in his youth it is likely that his readiness to take up a practice more usually associated with women resulted from seeing other male labourers on the farm embroidering (and generating additional funds through this activity). Also, a man's willingness to embroider does not necessarily signify his inclination to defy social norms, as in other respects he may support customary divisions of labour between men and women. Mhlongo's Tsonga-speaking wife is not a member of the Kaross Workers project and, rather than living with him on the farm, as do the wives of many other labourers, she remains at his homestead. Employed at a nursery in Tzaneen, she evidently also has the task of caring for his ageing mother, a domestic responsibility common among young wives in this region. It is, in effect, a gendered inequality – a concept that a wife should live at her husband's homestead as well as see to the needs of his ageing parents – that gives Mhlongo the time to do embroidery.[17]

Mapula

While what is now the Limpopo Province has come to be associated with needlework groups, other locales have also provided forums for projects of this type. Mapula (meaning 'mother of rain'), a project initiated in 1991, is in the Winterveld, an area that is now part of the North West Province and is about 45 km (28 miles) north of Pretoria (see Fig. 1.3).

In 1936, large farms comprising the Winterveld were divided into plots that were made available for purchase and agricultural development by black South Africans. But rather than undertaking farming, new owners found it more profitable to rent land to tenants on the lookout for homesteads a manageable distance from Pretoria and Johannesburg. Growth in the population increased still further when the area became home to victims of the forced removals that took place during the 1950s and 1960s when thousands of black families were evicted from suburbs identified for white settlement.

The Winterveld would also feel the impact of the apartheid government's policy of dividing areas of the country occupied by black people into independent 'homelands'. Although 90% of the population are not Tswana-speakers, the area was incorporated into the ostensibly Tswana 'homeland' of Bophuthatswana when it was granted independence in December 1977 (see Fig. 1.2). Under the control of Mangope's government, the Bophuthatswana 'homeland' leader, social problems already evident in the Winterveld worsened. Non-Tswana people, even those who had been born in the Winterveld or who had inherited land, experienced difficulties obtaining citizenship and, as a result, struggled to receive pensions and work permits. Furthermore, the Bophuthatswana government failed to take cognisance of the numbers of people living illegally in the area when they estimated the population of the region. Sister Immaculata (2002), who initiated literacy projects in the Winterveld in the 1980s, observes that 'the population was given as about 100 000 whereas there might have been about a million people: nobody knew. So when the government did provide facilities, these were insufficient'. Boreholes that had been drilled by the South African government in an attempt to create a fresh water supply for the burgeoning population were neglected, and disease and infant mortality became rife. Also, when all registered schools were required to use Tswana as their medium of instruction, so-called 'private schools' were established and were often no more than shacks staffed by teachers with limited levels of literacy.[18]

Mapula's formation was largely due to the work of the Sisters of Mercy, who had been involved for some time in efforts to upgrade the lives of the people of the Winterveld. In early 1979 a Winterveld Action Committee was established under the auspices of the Pretoria Council of Churches, and one of its agendas was the introduction of literacy projects in the area. This provided a framework for the Sisters of Mercy to build an adult education centre, the

D.W.T. Nthathe Adult Education Centre, which was opened in 1984.[19] The Sisters of Mercy approached Soroptomists International to assist in the Winterveld and this group of professional women began to develop programmes. Karin Skawran, then Professor and Head of the History of Art and Fine Art Department at the University of South Africa, volunteered to take on the portfolio of 'Literacy and Education' and, after her first visit to the Winterveld, the idea of introducing a needlework project came to mind (Skawran, 2002). Skawran drew other staff from Unisa into the project, including Janétje van der Merwe, who had previously assisted the Chivirika Embroidery Project, and who undertook the role of marketing the works, a role she still retains.[20] The Sisters of Mercy made available a room at the school as a base for the project and identified Emily Maluleke as a local person who could supervise the making of works. While there were at most 20 participants in 1991, the project was supporting about 80 members by the late 1990s, a number that has remained more or less consistent since then.

Antoinette du Plessis (1999), one of the Unisa staff members steering the project, observes that interest in participating was initially demonstrated by a small number of men. They soon withdrew, however, for reasons that are unclear. Unlike Xihoko, Chivirika and Kaross Workers, where men have participated in either the administration or production of works, Mapula is a project in which females handle all aspects of supervision, marketing and making. The only male who seems to have had any formal involvement with the project is Raymond Sibiya, a teenager in the community who does not embroider but, since 2000, has received a small salary for assisting some of the women with drawing.

In its early stages, members of Mapula embroidered cushion covers and calico shirts. While shirts disappeared from the project's repertoire within a couple of years, all the women continued to make cushion covers.[21] The earliest cushion covers by the group tended to represent animals (Fig. 8.4) or flowers. Derived from the types of illustrations that are common in popular reference books on the flora and fauna of the continent, or perhaps from illustrations included in compilations of African stories or myths, they were images that were somewhat distanced from immediate political and social realities. Only in 1993 did the women begin focusing on contemporary events, finding in the mass media a range of imagery which drew reference to South Africa's newly developed symbols of, and conceptions about, its nationhood. Shortly before the first democratic election, South African leaders began to feature as subjects on embroideries, as did the new South African flag (Fig. 8.5 and jacket illustration).

While works such as these may have played into a new pride in all things South African that had begun to flavour the tastes of buyers, they also seem related to fresh optimism on the part of their makers. Women in Mapula doubtless responded to immanent political change with a degree of enthusiasm

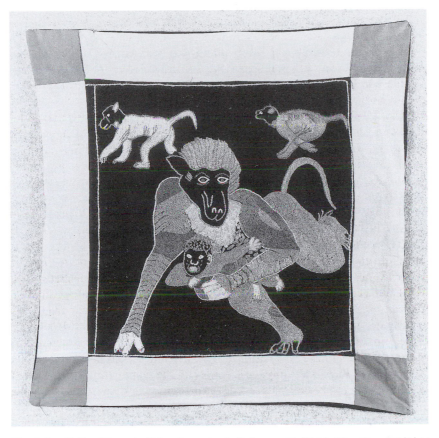

Fig. 8.4. Guilty Khoza (of Mapula project), *Baboon with Child*, 49 × 47 cm (19¹/₄ × 18¹/₂ inches) cushion cover – embroidery on cotton cloth, *c*.1992–93, Private collection. Photograph by Obie Oberholzer.

and interest far in excess of women in a project such as Chivirika. Jameson Maluleke (2002) observes that women in Chivirika were given some consciousness of their political oppression by villagers returning from the cities but, he feels, these remarks were made only in passing and had no particular impact. Oppression, he believes, was conceptualized by most members of the project as something 'outside our world, our Shangaan world' and 'getting arrested in the city or suffering discrimination was seen as part of life outside the homeland'. In contrast, most women in the Winterveld, including those in the Mapula project, had more immediate experience of discrimination. Johannesburg and Pretoria were not places that they may have visited occasionally, but were on their doorstep. It is clear that the vast

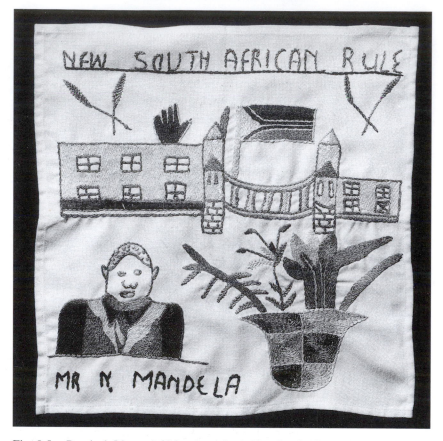

Fig. 8.5. Rossinah Maepa (of Mapula project), *New South African Rule*, 32 × 30 cm
(12¹/₂ × 11³/₄ inches), embroidery on white cotton cloth, *c*.1993–94, Private collection.
Photograph by Brent Meistre.

majority of the Winterveld population conceived of themselves as inadvertent
residents of Bophuthatswana rather than proud citizens capable of enjoying
full civil rights. An article published in 1983 identifies an 'atmosphere of
suspicion, mistrust and non-cooperation' as well as a lack of communal
cohesiveness amongst the Winterveld's inhabitants (Commission for Justice &
Peace et al., 1983), and this description of people's relations with one another
was still accurate a decade later. Hence the symbols of South Africa's new
sense of nationhood that appeared in Mapula embroideries do not only signify
women's hope for a better standard of living in a new dispensation, but also
speak of a quest to forge some sense of identity within a larger group, indeed
to attain a sense of belonging.[22]

While women in the Winterveld have not usually experienced the same difficulties as females in rural communities, who have often been prevented from earning monies for themselves, it has been usual for them to receive absolutely no support from the fathers of their children. A survey of the backgrounds of women in the Mapula project reveals that, almost invariably, they started life with limited opportunities and received rudimentary education, but found themselves obliged to act as sole breadwinners for their families. Florence Resenga, a Tsonga-speaker who has lived in the Winterveld since the late 1960s, was widowed in 1989 and was thus unable to rely on her husband's salary to support their five children. Before joining the Mapula project in the mid-1990s, she attempted to eke out a living by hawking fruit at Wonderboom Station, just north of Pretoria, but, because she was unable to secure a hawker's licence, was in constant fear of being arrested. Selinah Makwana, a Pedi speaker who joined the Mapula project in 1993, has lived in the Winterveld since 1976. She has no contact with the fathers of her seven children and, while her eldest child has now left home, the remaining six continue to depend on her for support. Julia Makwana, Selinah Makwana's sister-in-law, came to the Winterveld in 1993 and joined the Mapula project shortly thereafter. Already a mother of three children when her husband (Selinah's brother) was imprisoned for two years in 1988, she gave birth to a fourth child before he was imprisoned again in 1992 as well as two more children after his release. She indicates that prior to the first period of imprisonment 'his wages were too little to fulfil needs of our life' and it was necessary for her to seek out work. The year 1988 marked the beginning of a further deterioration in the quality of their lives – 'our suffering … started to grow in huge points than before', she notes.[23]

It would appear that even those women in the Winterveld who are more privileged than members of the Mapula project often struggle to secure any support from the fathers of their children. Phyllis Dibakwane, a Tswana-speaking teacher who acted as interpreter when I spoke to a number of the needleworkers, commented that whatever her husband earns 'goes on himself'. While she wishes to seek divorce, she would feel obliged to seek her parents' permission. But, she notes, 'they are old and sickly, and I would give them a heart attack – so I rely on my first daughter to comfort me and help me' (Mapula, 2002). As this comment indicates, social pressures tend to discourage women from addressing gender inequalities and instead work to foster an attitude of acceptance.

Aided by the government's Cultural Industry Growth Strategy, which focuses on the development of art projects that can generate income and job creation, the post-apartheid period has seen a dramatic growth in the numbers of needlework projects in South Africa. While new understandings of 'history' and processes of re-visioning the past have worked to invest the needlework of

recently formed groups with a different flavour to embroideries made in the years prior to the first democratic election, the endeavours of Xihoko, Chivirika, Kaross Workers and Mapula have been vital to these new initiatives. By devising structures that would enable project members to attain the skills to produce works with market appeal, they have indicated that it is indeed possible to use embroidery to help economically disadvantaged women achieve a modicum of financial independence. More particularly, the experiences of projects set up in the 1980s and early 1990s worked to increase awareness of the complex dynamics – most especially gender dynamics – within communities that might benefit from such initiatives.[24]

Notes

1. Findlay (1995, p. 1) observes, 'The Tsonga-Shangana were forged into a group by circumstances and events and were variously labelled Thonga, Ronga, Magwamba, Shangaan, by 19th century missionaries and anthropologists such as Henri A. Junod and Henri Berthoud.' The terms 'Tsonga', 'Shangana' and 'Shangaan' seem to be used interchangeably by people living in the communities discussed in this essay. For consistency, rather than because I have been persuaded that it is more appropriate than the others, I use the term 'Tsonga' in my examination.

2. When the borders of the nine provinces were defined after the first democratic election, the areas formerly in the north of the Transvaal as well as the 'homelands' in this part of the country became the Northern Province. 'Northern Province' was changed to 'Limpopo' in 2002.

3. Becker (2000, p. 109) indicates that *minceka* embellished with embroidery (or beadwork) are 'restricted to the area around Giyani, the capital of the former homeland of Gazankulu' and that they are not worn 'in Mhala, the southern section of ex-Gazankulu, and nor are they found in Tsonga communities in Mozambique and Zimbabwe'. She suggests that hand-worked *minceka* of this type originated in the 1960s or perhaps the late 1950s, that the style 'developed around a constructed centre at a particular time' and that it 'clearly has some connection to identity politics, encoding difference in an area where borders and local authorities were contested'.

4. The University of South Africa is a distance-learning university in South Africa. Aubrey Blecher is now employed at the University of the Witwatersrand in Johannesburg.

5. See Becker, 2000, pp. 109–10 for a brief consideration of *minceka* in relation to the idea of 'tradition'.

6. The text is Hugh Tracey's *African Dances of the Witwatersrand Gold Mines* (1952). Tracey (p. 16) writes: 'A decorative Shangaan feature is their passion for embroidery. Many dancers embroider their vests with symbolic figures of such things as cattle, birds, aircraft and trees or their own names in rickety letters. Not only do their vests receive this treatment but also their bed linen and curtains, luxuries which few men of other tribes consider essential.'

7. While Maluleke (2002) indicates that he knows of one male embroiderer in his home village, he observes that men no longer embellish dustcoats. Daina Mabunda (2001) insists that she has never observed any men from Xihoko engaged in needlework.

8. In an informal conversation with Bronwen Findlay, I ascertained that this illness was discovered when Mabunda visited Durban and Findlay arranged for her to see a medical practitioner.

9. Nkhwashu offered these comments to me when she was acting as interpreter during my interview with Mabunda (2001).

10. Since the late 1990s Maluleke has been employed as a reporter by *The Citizen* newspaper. In addition to writing three novels in Tsonga, he has translated Alan Paton's novel *Cry the Beloved Country* into Tsonga.

11. It has been even more successful in a post-apartheid context. When I undertook research on the project in 1999 for an essay published a year later (Schmahmann, 2000, Kaross Workers supported about 430 needleworkers. By the beginning of 2002, it was providing work to approximately 600 people.

12. My knowledge of the project's origins was gleaned from an interview with Irma van Rooyen (1999). I have observed previously (Schmahmann, 2000, p. 134) that the name of the project 'derives from an occasion in which the initial five women in the group were embroidering while seated on a ground-sheet or *kaross* under a tree'.

13. I am basing these deductions on interviews with a selection of members of the project (Kaross Workers, 2002).

14. In 1999 Solomon Mohati undertook some drawing and by 2000 Kelvin Machlawaule had begun contributing designs.

15. I refer here to characteristics of embroideries made during the apartheid years. There have been subsequent variations on this idiom. Designs that Kelvin Machlawaule produced in 2000 invoke reference to oral histories or represent scenes from contemporary life.

16. The opportunity to join Kaross Workers was welcomed by some women in the Xihoko project who found themselves unable to continue working with Daina Mabunda after her move to Runnymede. Two such women, Anna Ralebale and Sylvia Mathubele, joined Kaross Workers in 1992. Ralebale indicates that the transition from one project to the other was uncomplicated – the techniques used at Xihoko could be adapted to embroider a different range of animals and motifs (Kaross Workers, 2002).

17. Mhlongo was one of the needleworkers I interviewed (Kaross Workers, 2002).

18. A good overview of conditions in the Winterveld in the early years of independence is provided in a pamphlet produced and published by the Commission for Justice & Peace, Archdiocese of Pretoria, and the Winterveld Action Committee of the Pretoria Council of Churches (1983).

19. The Sisters also ran a feeding scheme and two day-care centres. Furthermore, the Mission provided a base for a 'care group' of 93 women living in the area, who assisted the population with health care as well as with such practical problems as processing pension applications and transporting children to school (see Millard, 1990, p. 11). Sister Immaculata (2002) comments on the choice of the name for the centre: 'I went to Ireland on a trip in 1986. When I came back I discovered the place was now called D.W.T. Nthathe. The reason for that was that Mr Nthathe was in the old Bop [Bophuthatswana] government and was in charge of education. And the only way we could get it registered was to name it after him.'

20. I have spoken to Van der Merwe informally on a number of occasions, and some of my understanding of the history of Mapula has been gleaned from these conversations. I have also conducted two lengthy interviews with her (Van der Merwe, 1999 and Van der Merwe, 2002).

21. Since 1996 members of Mapula have also embroidered large cloths.
22. Interestingly, some of the embroideries celebrated not only black leaders but also white leaders such as F.W. de Klerk. One cushion cover, reproduced in a newspaper article in 1994, represented Mandela's negotiations with the Afrikaner Resistance Leader, Eugene Terreblanche. This kind of imagery tallied with a multiculturalism that informed the rhetoric of African National Congress leaders, especially Nelson Mandela, in their efforts to define the terms of a new dispensation for the country. Klopper points out that it was an endeavour to 'accept and even celebrate difference in the interests of building an entirely new sense of nationness' and was 'predicated on the belief that it is important not to alienate any of the many constituencies currently competing for economic and other resources' (Klopper, 1996, unpaginated).
23. I have based these accounts on two sources. In 2001 Janétje van der Merwe encouraged women in the project to produce written transcripts of their lives; 15 documents had been produced by early April 2002 (Mapula, 2001–2). I have also drawn on material gathered from interviews with 15 women in the project (Mapula, 2002).
24. I am deeply grateful to Janétje van der Merwe, Jameson Maluleke, Irma van Rooyen and Bronwen Findlay whose assistance made possible this research. Thank you also to Aubrey Blecher, Sister Immaculata, Karin Skawran and all the needleworkers who set aside time to be interviewed. I am indebted to Obie Oberholzer and Brent Meistre for their superb photographs, and to Cordelia Nkhwashu and Phyllis Dibakwane for their thoughtful interpreting.

References

Becker, Rayda (2000), 'A stitch in time: the Xihoko Project', in Schmahmann, Brenda (ed.), *Material Matters: Appliqués by the Weya Women of Zimbabwe and Needlework by South African Collectives*, Johannesburg: Witwatersrand University Press, pp. 108–15.
Blecher, Aubrey (2001), unpublished interview conducted by the author in Johannesburg, Gauteng, 3 December.
Chivirika (2002), unpublished interviews with the following women in the project conducted by the author in the Mphambo Village in Limpopo, 7 April: Salphina Baloyi; Lucia Chauke; Johannah Chauke; Anna Hlungwani; Rosie Hlungwani; Lisbeth Makamu; Linah Maluleke; Violet Maluleke; Doris Maswanganyi; Hlakelela Mbiza; Noria Mkhabele; Rossinah Nkuna; Emily Novela; Maria Rikhotso, Maria Shivambu (interpreted by Cordelia Nkhwashu).
Commission for Justice & Peace, Archdiocese of Pretoria, and The Winterveld Action Committee of the Pretoria Council of Churches (1983), *A Profile on The Winterveld* (pamphlet).
Du Plessis, Antoinette (1999), unpublished interview conducted by the author in Pretoria, Gauteng, 15 September.
Findlay, Bronwen (1995), 'Aspect of cloth usage and adaptation among the Tsonga-Shangana women of the Northern Transvaal', unpublished MA dissertation, University of Natal.
Kaross Workers (2002), unpublished interviews with the following members of the project conducted by the author on the Van Rooyen farm in Letsitele as well as in surrounding villages, 6 April: Anna Becket; Anna Lebepé; Maria Mabunda; Tinyiko Mabunda; Anna Mathebla; Winny Mathubele; July Mhlongo; Lydia Mlangeni;

Flora Mnisi; Steffalina Mohatli; Dora Nkuna; Regina Nkuna; Nurse Rabothata; Anna Ralebale, Mijaji Vhukeya (interpreted by Cordelia Nkhwashu).

Klopper, Sandra (1996), 'Dressing for political success in post-apartheid South Africa' (unpublished essay).

Leeb-du Toit, Juliette (2001), *Bronwen Findlay; Faiza Galdhari; Daina Mabunda*. Catalogue for exhibition shown at the NSA Gallery in Durban, the Albany History Museum in Grahamstown and the Standard Bank Gallery in Johannesburg.

Mabunda, Daina (2001), unpublished interview conducted by the author in Runnymede, Limpopo Province, 24 November (interpreted by Cordelia Nkhwashu).

Maluleke, Jameson (2000), 'Toil for your survival: Chivirika self-help project', in Schmahmann, Brenda (ed.), *Material Matters: Appliqués by the Weya Women of Zimbabwe and Needlework by South African Collectives*, Johannesburg: Witwatersrand University Press, pp. 116–18.

———— (2002), unpublished interview conducted by the author in Johannesburg, Gauteng, 4 April.

Mapula (2001–2), unpublished handwritten transcripts of the life stories of the following women in the project: Johannah Mabasa; Rossinah Maepa; Beauty Makwana; Julia Makwana; Selinah Makwana; Elsie Maluleke; Sybil Modishwa; Sherley Munyuku; Dorcas Ncobeni; Josephine Rakubu; Florence Resenga; Pinky Resenga; Emma Shabangu; Jane Sono; Joyce Sono.

———— (2002), unpublished interviews with the following members of the project conducted by the author in the Winterveld, North West Province, 2 April: Doreen Mabuse; Mahlogonolo Maepa; Rossinah Maepa; Brenda Mahlangu; Selinah Mahlangu; Julia Makwana; Selinah Makwana; Jane Maseko; Stella Mnisi; Sybil Modishwa; Dorcas Ncobeni; Selinah Nkhumeleng; Florence Resenga; Pinky Resenga, Jane Sono (Interpreted by Phyllis Dibakwane).

Millard, Sue (1990), 'Winterveld: the festering disgrace on Pretoria's doorstep', *Pretoria News*, 1 February, 11.

Powell, Ivor (1995), *Ndebele: A People and Their Art*, Cape Town: Struik.

Schmahmann, Brenda (2000), 'Making, mediating, marketing: three contemporary projects', in Schmahmann, Brenda (ed.), *Material Matters: Appliqués by the Weya Women of Zimbabwe and Needlework by South African Collectives*, Johannesburg: Witwatersrand University Press, pp. 119–36.

Sister Immaculata (2002), unpublished interview conducted by the author in Pretoria, Gauteng, 3 April.

Skawran, Karin (2002), unpublished interview conducted by the author in Pretoria, Gauteng, 3 April.

Taljaard, Elize (1994), 'Translating the traditional: designs for Shangaan embroidery', *Image & Text* 4, December, 32–5.

Tracey, Hugh (1952), *African Dances of the Witwatersrand Gold Mines*, Johannesburg: African Music Society.

Van der Merwe, Janétje (1999), unpublished interview conducted by the author in Pretoria, Gauteng, on 12 September.

———— (2002), unpublished interview conducted by the author in Pretoria, Gauteng, 1 April.

Van Rooyen, Irma (1999), unpublished interview conducted by the author in Letsitele, Limpopo Province, 10 October.

Narratives of Migration in the Works of Noria Mabasa and Mmakgabo Sebidi

JACQUELINE NOLTE

The lives of Noria Muelwa Mabasa (b. 1938) and Mmakgabo Sebidi (b. 1943) were deeply influenced by apartheid. Having lived their teenage years during the formation of apartheid legislation, the artists were middle-aged women when the black liberation movements were unbanned in 1990 and the National Party finally agreed to negotiate a political settlement in South Africa.

Mabasa's sculptures are formed from personal experience and stories of a migration prior to her birth while Sebidi's paintings and drawings, revealing traces of her travels from the countryside to the city, indicate how 'migrant' journeys impinged on identity in apartheid South Africa. Mabasa's and Sebidi's works are concerned with the effects of relocation, voluntary and involuntary, at a period when place of residence and migration were marked by racial and ethnic designation, and government policy.[1] As children Mabasa and Sebidi lived on land designated for black occupation, outside of cities. Mabasa and her family experienced forced relocation within an area that was designated by apartheid authorities as the 'homeland' of Venda in 1979, while Sebidi's family managed to maintain tenure of land in what would become the so-called independent republic of Bophuthatswana in 1977 (see Fig. 1.2).

Mabasa was born to a Nguni mother and Venda father in Ha Thigalo (Xigalo) in the Ramukhumba district, then in the Northern Transvaal. Xigalo is about 40 km (27 miles) east of Thohoyandou. The family was forcibly relocated by the South African government to Ha-Ramokgapo within Venda, a place with little or no infrastructure (Mabasa, 2000).[2] Mabasa was raised in a community underdeveloped even by South Africa's peculiar brand of modernization, without access to the formal education then offered by mission or state schools.[3]

Mmakgabo Sebidi, born and raised in Marapyane near Tuinplaas, was a member of the Batswana bo ga Mohudi (Tswana from Mohudi) (Sebidi, 1994). Marapyane lies in the most western part of Mpumalanga in the Mmametlhake district, an area of 14 000 sq. km with residents in 33 scattered villages, most of which service Gauteng. Sebidi considers her family fortunate in having customary land tenure under traditional leadership but, owing to the

racially discriminatory apartheid laws, Africans could not own land in title. Although proud of her ties to the land, Sebidi does not regard Marapyane as her ancestral home since, over a century ago, white Afrikaner settlers forced her grandmother's people from the area now known as Sunnyside, Pretoria.[4]

Sebidi attended the racially segregated Khutsong Primary School where she completed her higher primary education. The 1949 primary school syllabus, introduced by the National Party, offered an Arts and Crafts syllabus that supported 'traditional' uses of fibres and clay but crafts were taught by under-trained teachers in under-resourced schools and Sebidi credits her knowledge of traditional crafts entirely to her grandmother.

In 1948 the National Party government began eliminating the remaining integrated areas and 'Homeland Territories' were instituted within a network of laws and coercive state powers to ensure that black people would be effectively policed into acting as an obedient work force. Mabasa and Sebidi grew up in these reserve territories effectively excluded from legal residence in cities unless legitimized by work deemed suitable for black persons.

Mabasa encountered the city at the age of 14 when she was sent to Johannesburg to care for her niece. For the next three years while resident in White City, Soweto, she experienced dreams of her deceased father calling her back to his grave in Giyani. The contrast between city living and her rural home was immense, particularly when faced with survival under the newly enforced influx control laws that followed the promulgation of the 1950 Group Areas Act. In 1955, Mabasa, aged 17, married a Shangaan man, Jim Mabasa. She was not permitted to live with her husband as government policy discouraged the permanent urban presence of African wives and families. To facilitate the implementation of controls over place of residence and work, the Natives Act required all black adults to carry passbooks and the year of Mabasa's marriage witnessed the groundswell of protests against passes for women that culminated in the first women's demonstration in Pretoria. Widespread demonstrations continued throughout 1956 until the second major gathering of women in Pretoria on 9 August.

Mabasa experienced political violence as a result of this legislation and the racist behaviour of law enforcement officers and recalls being assaulted by a white official when failing to produce a permit and passbook (Mabasa, 2000). In 1956 she moved to her husband's family home in rural Giyani, effectively debarred from urban life and restricted to domestic work within her husband's homestead while he commuted between Gazankulu and Alexandra. In 1965, five years after her second child was born, she experienced vivid dreams again. They were filled with foreboding and instructions but she ignored them despite becoming ill after each experience. For a decade she performed the domestic duties expected of her. She tells of physical assault from her husband and illness (Mabasa, 2000), and her nervous anxiety escalated until her husband 'returned' her to her parents' homestead in Venda (Mabasa, 2000). Here, with

young children, Mabasa supplemented help from her biological family with assistance from friends and neighbours.

Sebidi's schooling ended in Standard Six when she was called to join her mother in domestic service in the city in 1959. The Native Labour Regulations Act was introduced that year and, despite protests by women, the bill became law in 1960. Like their menfolk, all African women had to register with countrywide labour bureaux set up to allocate and distribute labour (Walker, 1991, p. 222). Sebidi, adjusting to life in the poor, congested townships allocated to black urban residents, began to understand that these dislocations of traditional community life resulted from economic exploitation by white people. Her response was to try to maintain her integrity: 'I never have pain and never worry about this treatment from white racists because I can see who they are and if I do get worried I might join them [in sentiment]' (personal interview, July 1995).

In addition to the racism she experienced in the city, Sebidi encountered sexism. Apart from being preyed on by men Sebidi was disorientated by the lack of formal ceremonies that, in the rural areas, acknowledged women's roles. No ceremonies marked a woman's departure to the city and still less did migrant men formally recognize their legitimate presence. No strategies regulated women's behaviour and few single young women escaped pregnancy (Mager, 2001, p. 261). Sebidi became pregnant, experienced tremendous stress doing domestic work and then returned to her grandmother for three years. Customary law made no provision for unmarried mothers and Sebidi, who had been born out of wedlock and denied security and status, now found herself in a similar predicament to her mother's. In 1962 she returned to the city to resume domestic work for a decade, during which she underwent renewed frustration and physical discomfort.[5]

The reasons why Mabasa and Sebidi decided to become producers of visual artefacts seem to be closely related to dissatisfaction with the roles they were expected to fulfil but had difficulty accepting. The modes of visual expression they chose to adopt are interesting in relation to their traversal of the rural–urban divide.

Mabasa has explained how her decisions to work with clay, and later wood, were based upon her dreams and what she describes as ancestral visitations followed by sickness.[6] She recovered only upon heeding the advice she extracted from her visions, which enabled her to assert her sense of self through an ancestral voice, thus affirming her place in a social and cultural matrix that had changed significantly from her youth to adulthood. Mabasa's connection with the ancestors suggests a link between the imagining, dreaming and intuitive self, and a self realized through a shared cultural past. She received guidance from her deceased father in her visions and, with her sister acting as intercessor, deduced that she should take advantage of the clay-working techniques revealed to her in her dreams.[7]

It is possible to understand Mabasa's post-dream sickness as spirit possession calling for acknowledgement of the ancestors and their demands.[8] It has been argued that migrancy led increasingly to women in reserves and migrant communities in cities being possessed and receiving calls from male forebears, and Mabasa's possession suggests an impulse to claim a familial connectedness lost when she separated from her husband.[9]

Mabasa describes the spirit realm as facilitating self-articulation and survival (Nolte, 2001, p. 247). She has referred to recurring dreams of her father who, she says, told her to ask her sister to perform ancestral propitiation and gain approval for Mabasa to make art and to pursue good fortune (Nolte, 2001, p. 35). In 1974, aged 36, Mabasa decided not to work traditionally with clay vessels but to produce her newly envisaged clay figurines, documenting human types she observed around her as well as symbolic animal forms.

Like Mabasa, Sebidi was initially afraid of community censure when she began making her own artworks. In time she understood that the images she painted and the cultural activities taught to her by her grandmother both asserted the continuing presence of her culture. Raised in the rural homestead of her maternal Tswana grandmother, Metato, Sebidi had limited contact with her mother and father who worked in the city. From her grandmother Sebidi learned the value of creativity and the fact that, despite financial need, her people enjoyed cultural wealth (Louw, 1993). She learned the practice of Tswana wall painting, *litema*, and the making and decorating of calabashes.[10] These lessons from her grandmother inform Sebidi's definition of culture as that which is intrinsic to personal and social well-being.[11] Sebidi honours the memory of her powerful 'protector', whose name, Metato, means 'the fence' that goes around the lake (Sebidi, 1994, p. 1). Sebidi explains the 'lake' as tradition (Ozynski, 1993) and recalls her grandmother as a 'sensitive and cultured woman' who did not want her to be confined to the role of domestic servant in the city (Jacobson, 1989; Shelley, 1990).

While in domestic service, surviving as a single mother, Sebidi became ill, left her work place and experienced persistent visions that led her to begin painting. She returned to Marapyane where she reports having woken one night in near delirium. Four ancestors offered her paths to follow: builder and agriculturist Ramabele Sebidi; *sangoma* (spiritual and herbal healer) Lotta Sebidi; wall painter Robert Sebidi; and an unnamed thatcher of roofs (Louw, 1993). She chose the path of image-maker, recovered and returned to the city with this vision in mind.

Sebidi understands her visions or dreams as affirmations of the link between God and her ancestors, connecting her to rural roots and teachings, countering her isolation in the city and reminding her of the social hierarchy that ensured continuity of custom and law in her rural milieu. She explains the dreams that inform her art as follows:

> When I'm saying 'dreams' I normally feel that the waking space comes
> from dreams ... The dream comes all the time, even when you're sitting ...
> You're really being kept very busy and need to explore your work through
> these dreams. Having these people [in dreams] coming to explain to you
> how you can start working, you don't have to feel sorry for yourself.
>
> (personal interview, July 1995)

A comparison of the techniques learned by Mabasa and Sebidi reveals interesting links in relation to what was borrowed from customary cultural practices in their rural abodes and what was absorbed from the practice of artists exposed to institutionalized modernism in the cities. Differing visual styles characterize the work of urban black artists during the 1950s and 1960s. Some pictured survival on township streets figuratively while others portrayed the decimation of the human spirit more abstractly.[12] To understand the art of Mabasa and Sebidi in relation to the manifestation of modernism in Africa requires recognition of the conditions endured by different cultural groups and the cultural position of black women, especially as they moved between the countryside and city.

Mabasa learnt from practices that had been customary in her community, initially coiling and firing clay and later carving wood. Using the coil technique, her first figure depicted a girl hitting a drum (Nolte, 2001, p. 36; Williamson, 1989, p. 50). Her figures seem to have been informed by the hieratic formality of 'door-post' figures that decorated the *lapa* (outside courtyard) walls demarcating Venda homesteads (Younge, 1988, p. 38). These early clay figurines became popular for their documentation of personalities and types in her community and were marketed for consumers outside of her community.[13]

Mabasa's daughter, Sikane, sold the figurines from the roadside to tourists. Monies earned enabled Mabasa to alleviate years of poverty and to date she supplements her income with the sale of such works. Having attained recognition, Mabasa was commissioned to execute clay images of members of the Venda cabinet for the Sibasa Museum, Thohoyandou, and for a clinic in Venda (Rankin, 1989, pp. 38, 120).

That she modelled her earliest figures upon clay and wood *matano*[14] figures used in the *domba*[15] initiation ceremonies generated debate amongst art historians who have explored the implications of Mabasa reshaping customary practices of visual production. A photograph of the artist with a recent relief work (Fig. 9.1: *c.*1996–98) illustrates her movement from earlier forms of three-dimensional clay figurines to relief work. Her imagery conveys aspects of the *vusha, tshikanda* and *domba* initiations that confer adult status on young women and pass on knowledge of sacred leadership and secular distinction. Here we see references to the sacred *vusha* enclosure within a specific corded perimeter, the 'master' in charge of the initiation, women beating the bas drums symbolic of the court of Venda or the womb of life and the *domba*, or python dance. There are also references to the phallic movement of the *domba* that signifies life in the womb and the gradual strengthening, confinement and

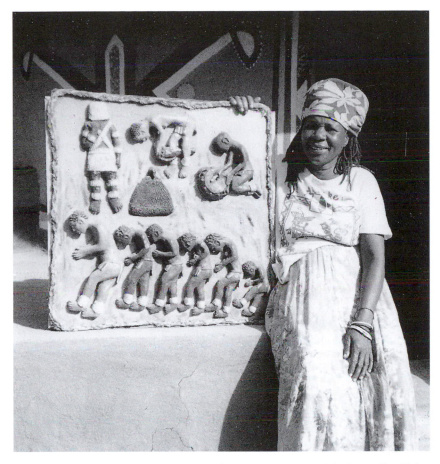

Fig. 9.1. Noria Mabasa holding clay relief sculpture. Photograph by Jacqueline Nolte.

birth of the novice.[16] Owing to her documentation of such details of secret ritual Mabasa's works have been analysed as transgressive productions.[17]

Although Mabasa's clay characterizations proved commercially popular, she preferred to execute her 'dream' visions as woodcarvings, a task customarily undertaken by men in her community. It seems clear from her statements that her decision to sculpt was informed by her 'visions', but it is also apparent that time and cost motivated her to focus on woodcarving rather than clay modelling.

In 1981 Mabasa experienced dreams of trees washing down the river and she realized she was being directed to carve driftwood retrieved from the riverbanks. Apparently she met fellow sculptor Nelson Makhuba in 1983 and

was inspired to carve[18] but this contradicts her own account of carving as early as 1981. Mabasa first exhibited her work at the Venda Sun Hotel in 1984, the year Makhuba introduced her to curator Ricky Burnett. Makhuba's influence is difficult to assess but Mabasa owes her inclusion in the influential 1985 'Tributaries' exhibition (curated by Burnett) to Makhuba. In 1985 Ditike, Craft House of Venda (a project of the Venda Development Corporation), began promoting her work. Suddenly in demand, Mabasa's art was subjected to critical reception by urban critics who coined the problematic term, 'transitional' art to describe the work of Mabasa and other rural-based artists.[19]

The context in which Mabasa learned to make objects situates her apart from artists who received training at formal institutions or community arts-based projects in cities, but her work entered the same urban-based market and the same arena of critical reception as urban artists.

Mabasa negotiated many locations. These include her initial situation in the rural reserves with little formal education, and her roles as a woman 'policed' out of urban areas back to the 'reserves', wife and mother in her husband's homestead, and 'othered' figurative sculptor of 'taboo' subjects largely unfamiliar to local and international art markets. At times Mabasa felt exploited by dealers, who made unusually large profit margins on her works (Powell, 1989b), and her lack of formal education and command of English (despite fluency in many African languages) led to a sense of disempowerment regarding distribution, promotion and critical reception (Nolte, 2001, p. 250). Her geographic and social location resulted in her work being used to illustrate the category of 'transitional' art as that which does not participate in contemporary international art discourse and is overlooked by curators unless their desire is to 'showcase' African difference.

Sebidi returned to the city with hopes of employment and creative outlets, and attempted to supplement her income as an occasional domestic worker by sewing. In 1966 she chose another form of expression. Employed in the Johannesburg home of Heidi Paetsch whom she would credit in helping her to discover herself and her creative potential ('No easy road to success', 1991), she was encouraged to emulate Paetsch's painting. She then sought part-time art tuition at Dorkay House, where she met Ezrom Legae (1937–99), who introduced her to charcoal and pencil drawing (Jacobson, 1989).[20] This tuition ended when attending night classes became difficult owing to lack of transport. In 1972 she met Koanakeefe John Mohl (1903–85),[21] who encouraged her to persist with oil paints (Shelley, 1990; Sebidi, 1994) and with whom she studied, once a week, for three years.[22] Her regular contact with Mohl ended in 1975 when she went back to Marapyane to care for her grandmother. Sebidi only returned to live in the city eight years later.

In Marapyane, Sebidi's grandmother recognized the paintings of Tswana rural life as extensions of the creative tasks she had taught Sebidi as a child. However, aware of possible problems related to Sebidi's unusual activity, she encouraged

Sebidi to protect her painterly practice from community criticism. Sebidi believes that her decision to be an artist complicated her life because she transgressed gendered expectations (personal interview, July 1995). Like Mabasa, Sebidi might have stood accused of *boloi* (witchcraft) if seen to be progressing in ways other than those culturally sanctioned. Her grandmother enabled Sebidi to leave the company of the visitors to return secretively to her painting and while in Marapyane Sebidi intermittently managed to take works to Mohl for feedback.

When Sebidi met Mohl he was an established artist and he became an important mentor who, in 1977, supported her inclusion at the 'Artists under the Sun' exhibition in Johannesburg's Joubert Park. His oils picture contrasts of rural and township life and his influence on Sebidi's early work is evident as she emulated the picturesque, figurative mode in which he worked. After her grandmother's death in 1981, Mohl provided the encouragement and guidance Sebidi sorely missed (personal interview, July 1995) until he died four years later. About 1985 she met Lucky Sibiya (1942–99) who supported her at a time when she was still producing paintings depicting idyllic community existence in rural settings in the manner learned from Mohl.

At the Party (1985; Fig. 9.2) portrays her idealized memory of rural life and work. She explains these early paintings in terms of her desire for cultural pride, integrity and self-sufficiency: 'I want to show the peace that was, when people enjoyed life and there was less hatred among them. It is the world my grandmother knew. I have no answers for the bad in life today – the reasons are too deep. That's why I don't paint about it' (quoted in McKinnell, 1986, unpaginated).

Her images are of women grinding and sifting corn, carrying harvested produce from lands they have tilled, preparing food and caring for children, men and the elderly. Sebidi points to *molao* (Tswana law) as the foundation of a proper life for the individual and community[23] and, given her social position as a single migrant mother, it is interesting that in all Sebidi's early works individuals are shown pursuing law-abiding lives within the community. Agriculture is shown as an inextricable component of culture and villages are pictured as nucleated settlements where the occupants sustain themselves from the land. *At the Party* presents the full benefits of this ideal lifestyle. Using a linear perspectival framework, Sebidi, who was then tending her dying grandmother and uncle, represents society as an ordered whole based upon predetermined and clearly defined roles.

Although supportive, Lucky Sibiya[24] suggested that Sebidi break away from conservative figurative imagery (McKinnell, 1986) but this took effect only in 1986 when, after meeting David Koloane (b. 1938), Sebidi enrolled at the Johannesburg Art Foundation. Here she studied under Bill Ainslie (1934–89) and Ilona Anderson (b. 1948) who encouraged a more expressive use of media.[25] Sebidi began interpreting her urban experiences, explaining that her 'artwork depicts the conflict between women and men, the past and

Fig. 9.2. Mmakgabo (Helen) Sebidi, *At the Party*, 73 × 51 cm (28³/₄ × 20 inches), oil on board, 1985, Sasol Collection, Johannesburg.

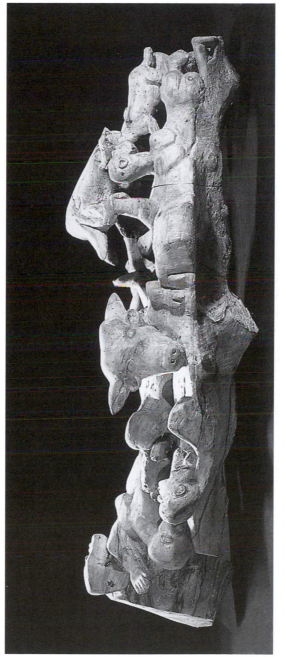

Fig. 9.3. Noria Mabasa, *Natal Flood Disaster*, 240 cm (94½ inches) in length, wood, 1988, Collection of William Humphreys Art Gallery, Kimberley.

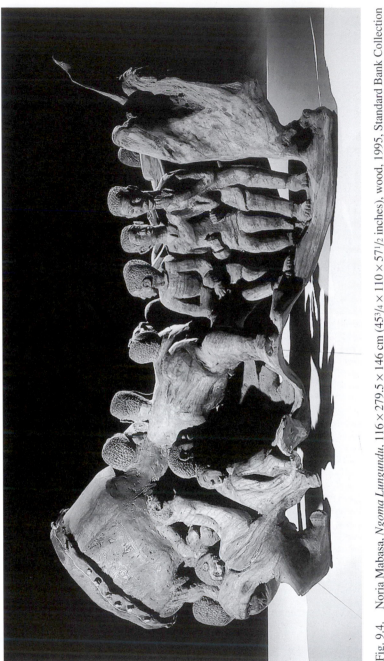

Fig. 9.4. Noria Mabasa, *Ngoma Lungundu*, 116 × 279.5 × 146 cm (45³/₄ × 110 × 57¹/₂ inches), wood, 1995, Standard Bank Collection (Wits Art Galleries).

the present' (quoted in Pemba, 1997).[26] References to the psychological impact of colonialism, sexism and racism, although new in Sebidi's work, were not new experiences for her.

Mabasa's and Sebidi's early works attempt to represent a cohesive worldview where players assume allotted roles. In the face of the brutalities of South African modernization, images of the *domba* and communal food preparation conjure up a mythical sense of home, suggesting a need to secure relations with living relatives and the dead, and evoking memories of ancestry and established rituals.

If, for the artist, memory offers an encounter with potential and desired meanings then image-making facilitates identity formation. Two works by each artist will be examined for evidence of identity formation; reading these works as narratives of migration permits us to understand not only physical references but also psychological associations and reflections. Viewing Mabasa's and Sebidi's imagery with this in mind alerts us to what artists might encounter in the process of creating and how traumatic experience might be located and subsequently dispersed.[27]

Mabasa not only represents people engaged in customary and more modernized political rituals, but also represents threats to order. In *Natal Flood Disaster* (1988; Fig. 9.3) and *Ngoma Lungundu* (completed 1995; Fig. 9.4) she recognizes the destructive and regenerative factors in life.[28] In these and other carved works, such as the *Carnage* series, she uses wood's organic growth patterns to create complex compositions of interconnected parts suggesting natural and social cycles. Her large memorials to flood victims narrate a sequence of events less cohesive than appears in the overall unity of composition. The carnage she depicts evokes struggle with the elements and all that poses as 'natural' order.[29]

In Mabasa's flood carvings interlocked human and animal forms speak of a lifestyle in which dependence on land and livestock is already fragile. Wood becomes bone and carcass, upside-down animal bodies float alongside severed, hollowed human torsos and protruding rib cages metamorphose into angel-like wings. *Natal Flood Disaster* also invokes mythic associations related to Venda cosmology, notably the idea of human return to a spiritual or watery realm, and the desire for a chief to become mediator in times of flood, drought, famine or plague.

Mabasa's images of carnage, flood and crocodile attacks come together in a recurrent theme in her work – the Venda migration southward, across the Limpopo River. Her depictions of this migration in the early 1700s feature the drama of negotiating the river, with cattle, domestic animals and people, all at the mercy of the crocodile-infested waters. *Ngoma Lungundu* comprises both three-dimensional and relief human figures, a cow's head and a large drum. On one side are carefully arranged clothed male figures that engage in the strenuous effort of carrying the large drum. Nettleton (2000) writes,

[*Ngoma Lungunda*] means, literally translated, drum of thunder and invokes both the concept of chieftainship and the most sacred symbols of Venda cosmology. The plural form of the word *ngoma*, *dzingoma*, not only refers to many drums but mysteries, things secret and sacred, often having miraculous powers, possessed by Chiefs who trace their lineage back to the Venda, founding heroes, Dyambou and/or Thoyo ya Ndou.

Nettleton notes that, according to legend, Tsilume, a paternal ancestor of Dyambou, was charged with leading the Senzi out of Zimbabwe by the supreme power, Mwari, who gave Tsilume a massive drum, *ngoma lungundu*, possessing magical powers. It had to be carried by many people, was never allowed to touch the ground and had to be protected from evildoers. Nettleton (2000) describes Mabasa's sculpture as a depiction, on one side, of those carrying the drum, and on the reverse, of fallen figures possibly overcome by its powers. The drum is portrayed as the heart of a culture, which can be seen, felt and heard. If the people and culture are to survive it is contingent on their transporting this drum. People carry it, labour under it, rest at its base and try to keep it afloat above them. The drum is counterbalanced at the opposite end by an abstracted bird-like form comprising a fusion of parts suggesting both bird and prow.

On the side with female figures in disarray, a looser conglomerate of intermingling forms exists. Almost naked, as they would be in the *domba* initiation, figures are lying or are seated; all turn away from one another as if exhausted or possibly in a sleeping/spirit state. According to Nettleton's reading, the figures, overcome by the power of the drum, may represent female dancers in the *domba* python dance, positioned as if 'crushed' by the weight of patriarchal traditionalism. The *domba* also makes use of the *ngoma* (one of the *dzingoma* connected with the past) and the *tshikona* recalls the reeds played by the Lemba when migrating south. Thus the content of the piece, indicated by its title, alludes to the origins of those who, today, are broadly referred to as Venda. It is clear that the centrality and weight of the drum signifies the migration myth and the power of the chieftainship as well as the 'pool' or womb of creation, thus alluding to cultural initiation.

Focusing on the migration myth, Mabasa's sculpture also asserts cultural identity through reclaiming 'collective' memory. Given Mabasa's experience of forced relocation by the South African government, as well as her experience of the government's orchestration of 'independence' in the Venda 'homeland' in 1979, it is understandable that she explores recovery of Venda history and identity. It is also possible that she uses this subject matter to discover how she, as woman, is positioned within this historical narrative, and how this coincides with her experience of marital and patriarchal structures of control.

Mabasa's sculptures picture mythic order as well as realms outside human control. Elements pertaining to the latter are loosely articulated; figurative

forms grow out of one another suggesting ceaseless transformation of matter. In *Natal Flood Disaster* and *Ngoma Lungundu*, Mabasa depicts interdependent cycles of life and death, exploring death as a surrender to fluid structures and states of being. Space is marked by a relative sense of peace compared to the tension depicted at moments of, or just prior, to death. Drawing from collective and personal memories of flood, Mabasa sculpts the river as metaphor of life and death, returning to this theme time and time again as if confirming an understanding of art that attempts to access memory and obliterate traumatic experience by giving it conscious form.

Modern Marriage (1988; see Plate 5) and *I Have Seen Through Him* (1989; see Plate 6) are executed in Sebidi's later style where, in contrast to the illusory three-dimensional perspectival space of *At the Party*, she demonstrates less confidence in outer appearances. She developed this more expressive style at the Johannesburg Art Foundation and as a participant in the Thupelo Workshops. Sebidi offers psychological insights into city life, a compressed geography and claustrophobic experience equivalent to survival under apartheid. In these collage-like paintings she plays with figure–ground relationships.[30]

However, although alluding to earlier techniques, she does not self-consciously construct spaces reminiscent of her past training.[31] Perspectival space is replaced by space that spills out towards the viewer as if to implicate one in these disrupted areas. In the process of trying to find form within her dense surfaces the viewer abandons certainty. Human figures no longer occupy vistas but are crowded in upon one another, overlapping, disassociated and without evidence of a supporting framework of natural resources. In *Modern Marriage* precious grain is spilled, eggs are cracked and storage containers are overturned. Figures with faces split lengthways desperately scramble to survive as clearly delineated boundaries give way to a kind of disfiguration. Permutations of physical and emotional confusion include figures with both male and female identities, plus modern and traditional dress.

This iconography is repeated through much of Sebidi's work. Individuals and their culture are subject to violent exploitation; all body parts are marked with a common patterning of striations, scumbling and cross-hatching as though to emphasize interminable energy and chaos. Sebidi seems to insist that viewers, witnessing tension, desire order.

It is clear from surveying Sebidi's work as well as from interviews with the artist that her artworks comment on life in urban environs. Although she has now lived in the city for three decades, she still refers to it as a confusing place, which only her art helps her to navigate (Sibanda, 1998). For Sebidi the city promotes amoral behaviour and excessive individualism, but despite the evil that disrupts social relationships, individuals are challenged to rise above it (Nolte, 2001, pp. 40–41). 'Evil' is understood in most cases to result from historical and material circumstances. It manifests in deceit, indecorum, selfishness, envy and, of course, fear and desperation related to poverty and oppression; all of these

inhibit compassion. The propensity for evil also exists abstractly and can be defined in some works in relation to non-human, carnate and incarnate agencies, either benign or malevolent. In the case of 'modern' Africa, they seem to manifest malevolence. Her titles – *Modern Marriage* (1988), *Modern Time* (1988), *Modern President* (1988–89) and *Lies in the Modern Meeting* (1988–89) – all attest to her obsession with harm caused by modern, urban ways.

As indicated by Sebidi, animals form the basis of life, preceding and teaching humans. She observes that if one experiences difficulty 'we don't say a thing outright – if you are having a hard life, we won't call your life bad, we will go around; we will say "you are fighting with an animal and if you catch his tongue then you will come right"' (quoted in Williamson, 1989, pp. 37–8). In Tswana culture animals are a central measure of one's self-worth and peace of mind (Alverson, 1978, p. 11). Sebidi (1994, p. 3) says of them:

> In most cases the animals are people ... The animals, which were our first brothers and sisters, have been taken from us. The animals that now enter the world are dangerous. These are the people who have killed the ancestral animals. They are impostors; separation between human beings and animals is part of this.

The animals in Sebidi's images are rendered as 'impostors'. In their state of lawlessness, humans imitate these undisciplined, non-reasoning animals and represent the 'evil' in modern society that one constantly battles. But not only are they metaphors for a disrupted human and ancestral order, they are also images of cunning. They are indicative of moments when one has to cope in an alien world through 'alien' means not approved of in times of old but sometimes *necessitated* by having to survive in 'white' cities. In this sense, these sly animal presences echo the multiple masked presence of those around them, exemplifying many survival strategies. That the situation leads to perverted states is evident in the malformed beasts in *Modern Marriage* and *I Have Seen Through Him*.

The horns pointing in contrary directions in *Modern Marriage* also allude to tensions between customary and modern practices with respect to women. The tension is between the practice of *bogadi* (bridal wealth) and modern exchanges that pay little heed to ensuring familial bonds, obligations and economic security. Thus it is not simply devastation that Sebidi pictures, but the need for ritual and divination to recover order. In the context of men disempowered, removed from their lands and often unable or unwilling to pay *bogadi*, it is women who, for Sebidi, retain links with tradition, preserving the family and the old ways.

The title *I Have Seen Through Him* suggests a sympathetic understanding of what lies at the root of black men's lack of power, namely his humiliation under apartheid. Here Sebidi refers to men losing their roles as mediators between the earthly family and the guiding paternal ancestors. As in *Mother Africa* (1988; illustrated in Williamson, 1989 p. 38), Sebidi comments on

women in rural or urban domains;[32] in the former they are left by husbands forced into migrant labour and in the city are without the protection of customary law or anticipated support. In these images women's sorrow and devastation is echoed by the malevolent beings that threaten their sustaining work but ultimately it is women who must act as protectors because to be isolated is contrary to one's humanity.

Sebidi's repeated use of these male–female figures raises the question of whether they contain a more personal level of signification for her.[33] Instead of 'living' the familial ideal, Sebidi paints it, emphasizing its importance whether as an affirmative imagining (as in her early works) or in mourning its rupture. The present is split from the past, people are split from their culture, woman is split from man and from herself. For Sebidi, the outer circumstances that disrupt established roles and codes of conduct demand a resolve to act with decorum. However, much of her work addresses the difficulty of meeting these challenges. One means of survival she explores is how to protect the inner self by assuming a public mask. The 'masked' face that appears in *Modern Marriage* and *I Have Seen Through Him* suggests superficial conformity and cunning survival but also shows that the inner self can be eroded at any moment.[34]

Mabasa and Sebidi directly experienced the effects of the European expansion and the capital growth that divested peasants of their secure hold on the land. Although they tried to resist uprootment neither could subsist though their art within local markets. Both artists had to participate in a market system in which they have not felt properly or securely represented. The modernization imposed in South Africa by industry and government in the mid- to late-twentieth century left few black people with delusions of progress. Instead, as is evidenced in later works by Mabasa and Sebidi, humanity is experienced as a kind of debris in infinite flux.

These artists' narratives of migration, whether based on distant collective memory or immediate personal experience, bring to consciousness the effect of migration upon women in increasingly complex and changing social landscapes. In their own lives Mabasa and Sebidi provide evidence of having forged new pathways. They first attempted to incorporate customary modes of expression into their painting and sculpture by alluding to earlier cultural forms, an initiative undertaken in situations that would otherwise have left them feeling displaced. As women whose circumstances situated them in tenuous relations with their immediate and rural communities, both artists asserted themselves creatively, thus transforming their circumstances and reshaping personal and collective memories into specific accounts and forms of migration. Their experiences of trauma and the challenges posed by enforced relocations are communicated to viewers whose task it is to witness such suffering and consider its origins.[35]

Notes

1. The 1913 Land Act required white farmers to expel black peasant 'squatters'. Black Africans could not own land independently on the reserves, and black tenants on white farms were obligated to give 90 days of labour to white farm owners.

2. See Platzky and Walker, 1985 for reference to the barren dumping grounds that constituted the destination of many of these forced removals.

3. The Bantu Education Act of 1953 removed African schools from provincial and private (mostly church) control, placing education under the auspices of central government. Art education received little to no attention at the secondary school level. (See Nessa Leibhammer's discussion of Bantu Education in Chapter 6 of this volume.)

4. During the nineteenth century Tswana territory was invaded by white Afrikaners, missionaries and indigenous military conquerors, including the Matabele (Alverson, 1978, p. 21). Land expropriation forced Tswana people into smaller territories and the impact of white settlement led ultimately to their becoming largely incapable of producing the material resources necessary for subsistence.

5. See Nolte, 2001, p. 41 and Sealey, 1988, p. 12.

6. Personal interview, January 1998. See also Williamson, 1989, p. 51; Solomon, 1994; Arnold, 1996, p. 142; and Hopkins, 2004.

7. After returning to her parental home she dreamt of an old leper who demonstrated clay work to her. These dreams persisted for nine years followed by periods of intense pain. In one dream she was immersed in the river and beaten with small reeds by her deceased father. He insisted that she accept the guidance of the old woman. Mabasa fasted and isolated herself until she received another vision from her father about the old woman's lessons. Hopkins (2004) relates that she shared this dream with her father's first wife, who performed a healing ritual, thus sanctioning Mabasa's choice.

8. See Boddy, 1994 for a discussion of spirit possession.

9. James (1999, pp. 168–9) points to spirit-induced dissociation that may be central or peripheral in a society, 'possession' being associated with deprived societies. Hammond-Tooke (1986) refers to cults with spirits of affliction originating in Africa south of the Limpopo over the last 80 years and suggests that predominantly female cults arise in response to fundamental social change in African society. This is the region where Mabasa lives. Hammond-Tooke (1986) and Sibisi (1975) argue that these beliefs are not ancestral but foreign, originating amongst the Shona in Zimbabwe.

10. See Jacobson, 1989 and The World's Women On-Line!, 2003.

11. Sebidi explains culture as that inner voice that we are born with and need to contact, that 'god-guide' that directs our actions (personal interview, July 1995).

12. The impact of modernism on the post-war generation of black South African artists is demonstrated with reference to George Milwa Pemba (1912–2001) and Gerard Sekota (1913–93) who met at the studio of Maurice van Essche (1906–77). Some black artists expressed scepticism about what they encountered in their modernist white colleagues' studios. Pemba did not believe he could learn from the Fauvist and Expressionist leanings of Van Essche (Nolte, 1996).

13. Berman (1987, p. 21) writes, 'The reason Mabasa offers for creating these highly idiosyncratic and often ironic and humorous figures is their apparent novelty.

Medical men, for example, are a new phenomenon in Venda whose requirements were previously catered for by the local *inyangas*. The black bureaucrats are equally as innovative and prominent a force in a newly designated "Independent homeland".' Powell (1989a, p. 27) describes her works as chronicles of the petit-bourgeoisie in the newly established Venda 'homeland'. Mabasa depicted doctors, nurses, businessmen, civil servants, soldiers and policemen.

14. See Nettleton (1989b, pp. 5–6) for references to both clay and wood *matano* figures used in the *domba* and made or commissioned by the *khombo* (specialist who runs the initiation school). *Matano* clay figures are generally limited to puberty initiation rites (*vusha*) and the wooden figures are generally used in the *domba* marriage school (Nettleton, 1989b, p. 6). These figures are used to illustrate the sexual mores and duties of Venda women.

15. Nettleton (1984, p. 372) describes the *domba* as follows: 'The major function of the *domba* is ostensibly to prepare the youth for marriage . . . for their adult roles within the Venda nation, especially the woman for her role as a wife and mother. The Venda has a system of patrilocal marriage and patrilineal descent and a wife always remains an outsider in her husband's group. She is subject to the authority of her husband or father throughout her life ... It is thus essential that the woman be imbued with a sense of her duty as a member of her husband's group, subject to the authority of males in ascending order from her husband and father to the chief.'

16. See Huffman, 2001, p. 89 and Blacking, 1969, p. 216 on the practice of the *domba*.

17. See the summary of this argument in Nolte, 2001, p. 36. Disregard of customary behavioural expectations is noted in Rankin-Smith, 1987; Hammond-Tooke and Nettleton, 1989, p. 176, citing Dell; Duncan, 1994; and Arnold, 1996, pp. 142–3. Mabasa has indicated her initial unease about 'going public' with her figurines (personal interview, January 1998), but insists that neighbours' early scepticism yielded to admiration when economic benefits began to accrue (Mabasa, 2000).

18. It is possible that Mabasa began envisaging her dreams in wood after seeing sculptures by Nelson Mukhuba and Meshack Raphalani in 1983 (Sack, 1991, p. 108). However, this does not rule out her integration of this experience with messages received from ancestral voices.

19. See Richards, 1990, pp. 35–44.

20. In the 1940s the Johannesburg Local Committee for Non-European Adult Education used a hall in Polly Street, Johannesburg. In 1949 a cultural recreation officer was appointed. Cecil Skotnes (b.1926) assumed this post in 1952 and started a flourishing art workshop and cultural centre. With the implementation of separate development, the West Rand Bantu Administration Board decided to close down the premises. About 1960 the Jubilee Art Centre replaced Polly Street but this too was closed towards the end of the 1970s and relocated to the Mofolo Art Centre in Soweto. Dorkay House was then established as an independent cultural venue (Sack, 1988, p. 17). Ezrom Legae, who studied at Polly Street under Skotnes and later under Sydney Kumalo (1935–88) became an art instructor at the Jubilee Centre and, when Sebidi met him in 1964, he was teaching at Dorkay House.

21. On Mohl's career see Miles, 1997, pp. 57–62.

22. In *Arts Calendar* (14[1], 1989) these years are mentioned as 1971 to 1973. Alexander and Cohen (1990, p. 151) specify Sebidi's tuition with Mohl as 1970–73. In '"Tloga Tloga E Tloga Kgale Modisa Wa" Kgomo O Tswa Natso Sakeng', Sebidi states that she met Mohl in 1972.

23. *Molao* pertains to procedural law, to social pressure and to self-imposed obligations (Alverson, 1978, p. 142).
24. Sibiya received advice from teachers trained in modernist abstraction, notably Cecil Skotnes and Bill Ainslee. When Sebidi met Sibiya in the mid-1980s he had exhibited extensively and his 1984 solo show at the Everard Read Gallery, Johannesburg, possibly influenced Sebidi's decision to exhibit through this gallery.
25. See Sealey, 1988, p.12 and Arnold, 1989, p. 12.
26. She also explains, 'The bold pictures are blacks and sometimes women struggling to make ends meet in the cities. There is also a change of culture and tradition projected in the paintings. This is what city life is like' (quoted in Cembi, 1990).
27. See Benjamin, 1968, pp. 159–60 on the explanations of memory by Theodore Reik and Sigmund Freud. If memory is understood as destructive in the sense that once consciousness comes into being the trace of memory is left behind, then we might also perceive the making of artworks as a means towards consciousness formation and as a means of eradicating memory.
28. Sometimes in Mabasa's sculptures great natural forces triumph, as in numerous carvings of crocodiles eating people. Living on the bank of the Levuba River, Mabasa has witnessed three people die struggling with crocodiles (Museum of Modern Art, Oxford 1990, p. 53). Her use of the crocodile refers to the creature's central metaphorical power in Venda cosmology. Nettleton (1989a, pp. 72–3) discusses the crocodile within Venda cosmological beliefs, noting the ambiguity of the crocodile metaphor and pointing to its various manifestations in and out of the water. She suggests it as possible protector and as threat associated with Lake Funduzi, where the Singo Supreme Being is said to reside. The Venda patrilineal chief is referred to as 'the great crocodile' or 'crocodile of pools', thus securing his status as guardian of the court (pool), while the Mbedzi (pre-Singo Shona migrants into Venda), who use the reeds supplied in the 'national' Venda dance known as the *thsikona*, also have a crocodile as their totem. Mabasa's sculptures seem to indicate that crocodiles are associated both with the demise of people and their spiritual destiny, as if returning their victims to the 'lake of creation' from which they arose.
29. Her sculptures depict suffering related to her personal experiences of intermittent flooding in her house on the Levuba River. They also highlight the effects of such disasters, particularly on people in rural reserves who invariably lose homes, crops, fields and livestock, and often receive no assistance.
30. Her attraction to the endless formal mutations of collage may arise from her early *litema* training. 'Their [the Tswana murals'] complexity often makes it impossible to decide such matters as figure/ground relationships, the borders of pattern units, and whether a pattern is more regular than irregular. They visually vibrate back and forth in space' (Van Wyk, 1993, p. 90).
31. Sebidi states, 'Working with my grandmother and my mother on everything they did, it created textures and somewhere you pick up on those textures and have a feeling of love because you loved that work. I would say mud work and clay work on huts and floors, chopped wood, chopped trees, cut grass for building houses – everything comes back, and that "feeling", it's like "proving" the culture' (personal interview, July 1995).
32. Sebidi observes: 'The woman is carrying the cross. She still loves him even though he has dropped her. She works, she cooks, she does everything. How she is struggling. What was supposed to be gained has been destroyed' (quoted in Williamson, 1989, p. 38).
33. This depiction of personal and cultural fragmentation could be understood with

reference to Sebidi's own experience of familial loss, and her wariness regarding the role that men were 'reduced' to in urban apartheid. Denied the status that would have been afforded by her father's lineal ancestors, the fabric of the kinship that Sebidi desires is barely evident in her own life.

34. *Modern Time* (1988) and *The Child's Mother Holds the Sharp Side of the Knife* (1988–89) show a distinct use of these masks, a 'doubling' of face with 'mask' turned outward. In *Tears of Africa* (1988) different emotions are held within one multiple, often 'masked', face depicting contesting countenances of peace, sorrow, anger, greed and suspicion.

35. My heartfelt thanks to Noria Mabasa and Mmakgabo Sebidi for their cooperation on this project and to Antoinette Zanda for her support and counsel.

References

Alexander, Lucy and Cohen, Evelyn (1990), *150 South African Paintings: Past and Present*, Cape Town: Struikhof.

Alverson, Hoyt (1978), *Mind in the Heart of Darkness: Value and Self Identity Among the Tswana of Southern Africa*, New Haven and London: Yale University Press.

Arnold, Marion (1989), *Helen Mmakgoba (sic) Mmapula Sebidi. Standard Bank Young Artist Award 1989* (Catalogue for Standard Bank Young Artist Exhibition 1989), Johannesburg: Standard Bank.

———— (1996), *Women and Art in South Africa*, Cape Town, Johannesburg: David Philip and New York: St. Martin's Press.

Benjamin, Walter (1968), *Illuminations: Essays and Reflections*, ed. and intro. Hannah Arendt, New York: Schocken Books.

Berman, Kathy (1987), 'Noria among the gods of her household', *Weekly Mail*, 19–25 June, p. 21.

Blacking, John (1969), 'Songs, dances, mimes and symbolism of Venda girls' initiation schools. Part 1: Vusha. Part 2: Milayo. Part 3: Domba. Part 4: The great domba song', *African Studies* 28 (1–4), pp. 3–36, 69–111, 149–91, 215–66.

Boddy, Janice (1994), 'Spirit possession revisited: beyond "instrumentality"', *Annual Review of Anthropology* 23, pp. 407–34.

Cembi, Nomusa (1990), 'Compelling paintings by bold South African', *Natal Witness*, 22 February, 9.

Duncan, Jane (1994), 'Factors affecting the positive reception of artworks: a case study of selected artists' sculptures from Venda and Gazankulu since 1985', unpublished dissertation, Johannesburg: University of the Witwatersrand.

Hammond-Tooke, William David (1986), 'The aetiology of spirit in Southern Africa', *African Studies* 45 (2), pp. 157–70.

Hammond-Tooke, David and Nettleton, Anitra (eds) (1989), *African Art in Southern Africa: From Tradition to Township*, Johannesburg: Ad Donker.

Hopkins, Pat (2003), 'Noria Mabasa. "The Gift"', Online, Internet, available at <http://www.mukondeni.com/html/Noria%20Mabasa.htm> (accessed 8 July 2004).

Huffman, Thomas (2001), *Snakes and Crocodiles: Power and Symbolism in Ancient Zimbabwe*, 2nd edn, Johannesburg: Witwatersrand University Press.

Jacobson, Ruth (1989), 'Such tragic art. Yet such a happy year for Helen', *Weekly Mail*, 10–16 March, pp. 23–4.

James, Deborah (1999), *Songs of the Women Migrants: Performance and Identity in South Africa*, London: Edinburgh University Press for the International African Institute.

Louw, Joe (1993), 'A rejected char makes her mark', *Saturday Star*, 6 November, p. 4.

Mabasa, Noria (2000), letter to J. Nolte written by lawyer G.N.K. Hetisani on behalf of Mabasa, 24 March.

McKinnell, Kate (1986), 'A painter of a past peace', Reference BK, unpaginated (newspaper clipping in *Star* archives, Johannesburg).

Mager, Anne (2001), 'Migrancy, marriage and family in the Ciskei Reserve of South Africa, 1945–1959', in Sharpe, P. (ed.) *Women Gender and Labour Migration: Historical and Global Perspectives*, London and New York: Routledge, pp. 259–74.

Miles, Elza (1997), *Land and Lives*, Cape Town: Human & Rousseau.

Museum of Modern Art, Oxford (1990), *Art from South Africa,* London: Thames and Hudson.

Nettleton, Anitra (1984), 'The traditional figurative woodcarving of the Shona and the Venda', unpublished PhD thesis, University of the Witwatersrand, Johannesburg.

——— (1989a), 'The crocodile does not leave the pool: Venda court arts', in Hammond-Tooke, David and Nettleton, Anitra (eds), *African Art in Southern Africa: From Tradition to Township*, Johannesburg: Ad Donker, pp. 67–83.

——— (1989b), 'Venda art' in Hammond-Tooke, David and Nettleton, Anitra (eds), *Catalogue: Ten Years Collecting (1979–1989)*, Standard Bank Investment Corporation Ltd and University of the Witwatersrand, Johannesburg Art Galleries, pp. 3–8.

——— (2000), text produced for *Ngoma Lungundu* (1995) for the *Siyawela* exhibition, 1995, Online, Internet, available at <http://sunsite.wits.ac.za/ag/html/new96htm> (accessed 8 July 2004).

'No easy road to success' (1991), *Star*, 17 September, p. 14.

Nolte, Jacqueline (1996), 'Sources and style in the oil paintings of George Milwa Mnyaluza Pemba', in Proud, Hayden and Fineberg, Barry, *George Milwa Mnyaluza Pemba*, Cape Town: South African National Gallery and Mayibuye Centre, University of the Western Cape.

——— (2001), 'Locations and dis-locations of personal, public and imaginary space in the visual production of ten women artists working in South Africa', unpublished PhD thesis, University of Cape Town.

Ozynski, Joyce (1993), 'Sebidi's evocative, semi-abstract artistry', *Sunday Nation*, 21 November, pp. 4–5.

Pemba, Titus, (1997), 'Women of colour', *City Press*, 5 July, p. 16.

Platzky, Laurine and Walker, Cherryl (1985), *The Surplus People: Forced Removals in South Africa*, Johannesburg: Ravan Press.

Powell, Ivor (1989a), 'Carving out a new way of seeing', *Weekly Mail*, 28 July.

——— (1989b), 'Galleries score in the mark-up art', *Weekly Mail*, 11 August.

Rankin, Elizabeth (1989), *Images of Wood: Aspects of the History of the Sculpture in the 20th Century, South Africa* (exhibition catalogue), Johannesburg: Johannesburg Art Gallery and Hans Merensky Foundation.

Rankin-Smith, Fiona (1987), 'A survey into the effects of the white market on a selection of recently popularised rural areas', unpublished paper for University of South Africa.

Richards, Colin (1990), 'Desperately seeking Africa', in Museum of Modern Art, *Art from South Africa*, Oxford: Museum of Modern Art.

Sack, Steven (1988), *The Neglected Tradition: Towards a New History of South African Art (1930–1988)* (exhibition catalogue), Johannesburg: Johannesburg Art Gallery in association with the Holland Insurance Company.

———— (1991), *The Neglected Tradition: Towards a New History of South African Art (1930–1988)*, 2nd edn (exhibition catalogue), Johannesburg: Johannesburg Art Gallery in association with the Hollard Insurance Company.

Sealey, Sally (1988), 'From domestic to artistic', *Star*, 7 September, p.12.

Sebidi, Mmakgabo (1994), ' "Tloga Tloga E Tloga Kgale Modisa Wa" Kgomo O Tswa Natso Sakeng', unpublished paper by Sebidi delivered to Michaelis School of Art.

Shelley, Elmarie (1990), 'It's been a long slow journey for artist Helen Sebidi', *Argus Times*, 21 May, p. 5.

Sibanda, Mapula (1998), 'She epitomises a resilient African soul', *City Press*, 18 January, p. 13.

Sibisi, Harriet (1975), 'The place of spirit possession in Zulu cosmology', in Whisson, Michael G. and West, Martin (eds), *Religion and Social Change in Southern Africa: Anthropological Essays in Honour of Monica Wilson*, Cape Town: David Philip, pp. 48–57.

Solomon, A. (1994), 'Separate but equal', *The New York Times Magazine*, 27 March, Section 6.

Van Wyk, Gary (1993), 'Through the cosmic flower: secret resistance in the mural art of Sotho-Tswana women', in Nooter, Mary H. and Abimbola, Wande (eds), *Secrecy: African Art that Conceals and Reveals*, New York: Museum for African Art, pp. 81–97.

Walker, Cherryl (1991), *Women and Resistance in South Africa*, Claremont, South Africa: David Phillip (1st edn 1982, London: Onyx Press).

Williamson, Sue (1989), *Resistance Art in South Africa*, Cape Town: David Philip and London: Catholic Institute for International Relations.

The World's Women Online! (2003), 'Artists: Mmakgabo Mmapula H. Sebidi', Online, Internet, 7 March, available at <http://wwol.inre.asu.edu/sebidi.html>.

Younge, Gavin (1988), *Art of the South African Townships*, London: Thames and Hudson.

CHAPTER TEN

Representing Regulation – Rendering Resistance

Female Bodies in the Art of Penny Siopis

BRENDA SCHMAHMANN

'Taking Liberties: The Body Politic', curated by Ptika Nthuli and Colin Richards for the First Johannesburg Biennale in 1995, was an important exhibition of representations of the body by South African artists.[1] In a discussion of the show, Richards (1995, p. 138) indicated that its theme

> was stimulated by the recognition that the body is precisely where social becomes personal, where nature and culture intersect, where the forces of history visibly impact on the individual. In and through the body, social life is transformed into lived experience and the body is the fulcrum of struggles between top-down and bottom-up forces which seek to structure and control the social order. Indeed, in a sense, the history of South Africa could be read off the fate of the body *in situ.*

The body, he continued, is inscribed 'sometimes gently, sometimes painfully directly, through the genteel disciplines of social etiquette, through social regimentation and restrictive movement, through stigmatising skin, through proscribing free association', all of which are 'legalised in the massive edifice' of many apartheid laws that have 'constructed and constricted our political, economic and personal space, and our actions and affects within that space' (ibid.).

Although Richards's commentary was framed as an explanation for an exhibition featuring various artists, it is also an apt synopsis of explorations of the body by one artist in particular – Penny Siopis.[2] Published one year after the first democratic election, Richards's observations have particular resonance for works by Siopis from the 1980s that are the focus in this chapter.[3]

Included within Richards's discussion is a dialogue about the body as the point of intersection between seeming dichotomies, whether the private and public or nature and culture. Furthermore, the body might be understood not only as a signifier or material result of forces of repression, but also as a site in which resistance to these controls can be articulated. Revealing this tension

was part of the aim of 'Taking Liberties'. As Richards (1995, p. 138) explained, he and Nthuli wanted their exhibition to give visibility and concrete form to their 'specific experience of those forces in South Africa which sought, and inevitably still seek in such mutable ways, to organise, regulate and discipline the body'. Simultaneously, however, they 'sought to render visible those figures and forces which resisted, and still resist, this organisation, regulation and discipline'. While it need hardly be emphasized that the act of producing art is by no means the same as curating an exhibition, Siopis's works might be interpreted as offering a similar dialogue.

Siopis's works explore a history of disciplining the female body through legislative acts and political structures that bolstered white authority in South Africa. In much of her art made during the apartheid years, skin figures not only as the perimeter of the body – the site marking the juncture between 'self' and 'other' or between the individual and society – but also as a potent sign for classifying people in terms of their (ostensible) race. Yet even before the content of her works included specific references to a South African history of racial oppression and the policies that the apartheid state used to discipline and manage bodies, she was working in such a way that the bodies she represented were ones that resisted, indeed offered a transgression or defiance of, regulatory mechanisms that would seem to have been imposed on them.

Key to her works is a focus on what Julia Kristeva defines as 'abjection'. Following anthropologist, Mary Douglas (1966), Kristeva explores the significance of taboos surrounding bodily emissions and fluids, arguing that these articulate more than simply a revulsion against a lack of cleanliness. Since the body can function as a metaphor for social structures, a dread of its emissions is bound up with recognition of their capacity to threaten the social fabric.

In *Powers of Horror*, Kristeva (1982, p. 4) suggests that it is 'not lack of cleanliness or health that causes abjection but what disturbs identity, system, order. What does not respect borders, positions, rules. The in-between, the ambiguous, the composite'. One might argue that 'abjection', at least as defined here, is precisely what apartheid legislators were at pains to suppress. If apartheid was based on the premise that people might be positioned geographically and socially according to their supposed ethnicities, policing 'borders, position, rules' was the necessary mechanism for holding such a system in place, as was a refusal to make allowances for 'in-between', 'ambiguous' or 'composite' spaces or bodies. Thus Siopis's focus on abjection had particular resonance in a South African context.

There is a further sense in which Siopis's images of the body are transgressive, one that speaks of the impact of postmodernist ideas on her works. If Siopis used oil paint extensively in the 1980s, the visual tropes associated with painting are nevertheless taken to task in her works from this period. The materiality of pigment, for instance, is not presented by Siopis

simply as the means for making a painting, and nor indeed is an emphasis on the texture or 'facture' of pigment presented as a confident assertion of 'truth to materials', 'expressiveness' or other associations a modernist tradition would have viewers accept as valid. Rather, paint texture operates in terms of what Hutcheon defines as 'parody'. It functions as 'a form of imitation, but imitation characterized by ironic inversion' and it 'marks difference rather than similarity' (Hutcheon, 1995, p. 6). Likewise, spatial devices such as perspective are not so much 'used' as subject to critical scrutiny. While in some sense they are like the devices viewers recognize from well-known European 'masterpieces', the spatial constructions in Siopis's works are – more crucially – demonstrably distinct from their prototypes, and it is these differences, these ironical unlikenesses, that operate subversively.

Recognition of Siopis's engagement with the devices of art is important. Her art is informed by alertness to the ways in which an inherited visual language has, historically, been bound up with unequal relations of power. Visual devices have been implicated in the assertion of the primacy not only of 'male' over 'female', but also of 'white' over 'black'. Furthermore, the visual tropes that are subject to critique in Siopis's art are ones that articulate power relationships through the body. Both pigment and perspective have a history of being used in such a way that a depicted female body is divested of subjectivity, while the viewer/artist, disembodied and detached, asserts mastery through a controlling eye (or 'I'). By subverting the usual meaning of such conventions, Siopis's works address the ways in which visual devices function to bolster hierarchical differentiations that are sexist as well as racist, that construct 'female' and 'black' as simply the negative or 'other' of the terms 'male' and 'white'.

Body as Sweetmeat

In the early 1980s Penny Siopis worked on a series of paintings representing various forms of confectionery set out on tables or pedestals. Amongst this group of works is *Embellishments* (1982: see Plate 7 and Fig. 10.1), a painting that seems almost 'modelled' from the oil pigment that has been built up on its surface with a palette knife or piped with an icing syringe. Embedded within the confections on the tipped-up table are tiny plastic ballet dancers, the type normally used as cake decorations.

In this painting and others from the period, confections transmute into evocations of the female body. Although in some sense reminiscent of representations of the vagina in works by a first wave of feminist practitioners working in America in the 1970s, the images nevertheless depart radically from the essentialism underpinning those prototypes. Judy Chicago and the

Fig. 10.1. Penny Siopis, *Embellishments*, 150 cm × 202 cm (59 × 79½ inches), oil and plastic ballerinas on canvas, 1982, Collection of the University of the Witwatersrand, Johannesburg. Photograph by Wayne Oosthuizen.

women enrolled in her feminist programmes[4] were motivated by the idea of finding a supposedly intrinsic sense of womanhood by focusing primarily on biological signs of femaleness, indeed by working in the belief that an individual's identification as female was a matter of sex rather than gender. In contrast, the 'bodies' in *Embellishments* are marked by experiences of socialization as well as discourses speaking of 'femininity'.

Siopis's rosettes of pigment and leaping dancers in pink tutus evoke a rhyme no less popular in the nurseries of English-speaking South African female children in the 1950s and 1960s than in the nurseries of their British counterparts:

> Sugar and spice,
> And all that is nice.
> That's what little girls are made of.

Here, however, conventional signifiers of 'femininity' – the sugar, spice and all that is (apparently) nice – are less than compliant. 'Fleshy' pink and mocha hues, melded with allusions to white lace, suggest stained underwear, as if they were infused with the fluids of a seeping body rather than being palpable flesh. Equally, 'icing' tendrils which seem to splay between the central pink confection and the mocha one on its lower right, entrapping some of the figurines, allude uncomfortably to flayed flesh, ripped lace as well as a snare.

If *Embellishments* transmutes signifiers of 'femininity' in such a way that they refer to violation, it also confounds distinctions between the body and its clothing. Pointon (1990, pp. 119–20) notes that clothing 'is that which not only links the biological body to the social being, forcing recognition that the human body is more than a biological entity, but more clearly separates the two. The body with its open orifices is dangerously ambiguous: clothing negotiates those ambiguities, but it also conceals them.' In *Embellishments*, however, the dangerous ambiguities posed by the open orifices of the body are neither negotiated nor masked by clothing. If the confections represented allude to frilly garments, ones that would more 'normally' work to obscure and control bodily seepage, they are simultaneously the body's actual traces.

The bodies here appear to have collapsed, and this is especially significant. Rankin (1992, unpaginated) notes how the outer surface of the oil paint Siopis applied to her canvas 'dried fairly rapidly, as does icing on a real cake but a far slower transformation takes place in the oil paint within'. According to Rankin, this slowly drying pigment results in the work invoking reference to bodily decline: 'Its sluggish metamorphosis was intended to suggest the changes that take place in the human body over time – a process of deterioration and decay.' This emphasis was furthered through Siopis's 'incorporation of fragments of old dried paint from her palette into the new wet surfaces while she painted' (ibid.).

Allusions to bodily decrepitude entail a transgression of aesthetics that work to contain the female form within secure and clearly delineated boundaries. In an influential study of the female nude (dependent to some extent on the arguments of Douglas and Kristeva), Nead (1992) observes that western aesthetics, particularly classical conventions, provide a basis for ordering the female body into an image of unity and coherence, for negotiating a threat posed by a body understood to be dangerously wayward and inchoate. She suggests that the 'forms, conventions and poses of art have worked metaphorically to shore up the female body', that such devices have been intended 'to seal orifices and to prevent marginal matter from transgressing the boundary dividing the inside of the body and the outside, the self from the space of the other' (p. 6). The confectionery in *Embellishments* appears susceptible to the pull of gravity and quite evidently defies this imperative to regulate the female body.

Furthermore, *Embellishments* alludes to but also subverts a historical use of pigment in such a way that it becomes associated with touch and sexual possession. As feminist writers have revealed, the viscosity of pigment has frequently served as a sign for the tactility not merely of flesh but, more particularly, of female flesh. Reilly (1992, p. 88) has shown that writers on art during the Renaissance often invoked an opposition between a masculine *disegno* and a feminine *colore*, urging painters to use (female) coloured pigments in such a way that they would yield to the demands of the (masculine) overall design. Oil paint, she suggests, proved particularly suitable for equating coloured pigments with female flesh: 'Painters explored the viscous properties of the oil medium, experimenting with its body, texture and opacity. Indeed, they were described as actually adding skin and bones to their creations' (p. 91).

The idea that a painter may be capable of transmuting art materials into seemingly sentient female bodies would, in fact, end up becoming intricately linked with the idea of the artist as male, virile and sexually insatiable. Not surprisingly, the association of the painter and his brush with ravenous desire, and the pigment with receptive female flesh had, by the twentieth century, become something of a commonplace in male artists' commentaries on their works.[5]

In *Embellishments*, painterly tactility is pushed to its limits. The confections, rendered three-dimensional through piled up paint from which they are constituted, seem flagrantly palpable. Their flesh-coloured pigment, thick and tactile, invokes explicitly the idea of painting as possessive mastery. Ironically, however, the textural exaggeration operates in such a way that it defies its own ostensible purpose. While seeming as if they ought to be available and luscious, the confectionary bodies Siopis depicts are actually grotesque. Not unlike stage make-up that has begun to drip under the hot glare of theatre lights, signifiers of sensuousness – not only the 'feminine' rosettes or the lace, but also the tactile paint itself – seem to be collapsing and melting.

Rather than suggesting that flesh might be palpable but is simultaneously a shield denying recognition of (inner) body 'realities', pigment becomes both cosmetic and abject matter.

Embellishments, it might be argued, disturbs a possessive, controlling mode of viewing. If, as Nead (1992, p. 6) notes, the assertion of bodily boundaries and containment not only functions as a means of regulating the body itself, but also disciplines the 'wandering eye' of 'the potentially wayward viewer', then here, certainly, the eye is invited to wander.[6] This subversion is to some extent the outcome of Siopis's handling of pigment but it is reinforced through her treatment of space.

In *Embellishments*, as in other 'cake' paintings, the confections are placed on a table that is tilted upwards, and the viewer sees them less as objects occupying illusionistic space than as fragments of bodies on the painting surface. If the structure of the work in some sense parodies modernist spatial rhetoric (in particular the devices used in Cubism), it also invokes ironic reference to a tradition of representing reclining female bodies so that they are available for the viewer's delectation, in the words of Callen (1991, p. 165), 'spread out, iconic, and – where supine – tipped up towards the spectator'.

Simultaneously, however, a deliberate avoidance of linear perspective undermines the viewer's capacity to adopt a position of mastery. Pollock (1988, p. 64) speaks of linear perspective as a method of organizing a painting that 'establishes the viewer as both absent from and indeed independent of the scene while being its mastering eye/I'. Although Romanyshyn (1984, p. 96) does not adopt a feminist perspective, he makes a similar point when observing that linear perspective 'places us in the world in such a way that we become fixed, *immobile* see-ers, visionaries if you will, who gaze upon the world as an object, as something over against us and to be viewed with the detachment of infinite distance'. In *Embellishments*, however, there is no fixed position for viewing. More particularly, the tactile confectionery projecting into the spectator's space refuses to allow the work's surface to function as a type of transparent screen separating viewer from viewed.

Linear perspective, Romanyshyn (1984, p. 92) observes, 'inaugurates a psychology of infinite distance which has as its necessary precondition a denial of the body'. *Embellishments*, however, compels viewers to recognize their own embodiment. This is partially attributable to the perspectival inversion in the painting, to the fact that objects seem about to topple forward into 'real' space. More particularly, it results from Siopis's construction of a dense network of surface textures that work to privilege touch over opticality.

Richards (1986, p. 75) says of Siopis's *Melancholia* (Fig. 10.2), a painting made four years after *Embellishments*, that, rather than painting 'at arm's length, a "respectful" distance, the brush is turned round with the back (amongst other things) becoming the instrument of articulation'. The turned-around paintbrush is also used in *Embellishments*. Siopis (2003) indicates it

Fig. 10.2. Penny Siopis, *Melancholia*, 197.5 × 175.5 cm (77³/4 × 69 inches), oil on canvas, 1986, Collection of the Johannesburg Art Gallery.

became the means for creating 'the "lace" effect – through circular movements (like regulated scribbles) of the back of the brush into a wet layer of paint'. Hence here, as in the later painting, the artist favours 'a tactile, rhapsodic threading and weaving of matter', and here too the viewer 'is compelled to relinquish a safe viewing distance and move up to and about the surface' (Richards, 1986, p. 75).

Theatrical Encounters

Melancholia was one of a series of works from the mid-1980s in which Siopis represented not one, two or three isolated confections, but an elaborate feast. The piled up edibles and collectibles on tables in the elaborate hall are, in many instances, parodies.

The components of Frans Snyders' *Still Life with Meat Basket* (c.1640)[7] appear on the round table immediately behind the main table, while the work as a whole, with its overripe edibles, egg timer, shells and other elements invested with *vanitas* symbolism, invokes generic reference to Baroque still-life paintings. *Melancholia* also includes allusions to reproductions or copies of nineteenth-century sculptures, Estrany's *Dying Lucretia* (1834) amongst others, as well as Renaissance and Romantic paintings, such as Titian's *Sacred and Profane Love* (c.1515) and Gericault's *Raft of the Medusa* (1819). The title of the work is seemingly itself a parody. As Arnold (1996, p. 174) points out, it reminds one of Dürer's *Melencolia 1*, 'a highly complex sixteenth-century engraving loaded with symbolism and objects that have never yielded uncontested interpretation'.[8] Siopis's painting is also deliberately theatrical, with a swooped-up curtain conveying a sense that the staged spectacle, replete with various simulations of 'masterful' art, is being ceremoniously unveiled for the viewer.

The elaborate dining hall is represented via a series of orthogonals (receding lines) that ostensibly lead the eye into a deep spatial vista. However, pictorial space simply masquerades as traditional one-point perspective, a construction that would normally enable the spectator to adopt a secure and fixed viewing position. Excessively rapid in their recession, the Mannerist orthogonals seemingly pull the eye into a tunnel-like space. Simultaneously there is an emphasis on the tactility and colour saturation of all elements that counters any evocation of recession. A statuette or edible at the far end of the hall is rendered with the same minute attention to its particularities as is one in the immediate foreground, while a blazing orange, red and yellow infuses all elements. In this contradictory space, the eye that would seek out infinite distance finds itself destabilized. Pulled into depth in one instance, it is then, with equal speed, hurtled back out.[9]

Along with this disturbance is an acknowledgement that the disembodied but controlled form of looking associated with 'masterly' painting is not

simply a by-product of linear perspective, but is implicated in a gendered hierarchical opposition between subject and object as well as viewer and viewed. The painting makes clear the presence of the artist, not simply by recording her mark-making, but also via a self-portrait. Towards the right of the canvas, Siopis represents a mirror that ostensibly reflects her standing before *Melancholia*, in front of the canvas that the spectator is viewing. A parody of Velázquez's well-known painting in the Prado, *Las Meninas*, Siopis's spectral presence conflates the image of the seventeenth-century Spanish artist posed at the easel and the mirror reflection of the king and queen at the threshold of the room. Yet if Velázquez's depiction of self was, arguably, bound up in making a claim for artists to be accorded increased status (Brown, 1978, pp. 87–110), here Siopis focuses on the uncertain subjectivity accorded to female painters. Although *Melancholia* represents her reflection, her features are rendered with the same emphatic tactility, the same avoidance of atmospheric illusionism, as the three-dimensional bodies around her. A parallel to the sculpture of a woman with her stomach stripped open to reveal a foetus (a three-dimensional rendition of a seventeenth-century medical illustration[10] appearing on the left side of the painting), her spectre is also a component of a triumvirate including an adjacent statuette of the *Venus de Milo* and a replica of Michelangelo's *Dying Slave*. Siopis is, as it were, wedged in an unstable space, neither outside nor inside the painting.

Siopis (1999, p. 248) has observed that 'a "sexual politics" was first consciously encoded' in her 'cake' paintings of the early 1980s. Although she also suggests that the period in which she made *Melancholia* was one 'in which "excess" became the greater focus', this new interest did not simply imply a departure from her earlier concerns. Instead, these works marked a point when she began to invoke specific reference to South Africa in an apartheid context.

If the allusion to *Las Meninas* in *Melancholia* allows for a critique of looking and art-making as acts of possessive mastery, as I have indicated, Siopis's reference to *vanitas* imagery, also characteristic of Baroque painting, reads as an allusion to a decaying and corrupt white regime overburdened by its acquisitions. Pollock (1994, pp. 1–2) observes that, through the use of distinctly opaque oil paint in *Melancholia*, Siopis has constructed 'a Baroque allegory of excess and corruption, fruitfulness and rottenness, illusion and deceit'. She suggests that the painting 'reads as an allegory of South Africa – appearing to the white population as a place of plenty but always based on a violence which underpins and undermines it' (p. 2). Law (2002, p. 19) likewise indicates that *Melancholia* and other works from the mid-1980s 'set out to reveal the thickened artifice behind a faltering regime', and that the 'spoils of Empire, objects of myth and monument, are thickly painted into increasingly claustrophobic spaces – tables threatening to cave under the burden of luxury, mountains of affluence blocking out the horizon'.

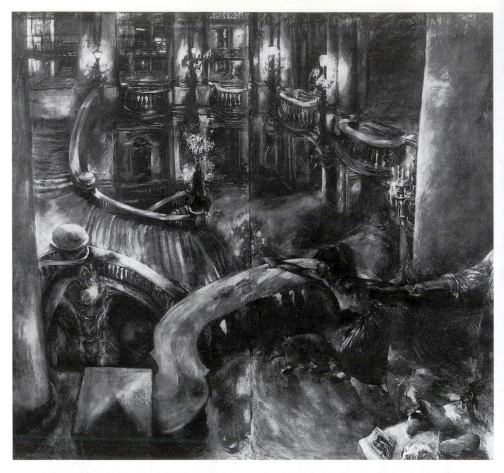

Fig. 10.3. Penny Siopis, *An Incident at the Opera*, 202 cm × 224 cm (79¹/₂ ×
88 inches), pastel on paper, 1986–87, Wits Art Gallery Collection, Johannesburg.
Photograph by Wayne Oosthuizen.

Melancholia and a contemporaneous work, *Unrequited*, won Siopis the
Volkskas Atelier Prize, enabling her to spend seven months in Paris in 1986.
An Incident at the Opera (1986–87; Fig. 10.3), made after her return, picks up
the implicit allusions to the stage in *Melancholia* but, unlike the earlier work,
represents a space that is, quite literally, a component of a theatre. Tour guides
at the Opera in Paris tell a story about a chandelier that once fell and killed a
young girl,[11] an anecdote that is not 'illustrated' by Siopis but is used to
explore ways in which a female might 'act out' trauma. The falling chandelier,
topless woman attracted not merely by light but seemingly compelled to reach

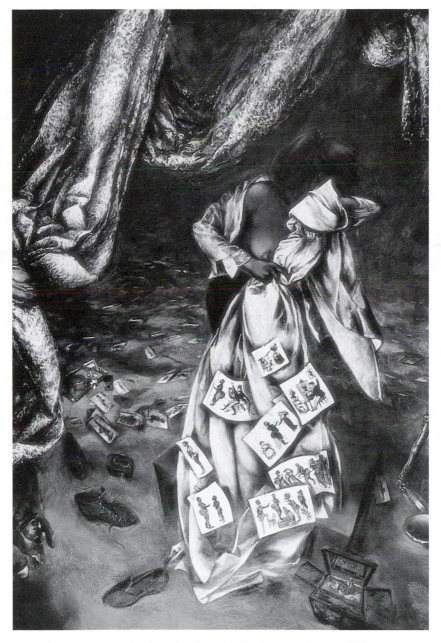

Fig. 10.4. Penny Siopis, *Dora and the Other Woman*, 153 × 120 cm (60^{1}/$_{4}$ × 47^{1}/$_{4}$ inches), pastel on paper, 1988, Private collection. Image cropped on left.

it, and male arm endeavouring to pull her away from the balcony, all allude to a theme that began to interest Siopis during her time in Paris – hysteria.

Siopis became especially fascinated by the figure of Dora (Ida Bauer) whom Freud had analysed. Eighteen years old when her father sent her for treatment, she 'had shown certain symptoms that Freud diagnosed as "hysterical" '. They 'were the result of Dora's involvement in certain familial sexual intrigues in which her father and close family friends were implicated' (Siopis, 1988). For Siopis, Dora's case was significant because of its re-consideration from a feminist perspective. 'I am particularly interested in those re-readings which see Dora (in particular) and hysteria (in general) in terms of women's resistance to patriarchal domination, or her protest against the colonisation of her body' (Siopis, 1988).

An understanding of hysteria as the refusal of patriarchal domination, a re-reading of the condition invoked implicitly in *An Incident at the Opera*, is explored further in *Dora and the Other Woman* (1988; Fig. 10.4). The word 'hysteria' is derived from the Greek word *hysteros*, which means womb (Ragland-Sullivan, 1992, p.163), and the 'Other Woman' in the title of the work is on one level a reference to the ways in which hysteria was presented as a symptom of the 'otherness' of woman in 'scientific' studies of the disorder. Particularly significant were the investigations of Charcot, the late nineteenth-century doctor who identified hysteria as a neurological problem. He organized photographs of women patients at the hospital for nervous diseases at Salpêtrière that endeavoured to document the affliction, breaking down this supposed disorder into manageable and explicable stages, ones he defined as Threat, Appeal, Supplication, Eroticism and Ecstasy. As Siopis (1988) notes: 'His "presentations" of hysterical patients became famous "scientific" spectacles, in which he displayed the afflicted patients before a select (male) audience.'

In *Dora and the Other Woman* hysteria is presented neither as an authentic signifier of female instability, nor as the symptom of a pathology about to be disclosed. Dora, who turns her head, covering her face with one arm, vaguely resembles Siopis herself, as does the female figure in *An Incident at the Opera*. By staging Dora in her own image, Siopis enacted the type of histrionic gestures that Charcot set out to visualize. Through this self-conscious role-playing, Siopis allies herself with feminists who re-read Dora's case, finding in her hysteria the visualization of resistance and rebellion against patriarchy, and the expression of dis-ease rather than disease.[12]

While alluding to the hysteric, the 'Other Woman' in the title of the work also refers to Sarah (Saartjie) Baartman, a Khoisan[13] woman shipped from South Africa to Europe in 1810 and toured as a sideshow spectacle, first in London and Bath, and subsequently in Paris. Known as the 'Hottentot Venus', Baartman was an object of fascination to Europeans not only because she manifested the condition of steatopygia (enlarged buttocks) but, even more invasively, because of the formation of her genitals known as the 'Hottentot

apron' or *tablier*. In Siopis's work, the various caricatures of Baartman that appeared in the popular press in England and France are pinned to Dora's drape or are scattered on the floor of the stage-like space. These representations point to the public's construction of Baartman's body as a manifestation of a primal sexuality, a reading that enabled her physiognomy to be considered 'evidence' that blacks belonged on a lower rung of the evolutionary ladder than whites.[14]

Apart from being scrutinized by a general public, Baartman was subjected to 'scientific' investigation. After her premature death on 1 January 1816, the French anatomist Cuvier dissected her corpse, including her genitals, and produced moulds of components of her body; these effects were stored in the Musée de l'Homme in Paris. Like the images of Baartman that appeared in the popular press, this collection of 'scientific' data – this compilation of physiognomic 'proof' of black otherness as well as the primal sexual compulsions of females – bolstered ideologies that were racist and sexist. As Coombes (1997, p. 120) noted in an interview with Siopis, 'her case obviously highlights very clearly the historical relationship between science, pathology and the masquerade of scientific objectivity, particularly in the development of racism. It also highlights the way in which women's sexuality, and black women's sexuality in particular, was pathologised and spectacularised.'[15]

If Sarah (Saartjie) Baartman was constructed as 'other' on the grounds of her physiognomy, Dora was marked as 'other' on the grounds of her hysterical response to sexual trauma. However, the two principles for constructing women as 'other' were not unrelated. Baartman's genitalia were interpreted as visible signs of her primitive sexual drives, and Dora's hysteria was, likewise, envisaged as a marker of dark primal urges awaiting discovery by the intrepid explorer/scientist. As Siopis (1988) put it, 'Freud's comment about female sexuality being "the dark continent" of psychology connects Dora and Saartjie.'

Siopis invokes the visualization of Baartman's 'otherness' through her quotation of caricatures that include the paraphernalia of optics – the magnifying glass, spectacles and binoculars, for example. This emphasis on visualizing, on revealing, can be interpreted in light of what Foucault, in the first volume of *History of Sexuality* (1978), termed a *scientia sexualis*, a form of hermeneutics aimed at extracting truths or confessions about sex.

In Freud's study of Dora, less than a century after Baartman had been caricatured and dissected, a *scientia sexualis* manifested itself via psychotherapy. The jewel-box that appears in the bottom right-hand corner of *Dora and the Other Woman* was, Siopis (1988) indicates, 'part of the narrative of the first of her [Dora's] two dreams' and 'was interpreted as symbolising her genitals – as were so many other "significant" things that appeared therein'. An emphasis on the 'container' alludes in turn to the packaging and bottling of traces of Baartman's body (an idea reiterated by the specimen jar which

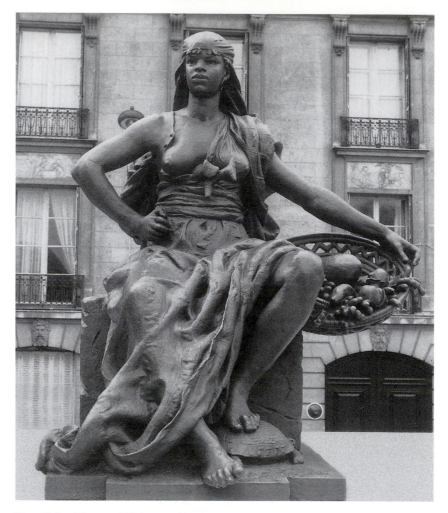

Fig. 10.5. Figure of *Nubia* outside the Musée d'Orsay, Paris. Photograph by Penny Siopis in 1988.

figures amongst the objects Siopis has depicted scattered on the floor). It is also suggestive of yet another manifestation of a *scientia sexualis* – the casts of African women's genitals displayed at the Musée de l'Homme. These are described by Coombes (1997, p. 122) as being 'totally disembodied with anus and vagina wrapped in cloth, in a kind of fetishistic embrace with the cloth opening out onto the plaster casts of truncated genital areas'.

Stage-like and with its swept-back curtain, the space represented here – like the opened jewel-box – implies sexual disclosure. However, this theatrical arena also suggests that ideas about female sexuality invoked by the work are 'enactments' rather than 'truths' or essences. Two gold picture frames are positioned on the stage. One, adjacent to the figure of Dora and cut by the right edge of the work, encloses a mirror, while the other, situated in the middle-distance, surrounds the specimen jar as well as a fragment of one of the caricatures of Baartman. Siopis (1988) acknowledges that these allusions to the devices of framing emphasize that the discourses quoted in *Dora and the Other Woman* are 'constructed, sometimes quite artfully' and are thus 'a matter of convention, not "nature" or some sort of "essential identity"'.

Embodied Histories

Emerging from behind the curtain, on the lower left of *Dora and the Other Woman* are two black hands peeling a lemon. (Fig. 10.4 is cropped on the left but the peel is just visible.) Suggestive perhaps of time unravelling as well as human skin, it evokes a sense of a bitter history. In *Patience on a Monument – 'A History Painting'* (1988; see Plate 8) the lemon re-appears. A black woman sits on the top of a 'monument', which is also a mound of waste, peeling a lemon skin. A second lemon, alluding ironically to the image of the orb in representations of British rulers such as Queen Victoria, is propped on her lap.

The woman parodies one of the allegorical figures depicting the continents of the colonial world outside the Musée d'Orsay in Paris, a sculpture entitled *Nubia* (Africa) that Siopis photographed during a second trip to Paris in 1988 (Fig. 10.5). The seated, sculptural figure of Nubia, one breast bared, holds a basket of fruit on her hip, thus personifying Abundance. Much like the figure of *Dovizia* that Donatallo made to adorn the commercial centre of fifteenth-century Florence,[16] Nubia celebrates the acquisition of wealth, in this context wealth founded on the spoils of colonial conquest. In *Patience on a Monument – 'A History Painting'*, however, there is no overflowing basket of fruit signifying plenty, but rather a giant detritus.

Nubia has transmuted into a domestic servant. The woman who modelled for Siopis adopted a pose similar to that of a domestic worker, Annie Mavata or 'Cookie', in a painting by Dorothy Kay (1956).[17] Here, however, domestic work is not excised from its roots in an ignominious history of acquisition and dispossession, conquest and enforced submission. If the figure in *Patience on a Monument – 'A History Painting'* refers to the Nubia sculpture, it is simultaneously a parody in its imagery and title of an abolitionist work Siopis encountered in her childhood – Thomas Nast's *Patience on a Monument*. A wood engraving first illustrated in *Harpers' Weekly* in 1868, Nast's work depicts a black man seated in a melancholic pose on an obelisk-like

monument. Listed on the monument are atrocities perpetrated against slaves and racist pronouncements of the period, and a dead woman and child lie at the base of the structure.[18] In Siopis's work, the notion that patience might be a virtue is, needless to say, peppered with irony.

An Incident at the Opera and *Dora and the Other Woman* are works in pastel on paper. *Patience on a Monument – 'A History Painting'*, like the other 'history paintings' Siopis would make in the course of the next two years, is not strictly speaking a 'painting' either, despite its title. It is a mixed-media work incorporating hundreds of small photocopied images cut out and glued to its surface.[19] The photocopied images have been overlaid in great profusion, and the work has a dense, tactile surface, apparently teeming with activity. *Patience on a Monument – 'A History Painting'* features, Siopis (1988) observes, 'adventurers, missionaries, boers, black warriors, tribal settlements, slaves, workers, British settlers, redcoats, wild-life, rugged countryside, battle scenes, etc. etc.', precisely the sorts of illustrations that appeared in textbooks read by schoolchildren during the apartheid years. Generic, indeed stereotyped, these images invoke a history of South Africa that is not only characterized by heroic action and productive change, but which also links courage and progress with white agency.

Patience on a Monument – 'A History Painting', while not a painting as such, engages with 'history painting' as well as the history of painting. Amongst its many references are allusions to the convention painters use to suggest deep recession: the collaged elements diminish in scale in accordance with their spatial positions. The vast space invoked alludes, specifically, to the panorama. When used in colonial history painting, Pollock (1994, p. 3) observes, the panorama conveys the idea that the territory represented is untouched by the forces of civilization and thus awaits settlement: 'Images of pioneers and voortrekkers, missionaries and discoverers are part of a language of imperial conquest where other people's worlds are remapped as blank, vacant, available. On this *tabula rasa* the coloniser maps himself as master.'

If *Patience on a Monument – 'A History Painting'* refers to the panorama, the premises of this representational mode are simultaneously unhinged. As in *Melancholia*, hot, saturated colour and all-over tactility counter illusionism. Furthermore, the collaged elements form a dense network that seems to enmesh and abrade the surface. Indeed, the illustrations of colonialist heroics in the work appear to be constituted as a melanoma, a disease on the 'skin'. The viewer is not encouraged to read the represented space as a vast, apparently uninhabited landscape receding into depth and possessing almost unlimited breadth. The eye/I that might seek to penetrate this ostensibly immense space is obstructed and deflected by the thick mesh of collage.

In *Patience on a Monument – 'A History Painting'* collaged forms are constituted into a palpable membranous surface. In *Cape of Good Hope – 'A*

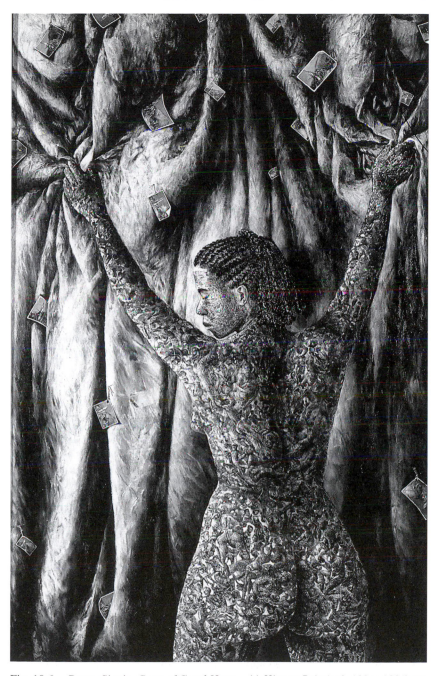

Fig. 10.6. Penny Siopis, *Cape of Good Hope – 'A History Painting'*, 182 × 123.9 cm (71^1/$_2$ × 48^3/$_4$ inches), oil, wax and collage on board, 1989–90, Private collection.

History Painting' (see Fig. 10.6), begun in 1989 and completed in 1990, collage is explicitly skin. Viewed from the back and with upraised arms clutching a blue curtain, the female represented in this work is 'modelled' from photocopies that form dense welts across her body.

Attached to the curtain are reproductions of an 1850 painting by Charles Bell depicting Jan van Riebeeck's arrival at the Cape of Good Hope in 1652, an event long-since celebrated as a founding moment in white accounts of South African history. Whether in written or visual discourses, this event represented the idea that the Dutch set foot on a terrain fundamentally primal and 'natural', one awaiting taming and shaping by the productive forces of 'civilization' and 'culture'. 'The Cape of Good Hope', a name conferred after the Portuguese explorer Bartholomeu Diaz reached the southern tip of Africa in 1488, was grimly ironic. Khoisan groups living in the area found their social structures entirely disrupted a few decades after Van Riebeeck's party arrived.[20]

The word 'Cape' in the title operates as a pun. In addition to designating a promontory, 'cape' means 'mantle': in this instance it alludes to the bodily markings, the collaged tattoos in which the figure is 'cloaked'. Siopis (2002) indicates that nineteenth-century illustrations of slavery were her primary source for the collaged elements used to shape the arms, back, buttocks and legs of the figure. As when making *Patience on a Monument – 'A History Painting'*, she looked to abolitionist images she remembered affecting her as a child, such as an illustration of slaves in the hold of a ship by Johann Moritz Rugendas.[21] The female figure's face, however, was collaged with traces from a conceptually related but more specifically South African case of dispossession, enforced relocation and loss, that of Sarah Baartman. Siopis (2002) observes that she used text photocopied from an archival photograph of Baartman's baptismal and death certificates that she acquired at the Musée de l'Homme. However, she deliberately fragmented this language of officialdom, rendering it incoherent. Split into many pieces, these documents become as 'speechless' as the dismembered and traumatised 'other' whose history they supposedly record.[22]

In *Cape of Good Hope – 'A History Painting'* folds in the blue curtain resemble waves and the figure's body becomes not merely a form marked by the horrors of slavery, but also, by association, a slave ship traversing the oceans. Doubtless Siopis had in mind a copper engraving illustrating the *Brookes* of Liverpool (1789).[23] This abolitionist diagram of the plan and cross section of a slaver includes an indication of the masses of captive bodies it was designed to accommodate, and Siopis had incorporated photocopies of these lined-up figures in an earlier collage, *Flesh and Blood* (1987).[24]

Illustrations of slave whippings often represent the disciplined body in a stance similar to that represented here. However, the pose adopted by the model Siopis employed to 'sit' for the work has further allusions. Siopis (2002) indicates that she also recalls the victim with upraised arms in Goya's

The Third of May, 1808 (1814–15), and a photograph of mineworkers stripped for a medical examination. Furthermore she thought of a photograph that appeared in *The Weekly Mail* newspaper in April 1987, accompanying a report of a police siege of the COSATU (The Congress of South African Trade Unions) headquarters.[25] Visible in this exterior image of the building are activities in its interior, people whom the police have evidently instructed to 'raise their arms' are lined up against the windows or walls.

By invoking reference to COSATU's headquarters, it seems that Siopis was not simply linking police brutality in apartheid South Africa with the atrocities of slavery and colonialism, but also reflecting on a lost capacity to speak out and assert one's subjectivity. The body with upraised arms is incapacitated, divested of agency; it enacts the effects of the apartheid government's efforts to subdue and silence journalists endeavouring to expose its machinations. The report on the COSATU incident in *The Weekly Mail* was censored, as were many other articles in that newspaper during the 1980s. Indeed the front page of the April 1987 issue where the photograph of the headquarters of COSATU is reproduced also includes the following statement: 'THE CONTENTS OF THIS NEWSPAPER HAVE BEEN CENSORED IN TERMS OF EMERGENCY REGULATIONS.'[26]

Cape of Good Hope – 'A History Painting' focuses on traumas that worked to render bodies 'abject' in the popular or common sense of the word, that is, 'wretched' or 'miserable'. However, it invokes these allusions through an emphasis on the 'abject' in the sense that Kristeva uses this term. The central motif in the work is tattooed flesh that has been cut, has bled, carries traces of infection and speaks of bodily seepages. These scorings and spillages signify resistance to discourses seeking to sustain bodily integrity and clearly differentiate between the space of 'self' and 'other'. However, the represented body, marked by colonialism and apartheid, is also allegorical. It is in a sense *itself* the country or the state. Indeed, the tattoo represented here *is* The 'Cape' of Good Hope. Understood in these terms, the tattoo transgresses boundaries and systems of management that structure not only the body but also the social and political domain. More specifically, it is the signifier of a refusal to blot out and smooth over the atrocities of a colonialist history, and it is a statement of opposition to the regulations and classificatory principles deployed to police the apartheid state.

Beyond the 1980s

Patience on a Monument – 'A History Painting' and *Cape of Good Hope – 'A History Painting'* were included in an exhibition entitled 'History Paintings', held at the Goodman Gallery in Johannesburg at the end of 1990. In her review of the show, Friedman (1990, p. 4) emphasized the artist's

departure from paint on canvas. Viewers, should not expect to find 'the lavish, illusionistic interiors' that, for many, had become the hallmark of her style, but instead 'works that resemble museum exhibits, framed in perspex plated, black boxes' as well as 'collages, "found" historical objects, painted over photocopies of 19th century popular engravings; even illustrations from high-school text books'. In subsequent years, Siopis would further this interest in mixed media by producing a number of installations as well as videos.

Siopis's works have never focused exclusively on public histories, but have always in some sense been about personal and private experiences as well. When speaking of the multi-layered references she used in *Patience on a Monument – 'A History Painting'*, Siopis (1999, p. 252) indicated that these 'give a sense of how the personal inveigles its way into even the most public, most politically shaped of works'. However, the balance between public and personal histories appears to have undergone a shift in Siopis's works from the 1990s.

Siopis's growing interest in psychoanalytic theories, especially ideas around 'the maternal', developed out of her concern with self/other and subject/object relations that she began exploring in the 1980s. Working from her own experience as the mother of a son, Siopis began to investigate how 'the loss entailed for the mother in giving her child a "voice" – his (male) subjectivity – entails sacrificing her own' (1999, p. 256). Simultaneously, she began to explore how this loss, this sacrifice of subjectivity, might have had particular kinds of impacts on black 'nannies', women who have long assumed the role of surrogate mothers to white children in South Africa. Exploring this dynamic, Siopis drew on recollections of her childhood. In her 'Tula Tula' (1993–94) series of works she focused specifically on an image from her past, a photographic negative from the 1950s showing her brother and the domestic servant employed to take care of him.[27]

If progressive artists working in the 1980s were united by a common imperative to express their outrage at the iniquities of apartheid, the nature of politically engaged art required revision in a post-apartheid context. Speaking of the changes in her own works and in those of other artists, Siopis (2001) comments: 'Our current passions may have less to do with larger ideals of the struggle (which have mostly been achieved in the obvious sense), than with the particular, the ordinary, the everyday, the intimate.' This does not of course mean that these meditations on the personal have nothing to do with a larger political context and Siopis (2001) emphasizes that 'no matter how these micro-narratives surface now, no matter what form they take, they remain entangled in our apartheid past'. What it implies, rather, is that the private or 'micro-narrative' that might perhaps once have been dismissed as trivial or self-indulgent has instead been recognized as a potent signifier of an impetus to remember and reflect on a troubled history.

An important underpinning for a new emphasis on personal histories and memory was the Truth and Reconciliation Committee (TRC) hearings, which

not only provided a framework for suppressed information to be revealed to the South African public but also placed emphasis on individual experiences and stories. Acknowledging that the TRC was in one sense about a politics of spectacle, and that it garnered wide media publicity, Siopis (2001) nevertheless indicates that the 'spectacle presented by the TRC … is not about exorbitant exteriority, but about interiority, introspection and intimacy. It is driven by looking backwards and inwards in the spirit of a search, an unsparing if partial quest to reveal exactly what happened and why. In detail.'

Considered in this light, it is neither unexpected nor inappropriate that a focus on the personal, always a presence in Siopis's works, should have become increasingly emphasized after 1994.[28]

Notes

1. See Araeen et al., 1995, pp. 100–101 for artists whose works were included in the show.

2. The exhibition included her installation *Permanent Collection* (1995). For further discussion of this work see Richards, 1995.

3. Born in 1953, Penny Siopis completed her Bachelor of Fine Art at Rhodes University in Grahamstown in 1974 and studied for a Master of Fine Art degree at the same institution. In 1978 she did a postgraduate diploma at Portsmouth Polytechnic, England, and returned to South Africa in 1980, taking up a position at the Natal Technikon in Durban. She has taught Fine Art at the University of the Witwatersrand in Johannesburg since 1984.

4. I refer to programmes Chicago set up at Fresno State College, now California State University, Fresno, and the California Institute of the Arts, 1970–75. See Wilding, 1994.

5. Vlaminck declared that he tried to paint 'with his heart and loins, not bothering with style' (quoted in Chipp, 1968, p. 144). Kandinsky, in turn, likened his canvas to 'a pure chaste virgin' submitting to his 'wilful brush which first here, then there, gradually conquers it with all the energy peculiar to it, like a European colonist' (quoted in Kozloff, 1974, p. 46).

6. Applying Norman Bryson's ideas about distinctions between the 'gaze' and the 'glance' to Siopis's painting, one deduces that it invites the latter mode of looking. Bryson suggests that paintings or drawings that expose transitions and shifts occurring during the making process encourage viewing via the 'glance'. The glance 'addresses vision in the durational temporality of the viewing subject' and 'does not seek to bracket out the process of viewing, nor in its own technique does it exclude the traces of the body in labour' (Bryson, 1983, p. 94). Works that obliterate signs of the making process invite access via the gaze. This leaning toward an elimination of signs of process results in works that encourage a 'synchronic instant of viewing which will eclipse the body, and the glance, in an infinitely extended Gaze of the image as pure idea' (ibid.).

7. Siopis's source was a reproduction on a postcard sent to her when she was living in Durban.

8. See Richards, 1986, pp. 74–5 for a comprehensive discussion of the sources Siopis parodied.

9. I am indebted to the discussion of space offered by Richards, 1986, pp. 75–6.

10. Richards (1986, p. 80) observes that the image was taken from Adrian Spigelius,
 De Formato Foetu (1626), a medical illustration made in Padua.
11. Siopis mentioned this to me in an informal conversation in the late 1990s.
12. Siopis (1988) comments: 'As re-read, hysteria, commonly considered the
 disease of the "other", is reclaimed as woman's (the other's) dis-ease, potentially
 both resistant and affirmative, something positive.'
13. Khoisan people are also referred to as the 'Khoikhoi'. It is thought that their
 ancestors were 'Bushmen' or 'San' who came into contact with groups who
 possessed sheep and cattle, and subsequently began combining the practices of
 hunting and gathering with keeping flocks and herds.
14. See Arnold, 1996, pp. 25–7 for a useful discussion of representations of
 Baartman. One of the images that Siopis parodies is reproduced on page 25 of
 Arnold's book.
15. Baartman's remains were returned to South Africa in May 2002 and
 ceremonially buried in Hankey in the Eastern Cape on 9 August (Women's Day)
 2002. Hankey is a small town approximately 70 km (43^1/2 miles) from Port
 Elizabeth, close to the Gamtoos River, that is accepted as Baartman's birthplace.
 During the official celebrations of the return of her remains in May, Baartman
 was mostly identified as 'Saartjie', but she was called 'Sarah' (the name
 recorded on her certificate when she was baptised in Manchester in 1811) in
 speeches made at the August ceremony. 'Saartjie' takes cognisance of the fact
 that most people identifying themselves as Khoisan or their descendants are
 Afrikaans speakers. However, this designation includes the diminutive '*jie*' and
 is thus perhaps inappropriate for a woman who has emerged as an icon for South
 Africans seeking to remedy colonial and apartheid injustices.
16. Bennett and Wilkins (1994, p. 71) write that the Commune 'awarded him the
 commission for the *Dovizia*, a representation of Communal Abundance and
 Wealth, which stood on a column in the Old Market. The statue has been lost
 …[but a] general reconstruction of the monument can be made from its image in
 paintings and from several della Robbia variations. It was an idealized allegory,
 heroically scaled, and towering about the Mercato Vecchio, the commercial
 centre of Florence.'
17. Dorothy Kay, *Cookie, Annie Mavata*, 69 × 57 cm, oil on canvas, 1956, Pretoria
 Art Museum. See Arnold, 1996, plate 47 for a good-quality colour reproduction
 of the work.
18. Thomas Nast, *Patience on a Monument*, 35.6 × 23.8 cm, wood engraving, 1868.
 See Honour, 1989, p. 245 for a reproduction of the work. Siopis (1999, p. 252)
 also notes that her mother would 'often ask (rhetorically) of our daydreaming:
 "What are you doing sitting there like Patience on a Monument?"' Both Nast and
 Siopis's mother presumably had in mind Shakespeare's *Twelfth Night*, II. iv. 111:
 'And with a green and yellow melancholy/She sat like patience on a monument/
 Smiling at grief.'
19. The glue that Siopis used to attach each motif to the surface is transparent when
 dry, and thus, as Rankin (1992, unpaginated) notes, provided 'a ground on which
 the artist … [was able to] draw and paint', enabling her to rework some images
 while over-painting others.
20. Apart from setting themselves up in competition with the Khoisan for land and
 livestock, the Dutch incited conflict between different Khoisan groups. They also
 brought European diseases to the Cape, notably a plague of smallpox that killed
 hundreds of Khoisan people in 1713. By the early eighteenth century, most Khoisan
 in the area were too impoverished to maintain an independent existence and were
 obliged to support themselves by seeking employment from the colonists.

21. Johann Moritz Rugendas, Illustration for *Voyage pittoresque dans le Brésil*, 1827–35. *Nègres à fond de calle*, 15.4 × 25.5 cm, lithograph by I.L. Deroy, 1827. See Honour, 1989, p. 145 for a reproduction of the lithograph.

22. The fragmented clippings from history that constitute tattooed skin form an ironic counterpoint to the figure's tightly woven braids adorned with brightly coloured ribbons and emphasized by being fashioned from wax combined with oil paint (Siopis, 2002). As Siopis (quoted in Friedman, 1990) observes, braids have historically 'been directly connected with black affirmation'.

23. Pan and cross-section of a slaver, the *Brookes* of Liverpool, 60.4 × 50.4 cm, copper engraving, 1789. See Honour, 1989, p. 65 for a reproduction of the work.

24. Penny Siopis, *Flesh and Blood*, pastel and collage on paper, 1987. See Rankin, 1992, for a black-and-white reproduction of the work. Produced for an exhibition focused on raising funds for detainees who had been held without trial, it has a dead quail at its centre as well as images of slavery and torture – including a 'frame' of figures collaged from a photocopy of the representation of the *Brookes* of Liverpool. See Siopis, 1999, pp. 250–51 for the artist's own comments about the work.

25. The photograph is labelled 'Up against the wall … Cosatu House on Wednesday evening, the night of the police siege'. The identity of the photographer is not recorded. The writer of the article, headlined 'Behind the barricades', is Sefako Nyaka (*Weekly Mail*, 1987).

26. Censored by the Emergency Regulations, *The Weekly Mail* (now *The Mail & Guardian*) exposed these incursions into its reports by refusing to obliterate them through reframing texts into seamless narratives. Instead it showed where its text had been blackened out or, alternatively, would include 'censored' wherever it had been forced to excise copy.

27. See Richards, 1994, p. 10 for a colour reproduction of Penny Siopis, *Tula Tula 1*, 111 × 67 cm, mixed media, 1993–94.

28. I am extremely grateful to Penny Siopis for providing me with information about her works and sources, and for offering thoughtful commentary on a draft of this essay. I thank Wayne Oosthuizen for taking excellent photographs of works in the Wits Art Collection, and Julia Charlton for facilitating this. I also thank Brent Meistre for printing images.

References

Araeen, Rasheed et al. (1995), *Africus: Johannesburg Biennale*, Johannesburg: Greater Johannesburg Transitional Metropolitan Council.

Arnold, Marion (1996), *Women and Art in South Africa*, Cape Town: David Philip.

Bennett, Bonnie A. and Wilkins, David G. (1994), *Donatello*, Oxford: Phaidon.

Brown, Jonathan (1978), *Images and Ideas in Seventeenth-Century Spanish Painting*, Princeton: Princeton University Press.

Bryson, Norman (1983), *Vision and Painting: The Logic of the Gaze*, New Haven: Yale University Press.

Callen, Anthea (1991), 'Degas' bathers: hygiene and dirt – gaze and touch', in Kendall, Richard and Pollock, Griselda (eds), *Dealing with Degas: Representations of Women and the Politics of Vision*, London: Pandora Press, pp. 159–85.

Chipp, Herschel (1968), *Theories of Modern Art*, Berkeley: University of California Press.

Coombes, Annie E. (1997), 'Gender, "race", ethnicity in art practice in post-apartheid South Africa: Annie E. Coombes and Penny Siopis in Conversation', *Feminist Review* 55, Spring, 110–29.

Douglas, Mary (1966), *Purity and Danger: An Analysis of the Concept of Pollution and Taboo*, London: Routledge and Kegan Paul.

Foucault, Michel (1978) *The History of Sexuality*, vol. 1: *An Introduction*, trans. Robert Hurley, London: Allen Lane.

Friedman, Hazel (1990), 'Siopis fans may be shocked by new exhibition', *The Star*, 14 December, 'Tonight' section, 4.

Honour, Hugh (1989), *The Image of the Black in Western Art*, Cambridge and London: Harvard University Press, vol. 4, part 1.

Hutcheon, Linda (1985), *A Theory of Parody: The Teachings of Twentieth-Century Art Forms*, London and New York: Routledge.

Kozloff, Max (1974), 'The authoritarian personality in modern art', *Artforum*, May.

Kristeva, Julia (1982), *Powers of Horror: An Essay on Abjection*, trans. Leon S. Roudiez, New York: Columbia University Press (published in French in 1980).

Law, Jennifer (2002), *Penny Siopis: Sympathetic Magic*, Johannesburg: Gertrude Posel Gallery (exhibition catalogue).

Nead, Lynda (1992), *The Female Nude: Art, Obscenity and Sexuality*, London: Routledge.

Pointon, Marcia (1990), *Naked Authority: The Body in Western Painting*, Cambridge: Cambridge University Press.

Pollock, Griselda (1988), *Vision & Difference: Femininity, Feminism and the Histories of Art*, London and New York: Routledge.

———— (1994), 'Painting, difference and desire in history: the work of Penelope Siopis 1985–1994', unpublished transcript of essay supplied to me by the artist.

Ragland-Sullivan, Ellie (1992), 'Hysteria', in Wright, Elizabeth (ed.), *Feminism and Psychoanalysis: A Critical Dictionary*, Oxford: Blackwell, pp. 163–6.

Rankin, Elizabeth (1992), *The Baby and the Bathwater: Motif, Medium and Meaning in the Work of Penny Siopis*, Johannesburg: Imprimatic (exhibition catalogue).

Reilly, Patricia (1992), 'The taming of the blue: writing out color in Italian Renaissance theory', in Broude, Norma and Garrard, Mary (eds), *The Expanding Discourse: Feminism and Art History*, New York: Harper Collins, pp. 87–99.

Richards, Colin (1986), 'Excess as transgression: reducing surface to depth in the still-life paintings of Penny Siopis', paper presented at the Second Conference of the South African Association of Art Historians, Johannesburg.

———— (1994), *Penny Siopis*, Johannesburg: The Artist's Press (exhibition catalogue).

———— (1995), 'Retaining this fire: comments on contemporary South African art', in *AtlAntica*, Las Palmas: Atlantico De Arte Moderno (exhibition catalogue).

Romanyshyn, Robert D. (1984), 'The despotic eye: an illustration of metabletic phenomenology and its implications', in Kruger, Dreyer (ed.), *The Changing Reality of Modern Man: Essays in Honour of Jan Hendrik van den Berg*, Cape Town: Juta, pp. 87–109.

Siopis, Penny (1988), unpublished notes which the artist supplied as reference material for Williamson, Sue (1989), *Resistance Art in South Africa*, Cape Town: David Philip.

———— (1999), 'Dissenting detail: another story of art and politics in South Africa', in Atkinson, Brenda and Breitz, Candice (eds), *Grey Areas: Representation, Identity and Politics in Contemporary South African Art*, Johannesburg: Chalkham Hill Press, pp. 245–66.

———— (2001), 'Home movies: a document of a South African life', draft of an article for inclusion in Picton, John and Law, Jennifer (eds), *Divisions and Diversions: The Visual Arts in Post-Apartheid South Africa*, London: Saffron.

———— (2002), unpublished e-mail correspondence with the author, 17–18 December.

———— (2003), unpublished e-mail correspondence with the author, 15 January.

Weekly Mail (1987), 24 to 29 April, 1–3.

Wilding, Faith (1994), 'The feminist art programs at Fresno and Calarts, 1970–1975', in Broude, Norma and Garrard, Mary (eds), *The Power of Feminist Art: The American Movement of the 1970s, Power and Impact*, New York: Harry N. Abrams, pp. 32–47.

Index

NB: numbers in *italics* represent illustrations; numbers in **bold** represent text and illustration

Botha, Louis 1
Brink, Elsabé 97
Bryant, Revd 114
Buffalo River 132
Burnett, Ricky 180
Buthelezi, Regina, *Once There Came a
 Terrible Beast 14*

Cairo International Exhibition for Ceramics
 (1994) 140
Callen, Anthea 202
Cameroon 117
Cape 1, 3, 61
Cape Colony 96, 99, 101–2, 104
Cape of Good Hope 212, 214, 215
Cape Town 1, 11, 17, 35, 37, 39, 42, 43, 52,
 57, 64, 145
Cardew, Michael 142
Carolina (Eastern Transvaal) 52
Caversham Mill 146
ceramists 22; Anglo-Orientalist 133, 139, 142;
 and Ardmore Studio 146–8; at Rorke's Drift
 134–5, 138–9; and curio market 141;
 gender/race aspects 132–8; rural Zulu
 women 139–41; technical problems 135;
 tradition in 132, 138, 139; and University of
 Natal 141–6; Western modes 134–5, 139;
 women as 134, 135, 138
Charcot, Jean Martin 208
Chivirika project 23, 155, 163, 164;
 acceptance of 162; and apartheid 159; and
 assertion of culture/identity 159, 162;
 establishment of 158–9; and female
 dependency 160–61; focus on *minceka*
 159–60; political consciousness of 167; and
 social stratification according to age 161–2
Clark, Garth 138
Coetzer, W.H. 99, 106, 107, 108
Collett, David P. 118
Comaroff, Jean 76
Comaroff, John 76
Congo 52, 64
'Congress of the People' (1955) 6
Congress of South African Trade Unions
 (COSATU) 215
Connaught, Duke of 41
Coombes, Annie E. 210
Craft Council 140
Craft House of Venda 180
Cruise, Wilma 24; *Strike the Woman Strike the
 Rock* 24, **26**–7

Cultural Growth Strategy 169
Cuvier, Georges 209

Dakar 64
Delegorgue, Adulphe 113–14
Delius, Peter 78
Dessau 83
Diamini, Laurentia 114, *115*, 116
Diaz, Bartholomeu 214
Dibakwane, Phyllis 169
District Six (Cape Town) 5
Ditchburn, Hilda Lutando 22, 142–5
Dlamini, Laurentia 127
Donatello, *Dovizia* 211
Dora (Ida Bauer) 208–11
Dorkay House 180
Douglas, Mary 197
Drakensberg Mountains 104
Dublin 34, 39, 43
du Plessis, Antoinette 166
Durban 35, 61, 140, 153
Durban Technikon 146
D.W.T. Nthathe Adult Education Centre 166
Dyambou 186

Eastern Transvaal 56
Eaton, Norman 83–4, 88
Edwards, Elizabeth 73, 75
Elisofon Archive 83
embroidery *see* Chivirika project; Kaross
 Workers; Mapula project; Voortrekker
 Tapestry (Pretoria); Xihoko project
Enloe, C. 53
Eshowe 140
Eskildsen, Ute 75
Evangelical Lutheran Arts and Crafts Centre
 (Rorke's Drift) 7, 22, 124, 132, 133–5,
 138–9
Everard, Bertha 16, 20–21; abandons painting
 60, 66; art training 55; birth/career 52, 54;
 Delville Wood paintings 58; in Europe
 57–8; and feelings about nature 55, 56–7;
 and identity 52–3; *Looking Towards
 Swaziland* 57, 58; *Mid-Winter on the
 Komati River* 55; *The New Furrow* 58, *59*,
 60; reputation 54; style of 58, 60
Everard, Ruth 54, 56

Federation of South African Women (FSAW) 6
Findlay, Bronwen 153, 155
Fingo 17